What Great Paintings Say

Old Masters in Detail

Volume II

This book was printed on 100% chlorine-free bleached paper
in accordance with the TCF standard.

© 1996 Benedikt Taschen Verlag GmbH
Hohenzollernring 53, D-50672 Cologne
© 1995 for the illustrations of Marc Chagall and Otto Dix:
VG Bild-Kunst, Bonn

English translation: Iain Galbraith, Wiesbaden
Coverdesign: Angelika Muthesius, Cologne

Printed in Italy
ISBN 3-8228-8904-0
GB

What Great Paintings Say

Old Masters in Detail

Rose-Marie & Rainer Hagen

Volume II

TASCHEN

KÖLN LISBOA LONDON NEW YORK PARIS TOKYO

Contents

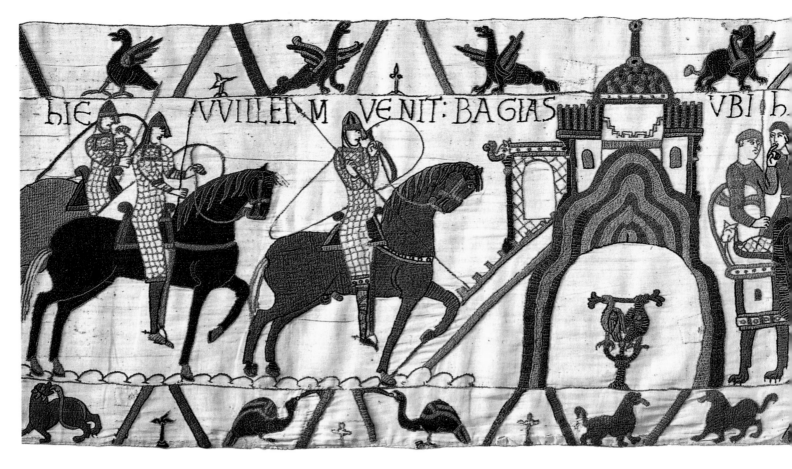

Artist unknown: The Bayeux Tapestry, after 1066

Propaganda on cloth

First exhibited at Bayeux Cathedral in 1077, the tapestry
(0.5 x 70.34 m) marks a turning-point in European history: it tells
the story of William the Conqueror's victory over the English army
at Hastings in 1066. The work now hangs in the Centre
Guillaume Le Conquérant, Bayeux.

In 1025, at the Council of Arras in northern France, the clergy decided to embellish their churches with decorations of a new type. Historical events and figures were to be portrayed on cloth hangings to help educate the many illiterate members of the congregation. *The Bayeux Tapestry*, the most famous example of this form of medieval instruction, is – as a historical document and work of art – *sans pareil*.

Consisting of several joined lengths of linen, the hanging is 50 cm wide and 70.4 m long. The final section of the work is missing, suggesting the original may have been several metres longer. The linen ground is embroidered in eight different colours of wool. It is not known who designed the cartoons or embroidered the cloth. The latter was probably the work of nuns. All that is known for sure is when and where the hanging was first exhibited: 14 July 1077, in the newly-built cathedral at Bayeux, a small town in Normandy.

The town is depicted in the detail above. In fact, it is less "depicted" than reduced, in symbolic form, to two essential features: a hill – most towns in those days were built on high ground to facilitate their defense – and a large edifice, probably a church or castle. To preclude misinterpretation, occasional Latin inscriptions were added to identify scenes. To the left of the town on the hill we read: "Here William arrives at Bayeux."

The narrative is framed above and below by a decorative border. Extending the entire length of the linen, these are filled with symbolic animals whose relation to the main action remains obscure. This is not always the case, however: the border under the battle scenes contains naked, mutilated corpses.

Notwithstanding its reductive symbolism, the hanging contains a wealth of documentary detail: the shape of the shields, the spores worn by cavalry, raised and reinforced bow-props at the front and rear of saddles. The props provided support during battle, but they could also jeopardize the rider. William was fatally injured when the pommel of his saddle ruptured his abdomen during a fall – but that was not until 1087.

William is one of two main protagonists of the narrative. The story is told from his point of view: crossing the Channel as the Duke of Normandy in 1066, he routed his English opponents at the Battle of Hastings, was crowned King of England and

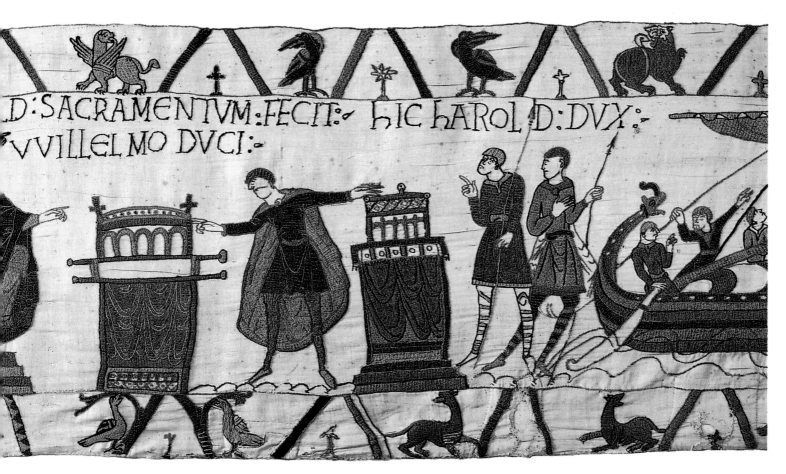

entered history as William the Conqueror. The sole topic of the hanging is the representation and vindication of the victory won over England. Hung at Bayeux Cathedral, it served as an official declaration, as well as a means of religious and moral indoctrination.

An oath, extracted and broken

William, the Norman duke, sits to the right of the hill of Bayeux, his power symbolized by the sword resting on his shoulder. The second protagonist, the figure standing between two shrines, is the English King Harold. In 1063 Harold was cast ashore on the coast of France and held captive there. After ransoming him, William promised Harold his daughter in marriage. Here he is shown swearing allegiance to his new liege-lord. The shrines on which his hands are laid contain relics.

The significance of the oath, a ritual whose function was pivotal to contemporary society, was far from confined to the

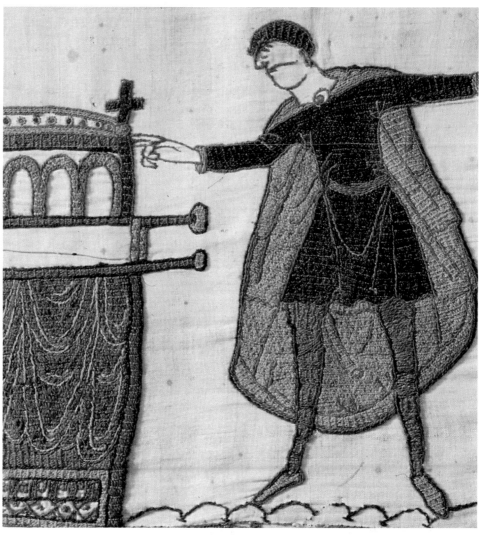

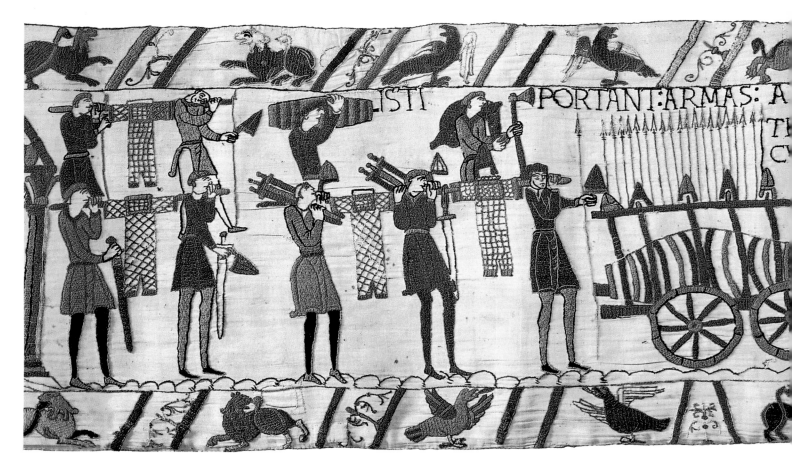

context of the *Bayeux* narrative. An individual was not the citizen of a state, but the vassal of a lord. Expressed in simple terms, feudal society was constructed along the lines of a pyramid: the peasants took their tenures from knights or barons; the baron was invested with estate by a count; the count received his county as a fief from the duke, while the duke himself was given land by the king. To defend the country against aggressors the monarch needed the military and financial assistance of his nobles, who, in turn, required the service of their vassals. With few exceptions, feudal obligation was established not by written contract, signed and sealed, but sworn in the form of an oath.

Oaths were sworn at a ceremony, with the procedure fairly strictly defined. Kneeling, the vassal recited a set formula by which he acknowledged homage to his superior. He would then stand and swear fealty to his new lord on the Holy Bible or on the authority of a relic. Following this, the lord granted his vassal a fief in the symbolic form of a branch, a staff or a ring.

The Bayeux Tapestry shows only the most important part of the ceremony: the oath sworn on the relics. This act had the force of conferring upon the church the of-

fice of official custodian. When Harold broke his oath, mounting the English throne in 1066, William sought the jurisdiction of the pope. Excommunicating the perjurious Harold, the pope placed a papal standard at William's disposal to accompany his Norman troops. William's campaign thus practically gained the status of a Holy War.

Things looked rather different from Harold's point of view. In swearing allegiance to William, he had not been a free man. By paying Harold's ransom, the Norman duke had become his superior. Harold's oath had acknowledged fealty to William, but without it, he presumably could never have left Normandy and returned to England. Furthermore, an English account of the event contests that Harold's oath was sworn on a table under which relics were concealed – with Harold quite ignorant of the trap William had set for him.

The previous king had promised the English throne to his cousin William. Harold knew this. He may have used his powerful allies to put pressure on the dying monarch. A contemporary chronicler cites the following dialogue: King: "It is known to you that I have taken steps to ensure my kingdom shall pass to William

of Normandy after my death. Were it to pass to Harold, I do not think he would keep the peace." Harold: "Give it to me and I will look after it!" King: "Then you shall have my kingdom, but if I know William and his Normans, it will be the death of you."

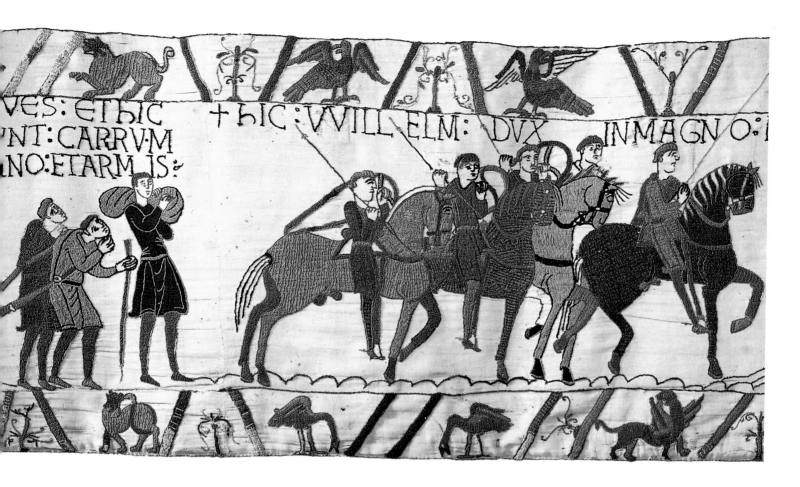

To England with weapons and wine

William built a fleet and prepared it to carry his soldiers across the Channel to England. The hanging shows swords and a battle-axe being carried to the ships, a cart loaded with a row of twenty spears, helmets ranged on posts along the side of the wagon, following which three men carry suits of chain mail, the typical armour of the day. The latter consisted of connected links of thin iron covering the trunk and stretching to the elbows and knees, with slits at the front and back ensuring freedom of movement on horseback. In the centuries that followed, chain mail was replaced by solid coats of armour, the spears by heavy lances. In the eleventh century, however, soldiers were relatively lightly armed and still quite mobile.

The prominence given to wine indicates its relative importance as a provision: the embroidery shows a larger and smaller barrel, as well as a leather bottle slung over one bearer's shoulder. In peacetime, wine was imported to England by merchants; it was also grown in England as far north as the Scottish borders. The most important beverage of the age, wine was cherished less as a luxury than for its nutritional value. With no effective means of storage, however, it was generally drunk when little older than a year. Beer was more perishable still, and, what was more, impossible to transport. It could therefore be drunk solely in regions where it was produced.

Raising an army to conquer England proved something of a problem. Like all vassals, those bound to a duke were obliged to perform only certain clearly defined duties. William could set them smaller tasks – punitive expeditions against unruly neighbours, for example – as often as he wished, provided he did not require their services for longer than a week at a time. Only once a year at the most could he call upon his vassals to undertake a longer military campaign covering larger distances, though even the duration of these expeditions was limited to 40 days. All further services were seen as voluntary, requiring additional remuneration by the duke. Fighting which took them across the Channel was considered entirely beyond the call of duty.

William therefore had to use all his powers of persuasion, an undertaking whose success was undoubtedly facilitated by the pope's blessing. However, the main form of enticement at his disposal was the promise of enfeoffment: one of his followers was offered an English monastery, another a town, a third might be lured with a whole county. William had to make promises on a grand scale, for the risks to which his vassals were putting their lives and livelihood were equally great. There was no way of predicting the outcome of the fighting.

Relatives were the most generous allies of all. At the time, power usually rested in the hands of an individual ruler, whose entire family profited as a result. In turn, it was in the family's best interest to support the ruler. William's brother, Bishop Odo of Bayeux, who took part in the campaign himself, provided financial backing for a hundred ships. Forbidden as a member of the clergy to wield a sword, he held a cudgel instead. William's other brother, Robert de Mortain, paid for a further 70 boats.

The ships were over 20 metres long and up to five metres wide. They had no deck, but planking drawn to a curve at prow and stern; amidships was a square sail, and a tiller was attached aft on the starboard side. This was the type of boat sailed by

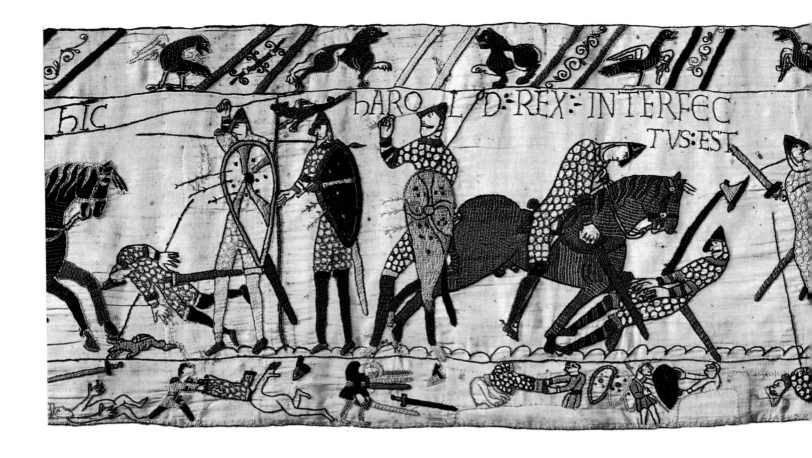

the Vikings, a reminder that the Normans themselves were originally Northmen. During the ninth and tenth centuries the Vikings had used such craft to occupy the coastal regions of Europe, founding new states of their own in England, Southern Italy and Normandy. To help him take England, William, himself a descendent of the Vikings, exploited the expansionist designs of the ruling Norwegian king, Harald Hardrada. He persuaded him to invade Northumberland, the most northerly county of today's England. The Norwegians landed and forced Harald to march north to meet them. The invading army was routed and the Norwegian king killed in the struggle.

King Harold falls in battle

Scarcely had Harold warded off the Norwegian attack when William landed south of Dover. Harold rode swiftly south, arriving with an army worn out after a hard-won battle and two forced marches. Taking up position on a ridge, he had ditches dug to thwart the Norman cavalry and waited for the onslaught. The Normans stormed the English position again and again, but could make no headway against the English shield-wall. Their principal obstacle was the English axemen, who cut down even their horses. One chronicle reports that "three horses were killed under William, one with a blow so great that the English axe, after severing his horse's head, cut deeply into the earth."

Realizing the ineffectiveness of frontal attack, William used cunning instead: making a pretence of retreat, he lured the English from their position. With their powerful formation broken, the English were no match for the Normans. Two brothers of Harold, both generals in his army, were killed. One of them had pleaded in vain with Harold to leave the fighting to them; for Harold, whether under coercion or not, had sworn allegiance to William, an oath that could not be broken lightly. Harold, too, fell in battle. The inscription in the detail reproduced above left reads: "King Harold is killed." The English king is shown with an arrow piercing one eye. The hanging shows the maimed king struck down by a Norman cavalryman while attempting to extract the arrow. The cavalryman was later banished by William, according to one chronicle, for to kill a defenceless opponent constituted a breach of chivalrous conduct.

In fact, such battles involved relatively little slaughter. The corpses heaped in the lower border are an exaggeration. Vassals, fighting to advance the – more or less – private interests of their feudal lords, were inclined to see their own interests best served by maintaining a certain reticence in battle. In any case, it was less worth their while to kill an enemy than take him prisoner. Prisoners could be exchanged for a ransom: the more powerful the captive, the greater the sum that could be demanded for his release. The mutual obligations agreed by vassals and their lords usually foresaw the provision of ransom, should either party fall into enemy hands.

Fighting took place only at certain times. In winter, at night and in wet weather, swords remained in their sheaths. Furthermore, William's war was hardly a protracted affair: the Battle of Hastings, important as it was, was over in a day. By the evening of 14 October 1066 the last obstacle had been removed between William and London, where he was crowned on 25 December. Thus England and France began a period of common history that was to last 400 years.

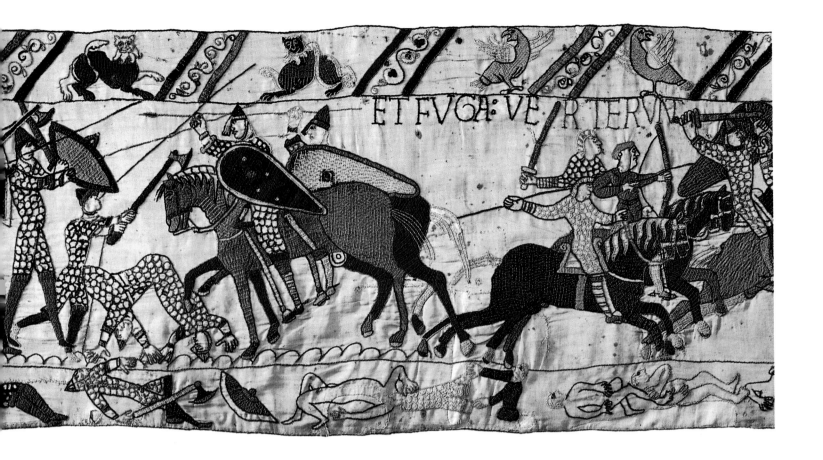

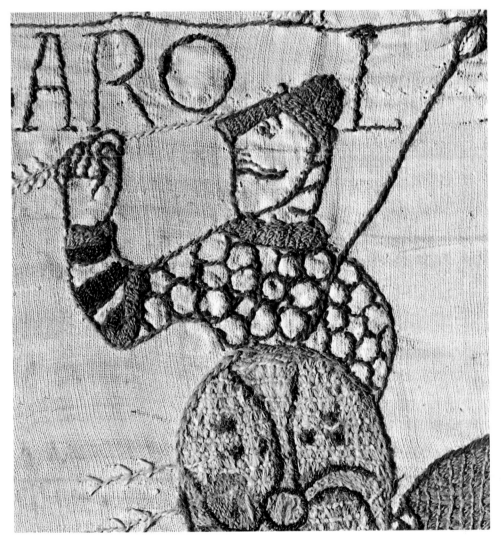

And since history is always the history of the victor, the Normans provided a testimony to their conquest of England in the form of the *Bayeux Tapestry*. Hung in the church of a bishop who rose to power in the land of the vanquished, the embroidery served both to vindicate and to advertise. No less astonishing than the quality and scope of the work is the fact that it has survived for 900 years – despite the Hundred Years' War between England and France, the repeated destruction of the cathedral, the struggles between Calvinists and Catholics and the Revolution of 1789.

The hanging was to serve propaganda purposes on two further occasions. Contemplating an invasion of England at the beginning of the 19th century, Napoleon had the historic tapestry brought to Paris for six months in 1803 in order to rouse "the passions and general enthusiasm of the people". While Adolf Hitler was concocting plans for an invasion, a book on the tapestry appeared under the title: "A sword thrust against England." But the Norman Duke William has remained the sole conqueror of the island kingdom.

"A garden inclosed is my spouse"

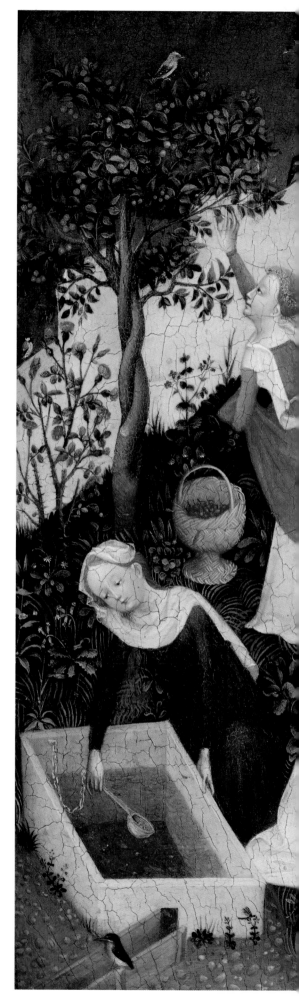

The painting, measuring 26.3 x 33.4 cm, is approximately the size of our reproduction. The work dates from c. 1410, and is now in the Städel, Frankfurt. It shows a detail of a past world: the sequestered corner of a garden within a castle walls.

The sole function of castles at that time was to provide protection. Conflicts between nobles were far less likely to be resolved by the emperor or his courts than by attack and defence. Fighting was a part of life at every level of society. The wall in the picture shields the peaceful garden scene from a violent world.

The scene is also secluded from the confusion and discomforts of everyday life: excrement on the roads, stray dogs and pigs everywhere, the stench, cramped gloom and cold of the dwellings, the constant presence of sickness and poverty. The garden idyll shows a pictorial antidote to the hardships endured by the people of the time.

Gardens designed for pleasure were less common in 1410 than today. The first gardens in northern climes dated from the Roman occupation, but these disappeared with the collapse of the Roman Empire and the subsequent chaos of mass migration. With the spread of monastic life the idea of

the garden again crossed the Alps, though the new horticulture was generally motivated by pragmatic rather than aesthetic considerations. Spices and medicinal herbs were grown in the cloister quadrangle, at whose centre stood a well. Part of the quadrangle was often set aside as a burial ground for the monks.

Monastic herb gardens soon expanded to include vegetables and fruit. The monasteries spread northward, bringing new agricultural techniques to the rural population and awakening their sympathy for Nature. There is a famous story about Abbot Walahfried, who, from 838, was head of Reichenau Abbey on Lake Constance: "When the seeds sprout tender shoots, Walahfried fetches fresh water in a large vessel and carefully waters the tiny shoots from the cupped palm of his hand so that the seeds are not hurt by a sudden gush of water ..."

Abbot Walahfried was mainly concerned with questions of labour and harvesting. It was not until 1200 that the garden was reinvented as a place of relaxation and enjoyment. Beauty emerged as a central criterion: the visitor was to spend his time in a pleasurable manner. Albertus Magnus (c. 1200–1280) of Cologne, a wise and learned father of the church, was a passionate advocate of gardens, and much of his advice relating to their design is found on the present panel. Entitled *The Little Garden of Paradise*, it was executed some two hundred years later by an unknown Upper Rhenish master. According to the 13th-century sage, a garden should have "a raised sward, decked with pleasant flowers ... suitable for sitting ... and delightful repose". The trees were to stand well apart "for they may otherwise keep out the fresh breeze and thus impair our well-being". A "pleasure garden" should contain "a spring set in stone, ... for its purity will be a source of much delectation".

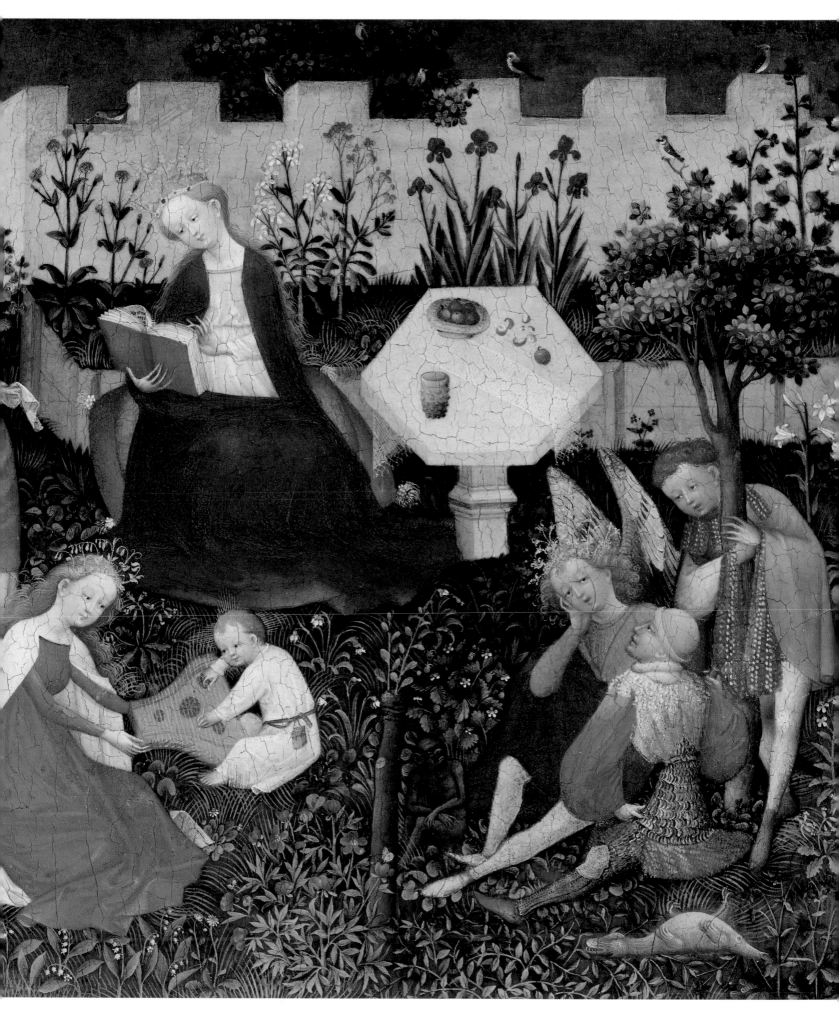

The artist has filled the castle garden with holy personages. The largest figure is Mary, wearing her heavenly crown and looking down at a book. She has no throne, but sits on a cushion in front of, and therefore below, the terraced part of the lawn. Contemporary spectators attributed significance to the relative height at which a figure sat. Though Mary was the Queen of Heaven, she was also humble and modest: "Behold the handmaid of the Lord."

Contemporaries of the Upper Rhenish master would have had little trouble naming the other women. They would not have identified them by their faces, however, to each of which the artist has lent the same gentle charm: small, very dark eyes, a small mouth with a spot of shadow under the lower lip.

Saints and other holy persons could be identified by the objects or activities

A legend for every saint

attributed to them. St. Dorothy, for example, is shown with a basket. According to legend, she was asked on her way to a martyr's death to send flowers and fruits from heaven; she prayed before her execution, and immediately a boy appeared with the divine gift – in a basket. Here, beyond the grave, she picks her cherries herself.

A legend was attributed to every saint, so a painting of this kind would have been full of stories to a contemporary spectator. However, some figures may have been more difficult to identify than St. Dorothy. St. Barbara, seen here drawing water from a spring, is shown without her usual attributes: a tower and chalice. Apparently, the artist could not find a place for them in his garden scene. Those who were acquainted with her legend, however, knew that her bones could work miracles, bringing water to dried up rivers and ending droughts. In contrast to the verdant growth of the surrounding garden, the area around the well is dry and stony. A realist might infer that the grass around the well had been trodden down by the many people who came to draw water. However,

a pious spectator would recognize the dry ground referred to in the legend, which the saint waters with a chained spoon to make it fertile.

The woman holding the medieval string intrument, a psaltery, for the child Jesus is probably St. Catherine of Alexandria. It was said that Mary and Jesus appeared to her in a dream. Touching her finger, Jesus had told her he was wedded to her through faith. On waking, she found a ring on her finger. According to medieval belief St. Catherine was closer to Jesus than any woman but Mary, which explains the position given to her by the artist.

Although the gospels make no reference to Jesus making music, medieval art often portrayed him as a musician. An illumination of c. 1300 shows him playing a violin, while an inscription reads: "Manifold joys Lord Jesus brings, to souls he is the sound of strings." Music was a sign of spiritual, or heavenly joy. The artist, unable to depict bliss by facial expression, chose a string instrument as a vehicle instead, a gesture understood by the contemporary spectator.

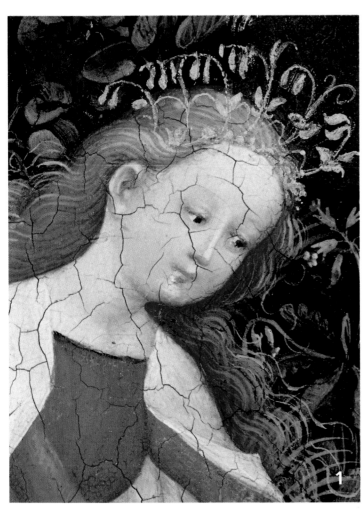

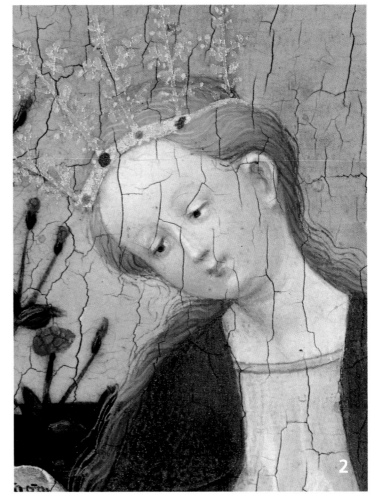

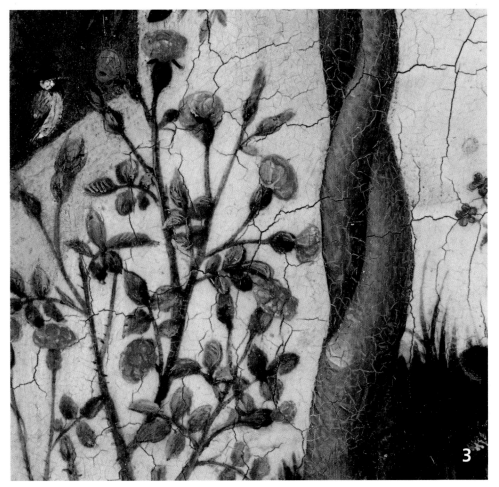

Like the string instrument, many details of the *Little Garden of Paradise* stand for something other than themselves. They are the signs and symbols of a pictorial language with which the majority of people in the Middle Ages were acquainted. Very few people could read at the time; in order to spread the faith, the church therefore needed a language of pictures, or, as we might call it today, a form of non-verbal communication.

Even the garden itself was a symbol, not merely the appropriate scene for a congregation of holy persons. Gardens were synonymous with paradise, presumably because of the Old Testament Garden of Eden. The unknown artist emphasizes the paradisial character of the garden by showing flowers in blossom which usually bloom in different seasons. He also avoids any sign of toil, to which Adam and Eve were condemned on their expulsion from the Garden of Eden.

A paradisial scene with a wall would be interpreted as a *hortus conclusus*, an enclosed garden. Walls do not usually have a place in paradise, but this one symbolizes Mary's virginity, underlining the special status of "Our Blessed Lady"; for according to Christian belief Mary conceived without penetration. This pictorial symbol, too, derives from the Old Testament, from an image in the *Song of Solomon*: "A garden inclosed is my sister, my spouse …"

Various superimposed layers of imagery interlace and merge in this painting; their independence is not painstakingly defined in the way we might wish it today. Thus paradise is represented not only by the garden but also by Mary herself: like paradise, where sexuality does not exist, Mary's immaculate conception places her in a permanently paradisial state. In a paean composed by the poet Conrad of Würzburg, who died in 1287, Mary is "a living paradise filled with many noble flowers".

The table situated in Mary's immediate proximity emphasizes, like the height at which she sits, the Queen of Heaven's modesty, her status as the "handmaid" of God's divine purpose. In practice, the stone-carved hexagonal tables found in many paintings of the time were used for picnics and board-games.

Various flowers also characterise the Holy Virgin. In several parts of Germany the primrose – seen at the right edge of the painting – is still known as the *Himmelsschlüssel*, or "key to heaven"; for it was Mary who opened Man's door to heaven. The violets are another symbol of modesty, while the white lilies represent the Virgin's purity. The rose was a medieval symbol of the Holy Virgin and, indeed, of virginity in general; the branches with roses have no thorns.

The flowers in this garden would make up a veritable bouquet of virtues – gathered, of course, with the female spectators of the painting in mind.

These signs, allusions and symbols stand for something which eludes direct representation. Modern man has learned to distinguish clearly and coolly between the thing and the symbol. People 500 years ago saw one within the other: Mary was painted as a humble woman, an enclosed garden and a rose, her purity revered in the whiteness of the lily; thus God's history of salvation revealed itself through Nature. A painting of this kind was more than a theological treatise.

A tree stump stands for sinful humanity

How a sinless Madonna could possibly spring from a humanity burdened by original sin and expelled from paradise was a subject which gave rise to much racking of brains. The artist of the *Little Garden of Paradise* makes a contribution to the debate in the form of a tree stump from which grow two new shoots: which is as much as to say that even an old tree can bring forth new life.

To ensure spectators knew the tree stump stood for sinful humanity, the Upper Rhenish master painted a small devil next to it. To contend that devils, dead dragons or pollarded trees do not really belong in paradise would be to grant inappropriate weight to logic.

The fact that the three figures near the devil and dragon are male can be ascertained from the colour of their faces, which are darker in hue than those of the women. Apart from colour, however, their faces follow the same pattern as those of the women: men and women have the same eyes, the same mouths, and even the same tapering fingers.

Two of the three male figures are easily identified. The one wearing greaves and chain mail is Sir George who liberated a virginal princess from the power of a dragon. Paintings that show George doing battle with the dragon generally make the mythical beast enormous and threatening; here it is shrunk to little more than a trademark. The angel with the headdress and the beautiful wings is Michael. He it was who hurled devils into the abyss, one of whom sits, well-behaved, at his feet: dragons and devils are powerless in paradise.

The identity of the standing male figure remains obscure, with no hint of the artist's intention. If we look hard enough, however, we find a black bird just behind his knees. Black is the colour of death. Perhaps the panel was painted in memory of a young man who died. Its small format suggests it was intended for a private dwelling rather than a church. The tree around which the young man's arms are clasped appears to grow from his heart – an ancient symbol of eternal life.

On the other hand, it is possible that the young man was St. Oswald. In Oswald's legend a raven acts as a divine messenger, carrying away the pious man's right arm when he falls in battle against the heathens. Yet another story! The spectator of 1410 would have found the picture full of stories combining religious teaching and entertainment. As an act of veneration dedicated to the Virgin Mary, the painting itself became an object of reverence, bringing solace to the faithful. It showed a better world in store for those who left this vale of tears. The artistic quality of the painting, so fascinating to today's museum visitor, was undoubtedly admired at the time. In terms of the panel's significance as a religious work, however, it meant relatively little.

Woodpecker, goldfinch and waxwing

Bliss in the life hereafter was not the only subject of paintings like this. Besides the garden of paradise there were also Gardens of Love, celebrations of worldly happiness. These did not depict sensuality in a crude manner, but harked back to the Arcadia of heathen antiquity, itself closely related to the idea of paradise. The effect was to show heaven on earth, so to speak.

As the subject of religious art, the garden of paradise did not last more than a few decades. By the second half of the 15th century it had practically disappeared: a late blossom, embedded in a medieval language of symbols. The worldly Garden of Love, however, a more readily comprehensible topic, appeared again and again in a variety of different forms. Manet's *Déjeuner sur l'herbe* is a more recent example.

The Garden of Love was a literary topos before it found its way into painting. The most well-known example today is Boccaccio's *Decameron*, written in Florence some 60 years before the *Little Garden of Paradise* was painted in the region of the Upper Rhine. The setting of these works is remarkably similar: the young Florentines tell each other stories in a garden "surrounded by walls", in the middle of which is a "lawn of fine grass adorned with a thousand brightly coloured flowers", where water gushes from a little fountain, "gently splashing … into a wonderfully clear well". Here men and women did not sit apart on their best behaviour, for all who were present "strolled together, weaving the loveliest wreathes of manifold sprigs" and telling each other erotic tales.

The French *Romance of the Rose* predates the Italian *Decameron* by over a century. It also sings love's joys and complaints, is set in a garden and, like Boccaccio's *Decameron*, was read widely in Europe by the educated élite of the day. In both books, feelings of happiness are accompanied by birdsong. In the *Romance of the Rose* we read: "Their song was comparable to that of the angels in heaven." And only three sentences later: "One was inclined to believe it was not birdsong at all but the voices of sea-sirens." Whether angels or sirens, divine messengers, or seductresses who were half beast, half human, whether Christian figures or those of antiquity, the example shows the essential ambiguity of all pictorial symbols at the time. Even spectators of a Christian garden of paradise would know that painted birds were there not only to sing God's praises.

The birds in the *Little Garden of Paradise* are rendered accurately. Zoologists have distinguished at least ten different species: great tit, oriole, bullfinch, chaffinch, robin, woodpecker, goldfinch, waxwing, hoopoe and blue tit. Had he been concerned solely with angelic music, the artist might have painted the birds as schematically as the faces of his saints. But he evidently wished to emphasize their variety, just as he did with the plants. He wanted to show what he saw; he wanted to be exact. The plants testify to this, with some 20 identifiable species.

Exact zoological observation betrays an interest in natural science. This was new in a painting of c. 1410. While it is true that birds and flowers were frequently painted with some degree of accuracy, they had rarely been rendered with such a powerful inclination to catalogue empirical data. Medieval painting was usually dominated by religion. While this painting might appear to confirm the rule, it also illustrates a growing awareness of Nature; no longer mere adornment, the distinctive presence of a natural world is felt as strongly here as that of the holy figures. However, it was not until the next century that the first botanic gardens were created in Germany: at Leipzig in 1580, and at Heidelberg in 1597.

The discovery and scientific exploration of Nature were first steps on the long road to modernity. *The Little Garden of Paradise* lends visibility to that phase of intellectual history. However, the beauty of the painting also resides in the harmony, evidently still attainable, between religious and realistic views of the world: two types of experience which did not appear to present the dichotomy felt by Christians in the Western world today.

Petrus Christus: St. Eligius, 1449

A Christian artisan advertises his craft

Three figures in a narrow interior. The convex mirror shows two men standing on the street outside. Like the spectator, they are gazing into the picture space: a goldsmith's workshop. Guild regulations demanded a shop be open to the street so that customers could assure themselves that a smith was not guilty of doctoring his precious metals.

The goldsmith is painted in the act of weighing a ring; a young, richly dressed couple looks on attentively. However, the eyes of the goldsmith are not focused on the scales in his hand but raised in an upward gaze. He is more than an ordinary artisan: he is the patron saint of goldsmiths, St. Eligius.

The artist has added a Latin inscription to the bottom edge of the 98 x 85 cm panel. Translated, it reads: "Petrus Christus made me in the year 1449." This was unusual in the 15th century; artists tended to remain anonymous and rarely dated their paintings. Little is known of the artist's life: he

acquired the citizenship of Bruges on 6th July 1444; in 1462 he joined a brotherhood; he is mentioned seven years later as a distinguished member of the artists' guild, which also registered his death in 1473.

Petrus Christus was born at Baerle, probably in 1415. It is thought he may have been the pupil of Jan van Eyck (c. 1370–1441), and that he completed works left unfinished by the master at his death before founding his own workshop, for which he was obliged to acquire citizenship. 1449, the year in which he painted St. Eligius, also saw the dedication in Bruges of the Chapel of Smiths, the guild to which goldsmiths belonged. Perhaps this event occasioned Petrus Christus's painting of St. Eligius in his workshop.

In the 19th century the painting entered the collection of a German who claimed to have bought it from a Dutchman. The Dutchman had apparently claimed to be the sole surviving member of the Antwerp Goldsmiths' Guild. Antwerp had overtaken Bruges as a centre of trade and commerce in the late 15th century. Perhaps the painting followed the flow of money. Today it is in the Metropolitan Museum, New York.

The painting is a devotional work, but it also served as a kind of advertisement for the goldsmiths' craft and guild. Behind the pious man, Petrus Christus has arrayed a selection of rings, silver pitchers, a chain, brooches and pearls – luxury goods for which, in the year 1449, there was considerable demand in the wealthy town of Bruges. At that time the town belonged to the Duchy of Burgundy, a kingdom amassed in three generations by the French dukes of Valois, extending from the French province of Burgundy, which bordered with Switzer-

land, to the North Sea. Its commercial capital, and indeed that of the whole of northern Europe, was Bruges. Ships sailed here from the Mediterranean, England and the Hanseatic ports. Bruges was a busy overseas trading centre for timber, cereals, furs and dried cod from the north, and for wine, carpets, silks and spices from the south. In one day in 1457, Bruges's harbour on the Zwijn at Sluis contained two Spanish and 42 British caravels, three Venetian galleys, a Portuguese hulk and twelve sailing ships from Hamburg. These were good times – not least for producers of luxury goods.

The merchants of the day devoted special attention to weighing goods, for different countries used different units of measurement and fear of fraud was widespread. In 1282, the merchants of the Hanse had managed to have one of their own weighing scales, constructed in Lübeck, set up in Bruges. That a saint should be painted in the act of weighing, in which trust played such an essential part, rather than executing some other form of work, is probably no coincidence.

Trade attracted finance, and Italian banks chose Bruges as a base for their northern branches. The gold coins of many nations circulated in the town. On the saint's counter can be seen gulden from Mainz, English angels and, of course, the heavy "riders" of Duke Philip the Good of Burgundy (1396–1467), regent during Petrus Christus's lifetime.

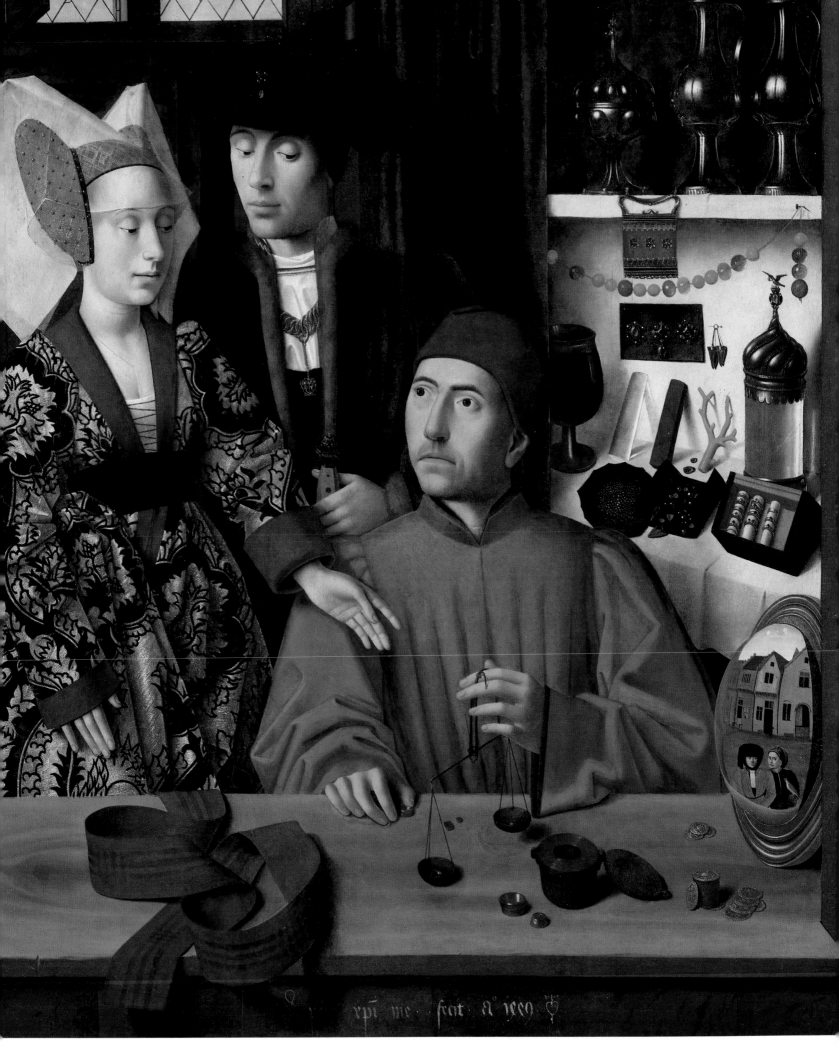

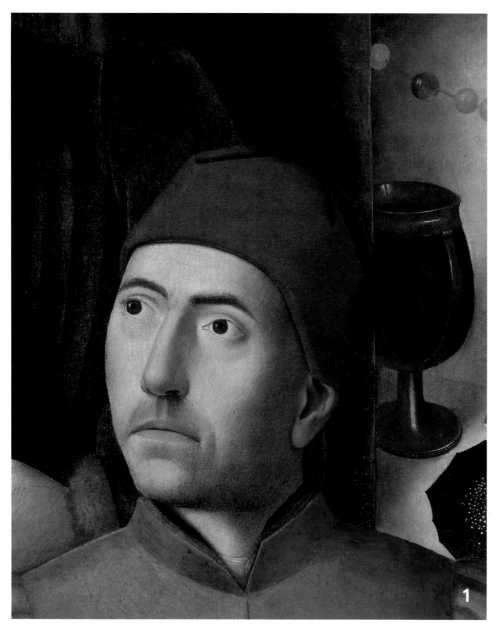

1

From blacksmith to minister

Even today Saint Eligius is well-known to French-speaking children as "grand Saint Eloi" who, in a popular ditty, informs absent-minded king Dagobert that he has his trousers on back-to-front, to which the king replies that he will just have to turn them back round again then. In one sense at least the song is based on historical fact: Eligius really did act as personal adviser to the Merovingian King Dagobert.

Eloi, or Eligius, was born at Limoges in c. 588, completed an apprenticeship as a goldsmith and soon gained a reputation as a thrifty and skilful craftsman. Commissioned by the court to make a throne, Eli-

gius, using the precious materials, gold and jewels provided, managed to produce two, whereupon the king appointed him minister and master of the mint. A coin, the "sou de Paris", bore his signature. Because Eligius was very pious, Dagobert also appointed him Bishop of the Diocese of Noyon, which included Bruges. As a bishop he is said to have led a lapsed population back to the Church. He founded several monasteries and chapels, and three churches in Bruges alone.

A number of miracles were ascribed to him, greatly strengthening his hand as a missionary. He is said to have started out as a blacksmith. When brought a particularly wild horse to shoe one day, so legend has it, he severed the horse's foot, fitted it with a new shoe, and put it back on again, whereupon the horse cantered friskily away. It became a custom on the saint's

feast day on 1st December to provide large quantities of wine for the blacksmiths and everybody who worked in the stables.

Rather than displaying him in episcopal robes, Petrus Christus paints the saint in the clothes worn by the citizens who were his customers. Eligius became the patron saint of blacksmiths, goldsmiths and money changers. These shared a common chapel and marched together at processions under the banner of the blacksmiths, whose guild, though possibly not the most elegant, was certainly the most powerful.

The guilds emerged in the Netherlandish townships of the 14th century. Their purpose was to prevent ruinous competition, to guarantee high standards of workmanship and represent the interests of craftsmen. Thus goldsmiths were required to work at an open window but forbidden – according to a 14th-century Netherlandish document – to draw attention to themselves or canvass custom by "sneezing or sniffling". They were also bound to confine their business practice to one place. Each guild had its own religious superstructure with a patron saint and, if wealthy enough, an altar or chapel of its own.

The medieval guilds of Bruges, like those of other towns, made a decisive contribution to the city's rise and fall. Originally progressive associations became clubs for the defence of privilege. Closing their ranks to new members and new methods of production, they constantly quarrelled with other guilds and thus were responsible for sapping the strength of the citizens' council, which, in turn, made it easier for the Dukes of Burgundy to bind the townsfolk to their will. When a revolt against the Duke's policies failed in 1436/37, the citizens were forced to beg on their knees for forgiveness.

By 1494, half a century after Petrus Christus painted his portrait of St. Eligius, "trade in Bruges had come to a standstill". Some 4000 to 5000 houses were left behind – "empty, locked up or ruined". The merchants and bankers moved to the more flexible town of Antwerp, where medieval guild regulations were no longer applied in quite such a narrow-minded manner.

Rich and famous customers

A ring, reputedly made by Eligius for St. Godeberta, was once kept at the Noyon Cathedral treasury (Eligius' see).

Wealthy suitors are said to have competed for Godeberta's hand, but her parents could not decide without the consent of the king, who may well have been interested in the girl himself. The matter was in council before the king when Eligius intervened with his golden ring, declaring the young woman to be a bride of Christ. Religious critics have inferred that the painting alludes to the legend. But rather than painting the saint as an opponent of worldly marriage, it is more likely, and probably far more in keeping with the patron's interests, that the artist wished to show him as a supporter and guardian of marriage. After all, the manufacture of wedding rings was a lucrative department of the goldsmith's trade. Eligius is seen weighing a ring in the painting. A traditional wedding girdle lies on the counter in front of the couple.

It is unknown whether the work – like Jan van Eyck's "Arnolfini" portrait – is the depiction of a particular couple. Both persons wear sumptuous, fashionable clothes only members of the Burgundian duke's court could afford, or the few wealthy burghers who mixed with the aristocracy. The lady's gold brocade with its exotic pomegranate pattern probably came from Italy; her golden bonnet is embroidered with pearls. Following a trend set by the duke, courtiers were richly adorned with jewellery. The lady's fiancé wears not only a heavy gold chain but a brooch pinned to his elegantly bound headgear. He may well have been one of the goldsmith's better customers.

However, the Bruges jewellers' best customer was the Duke himself. In 1456 French visitors reported never having "seen the like of such wealth or such brilliance" as witnessed at the Burgundian court, and one chronicler described Philip the Good as "the richest prince of his day". Every object he used, from his cup to his toothpick, was made of solid gold, and he possessed a large collection of precious stones, brooches, rings and clasps.

Not only was his festive table opulently laid for banquets, but tables along the walls, piled with plates and dishes and guarded by members of the goldsmith's guild, made a deliberate display of costly tableware owned by the Duke. A salt-cellar decorated with sirens was considered an especially valuable piece. It was valued at about 900 ducats, the equivalent of approximately 200 times the yearly wage of a craftsman.

There was a degree of pragmatism in this ostentation. Gold and silver demonstrated wealth, and wealth was an important pillar of power. Moreover, symbols of power had to be readily transportable, for like all great potentates, the Burgundian dukes were highly mobile, travelling constantly from one residence to the next. The treasure was carried from place to place, and it was quite common for services to be rewarded not with money, but with golden dishes, jewel-encrusted boxes or solid gold chains. In a manner of speaking, a goldsmith produced disposable assets.

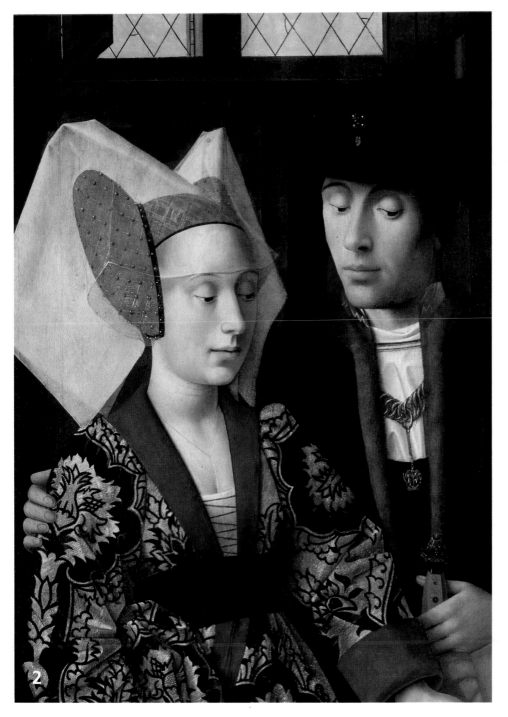

2

Probably the most valuable of the artefacts ranged on the workshop's shelves were the tiny, dark, trowel-like objects pinned to the wall on thin gold chains. They were called "adder's tongues" or "glossopetrae"; in fact they were fossilized sharks' teeth. They were supposed to detect poison by changing colour on contact. In view of their importance "touchstones" like this were given an ap-

Gems as a protection against poison

propriately showy setting. The preference for drinking from coconut-shell goblets was based on a belief that the exotic fruit had the property of a counter-poison. A vessel of this kind can be seen on one of the shelves, half concealed by a curtain. The demand for "touchstones" was great, for princes led dangerous lives. Both Philip's father and his uncle were assassinated. Rumours of attempts to poison various other members of his family abounded, and there was evidence of an attempt to poison Philip's heir, Charles the Bold, in 1461. Rulers had servants whose job was to taste the food before they ate it, thus protecting

them against poisoning. The vessels from which their food was served were covered by special lids to prevent anything being added *en route* between kitchen and table. The "privilege of lids" was a form of protection enjoyed solely by the ruling princes of the day.

Most of the objects on the goldsmith's shelves served a dual purpose: they were not only jewels, but a means of warding off evil. Magical qualities were ascribed to branching coral; it was supposed to stop haemorrhages. Rubies were said to help against putrefaction and sapphires to heal ulcers; the two oblong articles leaning against the wall were probably touchstones. Above them are brooches, a rosary of coral and amber and a golden buckle that would fit the wedding girdle. The vessel of gold and glass next to the branching coral was probably used to keep relics or consecrated communion wafers.

Religion, magic and symbolism have lent a particular aura to the art of the goldsmith. Besides their value and magical powers, precious stones were also seen as symbols of continuity and longevity. Gold was considered the quintessence of worldly riches, as well as a symbol of power. Whoever held power over the Germanic tribes gained possession of their golden treasure, as we know from the myth of the Nibelungs.

Tradition granted goldsmiths a special status as craftsmen. During the early Middle Ages they worked only for the church and for rulers, who were thought to rule by the authority of God. The most famous 13th-century goldsmith was a monk. In some Catholic regions the prestige enjoyed by goldsmiths may have survived to this day. A play published in 1960, for example, contains the figure of a goldsmith with highly unusual abilities and a particularly piercing gaze, a "marvellous" maker of wedding rings. "My gold balance", he explains, "does not weigh metal but the life and lot of human beings ..." The play, entitled "The Goldsmith's Shop", was even turned into a film. Its author, Karol Wojtyla, became Pope John Paul II.

Self-portrait in a mirror

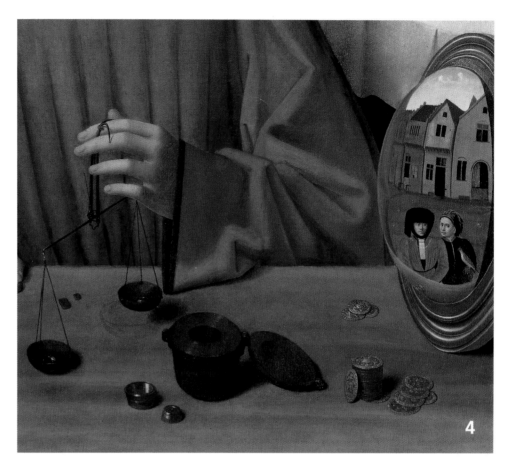

The weights for the hand-scales were evidently stacked inside one another and stored in the round receptacle with the open lid lying on the counter. The gold coins next to them may allude to the office held by Eligius: Master of the Royal Mint. In the 15th century Eligius was also the patron saint of moneychangers, an important profession in the banking town of Bruges; they also formed a sub-section of the goldsmiths' guild.

The convex mirror to the right of the coins reflects several of Bruges's characteristic red-brick houses. The two men outside the open shop-front are painted approximately where we might expect a spectator of the painting to stand. The trick with the mirror allows the artist to present a view taken simultaneously from within and without, enabling him to show what lies in front of and behind the imaginary spectator. The problem of spatial organization seems to have fascinated him. However, to judge by the angles of the shelves, the Bruges master was not acquainted with the mathematical laws of perspective recently discovered in Florence. Petrus Christus was still experimenting.

Convex mirrors, sometimes called "witches" for their "magical" powers, were frequently found in Netherlandish households; hung opposite a window, they could make a room brighter. Jan van Eyck paints a mirror of this kind in his "Arnolfini" portrait. Since it is probable that Petrus Christus was apprenticed to the older master, the mirror in the present painting may be a "quotation". As Van Eyck's mirror is presumed to show his own reflection, the present painting may equally contain a likeness of Petrus Christus in the figure of the man with the falcon, whose head is tilted in an attitude frequently found in self-portraits. Falconry was a favourite pastime at the Burgundian court, and falcons were imported from far and wide. For an artist like Petrus Christus, however, the sport would have been much too costly; he probably held a menial position at court.

Although the artist signed and dated this painting, his biography has remained something of an enigma to historians. The heart-shaped sign next to his signature may be a "master's trademark" such as was used in Bruges not by painters but by miniaturists and goldsmiths. Perhaps the artist was trained in one of these crafts. The biographies of several Renaissance painters, most notably Botticelli, refer to their apprenticeship to goldsmiths. If this were also true of Petrus Christus, it would explain his relationship to St. Eligius and the artefacts, painted so accurately, in his shop.

Many of these objects had a short life. They were used by powerful people as a form of cash payment. Depending on the needs of their new owners, they might then be taken apart or recast – much to the joy of the goldsmith, to whom it meant more work, and much to his sorrow at seeing his work done in vain. It is known that at least one goldsmith despaired to such an extent at the destruction of his artefacts that he threw in his trade and entered a monastery.

Little, too, has survived of the treasures once owned by the dukes of Burgundy. The last of the dukes, Charles the Bold, was defeated in Switzerland in 1476. The treasure he had with him at the time fell into the hands of Swiss goatherds who had no use for it. They sold the "Burgundian booty" below value, breaking the pearls and diamonds out of their settings and melting down the gold to make them easier to sell.

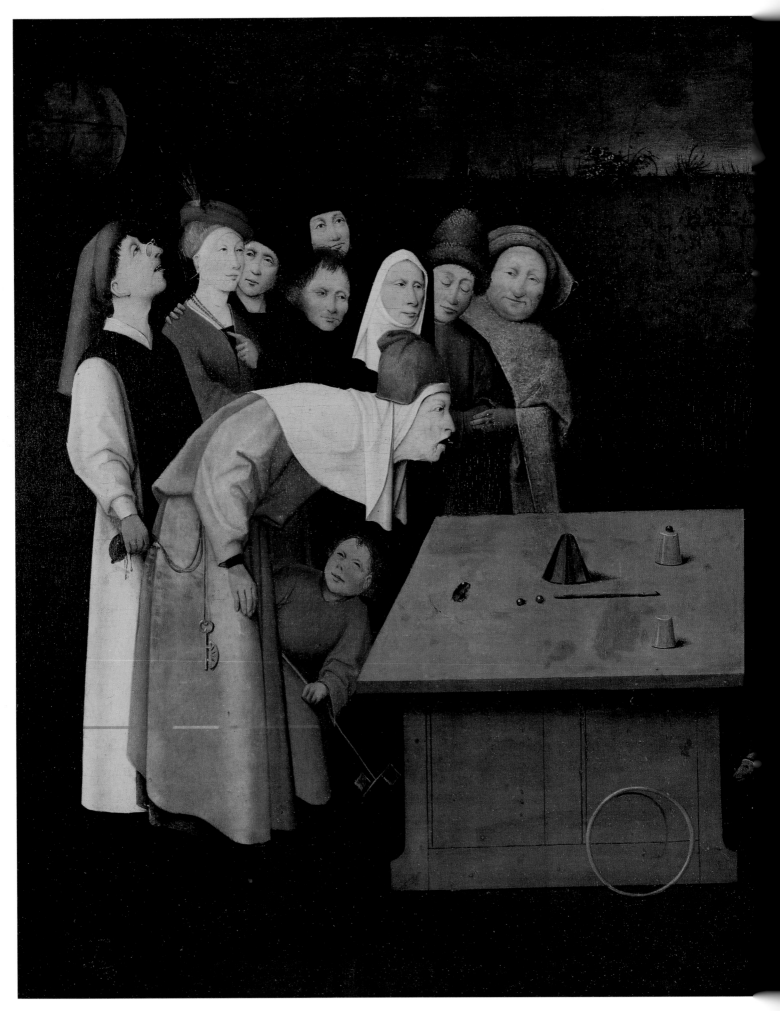

Hocus-pocus, Inquisition and demons

The name Hieronymous Bosch suggests images of pot-bellied demons and flying fish, spiderlike gremlins and gruesome half-animal, half-human beasties. In contrast to such nightmarish apparitions, the figures in this painting seem positively civilized.

The Conjurer belongs to a group of early works which Bosch probably painted c. 1475. The artist was born c. 1450, and was therefore about 25 when he painted these works. Demons may put in an appearance in some of them, but they have not yet gained the upper hand. The prevailing world-view is scathingly critical. In the *Ship of Fools*, for example, the artist paints a monk and nun indulging in gluttony and childish or erotic games instead of preparing for life in Heaven. The *Conjurer*, too, was probably an invective against the credulity of his contemporaries.

The arrangement is simple and easily surveyed. In the middle, a table with cups, balls and magic wand; also a frog, which appears to have sprung from the mouth of the large figure bent over the table's surface. A second frog appears poised between the person's lips, though this could equally be saliva. At the edge of the group of spectators a man in a monk's habit severs the purse strings of the person bent over the table. It is impossible to judge whether cutpurse and conjurer are in cahoots.

There are five versions of the painting, as well as an engraving. Scholars are unable to agree on the original, or on which comes closest to an original possibly lost; however, the majority have settled for the present version. The property of the municipal musuem of Saint-Germain-en-Laye, near Paris, the painting measures 53 x 65 cm, is unsigned and rarely exhibited. The cautious city fathers usually keep their hallowed treasure in a safe.

Other versions of the *Conjurer* continue the story of the theft. In these the scene is not enclosed by a wall, but opens to houses in the background on the right. In one the monk is imprisoned, while the more distant background contains a gallows where the monk (whether genuine or an imposter) will soon hang. Thus justice is restored.

The engraving is inscribed with rhymed admonitions to the general public. The world, we are told, is full of deceivers who succeed with all kinds of tricks in making us spit wonders onto table tops; trust them not, it says, for "when you lose your purse, you'll regret it".

The present painting does without written injunctions, nor are we told the rest of the story. The high wall permits the artist to isolate the scene from its everyday environment, thereby giving it exemplary force. The question is whether delusion and theft really were all he wished to show.

osch was born c. 1450 at 's-Hertogenbosch, where he spent most of his working life. It is also likely that he derived his pseudonym from the name of his native town. To be named after one's place of origin was by no means uncommon. His real family name was van Aken, for his family hailed from Aachen.

's-Hertogenbosch, today a peaceful country town, was at that time one of the most important market towns of the Low Countries. The town had 2930 households in 1472; by 1496 there were 3456. This was equivalent to a population of approximately 25,000.

If statistics available for other towns can be believed, population growth went hand in hand with an increased rate of theft. The best form of protection against theft in stable communities was mutual supervision. People lived in close proximity; they knew their neighbours well. An influx of strangers made supervision more difficult.

The thief and the Inquisition

Even greater fear and suspicion were aroused by travellers. The term used for such people in French courts was "demeurant partout" - at home everywhere, in other words nowhere. A person of no fixed abode had bleak prospects in a court of law.

Among these travellers were storytellers, musicians, conjurers, clowns, surgeons and hawkers of medicines and remedies, who trailed from fair to fair in search of clientele. A rising town where money flowed across the counters in large quantities was particularly attractive.

The thief in the painting wears a robe that strongly resembles the habit of a lay brother of the Dominican Order. His belt and the top section of his garment, including the cowl, are missing, but his pale dress and black scapulary make his status clear enough. His head tire alone is typical of a burgher.

The Dominicans were powerful in Bosch's day; but their power was also the object of considerable controversy. It is therefore no accident that the artist alludes to them through the figure of a thief in a friar's habit. They were powerful because they controlled the Inquisition. In 1484, Innocence VIII had proclaimed in a papal bull that "very many persons of both sexes,

lapsed from the Catholic faith, [have] entered unions of the flesh with devils, and, by means of magic spells, curses and other unworthy charms, [have] caused great distress to Man and beast". Belief in witches grew to an obsessive pitch, and the Dominican Order was the Pope's special anti-witch force.

They were powerful, but not all-powerful, and, in the Low Countries especially, the hysterical manner with which they persecuted their victims met with considerable resistance. When a Dominican priest declared a number of respected citizens of the city of Ghent to be heretics in 1481, he was promptly placed under arrest by the City Council. The Council also made it an offence to give alms to Dominicans or to visit their church services.

Fear of witches and the Inquisition alike were castigated especially by the humanists, whose spokesman, Erasmus of Rotterdam (1469–1536), courageously declared the "pact with the devil" to be "an invention of the Inquisition". Hieronymous Bosch possibly wanted to express something similar: the conjurer and the supposedly pious friar working hand in hand, the Inquisition feeding on the very heresies it was supposed to suppress.

The conjurer's tall hat

The figure who appears to have spat out a frog is usually seen as a man, though the profile could equally belong to an elderly woman. The key hanging at the figure's side, the attribute of the housewife, would seem to confirm the latter view. The two Dominican authors of the so-called *Hammer of the Witches*, an infamous handbook for Inquisitors, would also have argued that the figure belonged to the female sex. In their opinion women were highly frivolous creatures, making it easier for the devil to draw them into witchcraft than men.

The conjurer influences the woman without touching her or, since his mouth is closed, speaking to her. He need only look into her eyes: that evil could be performed through eye contact was established within the first pages of the *Hammer of the Witches*. The authors of the book were apparently authorities on technique, too: an evil eye, they wrote, "infects the air"; and the infected air, upon reaching the sorcerer's victim, causes "a change for the worse in the body of the affected person".

The tall, black hat worn by the conjurer bears no resemblance to the headgear of the other men present. This type of hat was traditionally worn at the Burgundian court in the early years of the 15th century, later – as Jan van Eyck's *Arnolfini Wedding*, executed in 1438, attests – becoming fashionable among the wealthy urban middle class.

By Bosch's day, however, this erstwhile symbol of courtly life and the wealthy bourgeois class was probably worn by vagabonds hoping to lend some semblance of dignity to their appearance. The conjurer in the painting – who evidently has hypnotic powers, and performs conjuring acts with cups and balls, as well as making his little dog leap through a hoop – is no exception.

But perhaps Hieronymous Bosch intended the hat to signify more than a *métier*. Like the garment worn by the thief, it may be an allusion: if the thief's habit insinuated the presence of Dominicans and the Inquistion, the hat may well have

2

played on the worldy rulers of the age – the Habsburgs and Burgundians.

The town of 's-Hertogenbosch belonged to the kingdom of Burgundy, which fell to the Habsburg empire in 1477, just as Bosch was setting out to establish himself as an artist. Many Netherlanders had fought against the Bugundian dukes, objecting to their unscrupulous exploitation of their country's wealth. But the Habsburgs, too, were seen as tyrants and exploiters.

The Habsburgs prosecuted the pope's worldly and spiritual interests. In return for this service, they collected a tenth of all church benefices in their sphere of influence. In the Low Countries, the pope's

most dedicated supporters in the struggle to suppress heresy were the Dominicans. It was thus only logical that Archduke Maximilian, the first Habsburg monarch to rule Burgundy, should co-operate with the Dominicans as closely as possible. On visiting s'-Hertogenbosch, he would stay in the Dominican monastery, demonstrating to the inhabitants of the town where his true allegiance lay.

It is therefore quite conceivable that Bosch's main intention in this painting was not to criticize the Dominican Order but to expose the profitable alliance between spiritual and worldly rulers, who oppressed the people and stole their money.

3

Monkey or owl – fun and symbol

The animal in the conjurer's basket cannot ultimately be identified: it is either a guenon, a species of long-tailed monkey, or an owl. Monkeys often provided an interlude in the repertoire of fair-ground artistes. The owl, one of the artist's favourite birds, puts in an appearance in several of his paintings.

In the symbolic language of the period the monkey signified cunning, envy and lust. The owl was ambiguous: on the one hand it symbolized wisdom, on the other it was the bird of darkness, the companion of witches during their nightly flights. Whether monkey or owl, the animal must be seen as a reflection on the character of the man from whose belt it hangs.

Frogs and toads, too, frequently painted by Bosch, signified equally positive and negative qualities. A figure with a frog's head was revered in ancient Egypt as a god-dess of resurgent life. The early Egyptian Christians adopted the figure, adorning it with a cross and making it the symbol of their belief in the resurrection of the dead on the Day of Judgement.

To some European church fathers, however, the frog and the toad were revolting creatures. They associated the animals' croaking call and habitat of mud and ponds only with devils and heretics. The frog is also a reference to the science of alchemy. The books of alchemists were full of pictures, for they used drawings and crypto-grams to illustrate their methods and aims. Frogs and toads were part of the base, earthbound element which was separated by distillation from its ethereal counter-part.

The aim of alchemy was the transmuta-tion of human and material substance by the union of opposites. Bosch makes ref-erence to this in his later works, showing couples copulating in alchemical retorts. The desired union was also represented through the conjugation of sun and moon: the sun as a circle, the moon as a sickle. This alchemical sign is hinted at in the top left of *The Conjurer* in the form of a round window which – strictly speaking – really ought not to be there.

A characteristic quality of the symbols used in alchemy (and indeed of medieval sign language in general) is their compli-cated multiple ambiguity. By contrast, our thinking today has adapted to the scien-tific demand for unequivocal precision. But even a shape combining sickle and orb did not always symbolize the unity of op-posites; sometimes it was simply the moon.

The moon has an important role in a re-lated discipline: astrology. Drawings of the "children of the planets", a precursor of the horoscopes printed today in various news-papers, were sold at fairs and local markets. At that time the moon was considered a planet. Among the moon's "children" were actors, singers, pedlars and conjurers. Sur-prisingly, at least one of the prints of the "planets' children" shows almost an exact replica of the motif used by Bosch: a travel-ling conjurer with a table and thimble-rig trick.

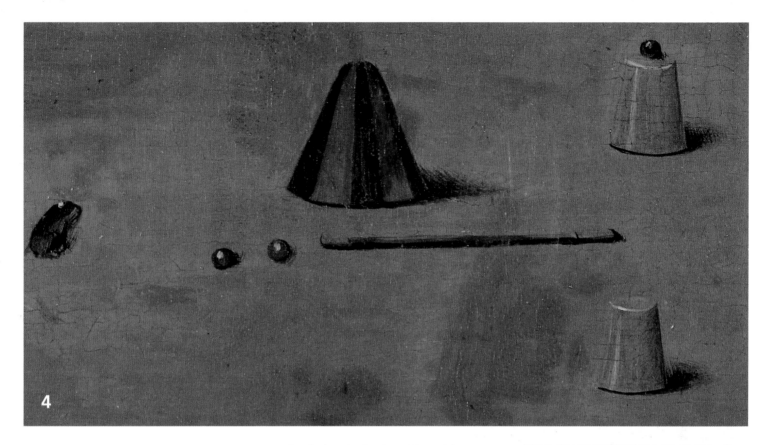

4

The secret of the tarot cards

Bosch was acquainted with, and used in his painting, not only the sign languages of alchemists and astrologists, but also the symbolism of the tarot pack, cards used in games and fortune-telling. It has been suggested that gypsies brought tarot cards to Europe from Egypt or India in the 14th century. Other sources claim that the Waldenses – a southern French sect whose persecution by the Dominicans was especially bloody – used the cards as early as the 12th century. While the design of the cards has varied from century to century, the basic motifs – supposedly revealing, or rather concealing, the knowledge of the ancients – have remained unaltered. With the advent of science and technology, these mystical figures were condemned to oblivion, though they have recently been rediscovered by the followers of "New Age" esotericism.

Comparison reveals that the couple in Bosch's painting, one of whom has placed his hand on the breast of the other, can also be found on early tarot cards. The sceptical, sombre-looking man with black hair

and a dark robe in the midst of the group of onlookers is also prefigured in the cards. One card shows a revolving wheel; above it an animal, possibly a dog, dressed in a costume. In Bosch's painting, the little dog does not sit above a wheel, but next to a hoop.

However, it is the conjurer with his table who bears the closest resemblance to similar figures on tarot cards and other contemporary pictures. Dressed in red, he is equipped with a magic wand and thimble-rig cups and balls. The trick of manoeuvering balls or small stones between cups or thimbles by sleight-of-hand had been performed since antiquity.

Cognoscenti would have recognized in the figure of the conjurer the Greek god Hermes, who, as a messenger between this world and the beyond, sometimes bestowed divine knowledge on human beings. Guides to the interpretation of tarot cards link this card with creativity, imagination and intelligence, as well as with delusion and disguise. It is called "The Magus" or "Conjurer" (French: "Le Bateleur"), resurfacing in later card games as the "Joker".

References to tarot – or alchemy and astrology – indicate that the painting's almost naive, anecdotal charm conceals more than a warning against tricksters, or against the combined forces of clerical and secular

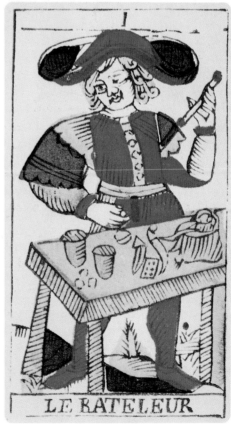

LE BATELEUR

power. Though the demons that hold sway in so many of Bosch's later paintings may be biding their time, restrained, as yet, from peering around corners, their otherworldly presence is nonetheless already palpable.

Sandro Botticelli: Primavera – Spring, c. 1482

How the nymph became a goddess

Iron ore, in quattrocento Italy, was found solely on the island of Elba, where the mines belonged to a family called Appiani. In 1478 Lorenzo de' Medici wished to acquire the mining rights. Lorenzo was known as "the Magnificent", the uncrowned king of Florence. The respective contract was signed, and, in May 1482, there was a wedding: Lorenzo the Magnificent's cousin, Lorenzo di Pierfrancesco de' Medici, married Semiramide Appiani. There is no evidence to suggest that the wedding was arranged by Lorenzo the Magnificent and the Appiani family – common practice in ruling families at the time – to promote trade. It nonetheless served that purpose ably.

The conjunction of mine owners and mining interests, or perhaps – who knows! – the joining in wedlock of lovers, was the occasion which prompted Botticelli's *Primavera*. This, in any case, is generally assumed. Nor is it unlikely either: although undated, the style of the painting is that of Botticelli's other works of this period.

It was usual in upper class circles to provide newly-weds with a fully furnished home, including works of art. The painting was later listed in Lorenzo di Pierfrancesco's inventory, so that scholars now suppose it was executed for the younger Lorenzo (rather than for Lorenzo the Magnificent, as previously thought); it hung in the antechamber of the master bedroom.

Lorenzo di Pierfrancesco, like his powerful cousin and in keeping with family tradition, was a patron of philosophy and the arts. The great humanist Ficino supervised his education, while the poet Poliziano dedicated verses to him. Besides the *Primavera*, Botticelli painted *The Birth of Venus* and *Pallas and the Centaur* for Lorenzo. For thirty years, Lorenzo di Pierfrancesco was entirely dominated by his powerful and more "magnificent" cousin, who made him ambassador to the pope and gave him the task of conveying the official congratulations of the ruling house of Florence to the newly crowned French king. At the same time, however, Lorenzo did everything he could to prevent his younger cousin from growing powerful. Tensions arose between them, and rivalry. When the Medicis were expelled from Florence after the death of Lorenzo the Magnificent, Lorenzo di Pierfrancesco was permitted to stay. He abandoned the Medici family name, calling himself "Popolano", after the "populist" party, instead. He died in 1503, at the age of 40.

He married at the age of 19, a time of life that is frequently compared to spring. *Spring*, too, or *Primavera*, is the title by which the painting is commonly known today. It was first described by the artist and writer Giorgio Vasari in the 16th century: "Venus, adorned with garlands by the Graces, annouces the Spring." During the 17th and 18th centuries the painting was called *The Garden of the Hesperides*. According to the ancient myth, golden apples grew in this garden. They were guarded by a dragon, and by the Hesperides, daughters of the Titan Atlas. There is no dragon here, and whether the dancing women really are Graces, or even Atlas's daughters, is a matter of some dispute. Venus stands at the centre of the painting. Zephyrus is the figure on the right, blowing pleasant breezes that bring eternal spring. The goddess Flora scatters her flowers, while on the left, the god Mercury keeps watch, sheltering the garden against threatening clouds.

Besides obvious references to fertility and spring, there are two hidden allusions to the name of the bridegroom. On the right, laurel trees sway in the wind; their Latin name was *laurus*, in which contemporaries would have heard Laurentius, the Latin name for Lorenzo. Venus' golden apples are here painted as oranges, known in antiquity as the "health fruit": *medica mala*. From here to the name Medici is hardly very far. Allusions of this kind were the joy of an educated public.

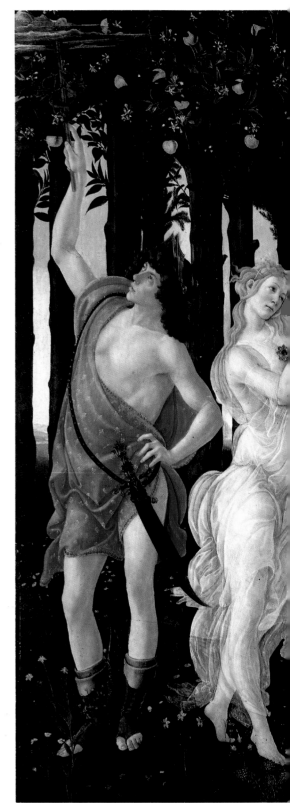

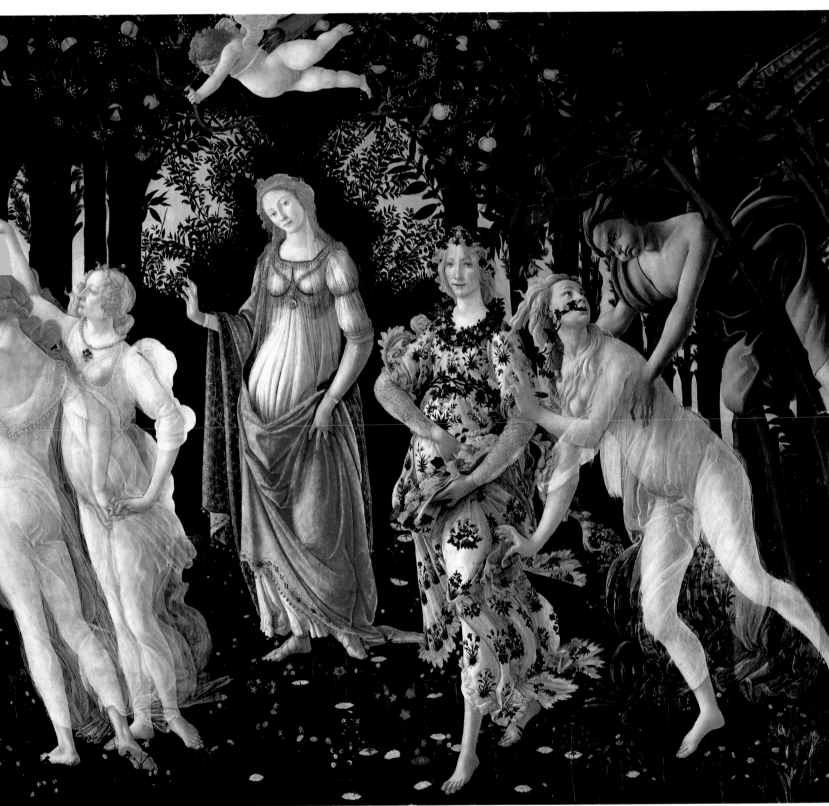

Chloris

Various nineteenth-century art buffs let it be known that the features of members and friends of the Medici family could be identified in the faces of Botticelli figures. There is no evidence whatsoever to support this claim. At the same time, however, the figures in Botticelli's paintings were certainly known to his contemporaries: not as individuals, but as figures from Greek and Roman mythology.

They knew that Zephyrus, a wind god, was pursuing the nymph Chloris in this picture. The story was familiar enough, recorded by the Roman poet Ovid (43 B.C.–18 A.D.), who allowed the nymph to tell the story herself: "Zephyrus caught sight of me, I avoided him, he followed, I took flight; he was the stronger …"

Of course, the pursuit and rape of Chloris had a happy ending; we would otherwise be unlikely to find them in a wedding painting: Zephyrus turned the nymph into the goddess Flora, and married her. Botticelli paints Chloris and Flora as a couple. And indeed from then on, so Flora tells us, she had no reason for complaint:

"I enjoy eternal spring, a radiant season … At the heart of the land of my dowry lies a fertile garden in the mildest of climates … My noble husband filled it with flowers, saying: 'You, o goddess, shall rule over the flowers!'"

Flora thus became the goddess of flowers; Botticelli's blossoms look as if Flora herself has scattered them. Flora: "I often wished to count the colours arranged on the ground, but I could not. Together, they were greater than any number could be … I was first to scatter new seed over countless peoples, before then the earth had but *one* colour."

There is nothing in Ovid to suggest that flowers sprang from Chloris' mouth when she cried for help. That is probably the artist's own invention. But when the goddess spoke, "spring roses were the breath that passed her lips". Afterwards she ascended "into the mild air, leaving nothing but a light fragrance. One simply knew: a goddess was here."

This lovely story comes from Ovid's "Fasti", a Roman calendar. Ovid tells a tale about the god revered on each feast day. Flora's feast day, for example, was called Floralia. Botticelli is unlikely to have read the "Fasti"; as the son of an uneducated tanner, he probably could not read Latin. However,

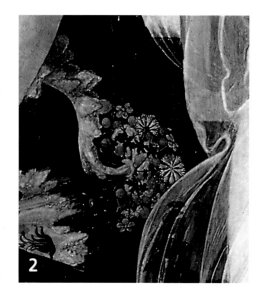

it is known that Poliziano, a poet employed by the Medici family, held public lectures on Ovid's festive calandar in 1481. The wedding took place a year later. It is possible that Botticelli was inspired by Poliziano.

The lectures on Ovid were enormously popular, coinciding as they did with the rediscovery by Poliziano's more progressive contemporaries of Classical antiquity. The majority of Greek and Roman writers had been committed to oblivion for over a thousand years. The ancient gods and heroes had been swept aside by the *one* God, by Christ, the Virgin Mary and the saints. But Classical authors now enjoyed a comeback. Their manuscripts were sought far and wide, and large sums were paid for copies. Ancient mythical figures began, in turn, to replace the Holy Family and saints.

In Florence, Poliziano was a major proponent of the rediscovery – or rebirth, for it became known as the Renaissance – of Classical art and literature. His real name was Angelo Ambrogini, born in Montepulciano in 1454. Like many humanist scholars and poets of his day, he gave himself a Latin name after his place of birth, the Latin word for which was Mons Politianus. He thus called himself Politianus, or, translated into Italian, Poliziano. It was he who coined the famous dictum: "Athens lies not in ruins, but brought her scholars, mice and men to set up house in Florence."

The flowers

Not only was Classical antiquity discovered anew, but Nature too. Botanists have identified the species of

flower that Flora, wife of Zephyrus, appears to scatter in the painting. Among them are forget-me-not, hyacinth, iris, periwinkle, pheasant's-eye and anemone. Around her neck the goddess wears a wreath of myrtle; in her dress she carries wild roses; in her hair are violets, cornflowers and a sprig of wild strawberries. Apparently, these flowers all blossom in Tuscany in the month of May. Whatever the dictates of mythology and style, Botticelli's choice was true to Nature.

Botticelli's botanic realism corresponded to a newly awakened interest in Nature at the universities, where botany had become an academic subject. Pisa and Padua, the university towns of Florence and Venice, were the sites of the first botanic gardens.

Besides all else, the special attention devoted to Nature also had a practical side. Any Florentine who could afford to do so had a country house and farm not far from town. Once there, they would eat vegetables and fruit grown in their own garden and use oil from their own groves. Lorenzo the Magnificent is known to have owned a country villa near Careggi where he bred Calabrian pigs; at one of his other villas he bred Sicilian pheasants. He also introduced a species of rabbit from Spain.

Even a relatively poor man like Botticelli's father bought a small villa near Careggi. On 19th April 1494 Sandro Botticelli bought a country house outside Florence, admittedly with the help of his brother and nephews. The price was 155 gulden. That was approximately what he was paid for one and a half paintings.

It was not uncommon in Europe for the inhabitants of towns to own agricultural

land. However, the difference between Florentines and the majority of other town dwellers, especially those in more northerly climes, was that the former also liked to *live* out of town. A book published at the time states: "In the crystal-clean air and pleasant countryside around Florence are many villas with wonderful vistas …" In the same book we read: "A country house is like a reliable friend … It keeps your troubles at bay all the year round."

Venus

Venus stands at the centre of the painting. The space between the branches of trees surrounding her head forms the shape of a halo. Her graceful pose and chaste clothes are rather more reminiscent of the Virgin Mary than of a goddess of sensual love. Classical antiquity ascribed two roles to Venus. On the one hand, certainly, she was the light-hearted, adulterous goddess, accompanied by her son Cupid, who (painted near the Graces in this picture), blindly excited passion with his burning arrows. On the other, she was all harmony, proportion, balance. A civilizing influnce, she settled quarrels, eased social cohesion. She was the incarnation of eroticism – a creative rather than destructive force.

The vision of a *Venus humanitas* informed the ideal of womanhood in 15th-century Italy. In his treatise *Il Libro del Cortegiano* Baldassare Castiglione (1478–1529) wrote: "It is surely beyond dispute that there could be no contentment in a life without women. Without them, life would be rough, lacking in tenderness, worse than the life of wild beasts. Can there be anybody who disputes this? Women drive from our hearts all evil, all baseness, all worry, misery, sadness. They inspire our minds to great things, rather than distracting us …"

It goes without saying that Botticelli clothed his Venus in the robes of a married woman: she wears a bonnet and, draped over it, a veil. Hair was considered the weapon of the seductress; only young girls were permitted to let their hair hang loose.

The figures of the three Graces allow the artist to display the elaborate artistry with which the women of his time arranged their hair. To make their hair seem fuller, women would often use silk bands, false plaits and

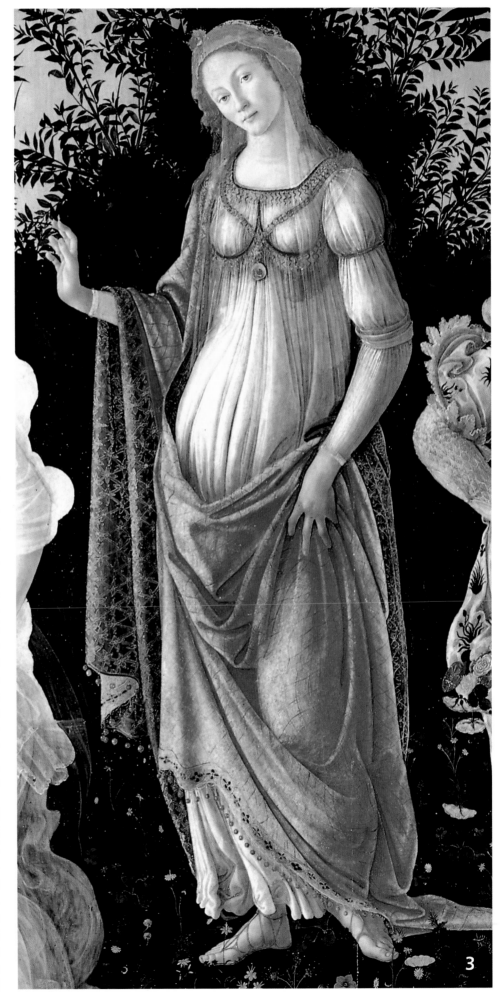

3

other hairpieces. The most fashionable colour was a delicately tinted blonde, the product of strenuous bleaching and dyeing.

Under her dress and shawl, Venus wears a long chemise, of which the arms alone are visible. This was quite usual for a lady of Florence. However, it was unusual for a married woman to reveal her feet, or drape her shawl or cloak with such evident disregard for symmetry. Mercury's toga, too, is deliberately asymmetrical. This was thought to be in the antique manner, and Florentines would have considered it a token of Classical mythology.

What was utterly contemporary, and utterly 15th century, however, was the ideal of beauty shown in Botticelli's paintings: eyebrows drawn as gentle curves rather than a double arch, foreheads no longer high and shaved, as they had been during the Middle Ages, but linear and Greek and twice as broad as long. A rounded, slightly protruberant belly was now considered graceful. The beauty of the hand was accentuated by exhibiting it against the background of a dress or shawl – as does Venus in the painting.

While in Rome to assess the qualities of a potential bride for her son, Lorenzo the Magnificent's mother, Lucrezia, mentions two characteristics that were highly treasured at the time: "She is tall and has a white skin." Almost all of Botticelli's women are large, indeed slightly elongated, if not unnaturally tall. And as for white skin, even country girls are said to have gone to some length in order to procure the ideal pallor, using tinctures, pastry packs, cosmetic pastes, and avoiding sunlight. If the three Graces dancing in the shadows in the present painting seem almost carved from alabaster, this cannot solely be attributed to idiosyncracy of style on the artist's part, for their appearance is fully in keeping with contemporary notions of beauty.

The Florentine ideal of womanhood demanded not only beauty, but education. In wealthier families, women were taught the Classical subjects alongside their brothers; they were expected to hold their own in a discussion, and to please their husbands with intelligent conversation. Besides this, a woman had to know how to run a household, an ability which the practically-minded Florentines held in high esteem. She had to be thrifty, keep a clean house and give sound direction to the servants. Only the cash-books were out of bounds.

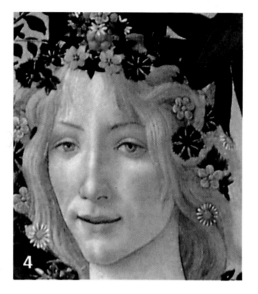

4

Flora

Flora is smiling. Smiling figures are a rarity in Renaissance painting. Flora's manner is confident and full of natural charm, possibly resembling that of the young women who posed as the goddess on carnival floats. Perhaps Botticelli was inspired by a spring festival in which the figure of Love was celebrated with dancing, jousting and banquets in the streets. The festival is supposed to have lasted two months.

Festivals were especially frequent in Florence under the Medicis. Craftsmen had previously been responsible for large festivals in the town, but now the new rulers footed the bill. Tournaments in medieval style were highly popular, giving an otherwise unwarlike class of merchants the opportunity to show off their strength and skills, as well as demonstrate their adoration of women by performing various acts of chivalry. A tournament of this kind, in honour of Lorenzo the Magnificent, took place in 1469. Its motto was "The Return of Time": an allusion to the return of spring. This was followed in 1475 by a famous tournament in honour of Lorenzo's brother Giuliano. This time the motto was "She is Incomparable"; "she" was in fact Simonetta Cattaneo, wife of Vespucci. Naturally, it was Botticelli who painted Giuliano's standards, and Poliziano who composed a poem to celebrate the event!

There are good reasons for the festive spirit which flourished under Medici rule: firstly, there was the more general mood of revival, the sense of vision that existed throughout the Renaissance; secondly, the success, as well as youth, of the ruling fam-

ily. Botticelli was 30 at the time of the 1475 tournament, Lorenzo the Magnificant 25, his brother Giuliano 21, Giuliano's lady Simonetta 22, Poliziano 21, while Lorenzo di Pierfrancesco was only 12 years old.

Simonetta died a year after the tournament. Giuliano was murdered, and Lorenzo the Magnificent wrote: "How sweet is youth, how swift its flight!" Ovid says much the same thing. Flora advises us to "pluck's life's beauty while it blooms".

The brooch

Botticelli's painting displays several examples of the goldsmith's art: Mercury's helmet and sword hilt, for example, or the brooches and necklaces of

5

the Graces. Botticelli, once apprenticed to a goldsmith himself, was well acquainted with the craft.

This was not unusual at the time; several Florentine artists began their careers as goldsmiths. Painting pictures was considered the work of a craftsman – no different in status from the work of a smith. The term "art" had not yet gained currency. During the 15th century the Italian word "arte" connoted manual skill, a trade, a guild.

But the Renaissance changed all that. The rediscovery of Classical antiquity drew the attention of Botticelli's contemporaries to the enormous respect accorded artists during antiquity. They recalled that the Muses inspired artists, but not artisans. Artists gradually received a more privileged position and, as a consequence, better pay. Michelangelo, a generation after Botticelli, was the first artist to leap to fame

and riches. Pointing out that artists do not merely work with their hands, but also with their heads, Michelangelo set himself apart from the class of artisans.

Mercury

Botticelli "uses his head" in a distinctive manner. Well acquainted with the theoretical trends and rediscovered myths of his day, he incorporates ideas – some veiled, some self-evident – into his paintings: he encourages his spectators to think. Paintings, in the Middle Ages, were the object of contemplation. Their new role was to provoke thought.

One theoretical trend dominant at the Medici court, for example, attempted to bring Christian ideas into line with those of Greek philosophers. Botticelli allows this project to enter the picture in the shape of Venus, who bears a striking resemblance to the Virgin Mary. The figure's head is surrounded by a halo which can equally be seen as a space between branches.

Besides Cupid and the Graces, Venus' entourage also includes Mercury. He wears his traditionally winged shoes, and carries a wand with which to ward off clouds that might otherwise disturb eternal spring.

Contemporary symbolism made an upward gaze the sign of relations to the Beyond. This is congruent with the mythological attributes of Mercury, who acted as a messenger between humans and the gods and who guided the dead to the realm of shadows. Perhaps he signifies the transience of spring, the fugitive nature of youth, as lamented in Lorenzo's poem.

But Mercury was also the god of merchants, and was therefore hardly out of place at a wedding with a commercial background. Besides this, he – together with the goddess Flora and countless painted flowers – provides a further allusion to the wedding month: Mercury's day in the Roman calendar was 15th May; his mother was Maia who gave the month its name.

The artist speculated on his contemporaries' ability to recognize such allusions. He played cat and mouse with the spectators of his painting, refusing to commit himself. Here, too, Botticelli is in tune with contemporary theorists, one of whom wrote: "Divine things must be concealed under enigmatic veils and poetic dissimulation."

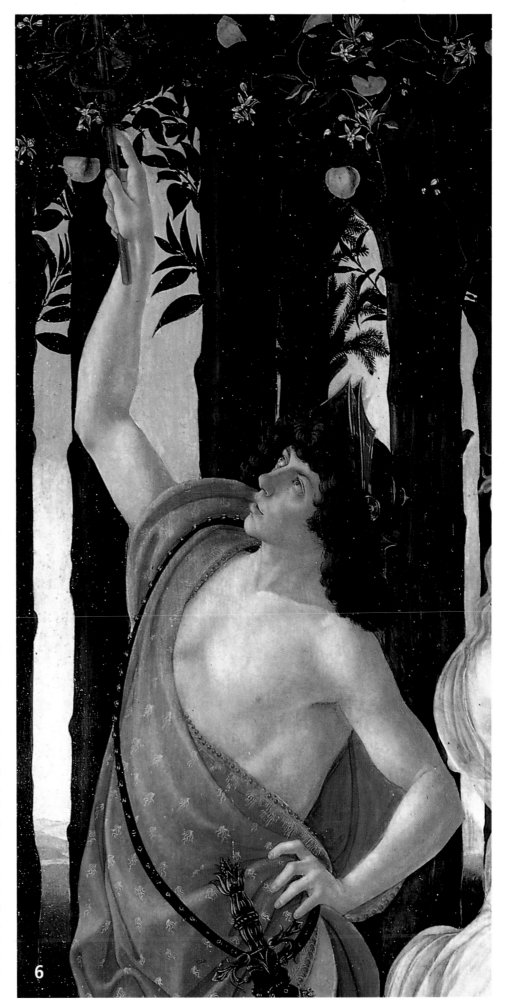
6

35

Strange quartet

In 1510 the artist Hans Baldung, alias Grien, completed a painting enigmatic enough to ensure that its theme has remained the object of speculation ever since. Who is the young woman, so engrossed in her own reflection: a goddess, the allegory of Vanity, a whore? The other figures are equally obscure. All that can be said for sure of this Renaissance work is that it retains no trace of that Christian notion of salvation which so dominated the art of the Middle Ages. The painting (48 x 33 cm) is in the Kunsthistorisches Museum, Vienna.

Of the four naked figures in the gloomy landscape, it is the young woman who draws our attention. A pale, attractive figure, she stands out starkly against the browns and darker hues of the other figures. To her right, a torn creature holds an hourglass over the young woman's head; a hag enters from the left, a child kneels at the comely blonde's feet.

The work belongs to the Kunsthistorisches Museum, Vienna, in whose catalogue of 1896 the old woman is described as Vice, the young woman as Vanity and the child as Amor. In the catalogue of 1938 the painting is entitled *Allegory of Transience*, and 20 years later: *Death and The Three Ages of Woman. Allegory of the Vanity of all Worldly Things*. The laconic title in a catalogue of works exhibited at the Baldung exhibition of 1959 reads: *Beauty and Death*.

Dispute has not been confined to the subject of the painting; the authorship, too, remained obscure for many years. Initially ascribed to Lucas Cranach and Albrecht Altdorfer, the painting was eventually attributed to the hand of Hans Baldung Grien. Little is known of the artist's life: he was born c. 1485, probably in Schwäbisch Gmünd. From 1503 to 1507 he was apprenticed to Albrecht Dürer's Nuremberg workshop. He painted the high altar at Freiburg Cathedral, but lived mainly in Strasbourg, where he died in 1545.

Despite the puzzle presented by the theme, it is nonetheless possible to reconstruct contemporary ideas associated with the four figures, while throwing light on the historical background of the ideas themselves. Numbers, for example, held a peculiar significance at the time. They not only served the practical purpose of ordering diverse phenomena, but were considered things in themselves, pillars of the world order. Numbers possessed a mythical aura that can be retraced to antiquity

and, in particular, to the work of Pythagoras. Though number symbolism had never quite sunk into oblivion during the Middle Ages, it nonetheless experienced a revival with the rediscovery of antiquity.

Three and four are the numbers most strongly felt in Baldung's picture: the three stages of life, and, as a fourth stage, Death. Both numbers were highly significant. Four were the points of the compass, four the elements and the humours; there were four periods of the day and four seasons. The times of day and seasons, too, were frequently associated with periods in life: spring and morning were childhood, night and winter the final years of a person's life, or death.

As a universal number, three was even more significant than four. The Holy Trinity, after all, was at the heart of Christian theology. In antiquity, the number three – the beginning, middle and end – stood for the totality. Aristotle had used the number three in his ethics: a bad action derives from an "excess" or a "deficiency", whereas the "just action" lies in the "mean". The Greek philosopher also applied the number three to the stages of a person's life: youth had too much strength, courage, anger and desire; old age had too little of these. Only persons in their prime possessed these qualities in due proportion.

Much thought during Classical antiquity was devoted to the division of life into three, or four (or even seven, or ten), stages, but these ideas did not find their way into the visual arts. The portrayal of the different stages of a human life in medieval art, in paintings commissioned by the church, is exceptional, for such distinctions were considered irrelevant in the face of that still greater division between life before and life after death. It was not until approximately 1500, when worldly patrons began to influence artistic themes,

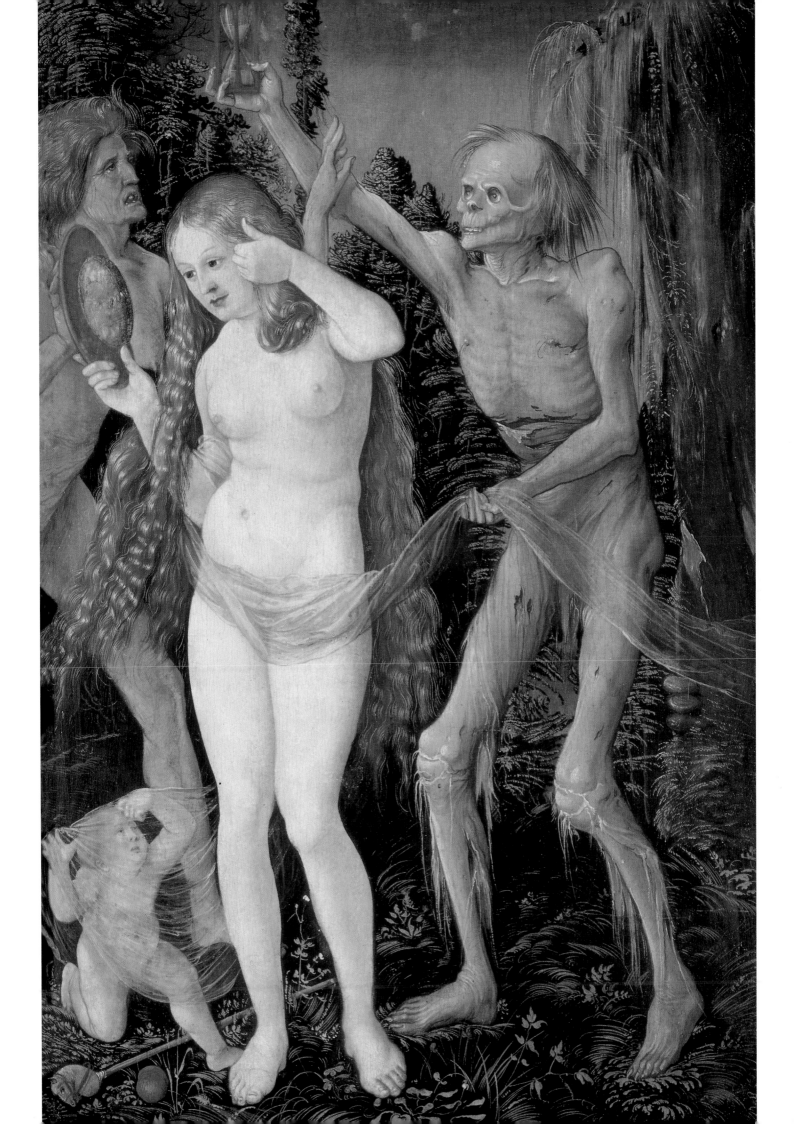

that the ages of Man were more frequently painted. Hans Baldung made them the theme of his own work on several occasions.

First steps

I t is difficult to judge whether the child at the young woman's feet is a boy or a girl; contours barely visible behind the veil suggest a boy. The hobby-horse, probably considered a boy's toy at the time, tends to confirm the suspicion. Conversely, however, if the painting is intended to portray "the three stages", why give childhood a different sex from that of maturity and old age?

Perhaps the gender of a child was of little importance to contemporary spectators. The difference was, in any case, rarely emphasized. During the first years of their lives boys and girls wore the same clothes: long frocks or smocks, and snug caps in winter.

At the same time, less interest was shown in children altogether than is the case in today's nuclear family: bonding between parents and children did not occur with quite the same intensity. Too many children were born, and too many died. Only a fraction of those born actually survived; it was better, therefore, safer, not to get too close. Perhaps such emotional reserve partly also explains why artists paid relatively little attention to children. They perceived the adult body more accurately than that of a child. This is certainly true of Hans Baldung Grien. Children who are not old enough to find their balance do not kneel with one leg stretched out in the manner shown in the painting. At least, the position would be extremely unusual.

The image of the child was determined not only by feelings and social relations, but by a whole superstructure of theological theory. This included the tenet, prevelant since antiquity, that children were intrinsically innocent. However, everyday relations with children made very little of the belief in a child's innocence. Children were treated as imperfect adults. Their special status existed only in theory, characteristically illustrated by a motif in the Bible story of the Garden of Eden: the bite taken from the forbidden apple, and Man's consequent loss of innocence. Baldung cites the theme in the shape of the round object on the ground: this could simply be a child's ball, but it could equally be an apple lying within the child's reach. The child is likely to pick it up before long.

To an educated spectator, the hobby-horse, too, was more than a toy that happened – by accident, as it were – to be lying on the ground. Cognoscenti would have linked it, through one of Aesop's fables, to the theme of the different stages of life. For the Greek writer attributes an animal to each of the three stages: the dog, the ox and the horse. The dog, a morose creature, friendly only to those who look after it, stands for old age; the ox, a reliable worker, who provides nourishment for old and young alike, represents life's prime; the horse personifies childhood, since, in this fable at least, horses are unruly creatures, lacking in self-discipline.

2

Beauty keeps her secret

The star of the painting is the damsel. The other figures seem present solely to make her stand out more starkly. Baldung achieves this effect by arrangement and colour: the young woman is furthest to the fore, the only figure whose body is not, at least partially, obscured by one of the others. At the same time, her skin is significantly brighter, indeed nearly white.

In his use of colour, Baldung follows a convention here. His teacher Albrecht Dürer, as well as his contemporaries Albrecht Altdorfer and Lucas Cranach, usually painted the bodies of women somewhat paler than those of men, and young bodies lighter than older ones. But in so doing, they showed moderation, were less given to extremes. Since, even in those days, male skin was probably no darker than that of women, and young skin no paler than old, artists must have been influenced by something other than Nature. Perhaps pallor was intended to indicate a

certain delicacy. It is more likely, however, that they were painting an ideal aspired to by women themselves. Pale skin was the fashion, at least in circles that could afford it: at court, or among the wealthy urban middle class.

The special status granted to the young woman may mean that she is intended to represent a special person: the goddess Venus, for example. The child, in that case, would be Amor. However, contemporary spectators of the painting, exposed to pictures of Venus and Amor more often than we, would have noticed immediately that something was wrong. Amor, for one thing, has no bow and arrow, his traditional attributes; secondly, since Venus is immortal, the hourglass held over her head is entirely superfluous.

If not a goddess, perhaps the young woman was intended as the allegory of Vanity. There is much in the painting to suggest this. The young woman, apparently absorbed in her own reflection, brushes back her lovely, long hair with her left hand, while, in her right, she holds a mirror, the symbol of Vanity. The mirror is convex; flat mirrors were difficult to fabricate, and therefore inordinately expensive. If the young woman is Vanity, then the older woman is a procuress: sup-

porting the mirror with one hand, she probably beckoned with the other, making sure the young woman did not lack admirers for very long. Death, too, has its place in this picture: anyone setting out to paint the vanity of beauty would probably also have its ephemerality in mind. This was doctrinaire Christian morality, for which the flesh, an obstacle to the spirit's journey to God, was evil. Outside the church, too, people were constantly forced to confront death and the ephemerality of life. The average life expectancy was thirty, almost half our own. Many died in their prime, especially women in childbirth. Hans Baldung Grien painted at least three women who had come under the shadow of Death.

In contrast to the three paintings mentioned, however, Death in the present picture seems merely to be imparting a polite reminder to the young lady that life eventually comes to a close. The hourglass has not yet run out: Beauty has time enough to regard herself in a mirror. But is she really the allegory of Vanity? The child would certainly be out of place in such an allegory. Baldung's composition does not comply with any of the many iconographical patterns of his time. Something is always left unexplained.

The body becomes a burden

Greek and Roman authors, writing of the different periods of life and death, had men in mind. They talked of young men and old, not of girls and old women. Men, during antiquity, were considered the true representatives of mankind, a notion which has survived the centuries and, even today, continues to find its way into people's minds.

Painting has often differed in this respect, not least that of Baldung himself. Three of his paintings show Death and a maiden. A panel in Leipzig shows the *Seven Stages of Life*, another, in the French town of Rennes, the *Three Stages of Death*: in both Baldung paints nude women. Only once does Baldung show Death and a man: the man is fully clothed, his dress that of a mercenary. Baldung's preference for women may derive from a more general preference for painting the female nude. But there may also be reasons less personal: women's bodies alter more visibly than men's, making it easier for the artist to illustrate the different stages of her life. Furthermore, beauty is considered more significant in woman than in man – more attention is therefore accorded to the passing of her charms.

Baldung's work belongs to a period in the history of art called the Renaissance, an era in which the human body is said to have been discovered anew. But that is only half the story. The body that was discovered, celebrated and painted over and over again was restricted to a single stage of human development: young adulthood, which, like the pale-skinned woman in the painting, was full of youthful energy. The other periods, age and childhood, were neglected. There are very few individual portraits of children, or paintings of nudes who are visibly past their prime.

If painted at all, then it was not for their intrinsic qualities, but for purposes of vicarious illustration. Children, for example, were a part of the traditonal inventory of allegories: as putti, angels or Amor. The bodies of old women, on the other hand, were generally linked to something revolting or contemptible: witches, for example, or the Fates. One such work is Dürer's fa-

mous illustration of parsimony, showing a bare-breasted old hag with narrow eyes in her wrinkled face, with more gaps between her teeth than teeth in her mouth, and a sack of gold in her lap.

The old woman in Baldung's painting may be intended as a bawd. In contrast to the younger woman, she is portrayed to her disadvantage, for her bodily proportions are incorrect. The arm with which she wards off Death is too long. Baldung frequently distorted proportions in this way.

The lack of respect and devotion granted older women at the time, with the exception, perhaps, of portraits like Dürer's

charcoal drawing of his mother, together with a pronounced tendency to portray the older female nude as ugly, probably derive from a peculiarly male perspective. The young woman, the object of male desire, was given a certain appeal; sexual inclination determined aesthetics. Conversely, an older woman's body was seen as worn out, its erotic properties dissolved. The male reaction to this was one of disillusionment, perhaps even disappointment. This decided how he painted.

4

Dancing
to death

The artist has crowded three figures into the left of the painting, leaving the right to Death. The proportional harmony and figural balance sought by Dürer is lacking here. Instead, the chief effect is one of movement: created, for example, by the old woman striding forcefully towards Death, or by the veil. The latter begins with the child, flows over the young woman's upper arm, is picked up by Death, finally drifting out of the painting on the right.

It has been suggested that the pale nude's veil is the badge of a whore, for in cities like Strasbourg at that time, prostitutes were obliged to wear veils. But then the Virgin was also frequently painted wearing a veil, as were Eve and Venus. It is therefore unlikely that Baldung's contemporaries would have linked the delicate fabric of the veil with the idea of fornication.

The veil is nonetheless an important feature. Firstly, it fulfils a practical and tradi-tional function in covering the pubic region; secondly, it creates a link between the child, the young woman and Death. The older woman, warding off Death with one hand and supporting the mirror with her other, completes the group.

All four are inter-connected. The cycle of figures thus suggests the motion of a dance: a roundel. Dancers often joined by holding a piece of cloth rather than each others' hands.

Bearing this in mind, it is possible that the contemporary spectator of this painting would not have thought only of Venus and Amor, Vanity and the bawd, the ages of Woman, beauty and ephemerality, but also of the widespread image of the *danse macabre*, the dance of death. It was an image often seen carved on the walls of graveyards and churches: a skeleton, usually playing an instrument, leads representatives of each of the social strata, from the peasant to the emperor to the pope, into the Hereafter. The message these pictures conveyed was that Death cancelled worldly distinctions; only God's judgement counted.

This religious and moral exhortation was evidently compounded by the widely held belief in ghosts. Death was not the only figure to haunt the living; there were also the "undead". People in those days spoke of revived corpses, dead persons taken before their time, the victims of murder, suicide, accident or war, who, deprived of last rites, roved the surface of the earth like a "tormented army".

One of Baldung's contemporaries, the doctor and philosopher Paracelsus, referred to these revived corpses as "mummies". The term aptly describes Hans Baldung Grien's figure of Death: no naked skeleton, but a dried-out corpse, whose finger and toe-nails continue to grow, whose parched skin hangs down in tatters like the dry bark of the nearby tree. But even a superstitious belief in zombies cannot fully account for the four figures in the painting. There is, at any rate, one thing that all these explanations have in common: the painting contains no reference to the Christian notion of salvation, not a trace of that doctrine of Divine Supremacy that was acknowledged and celebrated so frequently in medieval painting.

The battle to end all battles

The Wittelsbach Duke Wilhelm IV was hardly one of the more important rulers of his day. He governed Bavaria from 1508 to 1550, during the Reformation, but his strategy of shifting alliances with the powerful Habsburgs, French king and Protestant rulers brought him little advantage; he even made a vain attempt to become German king. On the other hand, he did achieve two things with lasting effect: Wilhelm ensured that Bavaria remained a Catholic land, and he commissioned one of the most important German paintings, Albrecht Altdorfer's *The Battle of Issus*.

The painter and architect Altdorfer lived in Regensburg, approximately sixty miles north of the ducal residence in Munich. Though situated in the middle of Bavaria, Regensburg was a Free Imperial Town,

whose allegiances alternated between the Emperor in Vienna and the Wittelsbach dukes. The same might be said for the Regensburg citizen Altdorfer. Altdorfer executed some 200 works for Emperor Maximilian, most of them miniatures and woodcuts, but he created his masterpiece for Duke Wilhelm in Munich.

Altdorfer must have been almost 50 when he received the commission to paint *The Battle of Issus*. His exact age cannot be established, since his date of birth is unknown. It is thought to have been *c.* 1480. However, documentary evidence does reveal that Altdorfer quickly rose to wealth and prestige. In 1513 he bought a house "with a tower and farmstead". In 1517 he became a member of the Outer Town Council, in 1526 a member of the Inner Council, and on 18th September 1528 he was elected Mayor. However, Altdorfer declined this high office. His reason for doing so is mentioned in the annals of the Regensburg Council: "He much desires to execute a special work in Bavaria for my Serene Highness and gracious Lord, Duke Wilhelm." This "work" was *The Battle of Issus*.

As an artist and member of the town council, Altdorfer became involved in the conflicts of his age. He announced the town's expulsion of its Jewish inhabitants, making a quick sketch of the synagogue before it was destroyed. His connections to the imperial court were such that, when Regensburg fell into disgrace with the Emperor, Altdorfer was entrusted with the mission of apologizing. When the Turkish army threatened Vienna, he was given the task of fortifying the Regensburg defences.

As a member of the town council, Altdorfer had to interrogate Anabaptists and sit in a committee to appoint a Protestant minister. In his will, he declared that he had no desire for "spiritual accessories", which probably meant that he rejected the administration of last rites, or the holding of a mass. By the time of his death in 1538, he was probably no longer a practising Catholic.

The schism within the church and the military threat that sprang from the non-Christian Orient were the two main factors determining life at the time. Insecurity and fear were widespread. It is against this background, too, that we must consider the genesis of the present painting.

The artist shows an event from the distant past, a battle fought near Issus in 333 B.C. This he sets against a panorama of sky and landscape; the battle in Asia Minor thus assumes the aura of a natural disaster, or a scene from some cosmic Armageddon. In fact, the battle was seen at the time as a turning point in world history: the Greek Occident had defeated the Persian Orient.

The contemporary signifcance of the subject was obvious, and the tablet proclaiming victory at the top of the painting assumed a special significance in the face of the Turkish threat. The tablet appears to descend from the vault of the heavens, and bears a message in Latin: "The defeat of Darius by Alexander the Great, following the deaths of 100,000 Persian foot-soldiers and more than 10,000 Persian horsemen. King Darius' mother, wife and children were taken prisoner, together with about 1,000 fleeing horse-soldiers."

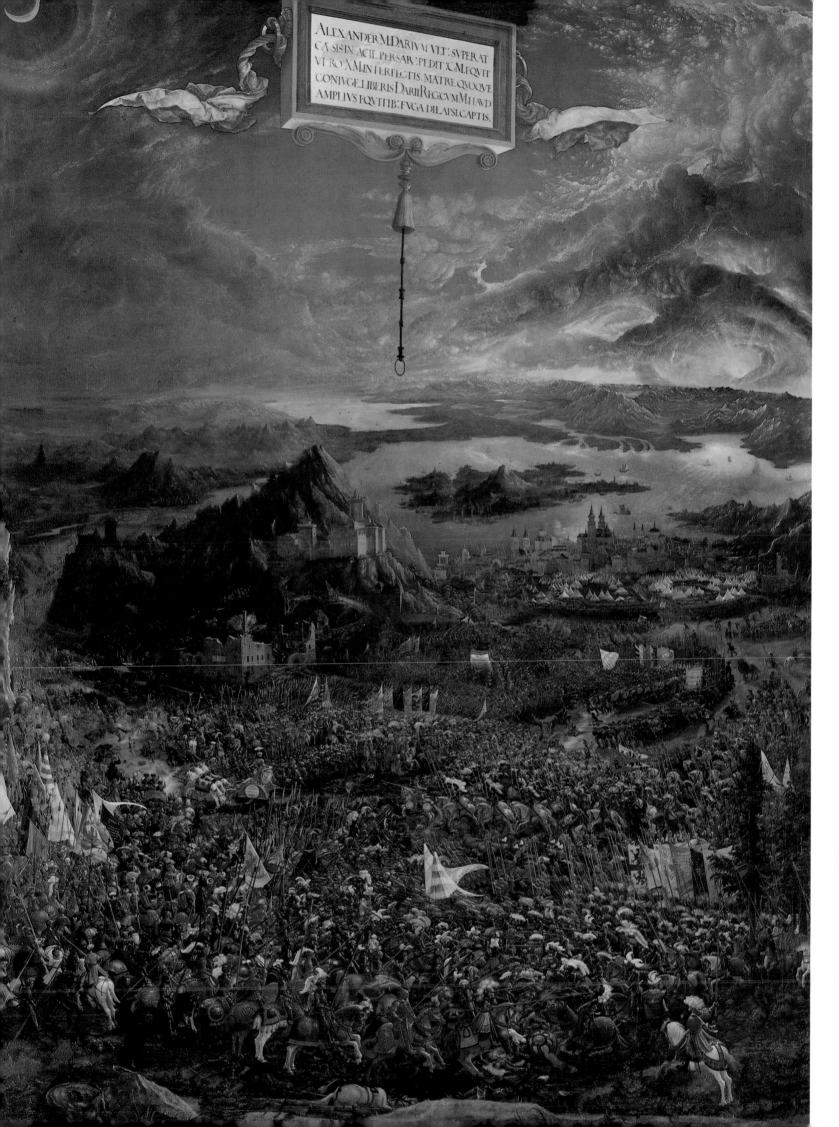

ALEXANDER M.DARIVM VLT: SVPERAT
CÆ SIS IN ACIE PERSAR: PEDIT:C.M.EQVIT
VERO X.M.INTERFECTIS, MATRE QVOQVE
CONIVGE,LIBERIS DARII REG:CVM M.HAVD
AMPLIVS EQVITIB: FVGA DILAPSI,CAPTIS.

A ltdorfer provides details of military strengths and losses not only on the large tablet, but on banners and flags. The painting was probably intended to serve several purposes, one being to keep alive Alexander's strategic fame, which derived from the Macedonian's defeat of an army many times larger than his own. According to figures cited in the painting itself, Darius commanded 300,000 foot-soldiers, while Alexander led only 32,000; the Persian king had a cavalry of 100,000, his opponent a mere 4,000. One of the great general's admirers was Napoleon, who, in 1800, had Altdorfer's painting brought to Paris and hung in his bathroom.

As an artist, however, Altdorfer evidently felt little obligation to illustrate the details he cited. There is nothing in the painting to sugggest the numerical superiority of Darius' army; nor has the artist followed historical accounts of strategic deployment. On top of this, he has clothed the figures in the dress of his own time. The cavalry wear heavy armour; some of Persians are shown in turbans of the kind Turks were seen to wear. The women in feathered toques look like German courtly ladies, dressed for a hunting party.

That Altdorfer painted women at all on a battlefield must probably be attributed to his passion for invention. The 16th century became increasingly preoccupied with western civilisation, but this was not necessarily accompanied by an interest in historic truth. Investigative research into the past had not yet begun; archaeology was a subject of the future.

One of Altdorfer's sources was probably Hartmann Schedel's "World Chronicle". Most of the artist's statistics are identical to those given by Schedel. The book had appeared in Nuremberg in 1493, 35 years before Altdorfer commenced work on *The Battle of Issus*. Another source may have been an account written by Q. Curtius Rufus, a document probably dating from the first century. However, neither work makes mention of women entering the fray – one of Altdorfer's inventions.

A highly dramatic scene involving women is indeed related in Curtius's account, only this takes place in a camp. According to Curtius, Darius' mother and wife, taken prisoner in their tents, suddenly began to wail: "The reason for this shocking scene was that Darius' mother and wife had broken into loud and woeful lamentations for the king, whom they thought killed. For a captive eunuch ... recognizing Darius' tunic, ... which he had cast off for fear that his clothing would betray him, in the hands of the soldier who had found it, and imagining the garment to be taken from the king's dead body, had brought false news of his death."

Women on the battlefield

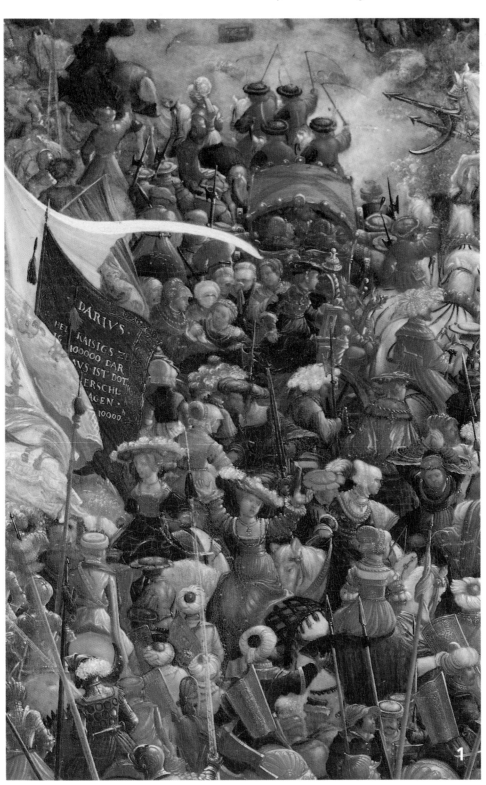

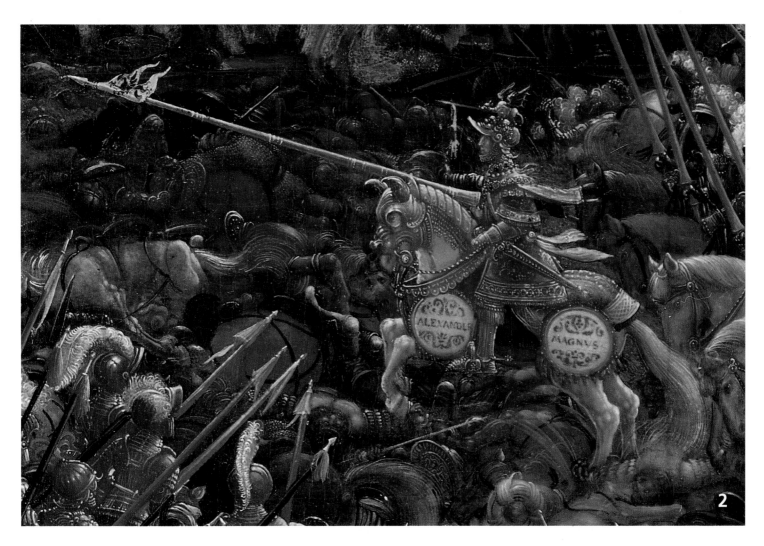

2

Heroes replace saints

Darius escaped with his life at the battle of Issus. He was certainly not pursued by Alexander to within a length of the latter's lance, as Altdorfer's painting suggests. At least, there is no mention of this in either historical account. The artist was faithful to historical truth only when it suited him, when historical facts were compatible with the demands of his composition.

It is not known what Altorfer's patron wished the painting to show: admiration for Alexander's strategic prowess, the parallel with the Turkish threat, or – since he was himself such an enthusiastic participant in tournaments – a celebration of chivalry? All that can be said for sure is that Altdorfer's painting reflected one of the chief preoccuptions of his age: the reappraisal of Classical antiquity was a charac-

teristic feature of the Renaisssance. During the Middle Ages, saints had grown in significance over the legendary figures of ancient Greece and Rome, and more value was attached to relics of Christian martyrs than to antique manuscripts. However, a change in attitude soon began to make itself felt in quattrocento Italy, spreading north across the Alps during the century that followed. The saints began to lose their exemplary status. Of course, this process was linked to the decadence of the Roman Catholic Church. Reappraisal of antiquity and the decline of the Church went hand in hand.

Wilhelm IV commissioned not only *The Battle of Issus*, but a whole series of heroic scenes: Hannibal defeating the Romans at Cannae, Caesar besieging Alesia, the captive Mucius Scaevola burning his hand to demonstrate to his adversaries the bravery of the young men of Rome; eight paintings (of which Altendorfer painted only one) in an identical, upright format. There is also a second series in horizontal format – possibly commissioned for the Duchess – showing seven famous women, many of

them Old Testament figures: Susanna bathing, before defending herself against the advances of two elders who slander her and condemn her to death; Judith cutting off the head of Holofernes, the enemy of her people; and Helen, Troy's ruin.

All of these men and women had distinguished themselves in some way or other. The interest they aroused during the 16th century was not only a sign of the period's rediscovery of antiquity, it was the mark of a new sense of self. During the Renaissance people no longer saw themselves solely as members of a social group, as the citizens of a town, or as sinners before God in whose eyes all were equal. They had become aware of the unique qualities that distinguished one person from another. Unlike the Middle Ages, the Renaissance celebrated the individual. Altdorfer may have painted row after row of apparently identical warriors, but the spectators themselves would identify with Alexander and Darius, figures who had names, whose significance was indicated by the cord which hung down from the tablet above them.

chedel's *World Chronicle* was a seminal work, treasured not only for its comprehensive survey of the historical knowledge of the age, but for its detailed approach to geography. The book contained illustrations of the more important figures of the Bible and Classical antiquity (naturally wearing 16th-century dress); it also showed the famous woodcut *vedutas* of towns executed in Nuremberg after the sketches of travellers.

The *World Chronicle* thus not only reflected contemporary interest in the history of civilisation "from the beginning of the world unto our own time", but also a widespread curiosity about geography. In this sense, it is a typical product of the age of discovery, an epoch marked by Columbus reaching America, Magellan sailing around the world, and attempts by cartographers to find the appropriate visual form in which to present distant parts of the world. Altdorfer attempted something similar. His *Battle of Issus* is set against the imposing panorama of the Eastern Mediterranean.

The inspiration for this was probably provided by a map in Schedel's chronicle. In the detail below, Cyprus is shown as a disproportionately large island, with the Red Sea above it to the left. Above right is the Nile delta, identified by its eight arms and by the lakes thought to be its source. The mountain range beside the Nile has no equivalent in reality, but is featured in Schedel's map.

The town situated on the near Mediterranean shore is probably not intended to be Issus. Issus was an unimportant town in Altdorfer's day, and is not mentioned in Schedel's book. According to the *Chronicle*, the battle took place in 333 B.C. near the town of Tarsus. This, by contrast, was a name to conjure with, associated in many readers' minds with a school of philosophy which, in Roman times, had been as famous as the schools of Athens and Alexandria. First and foremost, however, Tarsus was known as the birthplace of the Apostle Paul, a place of significance in church history. Perhaps this explains why Altdorfer – anachronistically – embellished the townscape with church towers.

For in spite of the Renaissance, the prevalent geographical and historical pictures of the world c. 1500 were still dominated by church doctrine. This, too, is reflected in Schedel's book. The acts of God in creating the world are there presented as no less factual than the number of soldiers who took part in the Battle of Issus. Because God created the world in six days and rested on the seventh, Schedel divided the entire history of mankind into seven "ages": "Now, seven is a perfect number, seven days there are to a week, seven stars that never sink …" According to Schedel's calculations, the human race c. 1500 had reached the seventh, and final, "age". The end of the world was nigh.

Painting in the age of discovery

The end of the world is nigh

Many of Schedel's and Altdorfer's contemporaries were tormented by the fear that the world was coming to an end. Even Luther believed it. One of Luther's commensals reported: "the following day he again spoke much of the Day of Judgement and of the end of the world, for he has been troubled by many terrible dreams of the Last Judgement this half year past ..." On another occasion Luther complained: "Dear Lord, how this world is reduced ... It is drawing to a close." Or: "When I slept this afternoon I dreamt the Day of Judgement came on the day of Paul's conversion."

Dreams, premonitions and prophecies of the end of the world were fed not only by calculations based on the "seven days" premise, as in Schedel's work. Calculations of an entirely different order, those of the prophet Daniel, seemed to point in the same direction. He had predicted that four kingdoms would come and go, before the coming of the kingdom of the Lord. The four kingdoms were thought to be Babylon, Persia, Greece and Rome. This was problematic, however, for the Roman Empire had long since passed away. A route out of the quandary was found by propounding that Rome still existed – in the form of the papacy. By Luther's time, however, the papacy was so much gone to seed that it really did seem on its last legs. Luther: "Daniel saw the world as a series of kingdoms, those of the Babylonians, Persians, Greeks and Romans. These have passed away. The papacy may have preserved the Roman Empire, but that was its parting cup; now that, too, is gone into decline."

This comment, along with other examples of Luther's "table-talk", was recorded in 1532, four years after Altdorfer began work on his painting. Altdorfer was undoubtedly aware of the eschatalogical preoccupations of his contemporaries. As a member of the leading body of the town in which he lived, he was forced constantly to deal with questions relating to the church.

If we take for granted that Altdorfer knew of these things, and that he, too, sensed what it was to live at the end of Time, then the sky over the Battle of Issus assumes a new meaning. In the original work, the sky was bigger; the painting was reduced in size at a later date when strips were cut from all four sides, with the largest section removed from the top. The moon, too, originally stood further from the corner of the painting. Even in its present size, however, the sky covers more than a third of the painting's surface. With its sharply contrasting lights and darks, dynamic congregation of clouds and sun reflected in the sea, it suggests the occurence of an extraordinary event.

The exact nature of this event was expounded by Daniel: the second of the kingdoms anticipated by God and prophesied by Daniel cedes, near Issus, to the third, as the Greeks defeat the Persians. However, the change of power is, at the same time, a stage further on the world clock, a step closer to the impending end of the world. Viewed in this way, *The Battle of Issus* had a direct bearing upon the present.

It is thought that Wilhelm IV wanted the painting to celebrate the grandeur of the individual. He wanted a Renaissance painting. What he got was a work whose view of the world was dominated in equal parts by new ideas and medieval tradition: even the cleverest and boldest of individuals cannot decide the course of world history – that is the province of God alone.

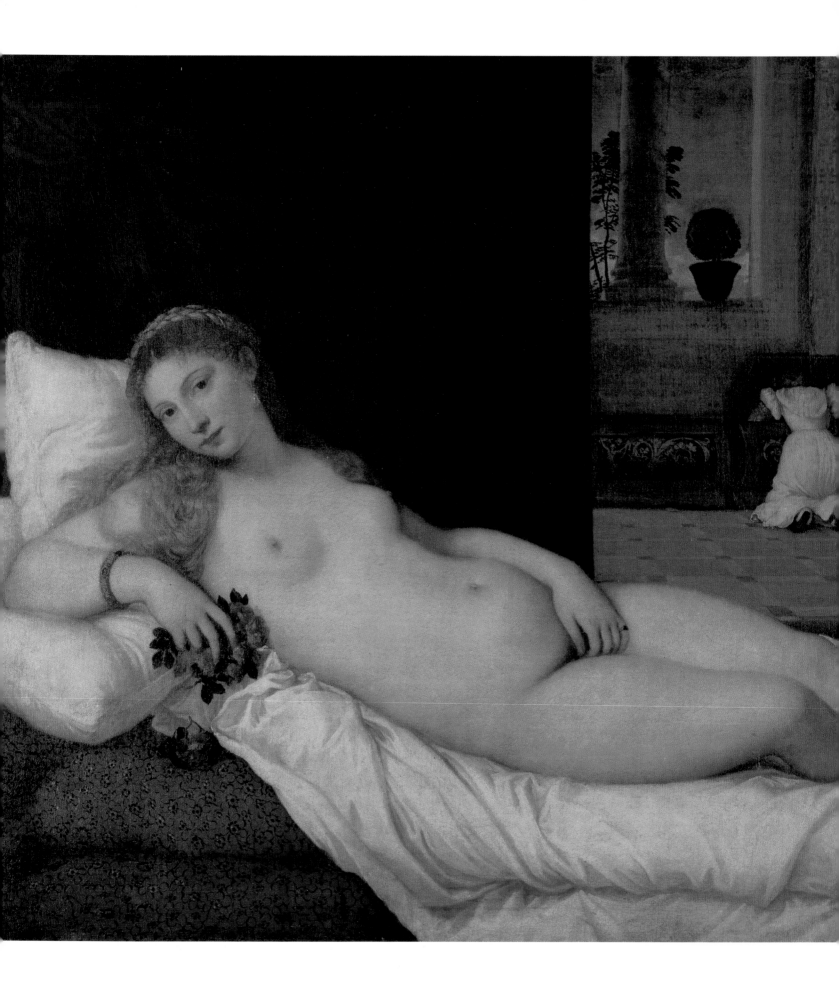

From the canopy of Heaven to a four-poster bed

On 9th March 1538 Guidobaldo della Rovere, son of the Duke of Urbino, wrote a letter to his father's ambassador in Venice. He was sending a courier, he wrote, or rather dictated, to "bring me two paintings currently in the hands of Titian". The courier was, under no circumstances, to return without the paintings, even if it meant waiting for two months.

The situation was complicated, for Guidobaldo did not have enough money to pay for the works. The ambassador, so he requested, was to use his good offices to elicit an advance, or a guarantee for the required sum, from his mother, the Duchess. In a later letter Guidobaldo wrote that "if the worst comes to the worst" he should have to "pledge that which is mine". He was determined to have the two Titians. One was his own portrait, the other was "la donna nuda", the "naked woman". Known today as the *Venus of Urbino*, this 119 x 165 cm Renaissance painting can now be seen in the Uffizi, Florence.

In the spring of 1538 Guidobaldo reached the age of 25 years. Titian (probably born between 1488 and 1490) was twice Guidobaldo's age. By that time he was, in all likelihood, the most highly-regarded artist in southern Europe. He had worked for churches and monasteries, for rich merchants and the Republic of Venice, for Italian princes and the Emperor, Charles V. Titian enjoyed the highest social and artistic esteem. Charles V had elevated him to the rank of Count Palatine and Knight of the Golden Spur – an extraordinary honour for a painter.

Guidobaldo may have become acquainted with Titian through his father, Francesco Maria della Rovere, Duke of Urbino since 1508. Francesco was known for his violent temper and prowess as a military strategist. He had killed a cardinal with his bare hands, fought for the papacy and led a Venetian army into battle: in short, he was a typical *condottiere*. He owned a palace in Venice and died in October 1538, presumably poisoned by his rivals.

This *condottiere* loved paintings and sophisticated company. He was married to the much-admired Eleonora Gonzaga: "If ever knowledge, grace, beauty, intellect, wit, humanity and every other virtue were joined in one body, then in this", enthused the writer Baldassare Castiglione. Francesco had commissioned paintings by Titian since 1532: a Nativity, a Hannibal, and a Christ for the Duchess. Later he commissioned a Resurrection and purchased a *Woman in a Blue Dress*. Portraits of the Duke and Duchess followed.

Guidobaldo continued the family tradition, commissioning new paintings more or less regularly until his death in 1574. Like his father, he served as a general in the Venetian army, frequently staying at Venice. His financial problems of spring 1538 were solved by the death of his father in the autumn of that year. He was now Duke of Urbino. And his mother had paid for her son's portrait, though not for the "naked woman".

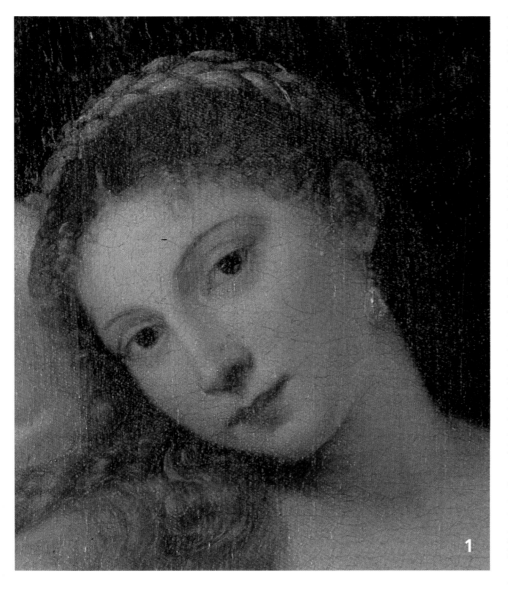

Who was the "donna nuda"?

It was later claimed that the future Duke of Urbino wished to possess the painting because it portrayed his mistress. Alternatively, it has been suggested that Titian painted his own mistress, for the woman appears in his paintings no fewer than three times. A rumour during the nineteenth century maintained that the painting showed Guidobaldo's mother, Eleonora Gonzaga, for it was difficult to ignore a certain resemblance between her portrait from Titian's hand and the "naked woman". Moreover, both paintings contained the same curled-up lapdog.

There is no evidence to support any of these theories. An Italian "lady of quality" was unlikely to have herself portrayed in the nude, for this would have been irreconcilable with her role in society: she was ex-pected to bear children, hold house, put her husband's honour above all else and stand by his side on public occasions. Though the human body was increasingly exalted during the Renaissance, the exhibi-tion of a woman's body unclothed to eyes other than those of her husband would have provoked ugly scenes indeed, had the terrible facts been revealed in public by a painting.

The ideal of uxorial respectability did not include the expression of sexual and sensual pleasure, so evident in the present painting. The church, with its repudiation of the body and disdain for women, did whatever it could to ensure that the re-spectable ideal became respectable prac-tice. Men were permitted to indulge their sexuality, women were not. It is probable that the opportunities for such gratifica-tion within marriage were limited, for mar-riage – both to the aristocracy and to the bourgeoisie – had less to do with personal inclination than with politics, or finance.

Families were expected to afford their members protection; safety was more highly valued than love.

The constraints imposed by men on their wives and daughters drove the former to seek their consolation in mistresses and prostitutes. According to the diary entry of a man called Priuli, there were some 11,000 prostitutes in Venice c. 1500, and, accord-ing to another source, there were 6800 in Rome c. 1490. If one relates these figures to the total population of the towns at the time – Rome had 40,000 inhabitants, Venice 120,000 – one arrives at the figure of almost 20 percent of the female population in one case, and over 30 percent in the other. Even if these figures seem too high to sustain credibility, they nonethless sug-gest that prostitution was anything but a marginal social phenomenon. Countless anecdotes confirm this. Payment for sexual favours was socially acceptable. Priests damned it, of course, but Cardinal de' Medici, during his stay in Venice in 1532, made no secret of living with a girl called Zeffetta.

Alfonso d'Este, who married Guidobal-do's sister Julia, was even praised for it on one occasion: instead of simply seducing young girls, he at least asked their parents' permission before taking the girls to live with him. Later, he married them off with an excellent dowry. For the poorer strata of the population, giving away one's daughter as the mistress of a wealthy man was prac-tically considered a normal means of secur-ing her existence.

The prerequisite was, of course, that the girl was as appealing as Titian's model. Ti-tian himself lived for many years with a barber's daughter, who bore him two children. Titian then did something quite unusual: he married her.

Titian painted a bouquet of roses in the reclining nude's hand. Roses were an attribute of Venus. Whether mythical figure or "donna nuda", her body reflects the ideals of beauty and erotic predilections of the High Renaissance.

Her high forehead, however, was un-typical of the period. Throughout the Middle Ages, women whose circumstances had granted them leisure to indulge in fashion had plucked their hair above the forehead in order to lengthen their faces.

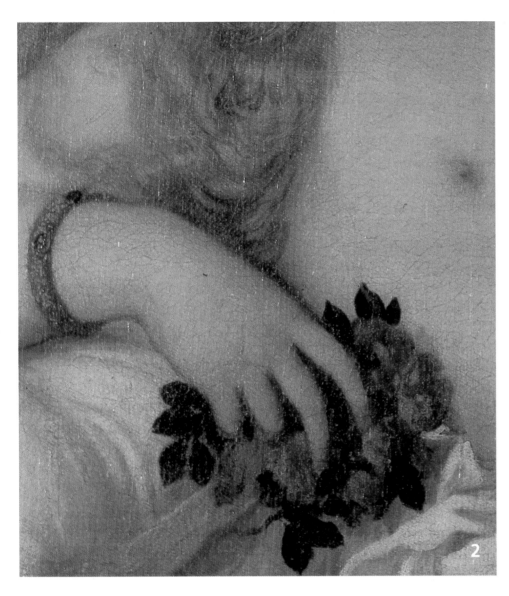

slender and elongate, an effect emphasized by their trains, tapering bonnets and sloping shoulders. The ideal female figure of the Renaissance was more solidly built. Broad shoulders, enlarged and embellished by the ploys of dressmakers, were an important characteristic of this type. Titian gives special emphasis to the reclining nude's right shoulder, while a servant in the background wears fashionably puffed sleeves. Breasts were considered beautiful only if small, round and firm, lacking the fullness of maturity. This was the view expressed in an Italian text of 1554, a view evidently shared by Titian. A narrow waist, the distinguishing feature of 19th-century fashion, was considered undesirable. The latest Spanish fashion was a high corset that flattened the breasts, denied the waist and enclosed the trunk of the body like a tube. However, this puritanical garment, turning the female body into a kind of geometrical figure, gained little acceptance in Italy.

Titian painted his nude with a gently rounded belly. In Gothic art, the stomach tended to protrude further than the breasts. Renaissance painters, on the other hand, hoping to capture a more natural attitude, did away with exaggerated curves. Nonetheless, the belly, the symbol of fertility and procreation, remained the focal point of the female body.

Bodies change with fashions

The curve of the head between forehead and cranium was considered attractive, and was emphasized for that reason. High foreheads, however, were now a thing of the past. Even married women no longer concealed their hair under bonnets, and the locks of unmarried women fell loose about their faces, softening their features.

Although the hair of most Italian women was black by nature, the most fashionable colour at the time was blonde. Almost all mythical figures painted during the Renaissance have fair hair. It was said of the women of Venice in 1581 that they used "spirits and other remedies to turn their hair, not only golden, but snow-white".

In Gothic art, women generally appear

4

A chest was part of every dowry

Titian's "donna nuda" reflected the Renaissance ideal in a number of details, and it was perhaps for this reason – as much as for its quality as a work of art – that Guidobaldo was so desperate to possess it. The artist emphasizes the nudity of the reclining woman by showing two fully-clothed servants in the background. The kneeling woman is seen from behind, an unusual posture. Indeed, Titian may be the only artist of his day to have painted a woman in this attitude.

The interior and furnishings are typical of the period. The kneeling woman is rummaging in a clothes-chest, referred to in Italian as a *cassone*. Clothes-hangers and wardrobes had not yet come into use, and clothes were kept in chests. They formed an integral part of every dowry and, depending on whether their owners were wealthy enough, would often be inlaid with marquetry, or painted. Titian, too, had painted *cassoni* in his youth. They tended to be low, since they doubled as seats. Some were even fitted with backrests.

The bed was probably a four-poster, supporting a canopy and with crossboards for hanging curtains; neither posts nor crossboards are visible in the present painting, however. With its curtains drawn, a bed was transformed to a room within a room, a realm of privacy. Maids and servants often slept in the master bedroom, or in front of the door, since the majority of houses did not have servants' quarters. Titian painted his beauty half-sitting; the pose reflects contemporary sleeping habits.

Titian's interior contains little but a bed and chests; in fact, these were the most important, and sometimes the only pieces of furniture to be found in a house. There were few proper tables; meals were generally eaten at boards which were laid across trestles and later stowed away. It is difficult to see whether the hangings in the background are tapestry or leather.

Venice, with lively trading relations to the Near East, was one of the main trans-shipping ports for oriental carpets, and the best, or most famous, gold-printed leather was imported from the Spanish town of Córdoba. Marble floors were found in all the wealthier homes. Artists treasured their regular square patterns, which provided a means of lending mathematical precision to perspective; this had been an important feature in painting since the development, in Florence a century earlier, of artificial perspective.

The windows of domestic interiors were relatively small, and were closed with wooden shutters. The open space shown in Titian's painting may be part of a room used only in summer, perhaps at a country villa. A view of pleasant, surrounding countryside was an essential feature in every Renaissance villa.

While Titian's work contains many details epitomizing life at the time, it was not his intention to paint a realistic picture. This is made abundantly clear by the dark plane dividing the painting into two halves, whose right edge ends just above the reclining nude's hand. Though evidently intended to suggest the curtain of the bed, it is entirely lacking in definition. The plane helps balance the two halves of the picture, as well as providing a background against which the upper half of her body stands out more clearly. The vertical border also emphasizes her *mons veneris*, which the nude coyly conceals.

The goddess becomes a woman

In c. 1485, Sandro Botticelli painted his *Birth of Venus*, one of the loveliest Venus nudes to emerge from the Florentine Renaissance. She is shown standing upright, almost floating. It was the Venetian Giorgione who devised the first reclining Venus. Against a natural setting, we see her asleep with her head resting on one arm. Giorgione died in 1510, before he could finish the work. Titian, his collaborator, completed it. He returned to the theme more than a quarter of a century later, this time replacing the outdoor setting with a domestic interior.

The three paintings show a progression. Botticelli's Venus is a supernatural apparition in human form, untouchable, not of this world. Giorgione's Venus has a realer presence. She is shown reclining in an attitude of abandon – to sleep, rather than a man's gaze. She, too, retains something of the aura of a Nature god-

dess. Titian has removed her from natural surroundings, placing her in a man-made setting instead: a four-poster bed. The goddess is transformed: a young woman meets the spectator's gaze, conscious of her appeal, revealing her body and expecting, if not caresses, then admiration. It was Titian who liberated the nude from the constraints of the mythical stereotype, seeing a real woman in the female figure. To his contemporaries, this must have been an exciting development. It can hardly be put down to accident that Guidobaldo, who wanted the painting so badly, spoke only of the "donna nuda", the naked woman.

It was not until later, through the intervention in 1567 of the art historian Vasari, that the nude became known as Venus. Her identity was confirmed in a later inventory. Though the chief attribute of antique Venus, her son Cupid with his bow and arrows, seems to have deserted her in the present picture, Titian nonetheless paints her with her characteristic flowers: he shows her holding roses, the symbol of pleasure and fidelity in love, and places a pot of myrtle on the window ledge to

indicate constancy in marriage. The lapdog is an unusual figure here. It symbolized carnal desire, but also devotion; on the gravestones of many married couples a dog was shown lying at the woman's feet. Perhaps it found its way into the painting quite by accident. Perhaps it belonged to the artist's workshop, and Titian simply enjoyed painting it.

Some scholars have suggested that Guidobaldo commissioned the work to mark the occasion of his wedding in 1534, which would explain his eagerness to possess the work. There is no evidence for this. At the same time, however, it is impossible to overlook the symbolic reference through roses and myrtle to conjugal fidelity. Titian may have wished to show more than Venus' conventional attributes. Perhaps he wanted to show an alternative to the widespread division of the female population into repectable housewives and paid paramours, demonstrating that sensual pleasure could be found in marriage too. Guidobaldo, as his letters testify, was very happily married.

The utopia of common huntsmanship

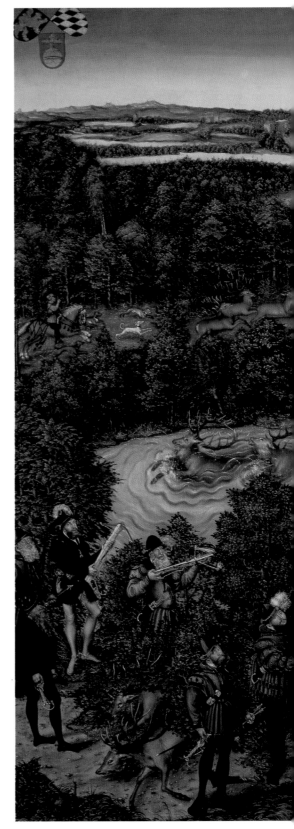

Painted in 1544 by Lucas Cranach the Younger, Elector John Frederick of Saxony and the German Emperor Charles V appear the best of hunting companions. But appearances are deceptive: the Protestant prince and Catholic monarch were rivals, soon to wage war. Their hunting expedition never took place. Cranach's painting (117 x 177 cm) is in the Kunsthistorisches Museum, Vienna.

A hunting scene in Saxony in 1544. In the background the river Elbe with Torgau on its banks. In the foreground two of the leading figures of their day: at the left edge of the painting, between two men with white beards, Emperor Charles V; further to the right, wearing a green coat, John Frederick the Magnanimous. As Elector of Saxony, John Frederick was the Emperor's subject; as a Protestant prince, he was the Catholic monarch's enemy.

Big hunting parties were at that time part of the traditional supporting programme at political meetings; while the deputies at Imperial Diets argued over formalities, their lords went out hunting in the forests. Hunts were organized for entertainment and representative purposes; the names of participants and numbers of head of game were recorded in letters, in written accounts of the chase, and occasionally in paintings.

Lucas Cranach the Elder once received the following advice: "When princes bid you accompany them on the hunt, you take your panel and, with the hunt all around you, show Frederick tracking a stag, or John pursuing a wild boar." For "it is well known", the writer explained, that the finished painting "affords the princes as much pleasure as the hunt itself".

The stag hunt of 1544 was probably not painted by the elder Cranach, but by his son, Lucas the Younger. The latter began work in his father's studio, which he later took over. Neither Cranach signed paintings with his name, preferring to use the trademark of the workshop, a winged serpent. This is painted on the prow of the boat, beneath the year 1544.

Only in tournaments and the hunt did princes and nobles find opportunity to train for the toils of war. However, the key figures in Cranach's painting would hardly be overstrained by the hunt depicted: they are shooting at driven game.

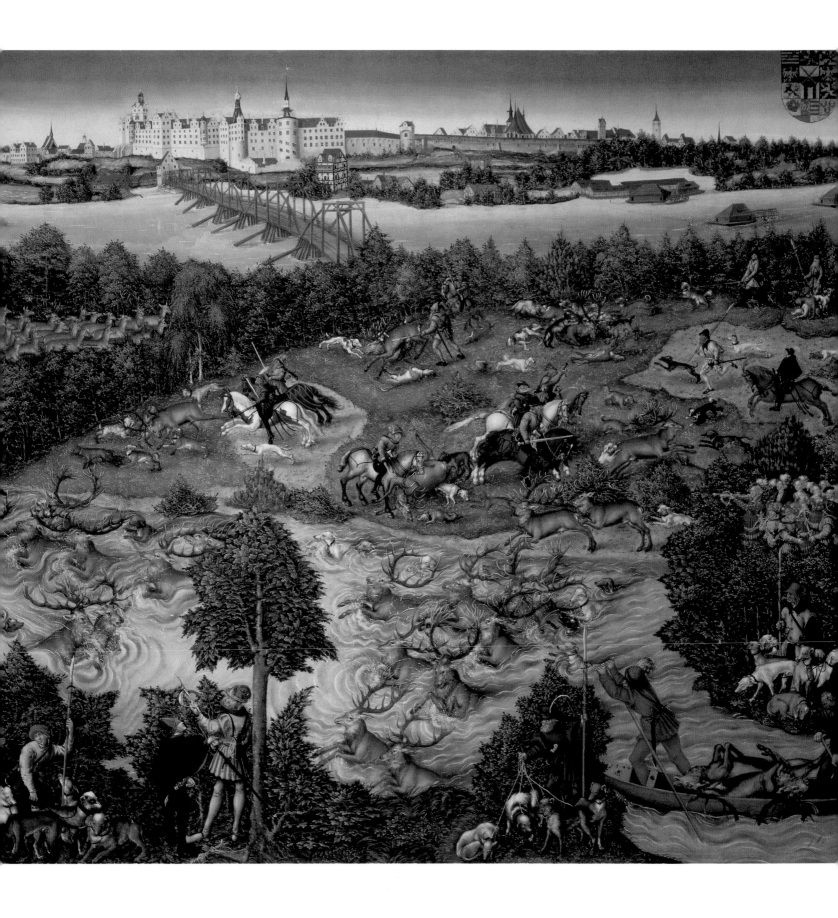

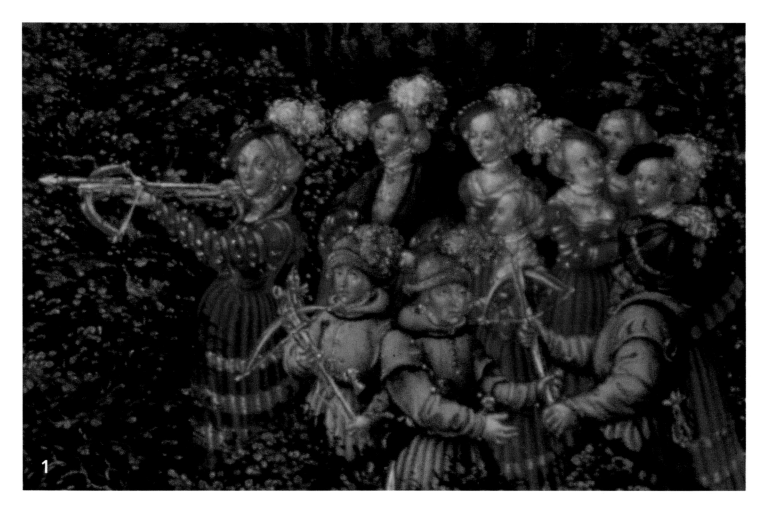

1

A retinue of genteel ladies

The lady furthest to the fore is John Frederick's wife, Electress Sybille. Little of the picture space is reserved for her or her retinue; when dogs and stags were present, thus the artist implies, women took a back seat.

The Electress is probably holding a loaded "German spring-bolt", a relatively light crossbow. She would not draw the bow herself, of course; an attendant would hand her the fully-loaded weapon when she was ready. The heavy crossbows or arbalests of the key huntsmen in the foreground could only be drawn with the help of a special jacking mechanism; the artist has rendered all these instruments – in the hunters' hands or lying at their servants' feet – with great precision. Firearms were still considered "unchivalrous" in the 16th century, at least for the hunt; they were too loud and not especially accurate, and the powder invariably refused to ignite in damp weather.

The variety of game species had shrunk since the Middle Ages. Bison and wild ox were now found only in Eastern Prussia, while bears had withdrawn to the Alps, the Bohemian Forest and further east. What remained – apart from birds – were roe and red deer, wild pigs, hares, foxes and lynx, as well as that most feared of all huntable predators, the wolf.

On the other hand, the populations of these species had increased since 1500, when hunting became the privilege of the ruling class. At the beginning of the century, game laws still allowed peasants to hunt at least small game or huntable predators; later, even this right was removed. Effective protection of crops was thus rendered impossible. The height of fences was strictly limited, while the use of pointed fence-posts was prohibited to prevent injury to crossing deer. Peasants were forced to collar their dogs with wooden bars or clubs to stop them hunting, and they were forbidden to put their pigs to feed in the forests, in case they frightened the game.

At the same time, the villagers were obliged by feudal law to provide labour for the hunt: they set up tents and built fences, drove the animals towards the archers, acted as bearers for killed game. The meat itself rarely came their way. Game was considered the fare of a privileged class. One critically-minded contemporary remarked of the nobility that they "turn up their noses at the sight of a common man or peasant with just a little of it to eat", considering themselves "the victims of grave injustice" unless they were "served game at every mealtime".

The hundreds of peasants who drove the stags for the princes are not shown in Cranach's painting; they remain behind the scenes, as it were, somewhere in the forest. The extent of the burden on peasants' lives caused by the courtly distraction of hunting is recorded in documents dating from the Peasants' War, fought almost twenty years before the painting was executed. At the time, peasants from the Black Forest region protested at having to "hang bars from their dogs' collars", while peasants from Stühlingen demanded the right, according to "the divine law of God", to "hunt and shoot" all kinds of game "and to satisfy our hunger". The game laws imposed by the rulers of the land, as well as their rejection of the peasants' demands, were among the factors which provoked the peasants' uprising.

2

A castle rebuilt as a palace

Cranach probably painted the hunting scene for the building in the background: Castle Hartenfels at Torgau, usually referred to simply as Castle Torgau. It is situated on the river Elbe some 25 miles upstream of Wittenberg: within an easy day's journey. Wittenberg was Elector John Frederick's "capital", Torgau his favourite residence.

Under John Frederick's aegis, the building, already some 500 years old, was redesigned for representational purposes. This was a consequence of the canon; rendered defenseless by the canon ball, castles had resigned their protective function, a development which led, throughout Europe, to their alteration and conversion. Powerful figures now began to use their residences as a means of demonstrating wealth and good taste: castles were turned into palaces.

Castle Torgau was rebuilt with oriels, bartizans, cornices, countless windows and, outstandingly, a grand spiral staircase. These winding stone steps are, to this day, considered one of the most remarkable examples of German early Renaissance architecture. The outer wall of the staircase resembles the tower on the right in the present work, though in reality it is not situated on the bank of the Elbe. The artist has altered the setting in order to include a famous architectural feature in his painting.

The Elector had employed an architect from Coburg, Cunz Krebs. His interior designer hailed from Wittenberg: Lucas Cranach the Elder. Wherever the latter worked during these years, Lucas the Younger was sure to be found. Their workshop, with countless apprentices, took care of all the necessary painting: they embellished shields, lances and horse-cloths; decorated wardrobes, beds and walls; they painted portraits and altarpieces, as well as antique themes with female nudes, copied and varied ten or twentyfold, according to demand. The Cranachs, like most contemporary artists, thought of themselves first and foremost as craftsmen; they simply met a demand. The *Stag Hunt*, too, was commissioned, executed during the final phase of the renovations conducted at Torgau, where the painting presumably also hung. The extent of the work carried out at Castle Hartenfels by the Cranachs can, today, be ascertained only with the help of the prince's account books. The transportable works have been removed; the murals, with the exception of residual islands of the original work, have peeled away or been painted over. Various documents relate that the hares, pheasants, peacocks and partridges these contained were so true to life that visitors would even attempt to remove them from the walls.

During the Reformation, Torgau was a place of some renown, though overshadowed by Wittenberg, the home of Martin Luther and site of a university founded in 1502 by Frederick the Wise. Torgau's historic importance is still felt in the form of two significant concepts: the "Torgau League", an alliance, formed in 1526, between Protestant lands who had sworn to support one another if attacked for their beliefs, and the "Torgau Articles", rules governing the life of the Reformed Church, established in 1530 under the direction of Luther and Philip Melanchthon.

Incidentally, the chapel at Castle Torgau was the first interior to be specifically designed for Protestant services. It was consecrated in 1544 by Martin Luther.

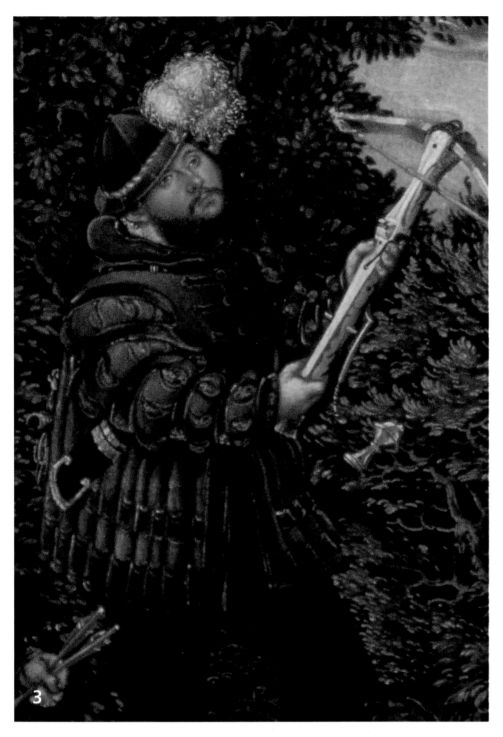

3

A prince
who stood
by his faith

loyalty were writ larger in his character than enthusiasm for humanist learning or political strategy. Early in life he became a zealous supporter of the Reformer, and devotion to his doctrine determined his politics and personal fate. Widely renowned for his physical prowess, he was an excellent horseman and a skilled and powerful combatant at tournaments. He was also a passionate, and frequent, huntsman – indeed he seemed positively possessed by the "fiend" of the chase. An "unholy" devotion to hunting was common enough among the nobility of the day; John Frederick's cousin Maurice, the Duke of the other part of Saxony (a Duchy that included Leipzig and Dresden), confessed on his death bed to deep regrets over his passion for hunting.

With the exception of the common pleasure they took in the chase, John Frederick and his cousin differed in many ways. Though both were Protestant, Maurice had always sought to influence the affairs of state to his own advantage. His loyalties shifted between the Catholic Emperor and the Protestant cause, as suited his interests.

John Frederick would not have been capable of this. He was one of the founding members of the Schmalkaldic League, an association, formed in 1531 on the basis of the Torgau Pact, which united the majority of Protestant cities and lands and, for a short while, facilitated the peaceful spread of the Reformation in Germany.

The Electorate of Saxony, with John Frederick at its head, was the strongest force in the Schmalkaldic League, and – owing to Luther and Wittenberg – also its spiritual and intellectual centre. It therefore grew to become the Catholic Emperor's main German rival. The Emperor's energies, however, were already directed towards dealing with the Turks, the Pope and France. In 1544, the year in which the present painting was executed, Charles appealed to the Schmalkaldic forces at the Diet of Speyer, asking them to support him against his enemies. Help was forthcoming when the Emperor gave the Protestants his word that he would do nothing to thwart them.

Charles V and John Frederick may have hunted together during the Diet of Speyer, but they never took part in a hunt at Torgau. Cranach's panorama illustrates the Elector's wishful thinking, his hope that the quarrel between the Catholic Emperor and the Protestants had been settled. The painting is the document of an illusion.

Elector John Frederick was born in Torgau in 1503. His mother died in childbirth, and pigmentation in the form of a cross on the baby boy's skin was immediately interpreteted as a sign of bad luck. In the panorama of the hunt, he is 41 years old, though he appears no older than on earlier paintings. This is hardly surprising, since the portrait was not done from life, but based on already existing likenesses. This was common practice. Charles V did not sit for Cranach, either. It was enough to suggest a few of the person's features; realism was not essential.

This applies to stance, too, for it might have been possible to show one of the two main protagonists in the act of shooting. Yet they appear to have been painted as if with the help of a single stencil. For Cranach the Younger, this evidently constituted the appropriate hunting pose for a sovereign who was not on horseback.

John Frederick grew up under Luther's influence in Weimar and Torgau. Piety and

The Emperor won in the end

Just as Elector John Frederick was a vehement defender of the Lutheran doctrine, Emperor Charles V was a champion of the one and only redeeming Catholic Church. And he was merely biding his time. In 1547, three years after the Diet of Speyer, his opportunity came: the Turkish threat had receded, peace had been made with the Pope, and his French rival, Francis I, had died. What was more, he had succeeded in forming an alliance with Maurice of Saxony.

By the time the Emperor took to the field, the Schmalkaldic forces had quarrelled and their army split up. John Frederick was stationed with only 6000 men on the bank of the Elbe 20 miles upstream of Torgau, unaware that the imperial army on the opposite bank was four times as large. The Elector had the bridge at Meissen burned, but Maurice, leading Charles' army with the Spanish general Alba, had discovered a ford. The armies engaged in comabat at the Battle of Mühlberg. While the imperial troops rallied to "St. George, Burgundy and Spain!", the Protestants' battle-cry was "God's Word is Eternal!"

The Elector's troops were routed on a patch of moorland closely resembling the hunting ground in Cranach's painting; his face bleeding, John Frederick was taken prisoner. According to one member of the imperial army: "Had all done battle as the Elector himself, he would scarcely have been beaten or taken prisoner."

Torgau was forced to surrender, but Wittenberg, with a garrison of 3000 troops under Electress Sybille, held out bravely. Instead of storming the town with great loss to life and limb, Charles called a military court, which, under Alba's presidency, condemned John Frederick to death. This had the desired effect: Wittenberg, the spiritual capital of the Reformation, surrendered to the Emperor.

On arrival at the imperial camp, Sybille kneeled before the Emperor and pleaded for her husband's life. She was permitted to visit him. While inspecting Wittenberg, Charles had Cranach the Elder, who had painted his portrait as a boy, admitted to his presence. Cranach, too, pleaded for the

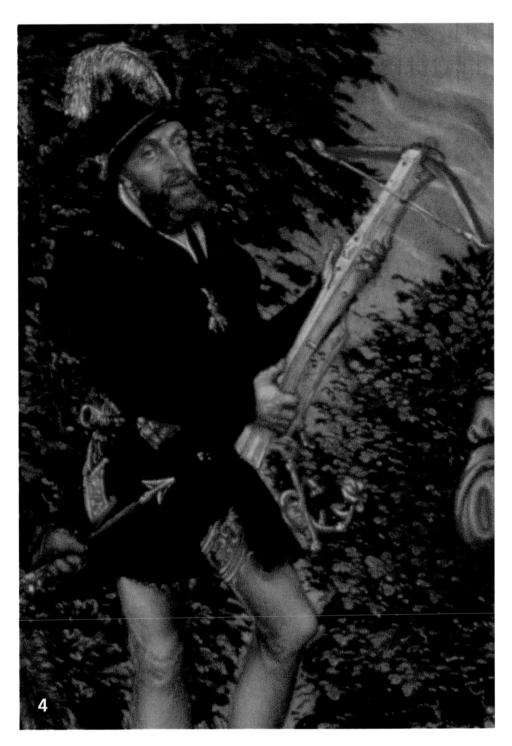

4

life of his lord and master, whereupon the Emperor assured him that John Frederick would come to no harm.

However, the title of Elector and much of his land fell to his cousin Maurice. Following long, drawn out negotiations John Frederick was conceded the right to refer to himself as "Elector by birth". He was imprisoned for five years and, though granted several opportunities to escape, stayed his sentence. For three of these years, Cranach the Elder joined his lordship in prison; John Frederick had called, and the painter had come: he, too, a loyal man. In the meantime, work continued at

his studio at Wittenberg, under the direction of his son.

Several days after the Battle of Mühlberg, a certain Sastrov von Mohnike rode over the battlefield and recorded what he saw. He wrote of the wounded and half-starving he found lying there. But he also remarked that the Elector had lost the battle on land where he had so often hunted, once a source of great enjoyment to him, and of chagrin to the local population who, "for the sake of the great pleasure he took in the chase, suffered great displeasure, discomfort and damage to limb and livelihood".

Tintoretto: Susanna and the Elders, c. 1555

The third voyeur stood before the canvas

A young woman, naked, sits at the edge of a pond. She gazes into her mirror, engrossed in the reflection of her body, unaware of watching eyes. Presently, the two old men will approach her. The painting shows the moment before she is startled.

The story upon which this painting is based is thought to have occurred in Babylon, where the Jews were in exile, some 590 years before Christ's birth. One of the "most honoured" of Jews was Joakim, who "was very rich and had a fine garden". He was married to Susanna, "a very beautiful woman and one who feared the Lord", who liked to bathe in the garden on hot days.

According to the Greek version of the Book of Daniel, two Jewish elders who had been appointed judges would often come to the wealthy Joakim's house to discuss law suits. On seeing Susanna, they were "overwhelmed with passion" and decided to wait for an opportune moment when they might find her alone and force her "consent". If she refused them, they would let it be known that they had found her with a lover. They made their advances and established their conditions, whereupon Susanna cried out: "I am completely trapped", for she knew that witness borne by two highly respected judges would weigh more heavily than her plea of innocence, and that she

would be put to death as an adultress. Should she give in to their blackmail, however, she would not only bring dishonour to her husband, but would break the divine law. Her decision was clear: "I choose not to do it; I will fall into your hands, rather than sin in the sight of the Lord."

During her trial the frustrated elders accused Susanna of adultery with a stranger, but "just as she was being led off to execution, God stirred up the spirit of a young lad named Daniel, and he shouted with a loud voice: I want no part in shedding this woman's blood!" Daniel demanded a return to court, where he subjected the elders to separate examination. Asked under which tree they had seen the lovers intimate, the first elder replied: "under a mastic tree"; the second: "under an evergreen oak". This was enough to prove they had given false evidence, and the Jews "did to them, as they had wickedly planned to do to their neighbour. Acting in accordance with the law of Moses, they put them to death."

Different translations of the story have led to a number of variants. The Greek version of the Book of Daniel, for example, refers to a "mastic tree" (the quotations above, taken from the Revised Standard Version of the Bible, are based on a Greek version attributed to Theodotion), whereas the most famous translation into German, by Martin Luther, refers to an indigenous German tree: the linden.

The original "History of Susanna" was not written in Greek but Hebrew, however, and Bible scholars have suggested the story once served to illustrate one side of the argument during a dispute between two Jewish schools of thought on the value of testimony. Yet other scholars think the story may derive from an older, oriental tale which, in time, was incorporated into the story of the prophet Daniel. Daniel is supposed to have come as a Jewish

prisoner to Babylon and, even as a boy, gained a reputation for his wisdom.

Theologians are generally unconvinced by this figure, however. Luther, for example, translated only parts of the Book of Daniel, collecting these in an Apocrypha with various other texts considered less authoratative than the rest of the Old Testament. Luther's Apocrypha opens with the "History of Susanna and Daniel", a theme that enjoyed immense popularity during the Reformation and Counter-Reformatation, especially in Italy and Germany. Various adaptations of the material appeared, including some for the stage. Sixt Birck's "History of the Pious and God-fearing Woman Susanna" appeared in 1532, and in 1535 a "Religious Play Concerning the God-fearing and Chaste Woman Su-

sanna, a Tale Entertaining and Terrifying to Read"; in 1562 the popular Nuremberg cobbler and poet Hans Sachs wrote "Susanna and the Two False Judges".

Cowardly assault on a woman's virtue

The dramatized versions invariably centre the action around the trial, with copious reference to the woman's piety and fidelity, as well as to the justice of God. Such features are absent in the work of the Venetian painter Tintoretto (1518–1594). Instead, he portrays a naked

woman enjoying the sight of her own body, watched by two voyeurs. Rather than moral instruction, the artist offers aesthetically ingratiating eroticism, together with the thrill of the illicit.

This was not always the case. Scenes from the story in 4th-century frescos in the catacombs, or on sarcophogi, or a 9th-century crystal vase, do not show Susanna bathing, but fully clothed, walking in the garden. One fresco depicts her as a lamb between two wolves. In this context, and at some remove from the original purpose of the tale, Susanna's besieged innocence was intended to illustrate the predicament of Christians, trapped between Jews and pagans.

Interest in Susanna as a female nude grew with the rediscovery by Renaissance artists and philosophers of the human body. In their search for appropriate themes and models, artists were drawn to the myths of pagan antiquity, especially to the figure of Venus, as well as to ecclesiastical and Biblical models. Countless versions were painted of St. Sebastian, whose body, pierced by arrows, was young, male and beautiful. Again and again, artists returned to Adam and Eve, as well as to Susanna bathing.

The artists, mostly men, characteristically played down the cowardly assault on Susanna's chastity by members of their sex, depicting it as little more than a friendly advance. Or they gave a certain frisson to Susanna's fear, flattering the superiority complex of their male spectators. In another *Susanna* by Tintoretto, now in the Prado in Madrid, the hand of one longbeard already rests on the breast of the unprotesting naked woman. The scene, like the versions of several other artists, makes the prospect of an adulterous "passion" seem far from unpleasant to the beautiful woman; on the contrary, she is apparently willing to give it some thought. Thus a paragon of virtue and piety is transformed to the object of male lust.

The Roman painter Artemisia Gentileschi (1593–1651), on the other hand, shows the perspective of a woman in desperate straits. Her Susanna sits on a bench, over whose backrest two men threateningly lean. The relations of power are exposed in the proportions, with enormous men towering over the slender figure of a woman. Court records reveal that the artist was raped in her youth. She was painting from experience.

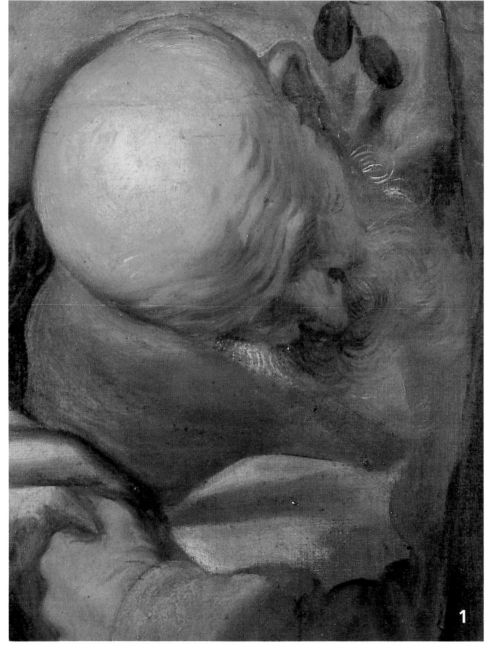

1

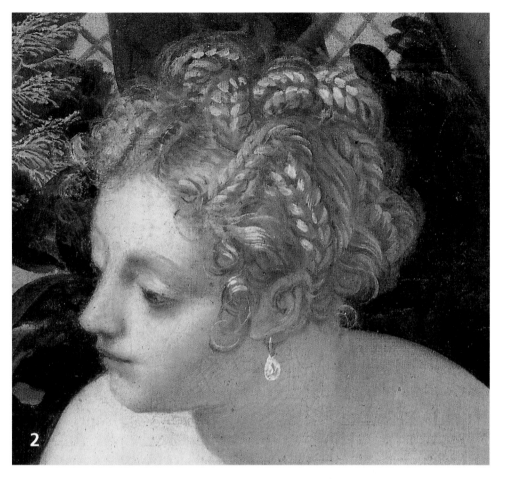

2

Beauty
in the shade
of trees

Tintoretto's painting in Vienna tells a different story. Certainly, there is something menacing in the appearance of the old man in the foreground. The shapeless red toga and powerful skull on the ground are reminiscent of a gigantic snake. The red cloak itself was seen as a symbol of power by Tintoretto's contemporaries. Only members of the patrician class were entitled to wear such robes during the 16th century, and only patricians attained high state office.

But the appearance of the two old men lays them open to ridicule, too. The behaviour of the one, crawling around on the ground, suggests a toddler rather than the dignity that comes with age, while the man in the background seems too preoccupied with his own feet and the danger of stumbling to remember the object of his desire. They would appear to have very little chance against the large, radiant body of the woman.

The painting (147 x 194 cm), now in the Kunsthistorisches Museum, Vienna, is undated, but most experts think it was executed c. 1555. This is in keeping with the contemporary hair fashion of braided hair.

By contrast, the pale red tint had always been fashionable among Venetian woman, who dyed their hair with special tinctures before letting it bleach in the sunshine while sitting out on the roof gardens of their houses. To this end they would cut out the middle of their straw hats, letting their hair fall over the broad brim.

However, one contemporary gossip claimed that the splendid coiffures of Venetian ladies were usually not theirs at all, but had been "acquired". Hair, he wrote, was sold every day in St. Mark's Square. Despite his long white beard, he had even been offered some himself.

The broad-brimmed hats with centrepieces removed were supposed not only to expose as much as possible of the hair to the sun, but also to protect the face and, by dint of an attached veil, the body too. For skin had to be pale.

White skin – not only in Venice – was considered the ideal of feminine beauty. It was also a class attribute: whereas working women could not afford to cultivate a refined pallor, a lady of the Venetian upper class was unlikely to be seen bathing in the open and exposing her body to the sun.

Tintoretto shows not only the pale skin but the plump figure favoured by contemporary women's fashion. He avoids all reference to pubic hair or nipples, though it was not uncommon for Venetian women to apply rouge to their nipples and expose them on festive occasions, their breasts well supported by a steel-stiffened bodice.

But other rules applied in art – for aesthetic reasons, or for fear of the Church's watchful eye. The Counter-Reformation was in full swing in Italy, and the Council of Trent (1545–1563) intended to harness the arts to a new propaganda campaign.

Erotically charged religious themes were not in themselves considered offensive, but a line was drawn at the erotic use of sexual imagery. In painting the nude, Tintoretto always toned down, or omitted altogether, the signal colours of the female genitalia.

The identity of the model remains unclear. It is maintained that women were forbidden to sit for artists, and that life painting was restricted to the portrayal of the male body. But this can only have applied to the academies, for in his account-books, Tintoretto's Venetian contemporary Lorenzo Lotto records: "to draw a nude, 3 libri, 10 soldi. For a mere showing, 12 soldi." Lotto noted that his sitters were "courtisans or common women without shameful scruples".

However, circumstances may have made it somewhat easier for Tintoretto. In 1553 he married Faustina, the daughter of a respected Venetian. His father-in-law was the headmaster of a religious "scuola", and became a patron of the artist. Venetian women usually married at the age of 15 or 16, so that Faustina, in 1555, was probably still under twenty, while Tintoretto was probably 37. Perhaps Susanna's gaze at her reflection while drying her leg, the contemplative grace of a woman who believes herself alone, was based on the artist's own observations of Faustina. Painters, too, are voyeurs.

Faustina bore him eight surviving children. At his death in 1594 Tintoretto left all he owned to his "carissima mia consorte madonna Faustina Episcopi", his deeply beloved wife.

A centre
of luxury
and fashion

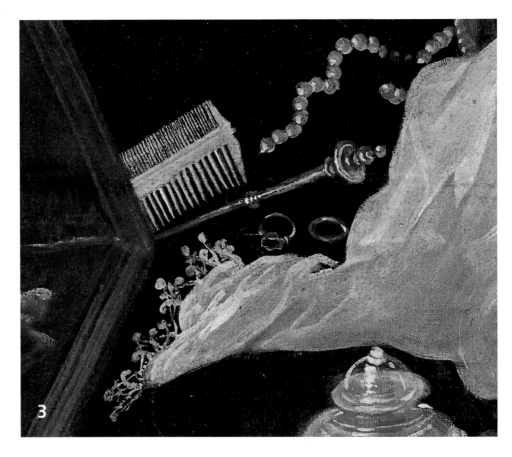
3

The Venetians' political and economic power had waned by the time this picture was painted. They had been driven from the eastern Mediterranean by the Turks, and a shifting alliance of forces was now ranged against them in the west. Venice was no longer the point of intersection of important trade routes. Ships now sailed from the Atlantic coast of Europe – around the Cape of Good Hope to Asia, or across the Atlantic to the American colonies.

Venice had lost its status as a world power, but its great wealth was undiminished, as was the zest for luxury displayed by its inhabitants. Jacopo Sansovino and Andrea Palladio, the architects, built the city's magnificent churches, bridges and villas. Tintoretto's contemporaries were Titian, Paolo Veronese, Giacomo Bassano and Lorenzo Lotto. Venice was a centre of the arts.

The town was also the manufacturing centre of luxury goods: in 1554 there were 12,000 workers alone employed in the production of silks. Velvet and silk, as well as jewels, silverware and Murano mirrors, were the most important exported goods. Tintoretto includes a small selection of exquisite objects in the form of a still life spread out at Susanna's feet: a pearl necklace, a hairpin, a silk scarf. The comb may

be carved from ivory, while the silver vessel with the glass lid would be used to keep creams or perfumes. Mirrors of glass, rather than metal, had not been long in use, and earrings of the type worn by Susanna in the painting had been permissable, and usual ladies' jewellery only since 1525.

Perhaps it was Faustina who persuaded her husband that beautiful objects were the appropriate accessories for a beautiful woman. She had been born into a wealthy, and more highly respected family than her artist husband. His father had been a silk-dyer, a "tintor". Though his real name was Jacopo Robusti, the artist chose to retain the name given him as a child: Tintoretto, the dyer's little boy. Though the artist's dress habits were generally demure, he is reported, as an older man, to have worn a toga "in order to please his wife". His toga would not have been red, however, but black, as befitted an ordinary citizen.

Venice may have lost power and influence in the 16th century, but it remained sacred in the eyes of its citizens, who were unanimous in their desire to maintain the status quo, including its law and order. This was reflected in the administration of justice in Venice: crimes against the state were punished ruthlessly. One of the

threats to public order was calumny, for magistrates depended on informants to report crimes, and denunciation was a pillar of justice. A law passed in 1542 therefore demanded that an executioner "cut off the right hand and then the tongue" of anybody who slandered an innocent person or gave false testimony, "to ensure that such persons shall not speak again". If false witness had led to the death of the accused, or to the exoneration of someone deserving the death penalty, "then the offender's head must be cut off".

In Babylon the two old men in the story of Susanna were put to death; in Venice the slanderers would have lost only their right hands and tongues, for adultery no longer carried the death penalty.

Cases of adultery, in any case, were generally settled with extreme discretion out of court during the 16th century. If the accused was a woman of patrician background, she would simply disappear into a nunnery. The crime of rape was equally rarely tried. Sentences were lenient: seldom more than a few months imprisonment and a fine. The judges were all men; and anyway, rape did not seriously undermine the public order.

Despite the unusual density of buildings on the Venetian islands, there were also gardens – though the majority of these were situated at the back of palazzi belonging to patrician families. Those who could afford to do so had a villa built on the mainland, where there was room to spread out.

Landscape gardening was highly fashionable in the 16th century, and Tintoretto's painting records several characteristic features of contemporary design. The ideal was the harmony of nature and art, order and wilderness. Statues were essential, and several are included in the present scene. The trellis fence, wall of roses and deep perspective provide a regular structure. Various authors had demanded that a proper garden include the flora and fauna of the region, and Tintoretto's deer, ducks and bird are a tribute to local variety.

However, the animals are there to remind us of the Garden of Eden, too. Contemporary spectators sought hidden allusions to anything beyond the apparent theme of the painting, and Tintoretto's work – with its cryptic reference to prelapsarian Eve spied upon by a serpent – is unlikely to have disappointed them. A desexualized female body also permitted associations with the Virgin Mary. Mirrors and water were considered symbols of purity; roses were a Marian attribute.

Besides hidden references and the illustration of horticultural fashion, Susanna's surroundings are primarily the painter's invention and arranged in such a way as to emphasize the radiant purity of the virtuous woman, while simultaneously creating an atmosphere of imminent catastrophe. The wall of roses, for example, is exceedingly dark, its triangular shadow almost black. There is an ominous-looking thicket of impenetrable trees and bushes at Susanna's back. Technically, the dark planes of colour serve to emphasize the brilliance of her body; psychologically, they signal impending doom. A similar effect is achieved by the vista in the background, which draws the eye past the old man and through the arbour to the trees in the distance. Technically, it stabilizes the compo-

sition, centering the painting along an axis; psychologically, however, it renders Susanna highly vulnerable, exposing a scene whose intimacy one might expect to find within the seclusion of a private interior.

It is not clear how often Tintoretto actually painted *Susanna and the Elders*. Five versions survive, of which the painting now in Vienna must surely rank as the most beautiful. These paintings, intended for private interiors, were bought by Venetian patricians, many of whom had themselves attained considerable dignity as the subject of one of Tintoretto's over 100 portraits. Several bear a strong resemblance to the old voyeurs in the painting. Whoever commissioned the work evidently was not disturbed to find – besides a beautiful nude – his own image, or those of two of his peers, portrayed in such a shameful role.

Rather than the mass production of portraits, or painting female nudes with Biblical or antique names, Tintoretto's main work, aided by his assistants, lay in the creation of gigantic religious works. On countless square metres of canvas painted for the Doge's palace, for churches and houses owned by religious brotherhoods, Tintoretto extolled the martydom of the saints, or opened the Heavens to view, drawing the spectator's eye, past hosts of angels, into the Beyond. Foreshortening, exemplified in the present work by the figure of the old man lying on the ground, dramatic lighting and surprise vistas, such as that in Susanna's garden, were typical features of his style. Exact perspective was of little interest, realism an alien notion. He painted his visions: and one of the most impressive was this – possibly quite private – view of Susanna in her enchanted garden.

Art and nature, harmony in a garden

4

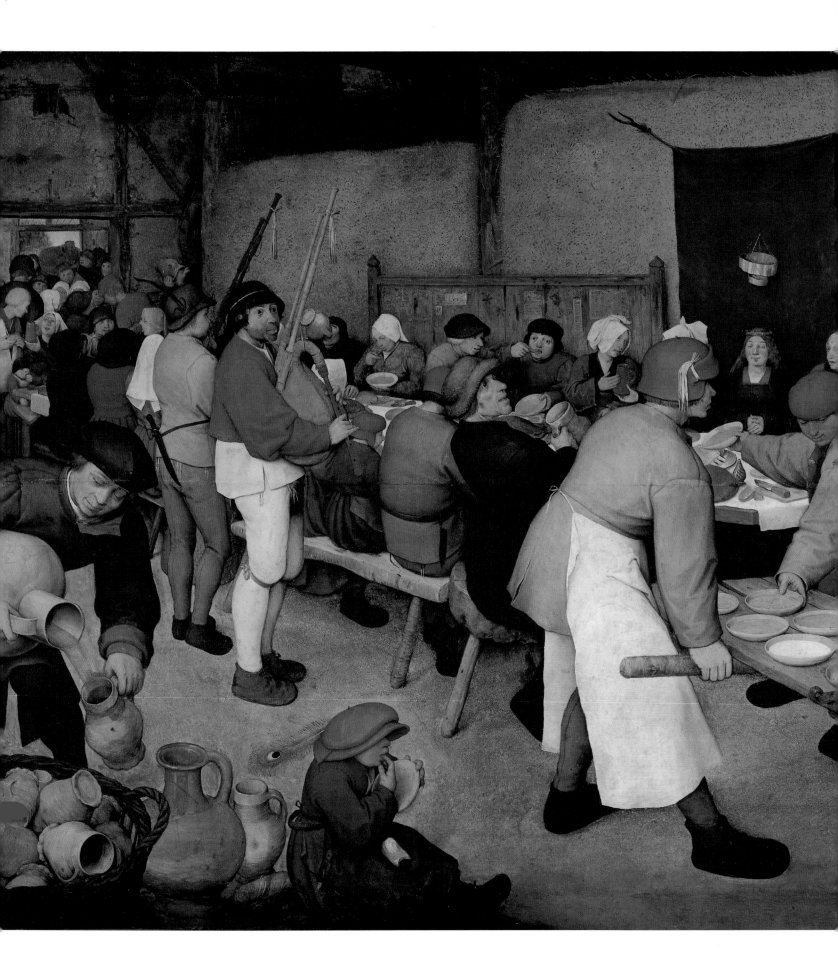

Pieter Bruegel the Elder: Peasant Wedding Feast, c. 1567

The barn is full – time for a wedding!

The painting, now measuring 114 x 163 cm, is in the Kunsthistorisches Museum, Vienna. It is neither signed nor dated. The signature and date were probably on the bottom section of the original oak panel, which was sawn off and replaced at a later date. The craftsmanship of the more recent section is noticeably poorer.

Experts think Bruegel painted the work c. 1567. He married in 1563 and died in 1569, aged about 40. The *Peasant Wedding Feast* was therefore executed during his short marriage, shortly before his death.

The celebration takes place on the threshing floor of a farm. Long tables – not even the rich had proper tables in the 16th century – were put together using wooden planks and trestles. The man in black on the far right is seated on an upturned tub, while most of the other guests sit on roughly hewn benches. The only chair with a backrest has been reserved for an old man: possibly the notary who drew up the contract of marriage. The prints pinned to the backrest of the long bench resemble those sold during religious festivals or pilgrimages.

In the foreground two men serve bowls of meal, using an unhinged door as a tray. Though merely servants at the feast, the left of the two, the largest figure in the whole painting, is the focal point. The colours, too, make him stand out. Presumably, the artist used the figure to stabilize a complicated composition. The half-diagonals formed by the two rows of eaters in the foreground intersect in the waiter; the edges of the back of his apron mark the central axis.

A bunch of ribbons, similar to those tied to the instruments of the two bagpipe players, or peeping out from some men's shirts, hangs from his cap. Usually, these were used to lace up trousers. Worn on the hat, or tied to instruments, they prob-

ably indicated membership of a group. Young men at the time lived very much in cliques, a source of fun as well as an opportunity to celebrate with people of their own age.

Scholars often attribute religious or allegorical significance to the work. Some see it as the marriage at Cana where Christ turned water into wine and vessels were filled over and over again. Others suggest this was Bruegel's version of the Last Supper. Yet another view has it that he was warning his contemporaries against "gula", the deadly sin of gluttony.

None of these hypotheses is especially convincing. However, *The Peasant Wedding Feast* is full of realistic detail, providing a window on 16th-century social reality. In his biographical *Book of Painters*, published in 1604, Carel van Mander describes how Bruegel often went "to visit the peasants, whenever there was a wedding or kermis".

The barn is full

Two sheaves of corn, held together by a rake, whose pole handle is buried in stacked cereal: at first glance the background of straw or unthreshed wheat, almost identical in hue to the trodden clay of the floor, looks like a normal wall. However, the projecting rake and, above the bride's head, the prongs of a fork used to hold up a decorative cloth, together with the blades of corn sticking out on top of the heap, make it clear what Bruegel intended to depict.

The image of a full barn evoked a different response four hundred years ago than in our own age of agricultural surpluses. Cereal was the staple diet; as bread or meal it formed the bulk of every mealtime. To Bruegel's contemporaries, the sight of a full barn meant the threat of starvation was staved off for the following twelve months.

It was a threat which, as in many developing countries today, recurred annually in Europe. The size of harvests varied enormously, and in the Netherlands, according to historians, losses of as much as 80% had been recorded from one year to the next. Prices were consequently unstable: a yearly increase of 500 percent for a standard measure of oats or wheat was not unknown. A craftsman's apprentice, for example, spent 70% of his income on food, which was mainly cereal. High prices meant insufficient nourishment, which, in

turn, led to reduced bodily resistance, illness and early death. Epidemics usually followed in the wake of famine.

Town authorities attempted to compensate by stockpiling and imports. At that time, the Baltic was the breadbasket of Europe, with the Hanse in control of shipment. A sea-journey round the coast of Denmark could take two months. With two months for the order to reach the supplier, and allowance made for winter stoppages, it is obvious that imports could not compensate for bad harvests. What counted was how full your barn was.

There were seasonal fluctuations in price, too. Cereal was cheapest in autumn, directly after the harvest. Most of the threshing was done between September and January – on the threshing floor, which provides the setting for Bruegel's *Peasant Wedding Feast*. Since weddings usually took place as soon as the harvest was gathered, the cereal here was probably unthreshed.

The Netherlandish peasants were better off in the 16th century than many of their class in other European countries. They had their freedom: serfdom had been abolished, and forced labour for the feudal lords was prohibited by law. In the Netherlands, the peasants' situation made it unnecessary to have a war of the type that raged in Germany. Initially, the Netherlanders found it possible to adapt to the colonial hegemony of the Spanish Habsburgs. In 1567, however, Philip II sent the Duke of Alba from Madrid to raise taxes and wipe out Protestant "heresy". The last years of Bruegel's life marked the end of an era of prosperity. The long struggle for the liberation of the Netherlands had begun.

A spoon
in your hat
meant poverty

There was no more densely populated region north of the Alps than the Netherlands. This was largely due to higher wages. The textiles industry flourished; the Netherlandish ports attracted coastal trade from the Baltic in the north to Lisbon in the south; for several decades Antwerp, the site of the first stock-exchange, was the economic hub of Europe.

The agricultural economy of the densely-populated Netherlands was thought especially progressive and productive. The fact that peasants, as free-holders, worked for their own livelihood, acted as a stimulant – even if the feudal lords owned their houses and land. As money circulation grew and capitalist forms of wage-labour developed, the wealthy bourgeoisie, who had begun to replace the nobles, invested in agriculture as a means of supporting their families in times of crisis.

The man in the dark suit with broad sleeves may have been the landlord. It is impossible to say whether he was a wealthy burgher or a noble, for to wear a sword was no longer deemed an aristocratic privilege.

The aristocracy and clergy each made up approximately one percent of the population. Relations between them were generally excellent. In order to preserve property and power, many sons and daughters of the nobility did not marry, entering various Church institutions instead. In this sense, the Church provided a form of social relief, and, in return, was made the benefactor of countless donations and legacies. For Bruegel's contemporaries it would have been immediately obvious why the monk in the painting converses with the only wedding guest who might be construed as an aristocrat.

The spoon attached to a waiter's hat was a sign of poverty. Since the abolition of serfdom and, its corollary, the obligation of feudal lords to maintain their serfs' welfare, the rural proletariat had greatly increased in number. Peasants with no property or means took whatever work they could find, harvesting, threshing, even assisting on festive occasions. Most lived in huts and were unmarried; wages were not enough to feed a family. Few had a fixed abode, for they spent too long on the road in search of work, a crust of bread or a bowl of meal. This explains the spoon attached to the man's hat, and his bag, of which – in the present work – only the shoulder-strap is visible.

The wooden spoon is round. Oval spoons came later, when – following the example of the courts – it was thought bad manners to open one's mouth too wide while eating. To put something into one's mouth with a fork was practically unknown in the 16th century. The alternatives to the spoon were fingers or a knife. Everyone carried their own knife; even the child in the foreground has one dangling from his belt. No instrument features more often in Bruegel's paintings – the knife was the 16th-century all-purpose tool.

3

4

Melancholia, a thirsty business

The jug being filled in the foreground is a man's drinking vessel. Women drank from smaller jugs. Whether they are serving wine or beer is impossible to say. Wine had been a popular drink in the Netherlands for several centuries and, at that time, was grown much further north than was later the case. By the 16th century, however, wine-growing was on the de-cline. The perimeter of the wine-growing regions retreated south, settling more or less where we find it today. Ludovico Guicciardini, reporting on Netherlandish wine in 1563, noted that the "little there was of it generally tasted sour".

Wine was replaced by beer. This was originally imported from Germany, from Hamburg or Bremen. Not until Bruegel's lifetime was beer brewed in large quantities in the Netherlands, where it was not only produced in breweries. The peasants cel-ebrating in this scene may have brewed their own beer. Home-brewing was wide-spread, and considered a woman's work. Calculations suggest an average daily con-sumption of one litre per person. Accord-ing to Guicciardini: "For those used to it, the common beverage of beer, brewed with water, spelt, barley and some wheat, and boiled with hops, is a pleasurable and healthy drink."

Beer was an important part of the 16th-century diet. It even caused rebellions – for example when the Antwerp city council prohibited the brewing of beer in the Old Town, or its transportation from the sur-rounding regions. The council "were quick to repeal the beer-law that had so dis-pleased the common people", wrote Guic-ciardini.

It is to this Italian that we owe the most interesting account of the Netherlands in the 16th century. In his own country, as in Spain, drunkenness was considered dis-graceful, and Guicciardini conseqeuently castigates the "vice and abuse of drunken-ness". According to his observations, the Netherlanders drank "night and day, and so much that, besides creating disorder and mischief, it does them great harm in more ways than one". As a southerner, unused to the north, he found an excuse for their be-haviour: the climate. The air was "damp and melancholy", and "they had found no better means" of driving away their weather-induced melancholia.

There is no sign of drunkenness in this painting, however. Indeed, the mood seems comparatively sober; an Italian may even have found it melancholy. Nonetheless, the mood would no doubt change as the meal progressed, or during the celebrations, which could last anything up to several days. Bruegel's *Peasant Wedding Dance* (Institute of Arts, Detroit), 1566, a painting of almost identical format, shows the guests in a frenzy of drunken revelry. The two paintings could almost be a pair.

In contrast to the ease with which the bride may be identified, it is difficult to de-cide which of the celebrants is the bride-groom; he may be the man filling the jugs, whose place, apparently unoccupied, may be at the top of the table on the right – ob-scured by one of the waiters. He would thus be sitting between two men, just as his bride is seated between two women. Wed-ding feasts are known to have taken place without the bridegroom being invited, for a wedding day was primarily the day of the bride.

The bride does not lift a finger

5

The bride, backed by green fabric, a bridal crown hovering above her head, is easily distinguished. She presents a strange sight: her eyes semi-closed, hands quite still, she is completely motionless. Brides were expected to do nothing on their wedding days; forbidden to lift a finger, she was thus guaranteed at least one holiday in a lifetime of hard labour. A person who avoided work was sometimes referred to as having "arrived with the bride". The nobleman, or wealthy burgher, at the right of the painting is the only other guest with his hands folded. He, too, was a stranger to physical labour, it seems.

The bride is also the only guest not to cover her hair. She is displaying her long hair in public for the last time. Henceforth, like her married cousins at table, she will wear her hair under a bonnet. Here, she wears a circlet, a "bride's coronet". In many parts of the country at the time, this would have a prescribed value. In the same way, the number of guests, the number of courses served at the feast and the value of the wedding presents were all determined in advance according to specific criteria. The authorities justified this measure by claiming that it was necessary to protect families against excessive expenditure, but the more likely explanation is that it provided a means of making social status visible. A feast of this kind would have given Bruegel's contemporaries a fairly exact picture of the financial standing of the newly-weds, or their parents.

The meal was preceded by a wedding ceremony. As far as Luther was concerned this was a purely secular affair, and a priest's presence optional rather than compulsory. This had also been the case among Catholics. In 1563, however, a few years before the painting was executed, the cardinals at the Council of Trent decided that only priests should join couples in wedlock. It is possible that the Franciscan monk at the table was invited precisely for this purpose. At the time, however, ceremonies were frequently held at the entrance of the church rather than in front of an altar.

Statistics for the period reveal that women raised an average of 2.5 children. There had been a child more in the previous half of the 16th century, but the peasant population was decimated by the wars of liberation which broke out in the wake of Alba's rule of terror, the wholesale pillage, perpetrated especially in unprotected rural areas, by marauding armies, and by ensuing famine and plague.

Bruegel did not live to witness this. His paintings were bought by wealthy burghers or nobles, many finding their way into collections owned by the Austrian Habsburgs. In 1594 the *Peasant Wedding Feast* was purchased in Brussels by Archduke Ernst. It later turned up in Emperor Rudolf II's famous collection at Prague.

There was practically no chance of peasants themselves seeing a painting like this. The only works of art they saw were in churches. If they owned decorative pictures at all, they were most likely to be religious prints of the type pinned to the backrest of the bench in Bruegel's *Wedding Feast*.

Antoine Caron: Caesar Augustus and the Tiburtine Sybil, c. 1580

Faith in the magic of festivals

A bizarre architectural landscape on the banks of the Seine provides the setting for an opulent festival hosted by Henry III of France. Antoine Caron (1521–1599) renders the event, centred around the staging of a mystery play, in a manner which is both artificial and assiduously attentive to detail. The painting (125 x 170 cm) is in the Louvre, Paris.

Amidst the storm of civil war, and notwithstanding its chronic shortage of funds, the French court stages a festival. Several events are shown simultaneously in progress in the extensive grounds of the Tuileries by the Seine, a setting alienated here by antique columns and circular temples. In the background on the left two knights in full armour joust in a tiltyard, while a barge, carrying a large number of musicians and singers, draws near to the riverbank.

However, the majority of figures in the painting are shown watching a play performed on an estrade, acted by persons in Roman costume. It is probably the "Mystery of the Incarnation and Birth of Our Saviour and Redeemer Jesus Christ". In a key scene of the play the Roman Emperor Augustus – here seen kneeling in a purple gown and laurel wreath, while three of his soldiers look on – meets the wise Sybil of Tibur. He asks her to predict the fate of the Empire, whereupon she points at the sky, where the Virgin Mary and Infant appear in a nimbus. Christ is thus presented to the pagans as successor to the Roman emperor and Lord of the Universe.

The mystery play, first performed in Rouen in 1474, was revived in Paris in 1580, for its mixture of antiquity and Christian piety was much in keeping with contemporary taste. Anything Roman or Greek was likely to appeal during the late Renaissance, and the work's religious slant undoubtedly satisfied the Catholic party dominating court and capital.

But the real star of a court festival was always the sovereign himself, whose intention was to demonstrate his own power and the glory of his house. It was this, more than anything else, that Antoine Caron had been commissioned to paint, by order of the Queen Mother, Catherine de' Medici.

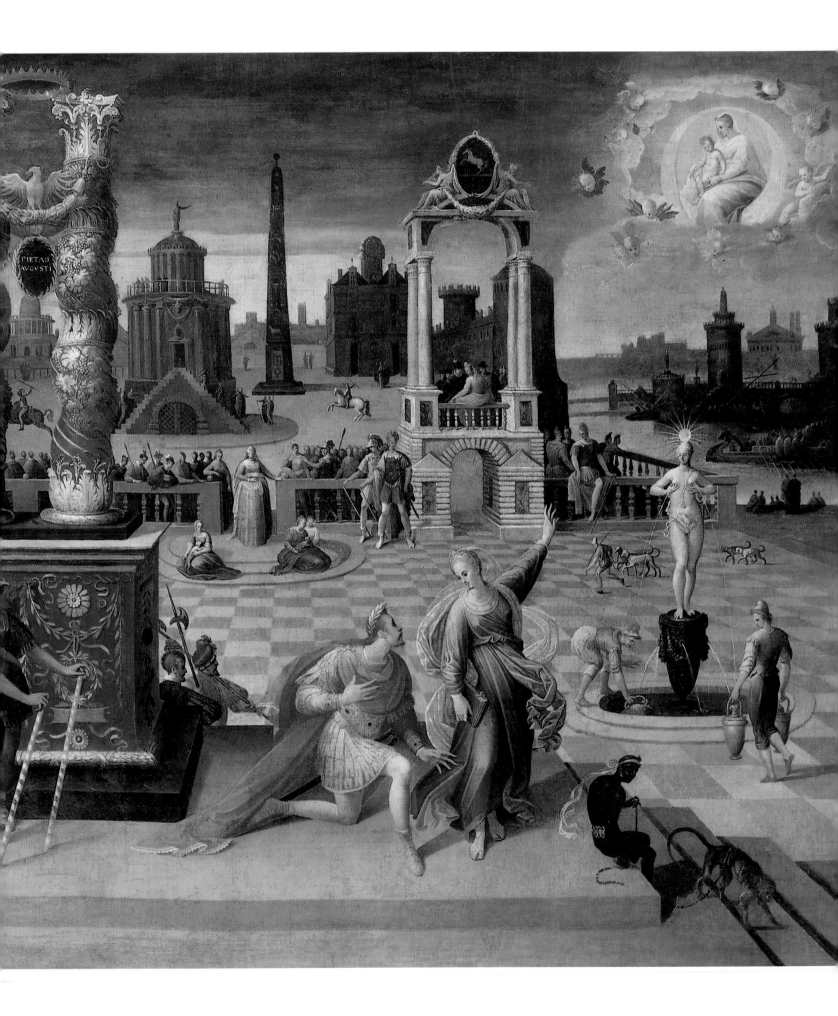

Though the sovereign was the centre of attraction at a courtly festival, the larger-than-life figure at the centre of Caron's painting is a woman, the Florentine Catherine de' Medici. Though by 1580 she had lost the regency, she was still one of the dominant personalities at the French court. Her position as queen and mother had helped her determine the course of French politics for two decades.

According to her own testimony, her sole motive in wresting power in 1559, following the death of her husband at a tournament, was to defend her children's inheritance. Her seven children were "the most important thing in the world"; with her love of family she was, in effect, a real "Italian mamma". Officially, her sons Francis II (1559–1560) and Charles IX (1560–1574) wore the crown, but both were tubercular and neurotic, one dying at

A powerful Florentine, larger than life

16, the other at 24. Catherine attended to their affairs of state, and was rarely squeamish in the methods which she employed. She had few qualms about murdering her opponents when interests of state or the progress of the Valois dynasty demanded it, and she shared much of the responsibility for the deaths of thousands of Huguenots killed at the St. Bartholomew Massacre of 1572. But it was also thanks to her that there was a French state left to speak of when her third son, Henry III, ascended the throne in 1574.

France had been torn asunder by the Reformation: while the Huguenots fought for religious freedom, another militant faction attempted to wipe out heresy in the name of the Catholic majority. Catherine herself was inclined to be tolerant, and she was tireless in her efforts to arbitrate beteen the two parties. She extracted countless compromises, made them sign peace treaties, but civil war usually broke out before their signatures had dried on the paper. Thus France sank into anarchy and poverty.

If a pamphlet written in 1573 is to be believed, it was Catherine herself who was

responsible for all this misery: after all, disaster was all that could be expected from the government of a woman, nay, a foreigner, the "daughter of an Italian grocer".

By 1580 Catherine had lost her political power, for her third son, Henry III, was less inclined to heed her advice than that of his protegés. Though firm in other matters, Catherine had nonetheless condoned his behaviour, for she idolized this son more than any other, and was prone to illusions about his abilites. However, once forced into negotiations with the warring factions, even he made use of Catherine's diplomatic skills. She had learned how to lead, how to use the passions and interests of others to her own benefit. In so doing, she enlisted the persuasive powers of some 300 alluring maids of honour. Known as the Queen Mother's "flying squad", they succeeded more than once in taming rebel leaders who were susceptible to feminine charms. In Caron's painting, however, the three ladies sitting at the feet of Catherine, who is not shown in mourning for once, are merely caressing their lapdogs.

The king's favourites compete

To further her political aims Catherine de' Medici not only enlisted the charms of her ladies-in-waiting, but was equally skilful in her use of festivals. The purpose of these, however, was not only to display the pomp and power of the ruling house. From her father-in-law, Francis I, she had learned that "two things are necessary in order to live in peace with the French ... One must keep them happy, and set them some sort of exercise to keep them occupied ..." The latter, as Catherine went on to tell her son, "prevents them from engaging in more dangerous activities".

In order to prevent quarrelsome sectarian leaders from inciting their followers to further bloodshed, the Queen Mother kept them as busy as possible with feasts, court balls and masquerades; she even organized snowball-fights between Catholic and Protestant nobles.

Tournaments were often the climax of such festivals, the risk and danger of martial displays providing their combatants with ample opportunity to work off surplus energy and aggression. Henry III's favourites, sporting young men disparagingly referred to as *mignons* (catamites), were particularly avid participants. It is in their company that Henry III, the last of the Valois dynasty, is seen following the joust from an elegant stand. In 1580 Henry was only 28 years of age, the victim, like his brothers, of tuberculosis. Like them, too, he failed to provide his country with an heir. Pendulating between scenes of wild debauchery and the pious observance of his spiritual exercises, he felt most at home in women's clothes in the company of his foppish entourage. A detail from the world of fashion, the black beret with the white feather, confirms that Caron's painting dates from c. 1580.

In the hope of lending prestige to an otherwise unpopular monarch who commanded little public respect, the festival had recourse to all kinds of symbols and allegorical motifs. Comparisons as flattering as they were undeserved were drawn

between the king and antique greats such as Caesar Augustus, or even gods.

Theologians, philosophers and humanists concocted the ideological flavour of the festival programme, selecting suitable images and deciding even minor details, so that even the confectionery served as a dessert was designed in such a way as to illustrate a mythological theme. In 1581, they had the sorceress Circe, together with a retinue of monsters and sea-deities, dancing on her enchanted island to the music of ten orchestras. During the fireworks that con-

cluded the spectacle, Jupiter, the father of the gods, and Minerva, the goddess of wisdom, descended to earth and, kneeling before Henry III, paid homage to "the authority, wisdom and eloquence of the great king". According to the report of one contemporary, the gods then went on to proclaim that the King owed these virtues to "the wise advice of the Queen, his mother". The event is supposed to have swallowed up 400,000 thalers and been seen by some 10,000 spectators at a single showing.

A genuine palace in an artificial setting

Translation of the festival theme into practice occupied whole teams of artists for months at a time, and these were always the best available. On 15th September 1573, for example, when the future king Henry III celebrated his "joyous and triumphal entry" to the city of Paris, the decoration of the capital and direction of festivities were entrusted to the poet Jean Dorat, the sculptor Germain Pilon and the painter Antoine Caron.

The festival team would usually include an architect; indeed he usually led it. Ever since the Italians had rediscovered Classical antiquity and embellished their towns with Renaissance palaces, building had ranked as "the queen of the arts". Building fever broke out in France, too, with the palaces at Fontainebleau and on the Loire emulating Italian design. It went without saying that a court festival required a Roman setting, even if the latter was constructed of wood, plaster and painted canvas.

Architecture also dominates Caron's painting; the natural world is practically absent. Whether erected to grace a particular festival or merely the artist's invention, his Classical edifices are laden with symbolic significance and flattering allusions to the monarch. The circular temple, designed after the Roman "tempietto" of the Renaissance architect Bramante, proclaims the king's fame. The obelisk next to it was a monument to his everlasting glory. The shield between two overladen, spiral columns on the pedestal in the foreground praises the "Pietas Augusti", the piety of the Emperor. To Caron's contemporaries, columns were symbols of power and grandeur.

Several triumphal arches have been adapted to provide elegant stands for spectators. Two of the arches are decorated with horses; the festival grounds were situated near the royal stables.

At the centre of the pseudo-antique townscape stands the real, newly-built town palace of the Queen Mother, who was obsessed with building. She had officially inaugurated it – with a festival of course – in 1573. It was built on the site of a former tilery ("Tuilerie") outside the old town walls, by which it was joined to an-

other new royal residence, the Louvre. On the right is the Seine and Paris itself.

The Tuileries building with its twin gables appears in so many of Antoine Caron's paintings that it could almost be described as his trademark. Caron learned his craft at Fontainebleau, the primary centre of Renaissance art in France, and, following the death of his Italian master, climbed to the position of "valet and painter to the Queen Mother". Forgotten for two hundred years, Caron has regained his renown as one of the leading artists of the School of Fontainebleau.

With their strange blend of the real and ideal, their utterly disproportionate, elongated figures set against the starkly contrasting accuracy of Caron's architectonic perspectives, the ten paintings ascribed to the artist today are at once captivating and disconcerting; they epitomize the bizarre, dreamlike artificiality of School of Fontainebleau mannerism.

Breasts that spout pure oil

In the "Mystery of the Incarnation and Birth of Our Saviour and Redeemer Jesus Christ" mention is made of a well. The Sybil has hardly had time to show the Emperor the future ruler of the world in the heavens, when her black servant Sadeth, shown sitting at her feet, reports that another of her prophecies has come true. As she predicted, a Roman well had begun to provide pure oil instead of water – "like a beam of golden sunlight". Caron – a breast fetishist like most painters associated with the School of Fontaine-bleau – shows oil spouting from the breasts of a figure standing on the well, who, naked, with a shining mirror balanced on her head, may symbolize (prophetic) Truth.

Various other statues can be seen in Caron's painting, several of which – particularly those that fit the category of the "ideal mother" or "wise woman", images with which she liked to be identified – probably resemble Catherine de' Medici. Among the latter were the Sybils, the ten legendary prophetesses of the ancient world. Their name means "god's decree", and their arcane books were consulted by the Roman senate at times of crisis. Next to her bed, the Queen Mother kept the medieval imitation of a book of this kind, a collection of obscure proverbs, together with a calendar and several engravings with architectural motifs. People all over Europe from Paris to Prague were reading the "Sybilline Books", as well as works by Nostradamus and Regiomontanus, hoping for knowledge of the future, or advice on how to get on in the present.

There seems to have been a powerful need for this at the time, a sense of uncanny powers at work, invisible forces conspiring to trap unwitting, helpless victims. To discover their fate, people consulted not only ancient books, but the stars.

One of Antoine Caron's paintings shows *Astronomers Studying an Eclipse*. However, the observatory which Catherine de' Medici had built next to her town palace is more likely to have been frequented by astrologers than astronomers. It was not without reason that the edifice was referred to as a "horoscopic column".

4

Astrologers, magicians and necromancers were naturally consulted when the plans were laid for a festival. People sought recourse to the supernatural not merely as a means of fathoming the occult forces that determined reality; they also hoped to harness such forces to their own ends, to influence events and effect political change. At its most destructive, this might involve casting spells on their enemies; in more positive terms, it meant organizing a triumphant festival. Choosing the right day of the year, or selecting suitable artwork, whether from the realms of music, painting or architecture, were tasks whose magical dimension was self-evident.

Thus the Queen Mother and many of her contemporaries were convinced that a link existed between the performance of the tragedy *Sophonisbe* at court in 1556 and the death of Henry II and outbreak of sectarian troubles soon afterwards. Thenceforth, Catherine prohibited the staging of dramatical works with unhappy endings, instead putting her trust – more or less in vain – in the benificent magic of harmonious festivals. Perhaps there was more to Caron's picture than a record of the event for posterity; it is possible that the picture itself was intended as a magical charm.

Two saints bury the munificent donor

The canvas, 4.8 metres high and 3.6 metres wide, covers the entire wall of a chapel, reaching from the arch of the ceiling almost to the ground. The figures are life-sized, painted in 1586 for the Santo Tomé church in Toledo by the Cretan artist Domenikos Theotokopulos, known in Spain as El Greco, the Greek.

El Greco's painting shows a miracle, said to have occurred in the Santo Tomé church at the burial of Don Gonzalo Ruiz in 1312. According to legend, St. Stephan and St. Augustine appeared and laid the mortal remains of Gonzalo Ruiz in the grave.

Ruiz, erstwhile Chancellor of Castile and governor of Orgaz, was a man of great wealth and influence, whose benificence had been especially apparent towards institutions of the church. Through his good offices, the Augustinian Order acquired a developable site within the Toledo town walls. He gave financial support to the construction of a monastery, too, and to the building of the church of

Santo Tomé. He even made provision that the town of Orgaz should, after his death, make an annual donation to both church and monastery of two lambs, sixteen chickens, two skins of wine, two loads of firewoood and 800 coins. According to the testimony of the saints who attended his funeral, their presence there conferred high distinction upon one who had "served his God and saints". On vanishing, they are said to have left a divine fragrance on the air.

El Greco made no attempt to clothe his figures in medieval dress. Social or political change was little understood at the time, and attention to detail of this kind would, in any case, have conflicted with his patron's wishes: the painting was not intended to recall an historical event, but to encourage contemporary spectators to follow the worthy example it honoured.

Emphasis on the contemporary relevance of the subject probably contributed to the artist's realistic rendering of many details in the lower, more worldly half of the painting: ruffs, lace cuffs, the transparent supplice. Furthermore, the Toledans would have recognized, among the gentlemen in black, several of their most well-known citizens.

El Greco gives to the two returned saints the appearance of ordinary persons (showing them without the nimbus which typically invested such figures). He portrays Augustine, the great church father, as a venerable greybeard in a bishop's mitre, while Stephan, reputed to be the first Christian martyr, appears as a young man. A further painting is inset in his mantle: the lapidation of St. Stephan. Stephan was the patron saint of the monastery to which Gonzalo Ruiz had given his support. The robe of the priest standing at the right edge of the painting carries a series of emblems referring to St. Thomas, patron saint of the

church and also of architects, whose attribute was usually a builder's square.

It seems the artist chose the theme of the miracle in order to deliver a lesson in hagiology. This may explain why, confronted with such an extraordinary event, the figures maintain their composure: not one is shown throwing up his hands in fright, or sinking in a state of shock to his knees. On the contrary, the monks on the left are engaged in discussion, while others calmly point to the event, as if illustrating a tenet of doctrine.

Indeed, to 16th-century Toledans that was exactly what the painting meant. The legend was part of general religious knowledge, related and reinterpreted each year in a service held on St. Stephan's day at the church of Santo Tomé. The artist's vision conflated past and present, simultaneously showing the miracle and its incorporation into ecclesiastical doctrine.

El Greco's Heaven comes in muted tones; only the Virgin Mary is somewhat brighter in colour. The figure behind her is Peter with his keys; further down are the Old Testament "saints": King David with his harp, Moses and the stone tablets of the decalogue, Noah and his ark. John the Baptist kneels opposite Mary, while Jesus Christ is enthroned on high. El Greco depicts the soul of the dead Gonzalo Ruiz as the transparent figure of a child borne up in the arms of an angel. The soul's progress appears obstructed, however, or restricted to a narrow strait between two converging clouds.

This might seem surprising, given the high distinction conferred upon the pious man at the burial of his mortal remains. An inconsistency perhaps? In fact, the artist had good reason not to take for granted the soul's unimpeded progress to heaven. The reason lay in the political predicament of the church at the close of 16th century.

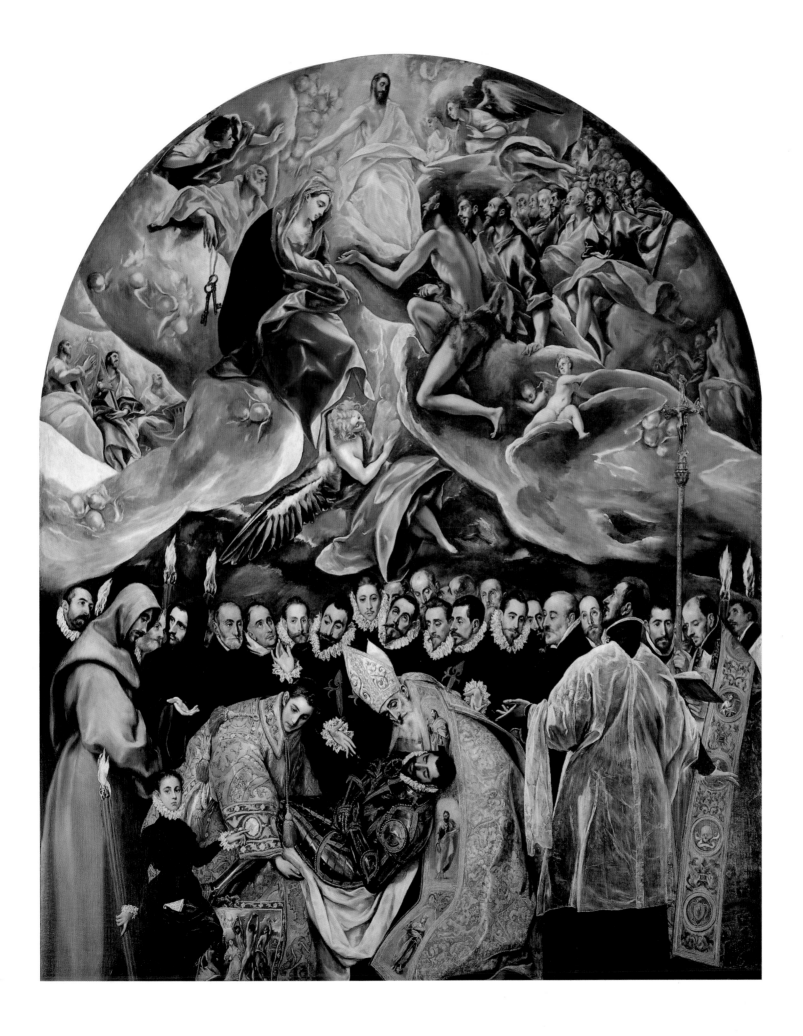

1

Fighting for the Holy Virgin

El Greco painted in the century of the Reformation. Protestant thought had found few followers on the Iberian peninsula, but the Netherlands, where it had spread very quickly, and where Spaniards and Netherlandish mercenaries fought each other over towns, ports and the true faith, was part of the Spanish empire.

News from their northern province filled pious Spanish souls with terror: church statues of saints had been cast down from their pedestals, paintings of the Virgin pierced by lances – satanic forces were at work. That the events had less to do with the revival of the church than with the

work of the Devil was confirmed by reports of iconoclasts tearing the saints to shreds and leaving the demons at their feet intact.

It was the demotion of their most highly venerated Virgin Mary that disturbed the Spaniards most. Luther, so it was reported, had said Mary was no holier than any other Christian believer, while yet another Reformer had said that if Mary had been a purse full of gold before Christ's birth, she was an empty purse afterwards, and that anybody who prayed to the Virgin was committing blasphemy by exalting a woman to the rank of a god.

The great respect commanded by the Holy Virgin south of the Pyrenees stood in peculiar contrast to the disregard shown to women in Spanish society. Their status was far below that of women in Italy, Germany or France. One explanation may lie in the

fact that large tracts of Spain, including Toledo itself, had been under Moorish rule for many centuries. The Moors thought of women as base creatures who, easily tempted, required constant surveillance. Although there were famous nuns in Spain, the mistress of a king, by contrast with her French peer, had no influence whatsoever. Women had no place in the public sphere, as El Greco's painting so ably demonstrates: Mary is the only large-scale female figure among countless men in Heaven and on earth.

In the 16th and 17th centuries the Virgin Mary was the most significant religious and cultural figure in Spanish life: many works by Lope de Vega and Calderón are dedicated to her.

The militant adoration of the Virgin climaxed in the dispute surrounding her Immaculate Conception. This did not, as might be imagined, refer to the begetting of Jesus Christ, but to Mary's own procreation. Her mother was said to have conceived her either without male contribution, or, if a man's presence at the event were conceded, without original sin, for the man was merely God's instrument. Although the pope did not raise the Immaculate Conception to a dogma until the 19th century, it had been tantamount to a dogma in Spain long before. In 1618 the Spanish universities were put under obligation to teach and actively defend the Immaculate Conception.

From a Spanish point of view, however, the Protestants had not only debased the Holy Virgin, they had also got rid of the saints, who were tremendously important to the Catholic faith. To say that El Greco underlines the integral function of the saints in this painting would be an understatement. Together with the Virgin, it is they who intercede with the distant, enthroned figure of Christ on behalf of the souls of the dead; only through their supplication can the barrier of clouds dissolve and the soul find its way to paradise unhindered. The painting's theological intervention demonstrates the rupture of the vital dynamic suggested in the brightly lit undersides of the clouds: the upward surge through the vortex of light to Jesus Christ is obstructed. Since the Reformation had degraded the Virgin and the saints, it was now the task of the Counter-Reformation to effectively demonstrate their significance.

The painting also contains a portrait of Philip II of Spain, who, in 1586, was still on the throne. He is shown sitting among the saints who, gathered behind John, are interceding for the soul of Ruiz. Philip's empire was the largest of all European states. It not only included the Netherlands and Naples with southern Italy, but colonies in Central and South America, some of which were literally borderless. This was the empire on which – in the words of the well-known dictum – the sun never set.

Of course, his life was as remote from his many subjects as any god. Furthermore, the court etiquette he had inherited from his father ensured that court and government officials kept their distance. Only a small elite was ever admitted to his presence, and anybody who handed something to him in person was obliged to do so on his knees. However, there was one important element of his father's etiquette which, characteristically, Philip altered: priests were no longer obliged to genuflect before him. He gave to the ambassadors of the kingdom of God, though appointed by himself, a status

A king among saints

far greater than that accorded to the representatives of worldly affairs.

This was altogether typical of Philip's rule. He set greater store by defending his faith than his empire. No personal loss could hurt him more deeply, he wrote upon receiving news of the Netherlandish iconoclasts, than the slightest insult or disrespect to the Lord and his effigies. Even "the ruin" of all his lands could not hinder him from "doing what a Christian and God-fearing sovereign must do in the service of God and in testimony to his Catholic faith and the power and honour of the Apostolic See."

Philip II had a powerful instrument at his disposal: the Inquisition. In other countries the authorities who condemned apostates, unbelievers and witches were purely clerical; afterwards, offenders were handed over to the state authorities, who would then enforce the penalty. In Spain even the trial was subordinate to the throne. The king appointed the Grand Inquisitor, and the persecution of non-Catholics served interests of state. For over 700 years the Moors, finally defeated in 1492, had ruled over almost the whole Iberian peninsula. Only families who converted from Islam to Christinity were permitted to remain in Spain. The same applied to Jews. They, too, suffered enforced baptism.

Though hundreds of thousands of Jews and Muslims had left the country, or were in the process of doing so, Philip still saw Catholic Spain threatened by unbelievers who merely paid lip-service to Christ, or by heretics secretly plotting insurrection. The Inquisition acted as a secret police force, defending the status quo and transferring to the state the wealth and property of those it condemned.

Combined religious and racial persecution was one of the chief factors leading to the decline of the Spanish empire. The Jews had been specialists in foreign trade and finance; the country's best physicians were Jews, and they constituted the cream of its university teachers. It was thanks to Jewish scholars and translators that forgotten manuscripts by antique philosophers were translated from Arabic into Latin, thus becoming available to Christian theologians.

For their part, the Muslims had farmed vast areas of the country, and the success of agriculture depended on Moorish irrigation systems. Now that they were gone, the fields were bare, the villages depopulated, and the businesses of the merchants collapsed. For Philip, however, as for the clergy, the Spanish grandees and a large section of the Spanish population, this was less important than defending the faith.

2

Yet Philip's unrealistic religious zeal was not the only factor that earned him a place among the saints in Heaven in El Greco's painting. Other artists, too, for example Dürer in his *All Saints' Altarpiece* of 1511, gave a place in Heaven to their most prominent contemporaries. In so doing, they enjoyed the support of St. Augustine's "City of God", in which the domains of Heaven and earth were interwoven, pro-

Monument to a priest

viding theological justification for the depiction of mortals as the inhabitants of Heaven.

The priest portrayed reading is Andrés Núñez, who, at the time in question, was responsible for the parish of Santo Tomé. It is to him that we owe the existence of this painting. Com-

missioning El Greco to execute the work was the final act in a campaign Núñez had conducted for decades in an attempt to bring just renown to Gonzalo Ruiz and – lest it be forgot – himself.

His first undertaking of this kind had been the attempt to move Gonzalo's grave. The pious Castilian chancellor had chosen an inconspicuous corner of the church of Santo Tomé as the resting place of his earthly remains – apparently a sign of his modesty. Núñez wanted his bones moved to a more auspicious place, but his superiors rejected the request, for "the hands of sinners" should not touch the body of one who had been "touched by the hands of saints".

Consequently, Núñez decided to build a chapel with a high dome over the immured coffin. Soon after this demonstrative deed in memory of the lord of Orgaz (it was his descendents who received the title of count), the citizens of Orgaz decided to annul the 250-year-old legacy of two lambs, 16 chickens, two skins of wine, two loads of firewood and 800 coins. Núñez instituted legal proceedings, winning the case in 1569. In order to record

his triumph he had a Latin text mounted above the grave, recounting the legend and referring to the rebuttal of the town of Orgaz through "the vigorous efforts of Andrés Núñez".

The smart priest thus created a monument to himself. After applying to the archbishopric in 1584, he was granted permission to commission a painting of the miracle of the interment. El Greco was commissioned in 1586 and delivered the painting in the same year. Whatever the work may owe to the personal ambition of a priest, it has to be said that propagation of the miracle of the burial was also fully in keeping with Counter-Reformation church policy. It was seen as important not only to exalt the Virgin and saints, but to defend the need for charitable donations and the worship of relics. According to Catholic belief, the route to Heaven was paved with "good deeds", a view rejected by Reformers, for whom faith and divine mercy were all that counted. The Reformers also vehemently opposed the veneration of relics, a cult of considerable significance in Catholic countries. It was at this time, too, that Gaspar de Quiroga, appointed archbishop in 1577, brought the bones of St. Leocadia and St. Ildefonso to Toledo, thereby greatly adding to the status of its cathedral. Santo Tomé's painting of the burial extolled the piety of charitable donations, at the same time defending the worship of relics. For had not two saints touched, and thereby honoured, the mortal frame? Was it not therefore correct to infer that all Christians should honour the mortal remains of the pious, the saints and the martyrs?

The painting's gigantic format complied with Counter-Reformation propaganda in yet another sense: its stunning visual impact. The Protestants, by contrast, wished to see their churches purified of all ornamentation. Places of worship were to be free of graven images, or at least not crowded with visual distractions from God's word. But the Catholics thought otherwise: since the church was God's house, why not use every means possible to decorate it in His honour? The exuberant splendour of Baroque churches was, not least, a reaction against the plain churches of the Reformation.

Reality as a stage set

The boy pointing so meaningfully at the saint was El Greco's son; his year of birth, 1578, can be deciphered on his handkerchief. When his father painted the miracle, he was eight years old. The contract was concluded on 18th March. El Greco finished the work, whose value was estimated by two experts at 1200 ducats, by Christmas. Since the price was too steep for the parish council of Santo Tomé, it appointed two experts of its own, only to find that they arrived at a value of 1600 ducats. It was not until July 1588 that the parties agreed – on the lower sum.

El Greco was dogged by financial problems almost all his life. He was not a prince among painters, like Titian, in whose Venice studio he had trained. "The Greek" was born in 1541 on Crete, which, at that time, was under Venetian rule. He learned icon painting, left for Venice where he became a master of spatial representation and architectonic perspective, then moved to Rome. When Pius V, disturbed by the nudity of some of the figures in Michelangelo's *Last Judgement*, wanted some of the frescos in the Sistine Chapel painted over, El Greco is reputed to have offered to paint an equally good, but more decent, work if the original were destroyed.

It is not known when, or why, El Greco settled in Spain. It is possible he felt ill at ease with the Italian artists' exaltation of corporeal and architectural beauty; perhaps he hoped his celebrations of the afterlife would find greater recognition in Spain. Spanish cardinals, resident in Rome, are likely to have spoken of the Escorial, Philip II's palatial monastery, and El Greco may have hoped to find work there. Instead he settled in the old religious capital of Toledo, the seat of the archbishop. In 1579 the king commissioned a painting from him – the only order he received from that source. Philip apparently disliked the Greek's paintings.

Spiritually they had much in common. For both, the afterlife was more important than this life. Philip longed to rule from the Escorial in the company of monks, and to be able to see an altar even from his bed. This view meant more to him than his empire: his Armada was defeated in 1588; in 1598, the year of his death, financial pressures forced him to give up his war against France, and the northern provinces of the Netherlands were already as good as lost.

El Greco's whole life's work, and this painting in particular, bears witness to his belief that the kingdom of heaven was more important and more real than the world in which we live. Though he is painstakingly exact in his detailed rendering of the lower, worldly half of the painting, the realistic heads and dress have the effect of drawing the burial scene into the foreground, while the isocephalic arrangement of onlookers' heads gives the appearance of the top of a stage set. It is only here, behind this dividing line, that the true life begins. Only the upper half is dynamic, vital through and through, an effect achieved with the help of lighting and a use of depth and line that draws the eye upward.

It remains to be said that not all Spaniards ceded to the uncritical renunciation of reality. The writer Miguel de Cervantes, for example, a contemporary of El Greco and Philip II, took a different point of view. Though he did not attack the religious zeal of his compatriots, his character Don Quixote, a chivalrous and deluded idealist, illustrates the dangers that may befall a person who inhabits a world of fantasy rather than facts, someone who, in pursuit of ideals, loses sight of the ground beneath his feet.

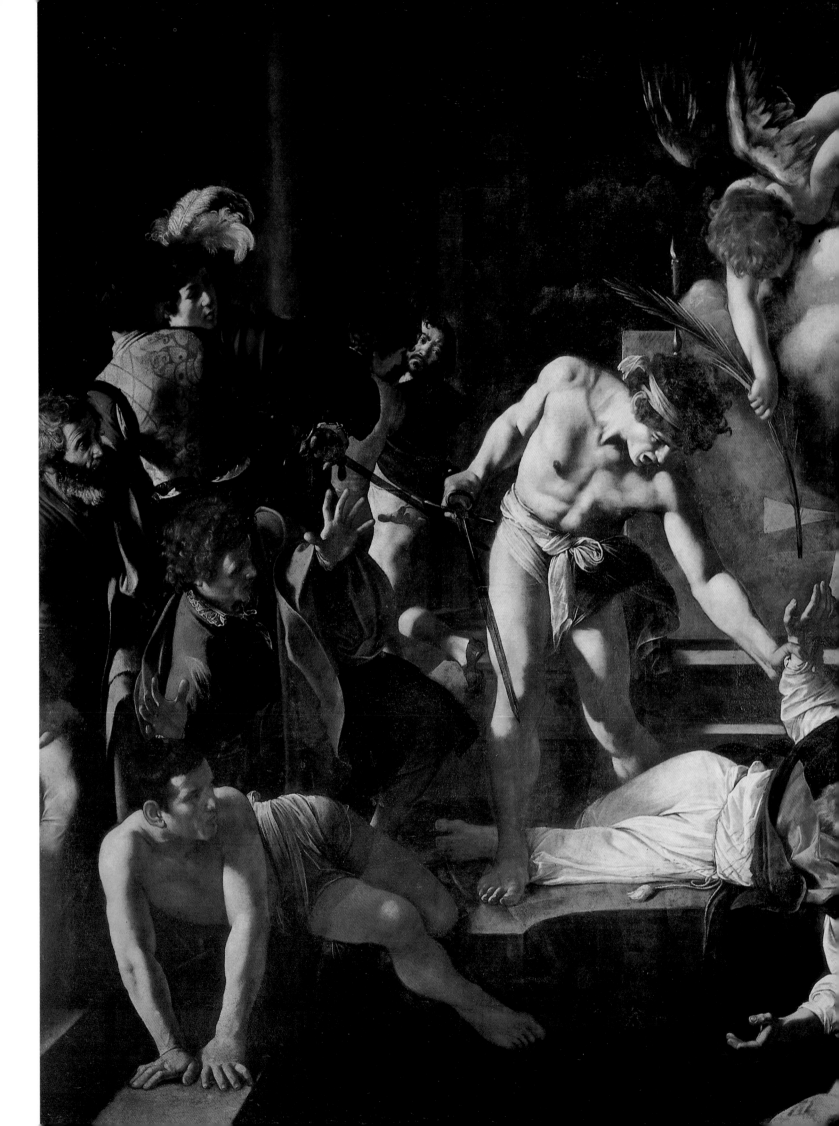

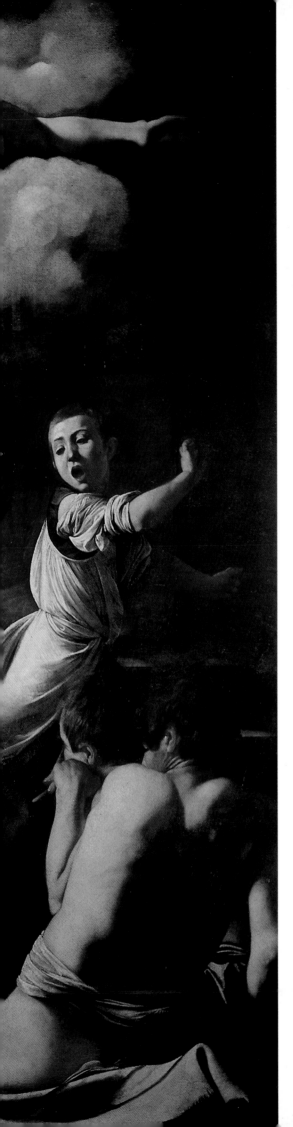

Michelangelo da Caravaggio: Martyrdom of St. Matthew, 1599–1600

The theatre of cruelty

It was Michelangelo Merisi's first large commission, given to the young artist solely because a finished work was needed as quickly as possible: the Holy Year of 1600 was nigh and half a million pilgrims from throughout Europe were expected in Rome. It was essential that the world centre of Christianity make a great impression on the visitors, thus spreading abroad the glory of God, as well as that of Pope Clement VIII and his triumphant Counter-Reformation.

Sacked in 1527 by Charles V's mercenaries, Rome had been rebuilt more beautifully and on an even grander scale than before. The cathedral of St. Peter's was already finished; wide streets, splendid palaces and countless new churches added to the town's attractions. Interrupted only by political instability or financial difficulty, building had continued for the better part of a century. The foundation stone for San Luigi dei Francesi, for example, the French Church, had been laid in 1518; the church was finally consecrated in 1589. On the very threshold of the year of celebrations, however, and much to the annoyance of the French priests, work on the fifth and last chapel on the left – the Contarelli chapel, named after its founding donor Cardinal Matteu Cointrel – was not finished.

The renowned artist Guiseppe Cesari d'Arpino, who, during the nineties, had decorated its ceiling with frescos, had run out of time before painting the walls. Like the majority of famous artists during the Roman building boom, Cesari's time was taken up painting more prestigious work. On 23rd July 1599, the works committee decided to offer the commission to the 27-year-old, almost unknown painter Michelangelo Merisi, self-styled "da Caravaggio" after his native town. By the end of the year, and at a total cost of 400 scudi, the young artist was to deliver two oil paintings, each measuring 323 by 343 centimetres: the *Calling* of the tax-collector Matthew by Christ, and his *Martyrdom*. The instructions he received, essentially those conceived for Cesari, demanded an act of homage to the donor's patron saint. The contract for the *Martydom* stipulated a "spatious interior of some depth, like a temple, with an altar at the head ... Here St. Matthew is murdered by soldiers while celebrating mass ... and falls, dying but not yet dead; while in the temple a large number of men and women ... most of them horrified by the dreadful deed ... show terror or sympathy."

The paintings were officially unveiled in July 1600, six months overdue. The manner in which Caravaggio had interpreted his "instructions" caused a "considerable stir" far beyond the walls of the Holy City. Four years later, news had spread to the distant Netherlands, where Carel van Mander reported that a certain Agnolo van Caravaggio was "doing extraordinary things in Rome".

Gentle angels for a cardinal

A palm branch, the symbol of divine gratitude, is proffered to the dying martyr by a young boy. The gesture, far from triumphant, betrays a certain degree of caution: leaning from a cloud, he supports himself with one hand, perhaps unsure his wings will carry him. The angel, with flaxen locks and pearly skin, is one of those gentle creatures so characteristic of Caravaggio's early work: dreamy strummers of lutes, scantily dressed and crowned with vine-wreaths, raising chalices of wine or holding ecstatic saints in their arms. Whether antique Bacchus or Christian angel, these figures reflected the taste and preferred company of Caravaggio's patron, Cardinal Francesco Maria del Monte (1549–1626), who, according to a contemporary biographer, "was enamoured of the company of young men".

For several years the church leader offered his protection to the young artist, providing lodgings, bread and wine in his Roman palace, situated diagonally opposite the church of San Luigi dei Francesi. The Cardinal gave him regular pocket money, too, and helped him out of the difficulties into which the artist's aggressive behaviour repeatedly plunged him. Born in 1571 near Bergamo, Caravaggio is reputed to have fled from Milan to Rome in 1592 to escape the consequences of a bloody quarrel. Once in Rome, he was forced to sell his paintings on the street, between "marrows, nougat, cleaning utensils, drums, water and heads of veal". But soon enough, according to van Mander, he had "climbed from poverty through hard work" – assisted, of course, by the protection of his patron, for whom, from c. 1594, he painted a series of beautiful boys, many of which betrayed Caravaggio's own features.

The influential cardinal also helped his protégé acquire his first big commission. Initially, Caravaggio had painted relatively small works with few figures for del Monte's private rooms. The two paintings of St. Matthew, on the other hand, would be seen by a large number of spectators: some 300,000 French pilgrims visited their church in Rome during the Holy Year, many of them staying at the hospice there.

The six-month delay with which Caravaggio delivered the works can be put down to his unfamiliarity with certain technical problems posed by the task. He was not only required to adapt his skills to a large-scale format, but had also gathered little previous experience of integrating such a large number of figures: seven in the *Calling*, and 13 in the *Martyrdom*. Furthermore, Caravaggio had difficulty calculating the perspective for the "spacious interior of some depth". With the help of X-rays, art historians have discovered several earlier versions of the *Martyrdom*, in which the artist experimented with smaller protagonists in various different arrangements. Apparently, the Apostle was first shown standing, then kneeling, while at his side a fierce angel, armed with book and sword, was ready to confront the murderer. Later, and possibly in the interests of decency, the naked heavenly messenger was banned to his cloud, where he duly abstained from further intervention, leaving the martyr to his fate, and executioner.

efenceless, the old man lies on the ground, waiting for the mortal blow. He is wounded, his robe stained with blood. While all around him flee in panic, the Apostle meets death "freely", in the name of his faith, as befitted a martyr. A "witness" to the truth of Christ's divine revelation, he looks his murderer straight in the eyes.

In order to heighten the dramatic quality of the scene, Caravaggio departs from tradition. According to the *Golden Legend* of the saint's life, his executioner stabbed him "from behind with his sword while St. Matthew stood before the altar, his arms outstretched in prayer". The Apostle, preaching "in the land of the Moors", had dared deny the heathen King Hirtacus access to "a virgin devoted to the Lord", thus incurring the King's wrath. "While mass was held, the King sent his henchman … thus the martyrdom was fulfilled."

Caravaggio's contemporaries were exposed to dramatic accounts of martyrdom not only in the legends of saints. In the age of religious struggle in Europe, both Protestants and Catholics suffered and died every day on behalf of their confessions. In England under Elizabeth I, the death penalty awaited anyone discovered holding mass. As a result some 40 priests were tortured and executed. By the beginning of the 17th century their portraits were exhibited at the "English College" in Rome, while the "German College", too, had five martyrs to its name.

These institutions had been set up by the pope to provide special training for young priests sent on dangerous missions to Protestant countries. The destiny of the pupils was a source of envy: "Could I but die the death of these just men!", enthused the church historian Baronius. They were solemnly addressed as the "Flores Martyrum" – the "flower of martyrs".

At that time, the Catholic church was attempting to regain those countries it had lost to Protestantism during the first half of the 16th century. Counter-Reformation strategy involved the mobilization of "Christian soldiers", who were ready to fight and, if necessary, die for their faith. The early Christian martyrs were held up as shining examples, especially after 1578, when a landslide revealed part of the forgotten Roman catacombs, rekindling popular interest in the heroic, founding years of the Church. Excavations began, and the catacombs were made the object of extensive research. During the celebrations of 1600, a host of pilgrims, in awe-struck reverence, followed in the underground tracks of the early Christians.

Resurgent interest in the martyrs, together with their suitability for propaganda purposes, prompted the pope to order a new edition of the martyrological catalogue, a work in progress since the 5th century. In 1584, Baronius' "Roman Martyrology" appeared in several volumes, a standard work of monumental stature, lending to the old legends the veneer of historical truth. Countless new editions of the work have since been published, most recently in 1956.

However, the Protestant side also had its martyrs, in whose honour, as early as 1563, John Foxe published his *Book of Martyrs.* On St. Bartholomew's Eve of the year after Caravaggio's birth, thousands of Huguenots were massacred in Paris for their beliefs. In 1600, when the painting of St. Matthew was unveiled, a man who regarded himself as a martyr was burnt to death at the stake: Giordano Bruno, referred to as a "magician" and "unrepentant, stubborn heretic", died neither for the Catholic nor Protestant faith, but for freedom of thought and science.

**To bear witness
and die
for one's beliefs**

2

The English College frescos have long since vanished, but in 1582 they showed the history of England reduced to a series of ghastly scenes of torture and execution. It was at this time, too, that the Jesuits ordered the decoration of San Stefano Rotondo, a church belonging to the German College, with 30 gory scenes illustrating the persecution of Christians. Their motivation for doing so was largely educational: investing in the persuasive power of the senses and imagin-

Bloodthirsty murder, fear and horror

ation, the Jesuits used art in their educational establishments to encourage the militancy of their pupils, at the same time acquainting them with their probable fate. Confronted daily, whether in the library, refectory or chapel, with sights of terror and suffering, the future martyrs were accustomed to the notion of martyrdom at an early age.

"One should not be afraid", wrote Cardinal Paleotti in his "De Imaginibus Sacris" (Of Sacred Images) in 1594, "to paint the torments of the Christians in all their horror: with wheels, grates, racks and crosses. The Church wishes, in this manner, to glorify the courage of its martyrs. But it wishes also to fire the souls of its sons." This was in accordance with the aims of the Counter-Reformation: at its

final session in 1563, the Council of Trent had decided to use art to spread the Catholic faith among the uneducated masses. The clergy were required (as in the case of the Contarelli chapel) to draw up detailed proposals for paintings, and to ensure not only their precise execution in the churches, but also their theological correctness, intelligibility and decorum. Paintings which indulged in the horrific minutiae of torture and suffering did not offend against these regulations, but responded rather to widespread predilection.

Renaissance artists had celebrated beauty and harmony, giving little space to human suffering or death in their work. Yet it was precisely these phenomena which appear to have fascinated both artists and the public towards the end of the 16th century – possibly due to Spanish influence, for Spain ruled most of Italy at the time. Pain, torment, death, cruelty and violence not only had a considerable impact on art, but were part and parcel of everyday life. Public executions were turned into pompous displays. The most exciting of these is said to have taken place on 11 September 1599, when members of the Cenci family were executed for patricide and the murder of a husband: a bloodthirsty, highly ritualized piece of theatre, in which both executioner and victim performed with great aplomb.

In clear contrast to the peaceful scene depicted in his *Calling*, Caravaggio's *Martyrdom*, too, celebrates violence. At the centre of the scene, with his long sharp weapon, stands the athletic, half-naked figure of the king's henchman. With a fearful scream from his gaping mouth he storms into the church. Throwing the martyr to the ground, he steps across his body to deliver

3

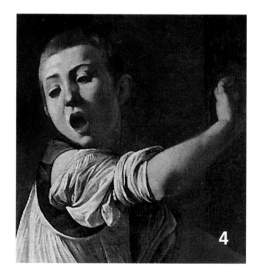

4

the deadly blow. In the commotion, by-standers flee in panic. A frightened boy screams. The full light falls on the terrible beauty of the executioner's body. While the others, including his victim, merely react to the assault, the assailant remains unchallenged: he is the sole source of energy, the seductive, irresistible force of aggression incarnate.

A "wild" and violent painter

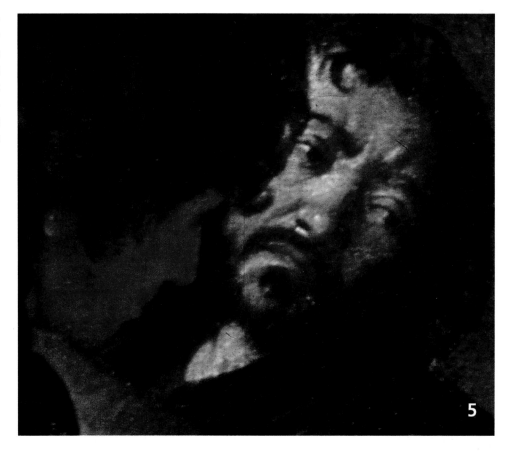

5

Screams of terror assume a prominent place in a number of Caravaggio's other works, painted in the same period as the *Martyrdom*: the gaping mouth of the Medusa's severed head, for example, or Holofernes' screaming mouth as Judith cuts off his head. By the turn of the century, images of horror had begun to replace the gentle youths of his earlier work. According to Caravaggio's American biographer Howard Hibbard, images of decapitation and torture now began to dominate his work to an alarming extent. The wildness of his personality had exploded into his art.

Police archives in Rome confirm the "wild" and violent nature of the man. His name turns up on record for the first time shortly after he delivered the Contarelli painting: on 19 November 1600 the artist "assaulted" a certain Girolamo Stampa, whom he "beat several times with a stick". According to one contemporary source, after spending several hours of each day in his studio, Caravaggio "would appear in various quarters of the city, his sword at his side as though he were a professional swordsman". Caravaggio went for his dagger at the slightest provocation. He spent a considerable amount of his time in front of the magistrate, and his patrons found it increasingly difficult to protect him from the

consequences of his violent temper. They were finally forced to give up when he killed a man, on 28 May 1606, in a quarrel over a wager. Caravaggio was forced to flee the Papal State, spending the rest of his life on the run, a tragic figure. He died in 1610, a mere decade after the two paintings of St. Matthew had brought his artistic career to fruition.

In his *Martydom*, the painter has lent his own features to the legendary King Hirtacus. According to a contemporary, Caravaggio was "ugly … pale of visage, with abundant hair and sparkling eyes set deep in his face". The heathen potentate is shown in the background of the painting, observing the murder of the Apostle by his henchman. According to the "Golden Legend", his punishment was fitting: "the victim of horrible leprosy, and unwilling to let himself be healed, he fell on his own sword."

Yet it was with this rather dismal figure that the 28-year-old Caravaggio, whose paintings of St. Matthew caused "a considerable stir", identified. New commissions for work confirmed his success. As early as 1600, he was asked to paint works for another chapel.

Caravaggio's work nonetheless remained controversial. Though the theme and violence of the *Martydom* were in

keeping with contemporary trends, their execution proved a shock to the Roman art world: this was a radical departure from the prevailing tone in fresco painting, whose scope was restricted to the bland repetition of patterns, attitudes and gestures in place since the early Renaissance. It undoubtedly needed an artist as idiosyncratic as Caravaggio to break the conventional mould: somebody, for example, who painted living models – a revolutionary innovation in 1600; or someone who put light and shadow to such novel use.

It is quite possible that Caravaggio's reasons for plunging entire areas of his canvas into inky blackness were entirely practical: on the one hand, cover of darkness enabled him to cast a veil over the technical difficulties he encountered with perspective; on the other, starkly accentuated areas of bright light were effective in attracting spectators to an otherwise inconspicuous chapel. The scenes depicted in his paintings in the chapel of San Luigi dei Francesi made an impression not only on the pilgrims of the Holy Year of 1600; their realism, high dramatic tension and masterful handling of light and shadow gave a powerful impetus to painting throughout Europe.

God's champion defeated in the war of the sexes

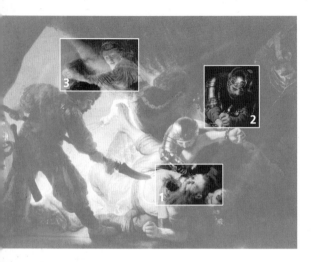

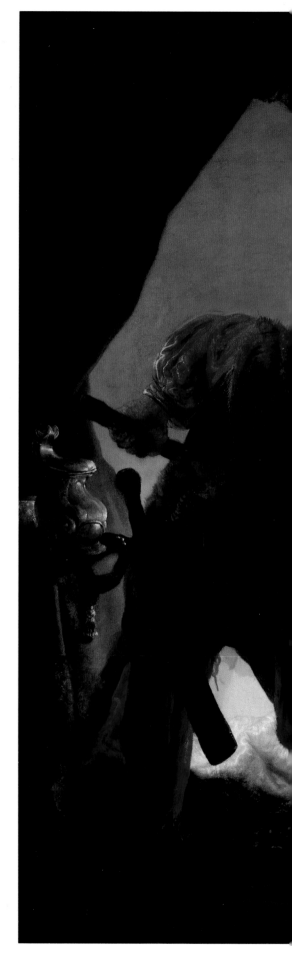

Samson was famous for his inordinate strength; only the help of a woman enabled his enemies to take him prisoner. His story is told in the Old Testament Book of Judges. Samson, too, was a judge, a leader among the people of Israel.

At that time, the enemies and oppressors of the Jews were the Philistines. Before his birth, an angel of the Lord had appeared to Samson's parents to tell them what God intended with their son: "For the child shall be a Nazerite unto God from the womb: and he shall begin to deliver Israel out of the hand of the Philistines." They were also instructed never to cut his hair.

As ill-luck had it, Samson grew up and fell in love with a Philistine girl, asking her to become his wife. The Old Testament explains that his unruly behaviour was directed by God: seeking an opportunity to incite animosity between the people of Israel and their Philistine oppressors, God had influenced Samson's feelings. Samson provoked a quarrel by telling a riddle, promising 30 changes of garment to the bride's 30 companions if they could solve it. Her companions then forced the young woman to entice the solution from Samson. Samson kept his secret until she used her strongest weapon: "thou … lovest me not."

On discovering that he had been deceived, the "Spirit of the Lord came upon him, and he went down to Ashkelon, and slew thirty men of them, and took their spoil, and gave change of garments unto them which expounded the riddle."

The Bible mentions three women in Samson's life. The first was his wife, or fiancée, whom his father-in-law refused him after the slaughter in Ashkelon, giving her to his companion instead. The second was a "harlot" in Gaza. Getting wind of Samson's visit to her, the Philistines decided to lie in wait for him at the gate of the city and kill him in the morning. But Samson arose at midnight and, tearing out the doors and the two posts of the city gate, he set them down – to the disgrace of his enemies – on top of a hill.

Only the third woman is given a name: Delilah. Samson loved her, but the lords of the Philistines bribed her. Her task was to find out the secret of Samson's great strength. In return "we will give thee every one of us eleven hundred pieces of silver." Three times her lover gave her the wrong information, until she too began to express her doubts over Samson's love. The big man's resistance was finally broken: "If I be shaven", he confided in her, "then my strength will go from me." So "she made him sleep upon her knees; and she called for a man, and she caused him to shave off the seven locks of his head … and the Philistines took him, and put out his eyes."

The Book of Judges does not explain why God allowed the defeat of his "Nazerite". Commentators have pointed out that Samson had ceased to obey the Ten Commandments. Nonetheless, the tables were eventually turned when Samson, blind and bound, was brought forth and subjected to ridicule at a Philistine festival. In the meantime, his hair had grown, and, praying to the Lord to give him back his old strength, he braced himself against two

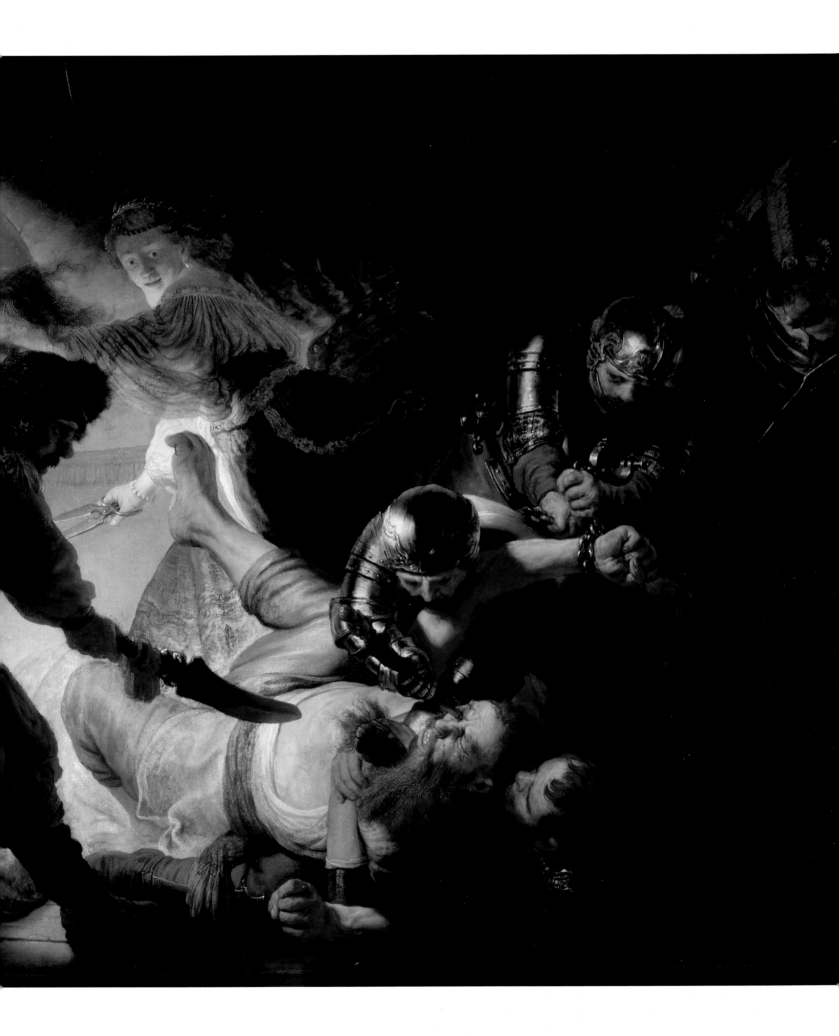

pillars, toppling them and bringing the whole house down on top of himself and thousands of Israel's enemies.

Samson conforms to the Calvinist outlook

Rembrandt painted five scenes from Samson's life, all of which, for different reasons, have ended up in German museums. The pious couple receiving God's message from his angel and Samson telling his riddle at the wedding feast can be admired at the Dresdner Gemäldegalerie. In a painting executed in 1635, now at Berlin-Dahlem, Samson shakes his fist at his father-in-law, who refuses to let him marry his daughter. Also in Dahlem, *Samson Betrayed by Delilah* (1628) shows the hero asleep with his head on Delilah's lap. Finally, *The Blinding of Samson* (1636), measuring 205 x 272 cm, belongs to the Städel Museum in Frankfurt.

All Rembrandt's pictures of Samson were painted between 1628 and 1641. For more than a decade, the artist was preoccupied with the strange figure of a muscleman, one of God's "chosen" who stood out from the rest of his people mainly because of his great strength and boorish insolence. The Bible makes no mention of intelligence, or spiritual qualities.

The decade in question was in the first half of Rembrandt's life (1606–1669), so that the young artist may simply have been fascinated by Samson's superhuman feats of strength and defiance of convention. Hercules, on the other hand, no less popular a superman, would not have been a suitable hero: Rembrandt's upbringing had been Calvinist, and Calvin's doctrine was a powerful influence on religious sentiment in the new state of the Netherlands, so that not only were dancing, music and luxury proscribed and the Catholic Church fought at every turn, but also reference to heathen antiquity was considered improper. Dr Tulp, a figure painted by Rembrandt, had publicly raised his voice against the exhibition of antique gods at festive processions. Hercules was popular, but unacceptable.

However, the artist's relative youth can hardly be deemed sufficient explanation for his choice of subject matter. It was the fact that the story of Samson complied with the Calvinist view of the world that tipped the balance in his favour. Yahweh, the God of the Jews, was the real leader and ruler of Samson's people. It was Yahweh who took away Samson's strength, and who also gave it back to him. Calvin's view of the world was very similar to that expressed in the Old Testament: God, the ruler, made his will known through the Bible, determining all morality and politics. Whoever did not obey was, like Samson, cruelly punished. Unlike Luther, the French Reformer did not conceive of God as a God of love and mercy, but as a hard-hearted overlord. Calvin propagated intolerance towards those who broke his strict moral code, or disobeyed church rules. Offenders were condemned to death or forced into exile. Over 50 death sentences can be traced back to Calvin's instigation.

There is another sense in which the figure of Samson complies with the Calvinist outlook: predestination was a tenet of the Reformer's doctrine, and Samson was "a Nazerite unto God from the womb". For even before his birth, an angel had told Samson's parents what his task and status were to be. The "Book of Judges" tells the full story. If the notion of predestination is applied generally, rather than to God's chosen few, then even Delilah was not only a money-grabbing traitress, but an instrument of the Lord.

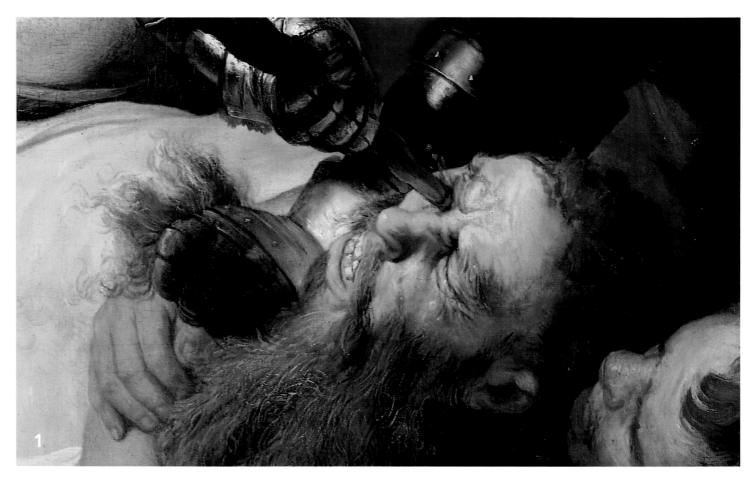

1

The pleasures of terror and cruelty

The helmets which Rembrandt sets on his Philistines' heads were rarely used in armed conflict by 1636. In fact, they resemble so-called Burgundian "pot-helmets", worn a century earlier. The same type of helmet turns up in several other works by Rembrandt, from which we may tentatively infer that it either belonged to the artist's collection of costume props, or was perhaps worn decoratively by members of militia companies on representative occasions. Realistic representation was not necessarily the aim of "history painting" in Rembrandt's time. Old Testament figures, for example, were often portrayed clothed in contemporary Turkish dress.

Like Samson's people, the Netherlanders were fighting a national liberation struggle against a powerful enemy. The country had fallen to Spain by inheritance, and Philip II had sent the Duke of Alba from Madrid to bind the Netherlandish provinces more closely to his empire. Alba's rule was draconian and vicious, provoking open resistance to his authority. It was not until 1648, however, that the Dutch northern provinces were granted independence, so that Rembrandt's *Blinding*, executed in 1636, was painted against a background of war. The fighting itself made little impact on Amsterdam, where the artist lived, for the warring parties had filled their ranks with mercenaries, and the battles were fought elsewhere. Nonetheless, the mercenaries were forced to feed themselves from what they could find in the countryside. The devastation by marauding armies experienced by the neighbouring German lands during the Thiry Years' War had demonstrated what lay in store for the Netherlandish civilian population. As if all this were not enough, reports of torture carried out by the Spanish authorities struck fear into the hearts and minds of the people.

At the time, atrocities of the kind shown in Rembrandt's painting were a good deal more widespread than is the case in central Europe today. They were more frequently painted, too, especially in Rome, Naples and Spain. Many of these works showed martyrs stretched on the rack or the wheel, or being stoned, beaten or stabbed to

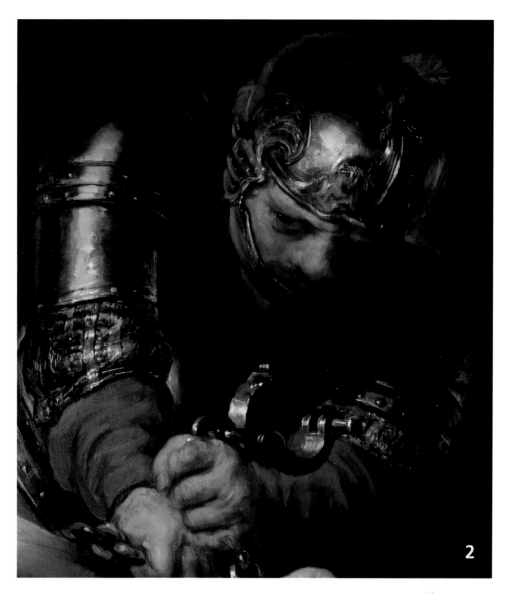

2

death. The illustration of martyrdom was part of Counter-Reformation propaganda: its function was to glorify the saints, and prepare priests for possible death. This, at least, was the official line.

However, besides church propaganda and the very real atrocities of the age, there seems also to have been a genuine need during the Baroque for depictions of Man's cruelty to Man; it is a need that is difficult to explain. Perhaps it was a reaction against even more frequently painted scenes showing ecstatic hermits, or abbesses triumphing over earthly temptation: a repudiation, in other words, of images of the human that were all too ethereal.

In none of Rembrandt's other paintings is physical pain depicted quite as realistically. He has chosen to show the precise moment at which the dagger enters Samson's eye. Pain not only distorts the face, it contorts the entire body from top to toe. Rembrandt has painted Samson's head in the foreground, placing the act of mutilation

directly in front of the spectator's eyes. An 18th-century owner of the painting evidently found its directness too hard to bear: he had the painting enlarged, creating distance between the spectator and the act by giving the scene more space. In the Städel, a frame covers the added parts, allowing one to view the work in the original format.

Delilah's betrayal of Samson, or triumph over him, was a common enough subject in 16th and 17th century painting, but these works usually showed Samson taken captive, rather than his blinding and bloody torture. Rubens, for example, thirty years Rembrandt's senior, used the theme of Samson and Delilah as an excuse for two wonderful figures leaning dramatically into the foreground; though a soldier in the background is seen raising a knife, there is no sign of impending horror on Delilah's face. Rubens evidently preferred to give her an amused, slightly thrilled smile, as if she were merely anticipating the outcome of some foolish prank.

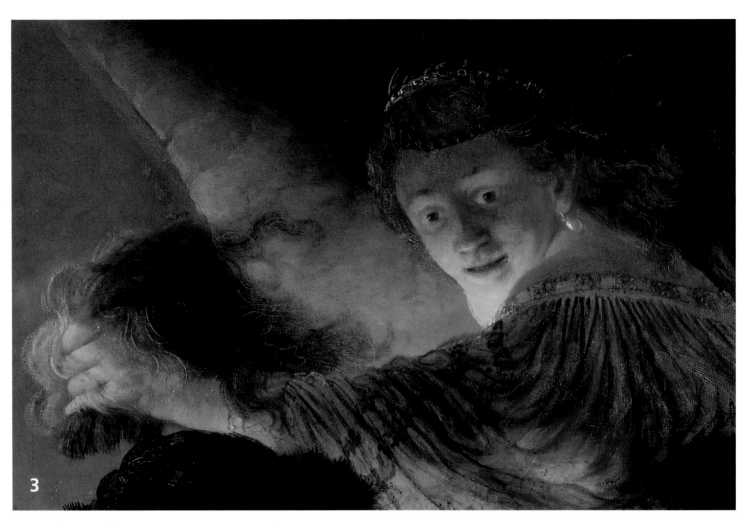

3

Cunning triumphs over physical strength

Rubens' figure could be construed as an illustration of the "wiles of woman", and it is certainly true that the phrase – which might sound feeble by today's standards – has been used often enough in connection with Delilah's deed. If the story of Samson and Delilah has retained any relevance, however, then not as an illustration of cunning, but as a narrative of the struggle between the sexes, of revenge taken by the physically weaker sex on a symbol of male potency; conversely, its narrative force may lie in the portrayal of the primordial male fear of vulnerability and loss of potency during coitus.

Holofernes' decapitation at the hands of Judith is a treatment of the same theme; he too had taken her to his bed. The Jewess Jael, too, kills the sleeping Canaanite general Sisera by driving a nail through his head. All three stories of women's victory over their sexual partners were from the Old Testament, and all three were painted again and again during the 16th and 17th centuries.

There are several indications of the significance attached by Rembrandt to the conflict between the sexes. Delilah is shown towering over Samson's supine body. The dark blade of the soldier in the foreground obscures the intersection of the diagonals which structure the composition, the precise location of Samson's invisible genitalia. More importantly, however, the Book of Judges says that Delilah "called for a man", causing him to "shave off the seven locks" that were the source of the sleeping man's strength. Rembrandt, however, has her do the deed herself, showing her with the scissors and hair still in her hand. Rubens, too, placed the scissors in Delilah's hand. It was common for artists to depart from the letter of a Biblical story to emphasize their own concerns.

Oddly enough, books about Rembrandt tend to ignore this great painting, or to speak disparagingly of it. Yet even in terms of scale, it was the largest of Rembrandt's works to date. Apparently, however, this in itself is enough to denounce the artist: Rembrandt is accused of conforming to the platitudes of comtemporary taste, paying lip-service to Baroque notions of grandeur, instead of following his own route into the depths of the human soul, beyond all crude realism or superficial drama. It is no accident that the work on which discussion of Rembrandt's treatment of the Samson theme tends to concentrate is the picture of the angel announcing his message to Samson's parents, who are shown kneeling beside each other, absorbed in prayer.

But the *Blinding* also reveals the inward state of the participant figures. This applies not only to Samson, but to the soldiers in the foreground and Delilah as well. The faces and gestures of the latter betray contradictory emotions: fear and aggression in the soldier, triumph, horror and inward reserve in the turned face of Delilah. To Rembrandt, however, Delilah's gaping eyes had a separate meaning.

One of the rules of "history painting" demanded the artist's empathy with the figures he painted. Samson, a colossus in revolt, could thus be seen as Rembrandt himself, turning blind and forfeiting his creative powers.

There can be little doubt that Rembrandt feared the loss of his eyesight. Though there is no documentary evidence to prove this, a sketch Rembrandt made of his father suggests the latter went blind towards the end of his life. The artist must therefore have witnessed his gradual loss of sight. Even if he had not seen members of his own family blind, he would have seen blind people wherever he went, for eye disease was common and medical treatment ineffective. The blind appear in many of Rembrandt's paintings: an aged Homer, Jacob blessing his grandsons, blind violinists, blind beggars, the blind hoping to be healed by Jesus. His most frequent use of the motif centres on the theme of Tobias and his blind father. There are some 50 sketches, etchings and paintings of Tobias, most of which, though not all, include Tobias' father. According to the Bible story Tobias healed his father's blindness by smearing the bile of a fish on his eyes. In so doing, he followed the advice of the archangel Raphael: in other words, divine inspiration. However, Rembrandt shows Tobias standing behind his father with an instrument in his hand: medical scientists have suggested this may be an operation to remove grey cataract. The painting, showing Tobias giving his father back his eyesight, was executed in 1636, the same year as *The Blinding of Samson*.

But Rembrandt's preoccupation with eyes and eyesight was not limited to that year alone. He was altogether fascinated by this bodily organ and its function. At the same time, he treated it with the caution normally reserved for subjects that are taboo. His portrait of his mother as the prophetess Hannah shows her with eyes closed, and with the folds and tiny wrinkles of her eyelids and aged facial skin rendered in minute detail; and it is as if skin had grown over her eyes. In another work Abraham, about to sacrifice his son Isaac, lays his left hand across his son's face, covering his victim's's gaze. Or in Rembrandt's astonishing *Self-portrait* of 1628, the artist's eyes, drowned in deep shadow, are practically invisible.

Considering Rembrandt's preoccupation with his ability to see, it is understandable that, unlike Rubens, he decided to paint Samson blinded rather than Samson taken captive. To Rembrandt, a painting of Samson not only meant the Old Testament, Calvinism, or the struggle between the sexes, for the theme gave him the opportunity to paint a picture about sight: Delila's gaping eyes see Samson's dead eyes, while the blinding brightness of the sky outside – and where else has Rembrandt painted a blue so bright! – is swallowed by the almost impenetrable darkness of the interior.

The first to paint such stark contrasts of light and darkness had been Michelangelo da Caravaggio (1571–1610), a manner imported to more northerly latitudes by Netherlandish artists. The technique heightened dramatic tension, and accentuated important details. In Rembrandt's work it appears also to have symbolized the act of looking itself, the power and impotence of the human eye. Rembrandt's self-portrait shows that the most important elements of a painting are not necessarily to be found in its brighter sections. The artist's forehead, eyes and mouth, features which generally help us recognize a person, are engulfed in darkness. However intent the spectator's gaze, its object will thus remain obscure. By contrast, relatively uncharacteristic features, such as the neck, ear and cheek, are well lit. The subject of the painting was not Rembrandt's face, but the act of looking. Its theme – like that of *The Blinding* – is the eye itself.

The eyes – fount of fascination and taboo

95

Diego Velázquez: The Tapestry-Weavers, 1644–1648

Manufacturing riddle

At first glance the painting, executed by Velázquez between 1644 and 1648, looks like a genre work. But *The Tapestry-Weavers* is not only one of the earliest representations of manufacturing in the history of art; it is first and foremost an allegory. In keeping with contemporary taste, the artist has filled the canvas with countless scholarly allusions. The painting, measuring 220 by 289 centimetres, is in the Prado, Madrid.

The painting is in dreadful condition. In the course of centuries it has been cleaned and "repaired" with unsuitable materials, and strips of canvas have been added to all four sides. In recent times, dry air and pollution have made the paints crack and peel, and it is now almost impossible to make out the former colours under the darkened varnish. International experts, examining the painting in 1983, concluded that it should be left in its present condition, since further restoration attempts might destroy it altogether.

In spite of its deficiencies, *The Tapestry-Weavers* remains one of Velázquez' most important works, contrasting sharply with the rest of his artistic production. For most of his life, Velàzquez, as painter to the Spanish court, was expected to deliver majestic renderings of the rulers of the day, while the present work shows wage-labourers at work. On the left is a whirring spinning wheel, on the right a turning reel of yarn. A bale of raw wool, the material processed here, hangs on the wall. The girl in the red skirt separates it with a comb; the woman with the white headscarf spins it to yarn on her wheel, while the worker wearing the white blouse winds the spun thread into a ball, which will later to be passed on to a weaver. In the background, at a higher level, is a different, brighter world. A figure in armour makes grand gestures, while opulently dressed ladies consider a tapestry. They are inspecting the luxurious product of the wool workers' labour.

The foreground and background of the painting evidently contain depictions of the two social strata between which Velázquez felt drawn. As an artist, he pursued the "menial" trade of a craftsman; but he also felt part of an aristocracy to whom all work was foreign, forbidden, indeed contemptible. It was a dichotomy, replete with tensions.

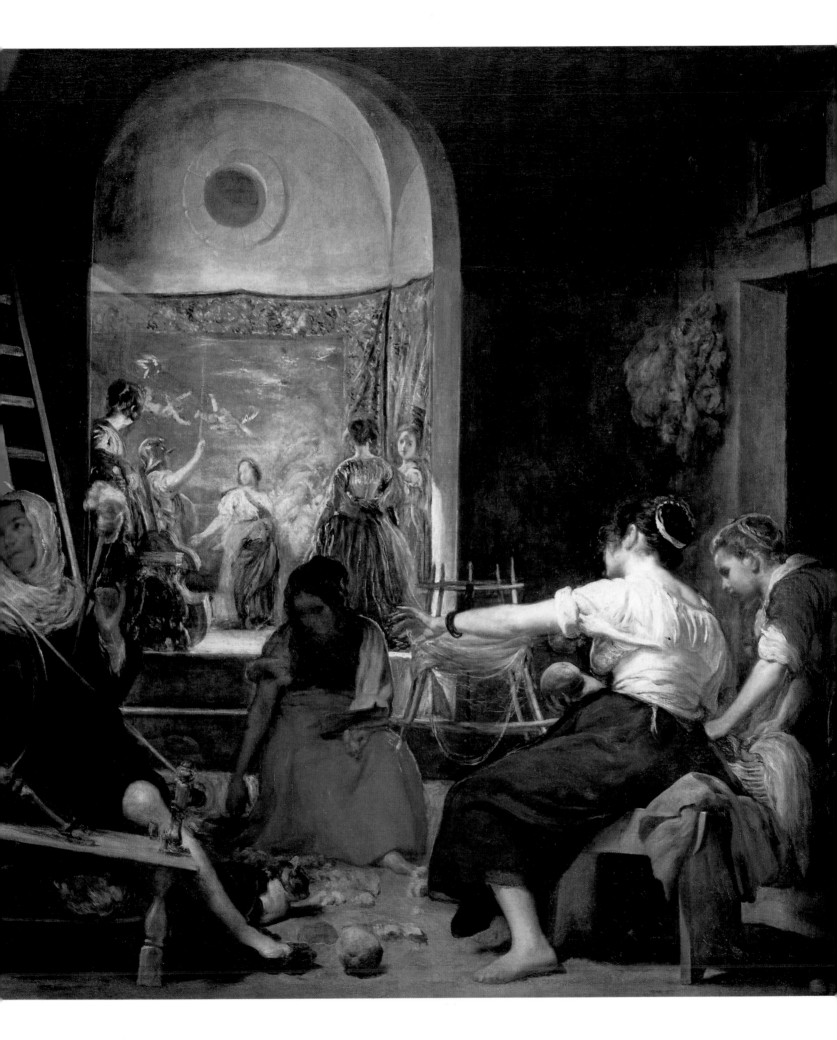

For centuries, the wool industry, with the support of the monarchy, had been an important pillar of the Spanish economy. Until the beginning of the 17th century, the rough highlands of Castile, where no cereal crops would grow, had provided pasture for some two million sheep. The wealth of towns such as Burgos, Salamanca and Toledo was based on the production and export of wool. However, the industry was eventually plunged into a serious crisis: between 1594 and 1746, several hundred textiles mills were forced to close in Toledo alone, leaving a mere 15 operative. As a result, the town lost half its inhabitants. During the same period, the number of households in Burgos, where most of the raw wool changed hands, sank from 2600 to 600.

A person who needs to work deserves contempt

The reason for the crisis was gold, shipped to Seville twice a year by Spanish ships, whose captains had discovered the Americas. Large quantities of money suddenly flowed into the country, only to flow out again equally quickly. For commodities that had once been produced in Spain were now bought abroad instead: Velázquez and his fellow citizens no longer dressed in Spanish cloth, but in textiles woven in Flanders or England. The "richest nation on earth" believed it could afford to import everything it needed, from cereals to sword blades, leaving all trade, together with the profits, in the hands of foreigners. Merchants arrived from France, Italy and the Netherlands; builders, smiths and tailors also came to Spain, taking over so-called "menial" tasks – mostly involving manual labour or money-making – which were looked down on by the indigenous population.

Most of Velázquez contemporaries preferred to work for a grandee, or do odd jobs, or even beg at church doors, rather than earn their livelihood with their hands. For, as a French traveller to Spain put it, the heads of the inhabitants of that country were "fuming with delusions of nobility ...". After all, their ancestors had defeated the Moors, conquered the Americas and fought for the Catholic Church against most of Europe. With such a heroic heritage, any Spaniard worth his salt saw himself as a conquistador or a knight, or, at the very least, a hidalgo. To be a hidalgo, a nobleman of the lowest class, was a matter of honour. A hidalgo did not work, nor did he pay direct taxes.

The clergy and nobility were exempted from countless taxes by which the king attempted to squeeze from his countrymen funds to finance wars in the interests of Spanish hegemony. However, since practically every inhabitant was a nobleman, very few taxpayers were left. Among the 3319 heads of household in Burgos in the year 1591, for example, there were 1722 hidalgos and 1023 clergymen, so that a mere 574 taxpayers made any sort of fiscal contribution at all. It was hardly surprising that the economy was stagnating and the Spanish Empire in decline.

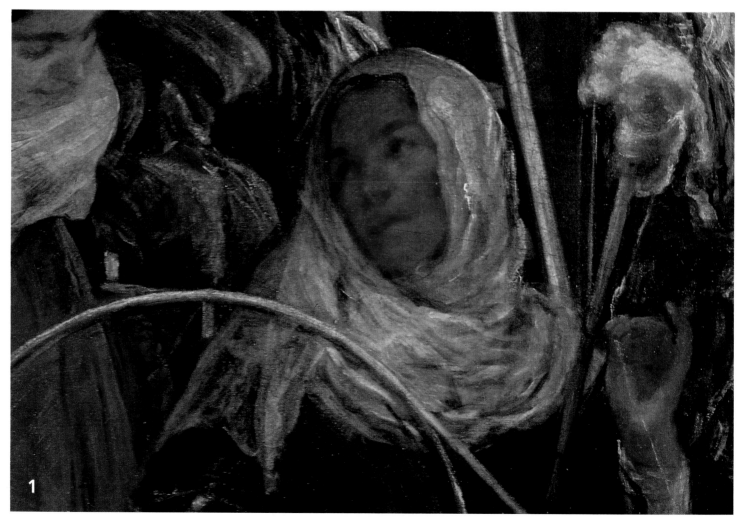

The importance of a career at court

Artists, too, were required to pay a tax: the Castilian "alcabala", a ten percent levy on all purchased goods. They fought against it bitterly, not because it deprived them of income, but because they felt it was demeaning to have the same fiscal status as potters and joiners.

"Painting is a liberal art; there is nothing slavish or craftlike about it", maintained the painter Francisco Pacheco, Velázquez's teacher and father-in-law. "It is more noble than sculpture, since it involves less physical labour. It is worthy of a hidalgo, and even kings do not spurn it."

Spanish artists were naturally prone to the prejudices and values of the class society in which they lived. Velázquez, born in Seville in 1599, was proud of his noble Portuguese extraction. However, nominated in 1658, at the height of his career, for the aristocratic title of Knight of the Order of Santiago by Philip IV, he was unable to prove his aristocratic ancestry beyond a few generations. He required (and was granted by Pope Alexander VII) official exemption from the obligation to prove his noblility.

Over a hundred witnesses were heard to establish whether the artist was worthy of the Order. For example, confirmation was required that he had never worked for a wage. One witness declared that painting came "as a talent to Velázquez, a gift, not as a trade or craft". He had never sold one of his works, painting solely for the enjoyment of His Majesty.

It is doubtful whether this can apply to the artist's youth in Seville. At that time Velázquez had chosen to paint quite ordinary folk, like the (later) weavers: a waterseller, or an old woman frying eggs in a kitchen. But at the age of 24 he entered a different, grander world: the Duke Olivares, one of the young king's ministers and favourites, introduced Velázquez to the court at Madrid. Here, over 1000 persons, their behaviour governed by the stiff court etiquette, orbited the godlike "Planet King". Velázquez did a portrait of the king which pleased him so much that he permitted only Velázquez to paint his portrait from then on.

2

Velázquez served the monarch for over 40 years. Two documents indicate the low status granted to the painter within the court hierarchy, whatever his value as an artist: "Like the king's barbor", the painter was to receive annually, besides his apartment and salary, "a suit of clothes to the value of 90 ducats". Together with the court fools and noblemen's lackeys he was given a seat in the fourth row whenever the court attended a bullfight. Velázquez could attain greater prestige in such a rigidly structured society only by applying, like other courtiers, for various official posts, though the work, which had little bearing on his work as an artist, prevented him from painting. He thus worked his way up through a series of appointments, such as Usher of the Chamber, Under-Chamberlain, and Assistant Curator of Royal Furniture.

It is therefore all the more astonishing that an artist so intent upon being seen as a nobleman should have painted *The Tapestry-Weavers*, one "of the oldest paintings of workers or factories" in art history, according to the art historian Carl Justi. In order to do so, he would almost certainly have had to obtain the permisson of Philip IV, himself an expert in artistic matters, who visited Velázquez nearly every day in his palace studio to watch him at work. For only the King could afford to abandon social prejudice to such an extent.

3

The revenge of the offended goddess

It was probably in the course of his work as Curator of Royal Furniture that the court painter Velázquez came into contact with spinners and weavers. Stored in the royal depots, besides furniture and paintings, were some 800 Flemish tapestries. From these the artist, aided by the Curator of Royal Tapestries, would choose the appropriate decoration for receptions held in the royal apartments. He would select tapestries with suitable themes, then pass them on to the Curator of Tapestries. The artist probably took charge of any necessary repairs, too, which were carried out in Madrid's carpet workshops. No carpets had been woven there for many years, and only mending work now took place. It was here, too, that Velázquez may have found his inspiration for *The Tapestry-Weavers*.

However, it is unlikely that the artist's sole intention was the realistic rendering of a working scene. His life was spent at a court where literary and scholarly allusions, as well as obscure codes, symbols and allegories, were highly fashionable. The riddle of the work known, since the 18th century, as *The Tapestry-Weavers* appears to have been solved in 1948, with the discovery by Spanish scholars that the painting, before entering the royal collection, probably belonged to Philip IV's Chief Equerry. It appears in his inventory of 1664 as *The Fable of Arachne*.

The young woman whose white arm is turning a reel of yarn is thus a mythical figure; her story is told by Ovid in the Sixth Book of his *Metamorphoses*. According to this account, the audacious Arachne challenged the goddess Pallas Athene, the inventor of the distaff, to a weaving competition. The goddess naturally won, and, to punish Arachne for her impudence, turned the young woman into a spider.

In the foreground of the painting Velázquez shows the young woman and the goddess at work. Pallas still wears her white veil: in order to enter the workshop she had disguised herself as an old woman, but her bare, youthful leg betrays her real identity. On the stage in the background she reappears victorious, now wearing her traditional armour, her hand raised to cast a spell over Arachne.

The double portrait of the goddess may have added, in the eyes of the artist's contemporaries who enjoyed discussing the relative significance of ranks and hierarchies, a further, allegorical dimension beyond that of the fable itself. In the lower half of the painting Pallas appears as the patron of embroiderers and weavers. At the higher level, in the background, four richly dressed ladies, possibly representing sculpture, architecture, painting and music (the latter with the attribute of the double bass) gather around the resplendent goddess. This is Pallas the tutelary goddess, whose sublime arts – which, with "nothing slavish" about them, are "worthy of the hidalgo" – triumph over a "menial" craft.

Homage to the Venetian master

Two putti can be distinguished in the tapestry at the back of the studio. They are shown against a cloud background above the sea, while on the right a pink veil floats skyward. The rest is hidden from view, but the subject would have been immediately familiar to a 17th-century connoisseur. For the tapestry is the reproduction of a famous and much-copied painting by Titian, in the Spanish royal family's possession since 1562: *The Rape of Europa*. Its theme was mythological, using an episode which also occurs in Ovid's version of the Arachne legend. Competing with Pallas, the young woman weaves a series of tapestries, the first of which shows the *Rape of Europa* by Zeus, disguised as a bull.

While cryptic allusions to hidden paintings complied with contemporary tastes in art, the reference in the present painting must also be seen as an act of homage by Velázquez to an admired Venetian master. Titian was the favourite painter of Charles V, Philip IV's great-grandfather, and several of his works hung in the latter's palace in Madrid. Velázquez made two extended journeys to Italy to study Titian's art and buy several of his paintings for the royal collection. He stayed there between 1629 and 1631, and from 1649 to 1651. This allowed him to escape the excruciating narrowness of the Spanish court, and to live unhampered by etiquette and hierarchy. In Italy he needed only to paint in order to gain recognition. He did not have to undergo the torments of a troublesome, time-consuming, appointment at court.

The Tapestry-Weavers was probably executed shortly before the artist's second journey to Italy. He was 47 years old at the time and still, after many years' service at court, the King's favourite. The monarch continued to forbid any other artist to paint his portrait, even when Velázquez was absent. His reputation as Spain's greatest painter was unchallenged, and his social standing improved, too. Since his appointment to the post of "Under-Chamberlain in Effective Service", which gave him the right to carry at his belt the black key to the royal apartment, he was no longer obliged to sit with the lackeys at

4

bullfights, but was given a more dignified position beside the Marshall of Ceremonies.

But there were other reasons to feel distressed. Like all court officials, Velázquez was a victim of the court's desperate financial plight. In 1648, shortly before his departure, he complained that he was still owed his salary for the years 1630 to 1634, as well as fees for paintings he had delivered between 1628 and 1640. But Philip IV and his country were bankrupt. The Spanish bid for European hegemony had failed; the enemy was ready to pounce, and the Spanish provinces were in a state of uproar. The situation was further exacerbated by the deaths of the Queen and the heir to the throne, making life in the monarch's immediate proximity doubly oppressive. It required the repeated and emphatic chiding of the King himself to induce Velázquez to return to Madrid from Italy. He returned to a palace where life was so dull that the poet Lope de Vega felt the figures on the palace tapestries, unable to escape, deserved the spectator's pity.

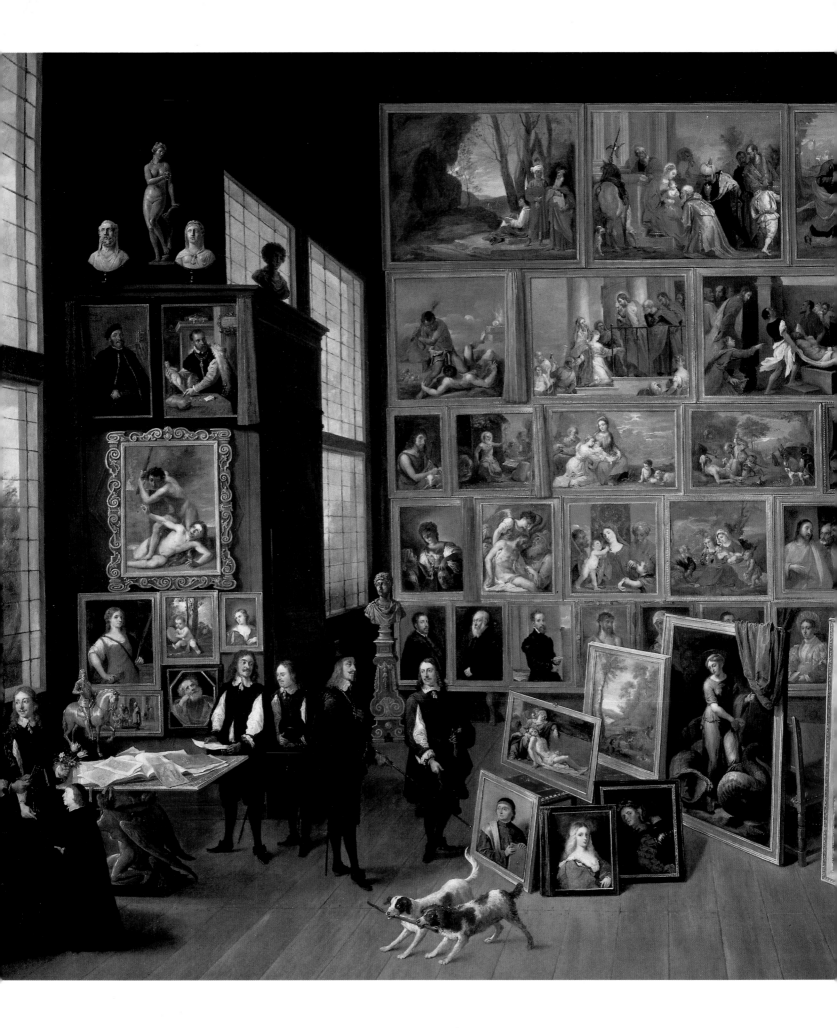

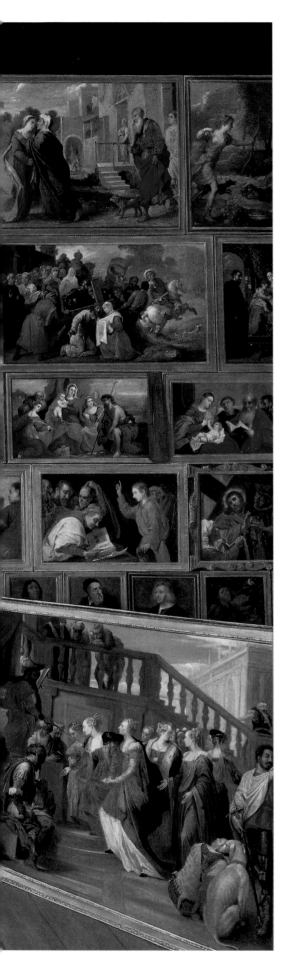

David Teniers the Younger: Archduke Leopold Wilhelm's Galleries at Brussels, c. 1650

The Governor's catalogue

Exactly 50 works are shown in this painting. Today, most of them can be seen in the Kunsthistorisches Museum, Vienna, but in 1650, when the painting was executed, they hung in the Brussels palace of Archduke Leopold Wilhelm, an Austrian Habsburg.

Teniers' work is an example of the so-called "gallery-painting", a genre first seen in the Netherlands c. 1600, and disappearing again approximately a century later. At that time the Netherlands were a great centre of arts and sciences. According to one admiring French traveller, the streets in the towns were wide and the gates of the wealthy burghers' houses decorated with beautiful sculptures, while the houses themselves were always home to "a large number of paintings".

Since paintings meant so much to the Netherlanders, they liked to have themselves portrayed with their personal collections. There was no more elegant manner of demonstrating wealth and taste, or showing friends in faraway places what they liked or had in their possession. The gallery-painting served as a "painted catalogue" of the owner's collection, as well as demonstrating his taste.

Archduke Leopold Wilhelm was not a Netherlandish burgher, however. As Governor of the Southern Provinces from 1647 to 1656 he lived at the palace of Coudenberg, near Brussels. His paintings filled three corridors of over twenty metres in length, as well as three rooms of the same length, each ten metres wide, one of which is shown here. In accordance with contemporary taste, the paintings are crowded together frame to frame, floor to ceiling.

Notions we might consider important today, such as allowing the individual painting a certain amount of space, or ensuring it has enough light, had no cur-

Where today's wealthy collector might ask an art historian to compile a lavish catalogue of his treasures, his 17th-century predecessor commissioned an artist to create a visual record of the paintings in his possession. The famous Flemish genre artist David Teniers the Younger, a skilful copyist, painted the galleries of the Habsburg Leopold Wilhelm, containing work by Italian masters such as Veronese, Giorgione and Titian. Teniers' painting, measuring 127 x 163 cm, is in the Kunsthistorisches Museum, Vienna.

rency then. Instead, it was the impression of abundance that counted. Paintings had to cover the entire wall, like wallpaper.

The Duke stands out as the only man wearing a hat. This was in keeping with Spanish etiquette. The Southern Provinces of the Netherlands belonged to the Spanish crown, and the Habsburg Leopold Wilhlm served as viceroy for the court at Madrid.

Leopold Wilhelm was born in 1614, the son of Emperor Ferdinand II. His exalted birth meant power and wealth, but not freedom. Just as a monk subordinated his actions and way of life to the greater glory of God, a Habsburg too was obliged to devote his life to serving the House of Habsburg. His father had determined that Leopold Wilhelm, his second in line, should take holy orders. Traditionally, the Habsburgs were great champions of the Catholic church, it was therefore only natural that a member of the family should enter its clergy. At the same time, a large part of the land and property of the "Holy Roman Empire" belonged to the church, and the incomes of the monasteries, con-

A bishop at the age of 11, a general at 25

vents, bishoprics and other institutions could be more easily made to serve family interests if one of its members sat at their head.

Thus Leopold Wilhelm was given the bishoprics of Passau and Strasbourg at the age of eleven, and was made Bishop of Halberstadt at the age of 14. When he was 25, however, his brother – Emperor Ferdinand III – appointed him Supreme Commander of the Habsburg army, sending him to participate in a struggle which history later referred to as the "Thirty Years War". With an experienced officer called Piccolomini at his side, his military career began with a number of successes in Bohemia, but he was soon defeated and removed from office. He retired to his bishopric in Passau, but was reinstated as Supreme Commander two years later, only to be replaced once again after another year. In 1647, Leopold Wilhelm left for the Netherlands, where he was to serve the interests of Madrid.

A year after his arrival in Brussels, the Peace of Westphalia, signed at Münster and Osnabrück, sanctioned the partition of the Netherlands. The new Governor was therefore no longer obliged to fight the Republicans and Protestants of the North.

However, it was his duty to ensure that the Southern Provinces at least remained Catholic, and loyal to the Spanish-Habsburg crown.

During the years he spent at Brussels, Leopold Wilhelm amassed one of the largest art collections in Europe. Buying and commissioning of works of art was a Habsburg tradition, Charles V and Philip II having employed the best artists of their day, the works of whom may still be viewed at the Prado. As for the Austrian Habsburgs, Rudolf II's mania for collecting was justly famous.

The personalities of sovereigns such as Charles, Philip and Rudolf have in common a feature apparently relating to their passionate interest in art: all three were reclusive, withdrawing whenever possible from the public stage. Charles V abdicated and entered the seclusion of a monastery; Philip sought the palatial solitude of his Escorial; Rudolf hid himself away in his castle at Prague, neglecting his official duties so badly that his brothers eventually had to depose him. Perhaps Leopold Wilhelm also withdrew to the relative privacy of his galleries, where his collection may have provided some refuge from the demands of war and politics.

The "antiquarius": painted by Titian, copied by Teniers

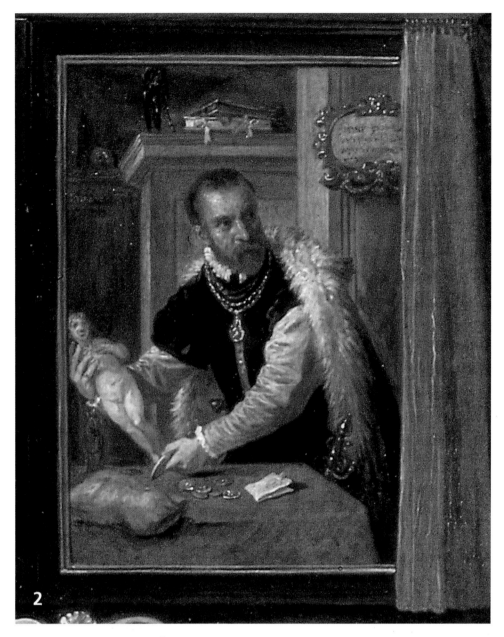

The collections of emperors, kings and dukes grew with the help of experts and go-betweens. One is portrayed in a painting in the painting: Jacopo de Strada of Mantua. The word "antiquarius", meaning an expert on Greekland Roman antiquity, is decipherable in a cartouche at the top right of the painting. Strada is portrayed exhibiting an antique statue of Venus, with a male torso on the table before him. Titian's original, also in the Kunsthistorisches Museum, is almost a metre in height, whereas Teniers' copy measures only 20 centimetres.

Titian's portrait dates from almost a century before Teniers' gallery-painting, a period in which collections tended to look somewhat different from that of Leopold Wilhelm. The maxims of the Renaissance were still largely in place; intense interest in the origins of European civilization and culture had led to a frenzied search for the remains of antiquity. Ancient manuscripts and statues fetched the highest prices. To purchase a Greek manuscript was considered as glorious a deed as successfully besieging a town, and was probably no less expensive.

Besides various testimonies to antiquity, objects bearing witness to superstition, as well as products of the new natural sciences attracted collectors. Thus the alleged jawbone of a sea-nymph would be found next to a tablet bearing a Greek inscription, or a deformed foetus, somehow preserved in a jar, consorted with a rung of the very ladder upon which Jacob was supposed to have seen angels ascending and descending. Between these: paintings by Raphael or Dürer. Leopold Wilhelm's uncle, Rudolf II, had, in Prague, possessed the most famous cabinet combining curiosities of the kind mentioned with works of art.

The Archduke was one of the first to oust such oddities from his art collection. He owned 542 sculptures alone, many antique or reproductions of antique works. Several are seen above the Strada portrait on a projecting structure resembling a cupboard in fact a small wooden vestibule.

Leopold Wilhelm's inventories present a reliable picture of the works in his possession. Besides the sculptures, there were 888 German and Netherlandish, and 517 Italian works. However, Teniers' painting includes only works by Italian masters, with one exception: a landscape, at floor level, by the Flemish aritst Paul Bril. Teniers made at least eight paintings of sections of the Archduke's galleries, each almost exclusively recording works by Italians: Titian, Giorgione, Veronese, Tintoretto and Raphael. Perhaps they were the owner's favourites; or perhaps it was in their illustrious company that he especially wanted to be seen.

His preference for the Italians might be put down to taste, possibly acquired in Madrid's remarkable galleries during his youth. Even if this were true, another reason is worth mentioning. The Archduke, as a member of the clergy and of the Habsburg family, was obliged to defend the Catholic faith. The Netherlandish iconoclasts of the north had rebelled against the opulent decoration of churches, and painting, since the Reformation, had anyway played a subordinate role in churches. For the Catholics, however, little had changed: a work of art was still considered an effective instrument of religious propaganda. Simple, but impressive works promulgated the Counter-Reformation and a glance at the wall of paintings in the present work confirms the Archduke's projection of himself as a champion of that movement: there is hardly a female nude to be seen, and, apart from the portraits, almost exclusively Biblical scenes are included, for example *The Lamentation of Christ*, *The Betrothal of St. Catherine* and *Christ among the Scribes*.

The king of England had no money

The two paintings shown at the top left were ascribed to Veronese and Giorgione, the three under them to Palma Giovane, Veronese and Pordenone, all of whom lived a century before Leopold Wilhelm. The route taken by these works before entering the archducal collection reflects something of the course of European history.

These works of art were from Venice. In the period when the paintings were executed, the Republic on the lagoon was still a powerful city, comparable, thanks to the accumulated wealth of the past, to a treasure trove. Not only the churches, but also private houses were replete with valuable paintings.

Following the discovery of America and the sea-route round the Cape of Good Hope to India, Venice had lost its leading position as the nodal point of all trade-routes, and the income of the Venetian merchants had sunk drastically as a result. The rich citizens were now living on their capital, and had begun to sell their property. The art collection of the deceased patrician Bartolomeo della Nave had been on the market since 1634.

Charles I, King of England, which by that time was an up-and-coming naval and colonial power, contracted to buy the entire collection. However, when the paintings finally arrived in crates at London in 1639, the monarch was unable to pay. Most of his money had flowed into curbing rebellions in Scotland and Ireland, and the Civil War against Cromwell had taken the rest.

The crates were delivered to the Marquess of Hamilton, who, sharing the fate of his friend Charles, was beheaded after the Civil War. Parliament confiscated the paintings. Eventually they were shipped to the Netherlands, besides all else the centre of the European art trade.

It is unlikely that paintings were produced in such numbers elsewhere and nowhere else did so many paintings change hands. Money was there in abundance, for towns like Antwerp and Amsterdam had now taken over the role once played by Venice on the Adriatic Sea, a harbour where all trade-routes had met.

The majority of paintings recorded here by Teniers were originally from the Bartolomeo della Nave collection, and the fact that they had found their way to Brussels by 1650 confirms a well-known rule of thumb: paintings follow money and power. This is also true of the later history of the archducal collection, for in 1656, Leopold Wilhelm returned to Vienna.

He took his paintings with him, eventually bequeathing them to the Emperor. They were to form the basis of the imperial collection which now may be seen at the Kunsthistorisches Museum.

Not all of the paintings remained in Vienna, however. Works of art were often given away as presents to retiring ministers of state, to viceroys, or family members. The Empress Maria Theresia was especially generous with art treasures which had accumulated in Vienna, and the present whereabouts of many of the works previously in the archducal collection recalls the erstwhile spread of the Austro-Hungarian Empire. For example, the *Raising of Lazarus* (at the bottom right of the detail above), by the Venetian Renaissance master Pordenone, is now at Prague, where the present gallery-painting also hung for many years. Several of the paintings brought to Brussels from Venice were later given by Maria Theresia to her governor in Transylvania, where they may be seen to this day in the Museum Brukenthal, Hermannstadt (Sibiu). An especially large group of paintings from the archducal collection found their way to the residential palace at Buda: 34 of them are now kept at the Museum of Fine Art, Budapest. The portrait of a young man by Giorgione, shown partly obscured in Teniers' painting (the fourth from the right in the row of portraits), can also be seen there.

Small copies of large pictures

Beside Leopold Wilhelm stands David Teniers the Younger (1614–1690), custodian of the Archduke's galleries. Teniers executed at least eight paintings of sections of the Archduke's collection. He also published a volume containing 244 copper engravings of the Italian paintings, entitled *Theatrum Pictorium*. The court painter and custodian of the archducal galleries copied the 244 paintings himself, at the same time reducing their format to that of the engravings. The engravers were therefore spared the task of working from the original paintings. Several of these small copies are exhibited at Vienna in the same room as the gallery-painting.

Examples of Teniers' genre painting, upon which his popularity during his own lifetime was founded, can be seen at the same museum. He is said to have painted some 100 alehouse scenes, as well as scenes of kitchens and stables, peasants in a barber's shop, soldiers in the guardroom. Realistic, everyday scenes of this kind contrasted sharply with the idealized works containing Biblical, antique or aristocractic motifs that were so greatly admired in the south of Europe. Louis XIV, on seeing a painting by Teniers, is said to have expressed his disgust with the words: "Otez-moi ces magots!" (Get rid of these eyesores!)

Leopold Wilhelm's opinion of Teniers and his northerly contemporaries differed from that of Louis, however; his collection contained over 800 paintings by German and Netherlandish artists, many of whose works, like those of Teniers, were genre paintings. The interest in everyday life as a subject of art, a reality undisguised by the veil of beauty, had grown in the Netherlands during the struggle against Spain. Religious subjects were the pendant to Spanish-Catholic rule, but genre painting was closer to a republican Protestant outlook. Leopold Wilhelm acquired both, but sat for the custodian of his gallery in the company of Italian paintings, for these alone corresponded to the spirit of his ecclesiastical and political mission.

Thus Teniers, with his Netherlandish devotion to realism in art, painted the Ital-

ian religious works of his patron. He does not forget to include the Archduke's dogs, and adds several figures, among whom only the dwarfish figure of Canon Johannes Antonius van der Baren can be identified. His name later became important to historians of art, not for the flower pieces he painted himelf, but because he compiled a list of paintings in the possession of the Archduke.

As in all his gallery-paintings, Teniers ventures more than the simple reproduction of a wall of paintings. As far as his instructions allow, he injects a certain dynamic into the composition, partly with the help of the figures, partly by including the paintings at floor level. The latter form a tangential line to the picture plane, rising diagonally to meet, in the far corner of the room, the confluent lines drawn by floor and external wall. The composition thus suggests an uneven triangle, distracting from the oppressive symetry of the wall of pictures.

Critical opinion today does not rank Teniers among the most original Netherlandish artists of his century, artists like Rubens or Rembrandt. He was outstanding only in the skill with which he made copies, and in the speed at which he worked. His many genre paintings, too, follow well-trodden paths.

However, his ability to copy paintings at such speed put him in a position to benefit from a a genre that became highly popular in the Netherlands during his lifetime: the gallery-painting. His vistas of the archducal collection made him famous, and his work is shown today in several large museums, including Brussels, Munich and Madrid, as well as Vienna.

Charles Le Brun: The Chancellor Séguier, after 1660

A careerist bathes in the Sun King's radiance

The aged Chancellor, shown on horseback with an entourage of young, fleet-footed pages, cuts a dignified figure. In stiff robes of gold brocade, Pierre Séguier, Duke of Villemor, has all the makings of an idol or a Chinese mandarin. In fact, his swagger was the official pose of the Lord Chief Justice of France and head of that country's civil service in the mid-17th century; above all else, the grandeur of the portrait by Charles Le Brun (1619–1690) shows how Séguier wished the world to see him. The painting, measuring 2.95 by 3.57 metres, hangs in the Louvre, Paris.

Two violet silk parasols sway above Séguier's head. Conspicuous insignia of his rank, these also provided welcome protection against the scorching sun under whose burning heat Paris sweltered on that 26th August 1660. Indeed, so great was the heat, according to one contemporary chronicler, that the Chancellor, contrary to official protocol, was obliged to allow his entourage to don their hats now and then. The representatives of the state chancellory were participating in a procession that moved gradually through a Paris decorated with triumphal arches and obelisks, while at His Majesty Louis XIV's side, his newly-wed wife Maria Theresia celebrated her entry to the capital.

The 21-year-old French monarch and the daughter of Philip IV, King of Spain, had been married shortly before in a town at the border. The purpose of the match was to seal the peace between the two states. France had emerged victorious from the struggle for European hegemony which had marred relations between the two countries for almost 30 years, but it had emerged almost as exhausted as the vanquished Spain.

Before Louis XIV came of age, the nobility and parliament had endeavoured to augment their respective power at the cost of the monarchy, plunging the country into civil war in the process. France was bankrupt; there was a depression; the population had been decimated by invading armies, famine and epidemics were rampant. It was time for a change.

The orderly procession was intended as a sign to the cheering Parisians that a new epoch of peace and glory had dawned. It was led by the retinue of His Eminence, the all-powerful minister, Cardinal Mazarin, who had arranged the peace treaty and wedding. Next came the royal household and then the royal stables. Following them, in fourth place, came the representatives of the chancellory. Besides Séguier himself, counsellors, treasurers and secretaries, as well as those at the bottom of the hierarchy, the beadles and court ushers, all took part in the procession. Their appearance is captured in an ironic description of the event by Jean de la Fontaine, written in rhyming verse:

"The sires of Council a splendid sight, in their midst was the Chancellor, a pillar of might, dressed from his head to his toe in brocade, while his retinue made the splendid parade …"

The parade was an impressive testimony to the power of a healthy monarchy. It was one of the first great manifestations of this kind to take place under the auspices of the young king. Louis XIV soon proved a master of the art of using pomp and circumstance for propagandistic purposes, in the service of absolutism as well as his own fame.

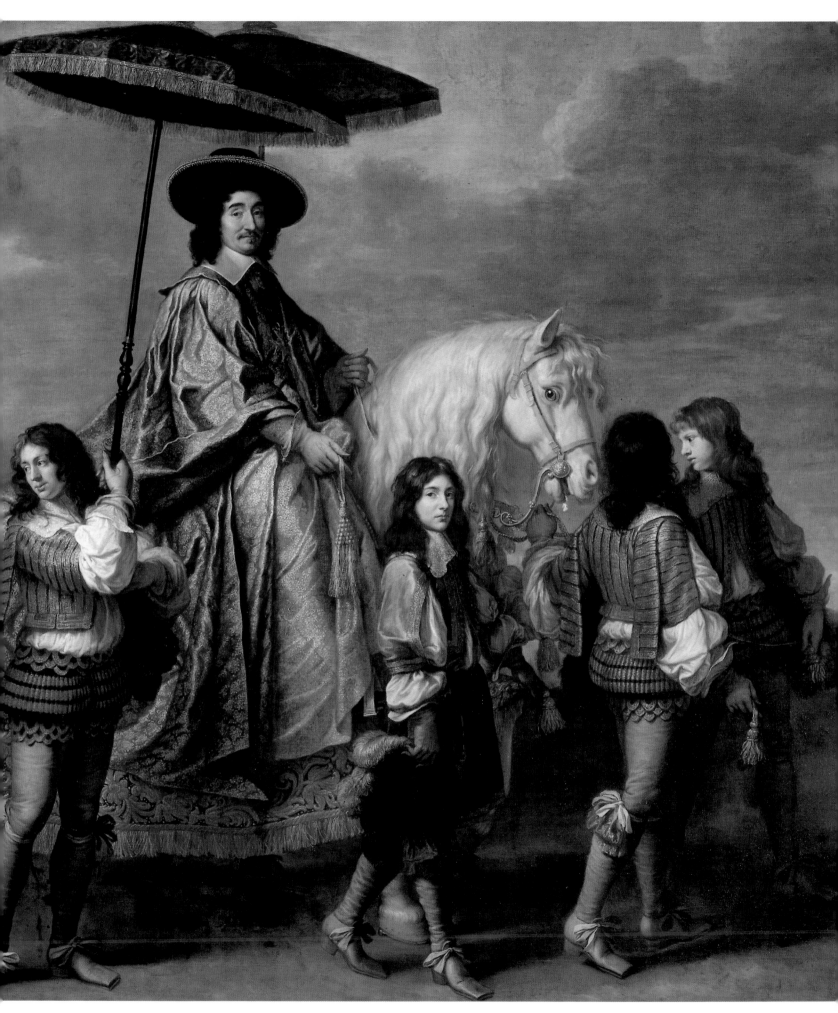

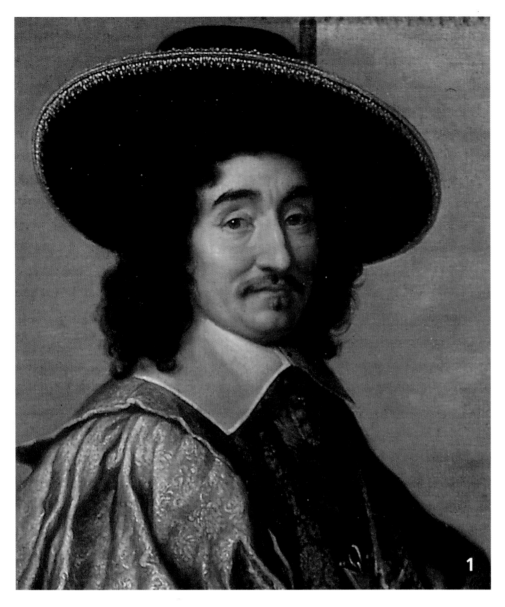

1

From burgher to duke

The Chancellor takes obvious pleasure in his appearance on this occasion. According to the anecdotal "Histories" of the writer and worst gossip of the 17th century Tallemant des Réaux, he was "greedy for glory", avaricious, and "driven by such extraordinary vanity that he was incapable of raising his hat to another person." Nobody attached quite so much importance as he did to "external appearances …, and he could hardly walk two feet without calling for his lackeys and an armed guard." Like most of his contemporaries, Tallemant was not particulary fond of the Chancellor.

Séguier, who held his exalted office for 37 years and exercised power ruthlessly, was one of the most hated men in France. In 1648, while civil war raged in Paris, he was obliged to hide from the people, who "wanted to tear him to pieces", in the lavatory of a private house until troops came to his rescue. The Marquise de Sévigné, famed for her correspondence, likened the Chancellor to the spiteful figure of Tartuffe, the hero of a comedy by Molière, first performed in 1664. It was not until 1672 when Séguier, with due composure, died the edifying death of "a great man" that the lady felt bound to remember his more positive qualities: piety, wit, a talent for oratory, and a remarkably good memory.

Séguier was undoubtedly an unusually gifted lawyer and administrator, abilities which rendered his services indispensible to two prime ministers in succession. As their "most loyal lackey", as Tallemant contemptuously put it, "a man who could swallow anything", he served Cardinals Richelieu and Mazarin, who ruled France under Louis XIII and during Louis XIV's youth.

Like many 17th-century politicians, the Chancellor was from a bourgeois background. His family came from Parisian merchant stock and had slowly climbed their way up the administrative ladder by marrying into the right circles and using their money to buy profitable public positions. It was quite normal at the time for public offices to be bought and sold; such posts were seen as a form of capital investment, offering their owners both income and independence: civil servants could be neither transferred nor dismissed.

The Séguiers supported each other wherever they could. In 1612 one of his relations lent Pierre, born in 1588 and made an orphan early in life, 56,000 livres for the purchase of his first public office. He became Counsellor of Justice to the Parisian parliament. Then, using the dowry of his wife, the daughter of a wealthy army treasurer, who brought 80,000 livres into their marriage, he purchased the office of President of the Parliament for the bargain sum of 120,000 livres. This allowed the career-minded public servant to recommend himself to Cardinal Richelieu by steering various political trials in an opportune direction. Having caught the minister's attention, Séguier rose rapidly in rank and position from then on.

In 1634 Séguier's daughter was married to Richelieu's nephew. To be connected with the house of such a powerful man brought advantage and honour, but it also meant the ambitious burgher was obliged to provide a dowry of 500,000 livres, an enormous sum of money. In the following year he was made Chancellor – a non-purchasable office – and remained so until his death. He survived, practically without damage to position or person, both the transition into Mazarin's service following Richelieu's death in 1642, and the confusion of the civil wars. In 1650 he was made Duke of Villemor. By his death in 1672 Pierre Séguier had amassed a fortune of over four million livres.

But the apotheosis of Séguier's career had come in 1639/40 when Richelieu, investing him with the power of a viceroy, sent him to Normandy at the head of a punitive force whose task was to subdue the revolt of the so-called "nu-pieds" – poverty-stricken rebels who went barefoot – against the war-tax. Suppressing the uprising with unprecedented ruthlessness, the Chancellor entered the conquered town of Rouen in triumph, sourrounded

by his generals and saluted by cannon. This time he was not part of another's entourage, but the most celebrated figure present.

Entering Paris with the royal couple, Chancellor Séguier was preceeded by a magnificent steed sporting a feather head-dress and decked with a lilac silk shabraque embroidered with lilies. The horse was unmounted and carried on its back a gold-plated casket containing the French seal of state, the instrument of Séguier's power. Four "chauffe-cires" (wax-warmers) held silk cords to steady the casket. Their work, heating the wax and applying the seal, could apparently be done only by illiterate nobles. This was thought to prevent abuse of their office.

Drawn in ink and red chalk, the scene is one of 14 drawings in Stockholm which, laid out in series, show the entire chancellory department of the procession. They include a portrayal of Séguier's immediate group that is identical to the group in Le Brun's painting. The drawing mentions by name several of the counsellors and secretaries in the Chancellor's company. The same names are recorded in lists, dating from the period, of chancellory employees.

The seal of state on a magnificent steed

The drawings probably formed part of a project commissioned by the Chancellor and carried out by one of Le Brun's collaborators. A display of chancellory personnel with its dignitaries dressed in the pomp of office must have been a welcome prospect to the vain Séguier, with all his concern for external appearances. Whether the sketches were intended as preliminary studies for a series of prints or oil paintings is unknown. Only the Séguier group found its way onto canvas.

It was the Chancellor's solemn duty twice a week to preside over the application of the seal – given such lavish pride of place in the drawing – to royal correspondence, decrees and documents. Without the seal, sentences, pardons and elevations to noble rank remained null and void.

If necessary, the Chancellor could refuse to apply the seal, for he was answerable only to the king, who, in person, had appointed him for life. He combined the functions of a viceroy and Chief Justice, and as head of the civil service he also had various executive powers. However, his main function was as the king's official spokesman.

"I have come to bestow my good will upon the parliament. The Chancellor will tell you everything else." Thus Louis XIV's dignified utterance on the occasion of his first political appearance in 1643, following the death of his father. He was four years old.

Séguier, together with the queen-mother and Mazarin, held a seat in the regency council. He occasionally took a personal interest in the infant king's upbringing. "My Lord the Chancellor was here", writes one courtier in his memoirs of 1651, "to see the king at his studies. He was highly satisfied and exhorted the king to continue." Ten years later, Séguier's condescension towards the king would have been considered quite inappropriate. The day after Mazarin's death, the king, though previously so submissive, threw off the shackles of patronage. On 10th March 1661 at seven o'clock in the morning, according to one report, he called for his ministers and addressed the Chancellor in a tone worthy of a man who was "Lord over himself and all the universe": "My Lords, I have asked you to assemble here to let you know that … the time has now come for me to govern my own affairs. You shall come to my aid with your council should I require it … I demand of you, indeed I order you, Lord Chancellor, to put my seal on nothing, and to do nothing in my name, until we have spoken of the same, but to act solely at my command."

The old Chancellor continued to serve the young king for several years before his death. On his deathbed, he asked his confessor to convey his undiminished loyalty to Louis XIV and had his seal returned to the king: it was Séguier's last official act.

The elegantly poised figure in shining white linen holding the parasol is said to be Le Brun's self-portrait. Showing himself in the Chancellor's company was realistic enough; the son of a Parisian sculptor, he had enjoyed Séguier's patronage since his childhood. The arts and sciences not only fell under Séguier's official brief, he was also a patron of the arts in his own right – hoping, no doubt, to "have his praises sung", griped Tallemant.

The Chancellor had become acquainted with the talented young lad in 1631 or 1634, at an early stage in the latter's career. He provided lodgings for him at his town palace, where he had also set aside a num-

Artist with a parasol

ber of stipends for writers. He sent Le Brun to study under well-known masters and was soon able to show his work at court: a drawing, executed in 1638, celebrating Louis XIV's birth, and an allegory dedicated to Cardinal Richelieu. For his patron, the young artist painted mostly altarpieces and portraits. In 1642 Séguier sent him to Rome, equipped with letters of recommendation, expenses and a commission to make copies of Raphael's works.

Three years later, defying the orders of his patron, Le Brun returned to France. He had shown signs of insubordination before, during the years of his apprenticeship in Paris. However, once back in Paris he remained obedient, gradually adapting his personality to the dictates of an era in love with order, in which artists were re-

quired to show discipline and good manners.

Le Brun led an exemplary life. He was pious and diligent, showing little sign of passion, and none of vice. Women (other than his wife) had no place in his life or work, to which he dedicated himself assiduously. His career was favoured by the timely death of two important painters and rivals: Simon Vouet (1590–1649) and Eustache Le Sueur (1617–1655). As soon as the Sun King climbed the throne, they left the stage to Le Brun without a struggle.

Le Brun had caught the monarch's attention through his work on the palace of the Minister of Finance, Fouquet, at Vaux. The artist was responsible for the entire decorations there, from frescos to fountains in the park and displays of fireworks on festive occasions. Louis ordered the artist to paint a scene for him from the life of Alexander the Great. Le Brun executed the large heroic work to the full satisfaction of the monarch, painting it in front of his very eyes. From that time ownwards he enjoyed the king's favour and worked to spread his sovereign's fame.

However, Le Brun did not forget Séguier, his first patron. Though the exact date of his portrait of Séguier entering Paris is unknown, Le Brun designed, following the Chancellor's death in 1672, the decorations for a church in which Parisian artists held a memorial mass in the Chancellor's honour. Madame de Sévigné was present, and reported as follows: "The mausoleum was as high as the dome itself, decorated with a thousand candles and several statues made up to honour the man … with the insignia of his high rank … the judge's cap, ducal coronet and order … They really were the most beautiful decorations imaginable."

If Pierre Séguier really did attach so much importance to having "his praises sung", then he could not have done better than invest in Charles Le Brun.

Fashion as royal propaganda

To "lend distinction to the highest ranking courtiers", according to the philospher Voltaire (1694–1778), Louis XIV personally designed "a blue

3

doublet, embroidered with gold and silver. To be invited to wear this piece of clothing was considered a great honour, an occasion for pride, and it was as highly coveted as an order on a chain."

Elements of fashion such as patterns and colours, especially gold, assumed a special value under the influence of the young monarch. To help establish his absolute authority as the Sun King, he subordinated all style, form and design, as well as politics and etiquette, to the interests of his personal propaganda.

Le Brun soon emerged as the dominant figure among the group of artists employed by the king. He brought discipline to the art world, turning the Academy of Fine Art, previously little more than a loose association of artists, into a tightly-knit state organization. The Academy assumed a monopoly over the teaching of art; it awarded stipends, prizes and state commissions, imposing strict stylistic orthodoxy. Art, shown to be reducible to a universally ap-

plicable set of precepts, was required to subject itself to a doctrine of clarity and rationality explicit in the rules of French Classicism. For twenty years, Le Brun, the chancellor of the Academy, kept a dictatorial eye over the strict observance of these rules.

Le Brun was also responsible for establishing norms for the mass-production of artworks and artefacts. Under his direction, 50 painters and 700 craftsmen worked at the Royal Gobelin Factory, which opened in 1663. Here, not only tapestries, but frescos, wood panelling, furniture, vases, locks and coaches were made to Le Brun's design. Produced to the highest standards and showing excellent taste, these artefacts were intended for Versailles and for export. Le Brun was the arbiter of taste in all matters of art, design and cultural management; he created Louis XIV's official court style, which, like the French language and French fashions, quickly spread to the rest of Europe.

All this left Le Brun with little time for

his own painting. His great masterpiece, the decoration of Versailles – he also influenced the architecture of the palace and gardens – proved ephemeral. He was forced to stand by and watch as furniture and vases of silver and gold which he had designed were melted down to provide funds for Louis' wars. The unique synthesis of art and design that was Versailles may have existed to perfection only at such moments when, paying homage to the "Roi Soleil", courtiers perambulated in the galleries to the music of Jean-Baptiste Lully. Le Brun, who had devoted his life to his sovereign's fame, was permitted, upon his elevation to the nobility, to include Louis XIV's personal emblem in his coat-of-arms: a resplendent, golden sun.

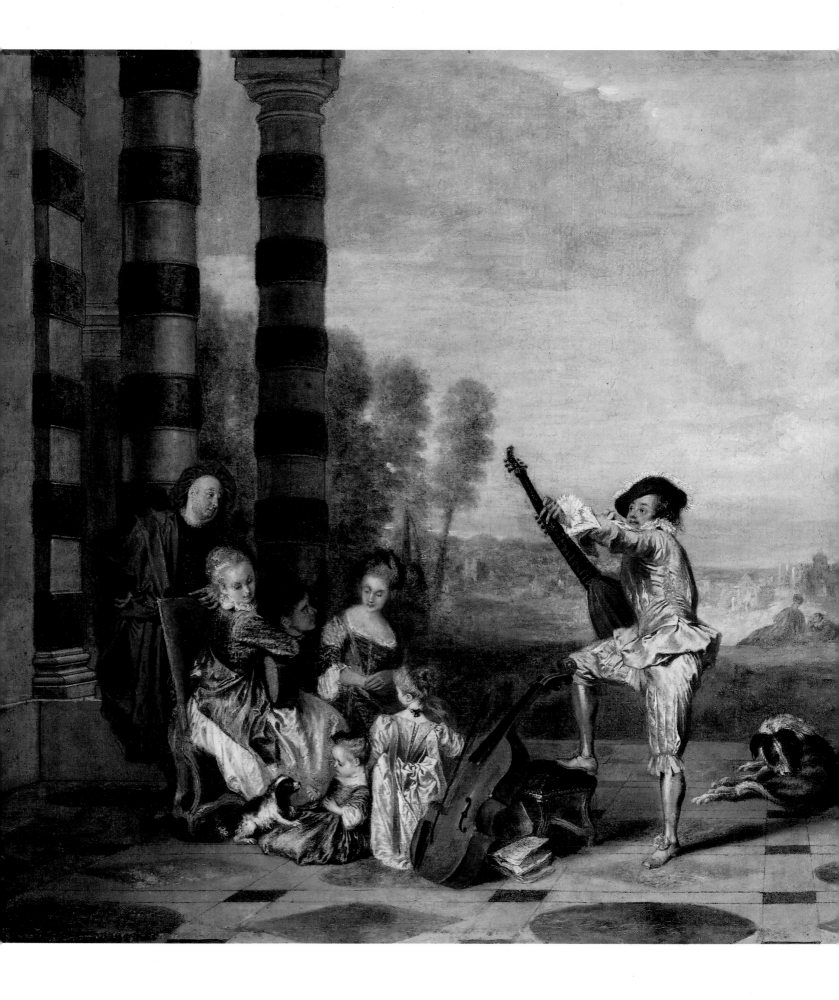

Antoine Watteau: The Music-Party, c. 1718

Cultivated leisure, music and champagne

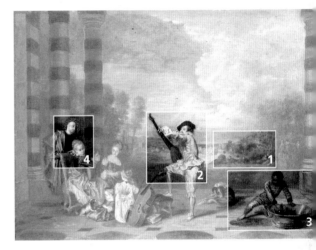

A small company of friends gathers to make music on a parkland terrace. Between dogs and children at play a pleasant conversation unfolds while instruments are tuned. The park in the background is an invitation to stroll. The scene, painted c. 1718, shows Antoine Watteau's rendering of one of the more popular "innocent pleasures" of the age. Among such pleasures, a contemporary listed the "joys of dining, music and the gaming-table, conversation, reading and walking".

To enhance the "joys of dining", a "Moorish boy" cools champagne, which, patronized by the highest in the land, had lately become a highly fashionable drink. Duke Philip of Orleans was known to drink this sparkling wine in large quantities at his "petits soupers". Philip was Regent, governing France between 1715 and 1723 during the minority of his grand-nephew, the future King Louis XV. During this short era, which coincided with Watteau's most productive period, the Duke brought change not only to the worlds of fashion and taste, but to politics as well.

In the twenty years prior to his death, Louis XIV, known as the Sun King, had kept France almost constantly at war. The Regent, by contrast, signed peace treaties, paid off crushing state debts and encouraged industry and commerce. While 20 million French breathed a sigh of relief, no longer victim to the worst deprivation – 1709 had been a year of starvation in Paris – a small, privileged minority scented the chance to live life to the full. And they grasped it with both hands.

Under Louis XIV, political expediency and religious orthodoxy had been felt as crushing burdens, stifling all individuality. The ideals of a French "classical epoch", promulgated in church by Bishop Bossuet and on stage by the poets Racine and Corneille, were discipline and self-denial, the

sacrifice of self-fulfilment to the higher principle of public order and well-being. The affected piety of an ageing king had made matters worse. All in all, it was hardly surprising that France slaked its thirst for pleasure and luxury the moment the king died.

Christianity and stoicism were set aside for more worldy philosphies. In the tradition of the Epicureans, the "Régence" devoted itself to the ideal of sensual delight: "the art of sensual refinement, heightened by feelings of virtue", according to Rémond de St. Mard's definition in the Parisian magazine Mercure in 1719. The son of a wealthy financier, Rémond de St. Mard was one of the few privileged enough to devote themselves to the pursuit of this art. The "hedonists" went further, demanding a right to individual happiness, which the Encyclopaedists of the second half of the 18th century described as "a contemplative state, bejewelled here and there with the brighter tones of pleasure". Happiness and sensual pleasure are also the subject of Watteau's painting, which, measuring 69 x 93 cm, is now in the possession of the Wallace Collection, London.

The small chateau on whose terrace the musicians have gathered belonged to a wealthy banker. It was called Montmorency and had a vestibule, or roofed, columned forecourt, with a panoramic prospect of the surrounding park and countryside. Its owner, Pierre Crozat (1665–1740), nicknamed ironically "the pauper", was one of the richest men in France. He used his wealth to collect Old Masters and support young artists. In 1718 Watteau lived at Crozat's palatial home in Paris. He undoubtedly made frequent visits to Montmorency and was able to observe and paint the life of the townsfolk at their country retreat.

Though for many centuries a privilege of the aristocracy, ownership of large areas of land now began to appeal to members of the ascendant bourgeoisie. The privileges of the latter did not accrue to them by birth, but were won through business acumen and the pursuit of profit. Developments, set in motion under the Sun King, had accelerated during the regency. Paradoxically, country life had became fashionable just as Paris started to enjoy a boom. In 1715, accompanied by the nobility and

Townsfolk in the country

royal household, the Regent, who hated Versailles, had returned to Paris. "All the French love Paris more than anything", noted his mother, the German Elizabeth Charlotte of the Palatinate, although it was, in her opinion, "a dreadful place. It stinks … People just piss on the street; it's intolerable." Whoever could afford it therefore had good reason to flee to the country – although few strayed far, for it was important to remain within easy reach of the centre. Montmorency was situated some 15 miles from Paris, and Crozat's coaches took only two hours to transport the banker and his guests to its theatres and salons.

Though the townsfolk were undoubtedly drawn to the clean air and the pleasant countryside, they also sought the ease and unbuttoned informality of a new philosophy of life. Far from codes of behaviour which constrained life in every class of society, far from the strictures of etiquette and obsession with external appearances which dominated their own class, they were able to converse with their friends from morning until night, reclining on the mead with them if they so wished, or strolling in the park. Walking no longer meant the stiffness of a promenade "à la Roi Soleil" in the garden at Versailles, between geometrically

arranged flower-beds and closely-cropped box-hedges. Nature was gradually unshackled. In Watteau's day and age, the Jardin du Luxembourg, the most popular Paris park, was said to be "crude and unkempt", with the trees' skyward growth and uncut hedges' spread unhindered.

The demand that a "garden should owe more to Nature than to art" was entirely new ("The Theory and Practice of Gardening", Paris, 1707). This was the era of the English landscape garden, with its lawns, copses and hillocks, a style possibly seen by Watteau at one of the properties owned by his rich, anglophile patron. For it was in this type of landscape – natural scenery, undoubtedly "unkempt" by contemporary standards, but nevertheless pleasant, and constructed solely for human enjoyment – that he chose to situate his amorous couples and musicking friends.

It was Watteau's landscape painting, more than anything else, which found the admiration of his contemporaries. These paintings captured all that was modern about the era in which he lived: its new relationship to Nature, the new ideal in landscape. An anonymous portrait of the artist as a young man contains an admiring text declaring that Watteau was always *si nouveau*: so new.

A difficult instrument to play

In his *Life of Antoine Watteau, Painter of Figures and Landscapes*, published in 1748, Count du Caylus, describing his deceased friend, writes: "He may have received little or no education, but he had a finely attuned ear and a highly discriminating taste in music." Watteau painted his musical instruments with such precision that experts can even identify their manufacturers.

At the centre of his *Music-Party* Watteau painted a theorbo. This lute was so difficult to tune and play that it was neglected almost to the point of extinction even in Watteau's day. Amateur players could hope to learn little more than the easiest of accompaniments and simplest of tunes. In professional music it had long been used to supply the *basso continuo*, or thorough-bass. However, the last composition for the theorbo was published in Paris in 1716, and by 1732, "no more than three or four venerable old gentlemen" could play the instrument. New instruments, such as the violoncello and harpsichord, were imported from Italy. The thorough-bass passed to the cello, and to the harpsichord. Though Watteau is said to have decorated the latter instrument, it did not appear in any of his paintings; it would not have been played at one of his outdoor concerts anyway.

Many of his works show musicians, thus reflecting one of the favourite pastimes of the era: "They are all learning to play music", wrote Elizabeth Charlotte of the Palatinate, "it's the latest rage, followed by all young people of quality, whether male or female."

What did they play? Music by the Italian composers Albinoni, Stradella and Scarlatti – works demanding smaller, more intimate ensembles – predominated in the music library of Watteau's patron, Pierre Crozat. Together with church music and opera, chamber music, a new form, enjoyed increasing popularity among progessive, or "modern", circles in Paris. "Sonatas and cantatas", wrote the *Mercure* in 1713, "are spreading like mushrooms". Watteau's choice of instruments – theorbo, guitar and violoncello, to which a voice

would be added – suggests that the musicians gathered on the terrace were preparing a cantata.

Once a month, a mixed society would meet to listen to chamber music at the salon of the wealthy bourgeois Crozat. The Venetian painter, Rosalba Carriera, visiting Paris at the time, gave an account of one such concert. The Regent appeared in person – for not only were the Crozat brothers' services useful to him for various credit transactions, but, like his hosts, he loved Italian music, and indeed is said to have composed an opera himself. The painter Watteau was also present, back from several months in England. Famous soloists, like the Italian castrato Antonio Paccini, performed alongside amateurs – the niece of the painter La Fosse taking a voice part, the papal internuncio plucking the theorbo.

Watteau's painting probably shows a group of amateurs. Making music was also a favourite pastime for those who chose to sojourn in the country, for country life "is made for love", while "music" itself, so it was said, was "the agent of love". Music served as a pretext for advances, and music gave expression to things one had not yet found the opportunity, or courage, to express.

The group appears to be waiting for the theorbist to tune his instrument – a long and complicated business. It is possible that the artist intended an erotic innuendo: to Watteau's contemporaries, versed in the erotic symbolism of their time, the instrument would have suggested an allusion to the female body, played by her lover's hands. A chateau in the country provided its guests not only with terraces, salons and dining-rooms, but discreet alcoves.

To have a "Moorish" boy, dressed all in silks and velvets, was one of the more luxurious fashions of the 18th century. He might be seen holding the train of a duchess, or cooling a banker's bottles, and always, he invited onlookers to ponder on the great wide world, and on the riches of the French colonies. Among these were Guadaloupe and Martinique in the Antilles, whose rising importance in economic terms brought fat profits to merchants and shipowners like the Crozats. They bought black slaves in Africa and exchanged them for exotic goods in the Antilles, where the slaves were exploited in the sugar plantations. A royal edict of 1716 accorded to "all merchants of the realm" the right "to trade freely with negroes". An attractive "Moorish boy" was a "colonial luxury" as coveted as the chocolate which he served his mistress at bedtime. Because – so the rumour went – the Marquise de Coëtlogon

Luxury goods from the colonies

had drunk too much of this dangerous new beverage during pregnancy, she gave birth to a son "as black as the devil".

Trade with new luxury goods such as sugar, coffee, tabacco, tea and chocolate was encouraged by the highest authority in the land, partly for economic reasons, partly also because the Regent had developed a taste for luxury goods himself, a taste that extended to the sparkling wine which vintners in Champagne had recently begun to produce by secondary fermentation. "The wine from Rheims is at its best drunk chilled with ice", according to one contemporary source. "That prickling sensation which tickles the nose and can raise the dead to life" helped the Regent back on his feet for an evening's entertainment after working a twelve-hour day. He liked even to add champagne to the sauces he prepared for his friends. He wanted his dishes to taste simple and yet highly refined. It was an era that witnessed the birth of what is generally referred to as "French cuisine". Whoever could afford to do so ate – judged by today's standards – enormous quantities, whether of the traditional fare or the latest culinary

inventions. The richest gorged themselves regularly at the most astounding orgies of drunkenness and gluttony. The Regent himself would drink six or seven bottles of champagne every evening. His mother, Elizabeth Charlotte of the Palatinate, writing in 1719, commented: "The great fashion in Paris is presently for ladies and men in equal part to drink overmuch and engage in all sorts of ignoble and disorderly activities."

There is no mention here of those "innocent pleasures" whose enjoyment with "refinement" and "feelings of virtue" the *Mercure* of that year had encouraged. Elizabeth Charlotte compares Paris to Sodom and Gomorrah, and indeed, the excesses of the French upper classes were to have dire consequences during the Revolution of 1789, when the people gave short shrift to the privileged strata. "Luxury and over-refinement in a state", warned the 17th century Duc de La Rochefoucauld, "are a sure sign of its decadence, for individuals can only serve themselves to such an extreme by neglecting the common weal."

3

A painter of the avant-garde

Watteau's figures are never seen eating; his paintings rarely show filled champagne glasses or bottles. He portrayed reality only to the extent that it corresponded to the ideals of his age. He painted cultivated ladies and gentlemen who were beyond the slightest suspicion of excess participating in so-called *fêtes galantes*, a thematic innovation which, in 1717, having rapidly gained recognition as a new genre, won him a place in the Academy. Watteau, finally successful after the hard years of his early career, now lived in a world of luxury, far from that of his upbringing. He had been born in 1684 at Valenciennes, the son of a master tiler.

In late 1717, Watteau stayed at the Parisian palace of the banker Crozat; a year later he was sharing living quarters with the painter Nicolas Vleughels, who, like Watteau, hailed from the north of France. Unlike Watteau, however, Vleughels had already travelled to Italy; he was later appointed Director of the French Academy at Rome. Watteau shows him biding his time, leaning against a column in his red coat and beret, a costume his spectators would have thought old-fahioned even in those days. Watteau is said to have owned a collection of theatrical costumes in which he dressed his models. The silk suit and white ruff were articles in regular use at the Italian theatre – but it is hard to imagine the papal internuncio who played the theorbo at Crozat's house-concerts allowing himself to be seen in such a "get-up".

Besides other artists, Watteau's acquaintances included the journalist Antoine de La Roque, who took over editorship of *Mercure* in 1724, Count du Caylus, who painted nudes with him and later wrote his obituary, as well as art dealers and the wealthy collectors of the bourgeoisie. Among the latter was the glass dealer Sirois, the first to buy a painting by Watteau, and the paint manufacturer Glucq, who is known to have owned *The Music-Party* in 1720.

Crozat himself does not seem to have owned paintings by Watteau, although he had his dining room decorated by the artist. "Of all our artists", he wrote to Rosalba Carriera in 1716, "I consider solely M. Va-

teau capable of creating something that you would value." Crozat gave the painter the freedom of his house, offering him every opportunity to study his art collection and become acquainted with the revels of the upper class – those "joys of dining, music and the gaming-table, conversation, reading and walking".

To what extent did Watteau himself partake in such revelling? Was he capable of excess? He is said to have worked constantly, his sketch-book always to hand, and while certainly knowledgeable in matters musical and an avid reader, it is difficult to imagine him engaged in flirtatious conversation. According to his biographers, he was "timid" and "melancholic" by nature, always "dissatisfied with himself, and with everyone around

him", too restless to stay anywhere for very long, whether with Crozat or Vleughels.

Luxury seems to have meant little to Antoine Watteau: to those who exhorted him to count his earnings and get on with his career, he replied that he could live in the poorhouse if the worst came to the worst. In 1717/19, when Watteau was painting his deliciously sensuous *Music-Party*, he was already a sick man. He had tuberculosis, or possibly paint-poisoning. In 1721, at the age of 36, he died. The image we have of the 18th century is largely determined by paintings Watteau executed in its first two decades. He was "so new" that he anticipated much of what came later. Today he would undoubtedly be referred to as a painter of the avant-garde.

Giambattista Tiepolo: The Death of Hyacinthus, 1752–1753

Tennis with Apollo

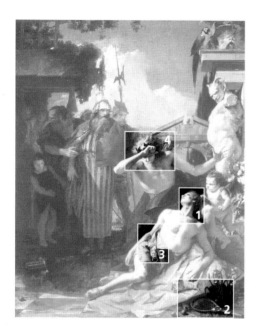

According to tradition, the Greek god Apollo, in a sporting competition with his lover, injured him fatally with a discus. A German ruler and connoisseur of fine art, Count Wilhelm zu Schaumburg-Lippe (1724–1777), commissioned an unusual rendering of the story from the Venetian artist Tiepolo. The painting suggests that Apollo's friend fell victim, not to a discus, but to a tennis ball that was travelling too fast. The canvas, measuring 287 x 235 cm, is in the possession of the Museo Thyssen-Bornemisza, Madrid.

A youthful body with pale gleaming skin lies draped in decorative abandon on shimmering silk. For all its tender-seeming femininity, the body, painted by Giambattista Tiepolo, belongs to a man – the dying lover of the god Apollo.

Most art historians assume the artist arranged the scene – showing the fatally wounded Hyacinthus, Apollo's favourite – at some time in 1752 or 1753; the painting itself is undated. By the mid-18th century, the Venetian was one of the most famous artists in Europe: his use of light, his radiant colours and evident pleasure in idealized figural beauty were exactly what contemporary art lovers and buyers cherished.

Tiepolo did not paint the sensuously reclining youth in Venice – nor, indeed, under southern skies. Prince-Bishop Carl Philipp von Greiffenclau had enticed the artist to Würzburg with an enormous fee, commissioning him to decorate with frescos the residential palace built by Balthasar Neumann. "Al fresco" paints were applied to a ground of fresh plaster, a process which, at that time, could only be carried out in the warmer summer months. During the winter months of his three-year stay at Würzburg, Tiepolo therefore designed the cartoons for his murals, as well as executing various works at his easel: alterpieces, love scenes based on literary texts, mythologies.

The Death of Hyacinthus was not painted for the Catholic Prince-Bishop, however, but for a Protestant count who lived even further north, Wilhelm zu Schaumburg-Lippe. In a catalogue of the Count's paintings the work is listed as having been bought directly from the artist for 200 Venetian "zecchini" in gold.

Neither the Prince-Bishop of Würzburg nor the Count zu Schaumburg-Lippe were among the more influential German rulers; they could not compete with the rulers of Prussia, Saxony, Austria or Bavaria. Nor were they financially powerful. This can be illustrated in demographic terms: a large

town might contain some 100,000 residents, whereas Würzburg had 14,000 and Bückeburg a mere 1600 inhabitants. The destination of Tiepolo's *Hyacinthus* consisted mainly of its castle and those employed there, including the workmen and tradesmen who provided services for the Count and his entourage.

Compared to Bückeburg, Würzburg was a thriving metropolis with a magnificently wealthy prince as sovereign. The respective fees paid to Tiepolo illustrate the difference: 200 zecchini against 30,000 Rhenish gulden. For this handsome sum Tiepolo decorated Würzburg's Kaisersaal, painting a dramatic history of the town's Catholic princedom, while the ceiling above the grand staircase shows a monumental cosmology comprising the four continents. The figures of Apollo, Mars and Venus appear against a cloud background, while the hub of the universe is a resplendent portrait of Herr von Greiffenclau himself.

Several motifs used at Würzburg recur in the painting that went to Bückeburg. The pediment broken by a ball on a plinth is found in the background of "Europe" at Würzburg; the parrot features in "America", while the long robe with double stripes worn by the elderly man is found in "Africa" and "Asia". In the Kaisersaal at Würzburg Hyacinthus' head, seen from an identical angle, belongs to a trumpeter, albeit one whose eyes are open.

The recurrent use of identical motifs was not seen as self-plagiarism, but was considered normal practice at the time. Artists constantly rearranged their stock of set-pieces, according to context or contract. In Würzburg the artist's task was to present the historic town and its present ruler to their best advantage. In the case of the Bückeburg painting, however, now in the Museo Thyssen-Bornemisza, the relationship of picture to patron was of an entirely different order.

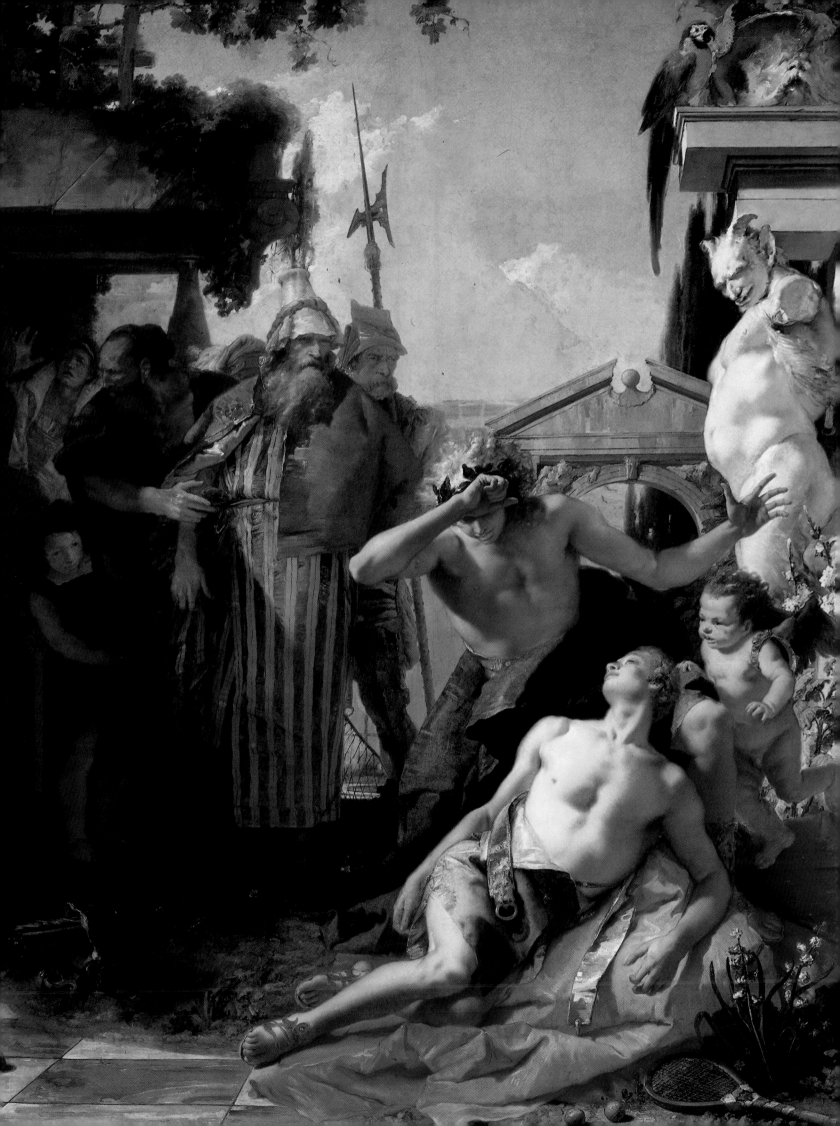

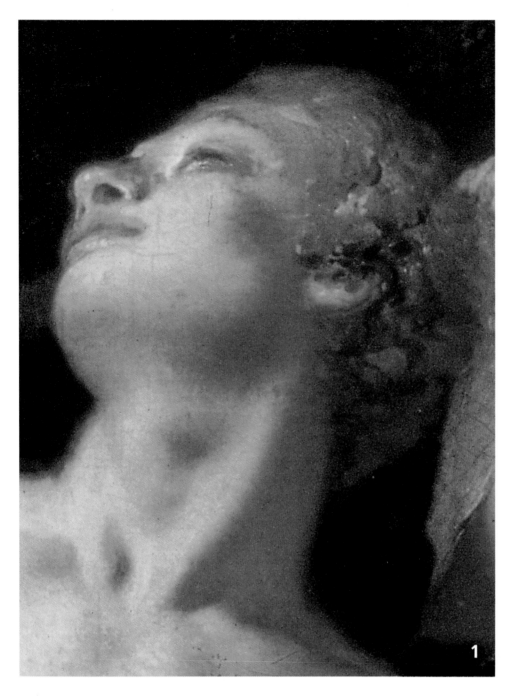

1

A god plagued by dreadful guilt

Wilhelm Graf zu Schauburg-Lippe was c. 28 years old when the painting was executed. He was born in 1724 in London, where his father held high office at the court of the Hanoverian kings George I and George II. He grew up at Bückeburg, however, where he was educated, as was customary for someone in his position, by a private tutor, a church minister. He studied at Geneva and Leyden, spoke French elegantly and German tolerably, and was a lover of music. He later employed Johann Christoph Friedrich Bach at Bückeburg. A lover of fine art from an early age, he had collected engravings by the French artist Jacques Callot while still a boy; fully grown, he sat for Joshua Reynolds, who portrayed him as a general.

The artistically-minded count, undoubtedly the recipient of an education in the classics, would naturally have known the Roman poet Ovid's *Metamorphoses*, whose 10th Book tells the story of Hyacinthus, the favourite of Apollo. The story finds them engaged in sport: "the god and the boy removed their garments, rubbed their bodies, till they gleamed, with rich olive oil, and began to compete with one another in throwing the discus." When Apollo hurled the discus to the clouds; Hyacinthus "ran forward without stop-ping to think, in a hurry to pick up the discus, but it bounced back off the hard ground, and rose into the air, striking him full in the face. The god grew as pale as the boy himself: he caught up Hyacinthus' limp frame … - the wound was beyond any cure."

According to Ovid, the god, plagued by dreadful feelings of guilt, could not understand what he had done to deserve such loss. "Yet how was I at fault, unless taking part in a game can be called a fault, unless I can be blamed for loving you?" From the blood that gushed from the wound, Apollo caused a flower to spring, bearing the youth's name. "Still in what fashion you may you are immortal: as often as spring drives winter out … so often do you come up and blossom on the green turf."

Far from the whim of an artist, the subject of a painting was generally chosen by its patron. The young Count Wilhelm probably commissioned this one himself. But why? He may simply have been an admirer of Ovid's *Metamorphoses*. Goethe wrote that "nothing can be more stimulating to a young person's imagination than to linger in that fabulous, serene region where gods and goddesses share with us their deeds and passions …"

However, it is equally possible that something more specific than the Pantheon had stimulated Wilhelm's imagination. To judge from his correspondence, Wilhelm had felt attracted to young men from an early age. At the age of twenty-two he described a young Hungarian as "his beloved Festetics" and "my other half". When Festetics was about to marry, Wilhelm advised him rather to die than wed a woman against his will. At approximately the same time, one of his father's friends, a woman, asked whether Wilhelm had maintained "sa froideur pour les femmes", his coldness towards women.

Not long after this he eloped with a Viennese *theatre belle*, taking her with him to Venice. Once there, however, he lived not only with her, but with a Spanish master of music, entering *a menage à trois* which later shifted its focus to London. In a letter to his son, Wilhelm's father mentioned the Spaniard as "your friend Apollo". As ruling Count, Wilhelm tried to bring his Apollo to Bückeburg. The latter even agreed to come, but died in 1751, just before the present painting was executed.

Rather than competing at discus, Hyacinthus and Apollo in Tiepolo's painting have evidently been playing tennis, or – as it was often referred to at the time – *jeu de paume*. The artist, at least, suggests as much by showing a racket, balls and a net, instead of a discus, and placing the racket next to the flower growing out of Hyacinthus' blood.

Tennis balls were not soft and elastic – air-filled rubber balls were not developed until the 19th century – but made of leather and filled with wool, hair, or even sand. They were hard and rather dangerous, and indeed frequently the cause of injury or even, on occasion, death. In 1751, Frederick Prince of Wales was hit so badly in the stomach by a tennis ball that he died of internal bleeding. Count Wilhelm, who maintained close relations with the English royal family, would naturally have heard the news.

Tennis was not played on a lawn, but indoors in a court. Nor were such courts de-

A sport
with deadly balls

signed to standard measurements. Those at the Louvre in Paris were 36 by 12 metres; other courts were half that size. The net was hung at breast-height, and the participants, like those in today's game of squash, played off the walls. Each court had an enclosed spectators' gallery, one of which is suggested at the top left of Tiepolo's painting.

Jeu de paume, or real tennis, was not, unlike riding, hunting or dancing, an accomplishment required of the young aristocrat, but it was nonethless "rightly included among those exercises designed to divert the mind and maintain good health", as a manual of 1742 advised.

In a different tract of the same period, we read: "The tennis court is a form of exercise for the nobility rather than the ordinary citizen, for it requires much money." It was therefore hardly a sign of disrespect if the artist portrayed the god Apollo engaging in a modern, aristocratic – rather than antique – sport.

However, the racket and ball bear a more direct relation to the patron, for one of Germany's 60 tennis courts was actually situated at the small castle of Bücke-

burg, and Wilhelm himself was an extraordinarily good player. At the age of twenty-two he reported from Dresden that the male members of the royal family, except for the king, who had been away from home at the time, had all watched him playing tennis, and that he had been urgently requested to stay until such time as the king, who would certainly want to play with him, had returned to Dresden: "I am told he is an excellent player, but I am sure you will understand that Festetics comes before all the kings in the world." Festetics was his Hungarian friend, to whom he wished to return as quickly as possible.

In Vienna, according to Wilhelm, the Emperor himself had watched him play, shouting: "Bravo, Comte de la Lippe!" A close friend confirmed to his father the young man's success: "His unusual strength and adroit mastery of the game of tennis have … contributed much to the astonishment, approval and renown which he is accorded everywhere, and, indeed, have induced both the imperial majesties to watch and applaud his game …"

2

Over their light clothing, 18th-century real tennis players wore "a broad belt of cloth fastened around the hips with two knots … and no player goes without such a girdle, for its firm binding protects the body, especially the intestines and liver, against sudden movements and blows." This, at least, was the opinion expressed in a doctoral thesis submitted to the Medical Faculty of the University of Paris in 1745.

Long robes, of the type sported by Apollo, were commonly worn by antique or mythical figures in Tiepolo's paintings.

Count Wilhelm ruins his reputation

Hyacinthus' short, and rather tight, kilt, however, fastened about the ribs, is quite unique in this form. The artist has probably turned a contemporary tennis costume into a quasi-antique garment.

Hyacinthus' kilt is held by a broad belt whose ring is attached to the golden head of a satyr. A second satyr, in the form of a statue in the top right of the painting, grins down at Apollo and Hyacinthus. An identical statue appears in a further painting executed at Würzburg, entitled *Rinaldo under Armida's Spell*, which also contains a parrot and broken pediment. However, the twofold appearance of a satyr in the present work can probably be no more attributed to accident than can the allusion to *jeu de paume*. The explanation may lie in Wilhelm's way of life. Satyrs, usually pictured with goats' horns, tails and hooves, were thought of as particularly wild types. Incapable of leading a civilized existence,

they perpetually indulged in priapic excess, constantly insulting and shocking people.

This echoed Wilhelm's own behaviour. He was indeed the wildest of types, unconventional to the core.

He was locked up in England at the age of 18 for disobeying military regulations: for a wager, so it was said, he had ridden a horse from London to Edinburgh, sitting back to front in the saddle. Once, for fun, he had travelled the country dressed as a beggar. Several years later, in Vienna, he applied for a commission as colonel, and was refused by Empress Maria Theresia. Wilhelm thought it was because he was not a Catholic, but his ill repute was the more likely reason.

The genuine admiration he inspired as a tennis player did not help him much, and though he showed real bravery on one occasion by defending a friend against four attackers, the affair only made matters worse, for the friend was a rather unscrupulous character himself, with an equally bad reputation. When, finally, he eloped with a *theatre belle*, the mistress of a respected nobleman, Wilhelm was forced to flee Vienna.

Living with an actress and a Spanish conductor in Venice was hardly designed to improve his reputation. Furthermore, it was considered somewhat eccentric to employ a so-called *marqueur* as a personal cook. A *marqueur* was basically a kind of all-round tennis slave: a coach who doubled as ball-boy, opponent, umpire and court caretaker. *Marqueurs* were often also responsible for collecting the money from wagers taken before a tennis match.

The Count is known to have played in Venice in c. 1747. Unrestrained, as yet, by the burdens of office, the 23-year-old Wilhelm enjoyed the free and easy life of a gentleman of quality. He evidently gained a number of friends among the Venetian patricians, the influential family Grimani even dedicating a Carnival opera to him. It was in Venice, too, that he probably became acquainted with Tiepolo, possibly even discussing plans for the painting which Tiepolo later executed in Germany.

4

An enlightened despot

Apollo, one of Tiepolo's favourite deities, also appears in the palace at Würzburg, where the artist has included him in two separate scenes. Apollo was god of light, and since light, brilliance and clarity maintain a powerful presence throughout Tiepolo's work, it is easy to see why he felt drawn to the deity. However, Apollo also personified the mood of 18th-century philosophy in the era of Enlightenment. In French, which at that time was the language of the educated, the link with Apollo is made clearer still: the Enlightenment was the "siècle des lumières", the age of leading lights and of the enlightened. However, Apollo was also seen as god of the Muses, and Tiepolo's painting shows not only the victory of reason, the light of understanding, but also the triumph of the arts, of culture itself. To Wilhelm, both the Enlightenment and the arts were of equal importance: he employed one of Bach's

sons as his court musician, bought paintings, did everything he could to keep Johann Gottfried Herder, the philosopher of history who prepared the ground for German Classicism, at Bückeburg, and was a keen follower of developments in philosophy and natural science. He also allowed the principles of the Enlightenment to guide him in governing his own, small land. Had he ruled over more than 15000 subjects, he undoubtedly would have been one of the outstanding German potentates of his time. As it was, Wilhelm went on to have an influential career as an artillery expert, became Commander-General of the Artillery of the Electorate of Hannover during the Seven Years' War (1756–1763) and then Commander-in-Chief of the Anglo-Portuguese army in the war against Spain.

His fame now depends largely on military scientific writings which he did not publish during his lifetime for fear of ridicule; the sovereigns of petty-princedoms were discouraged from thinking aloud beyond their station. Besides, his opinions would have been quite unacceptable to the

military establishment of his day. Wilhelm declared the prevention of war to be the sole aim of all military strategy. A way of achieving this, according to the author, was to make one's defences strong enough to deter potential aggressors from risking an attack.

Apollo, crowned with a laurel wreath, was not only god of light and the arts, but also of beauty and youth. Since so many mortals – not only Hyacinthus – had met their end through him, his name was linked with death, too. Like the majority of educated people of his day, Wilhelm would have been well aware of the multi-faceted nature of this deity.

Wilhelm was a young man when he ordered the work from Tiepolo. It is therefore not difficult to imagine the feelings and memories that must have haunted him when, grown so much older, he contemplated the painting at Bückeburg in later years. Wilhelm died in 1777 at the age of 53. He was succeeded by his nephew. Whether coincidence or not, the man entrusted with administering Wilhelm's estate after his death bore the forename Hyazinthus.

A star-machine explains the universe

The painting takes science and the dissemination of scientific knowledge as its theme, a rare subject in art, with Rembrandt's *Anatomy Lesson of Dr Nicolaes Tulp* perhaps one of its few, well-known examples.

While Rembrandt's painting focuses on a corpse, the centre of attention in Wright's work is a machine, referred to as an "orrery", after an Earl of Orrery who financed its construction in the early 18th century. The apparatus demonstrates the path of the planets around the sun. The Earth and Moon can be made out, as well as Saturn with its rings; the Sun is hidden, as are the operating crank and a complicated lever system with whose aid the planets were set in motion.

The philosopher in his broad, red jacket-coat stands head and shoulders above the figures listening to his lecture on the orbits of the planets. The presence of a woman on the left, and of children, indicates that we are not witness to a university seminar, but a private lecture. Books are shown in the background on the right. The eight figures are gathered in a darkened library.

In Rembrandt's *Anatomy Class*, executed in 1632, the sight of a corpse, the image of a human being, inspires thoughts of death and the fleeting nature of existence. Wright, 130 years later, places a machine at the centre of his painting, an automaton that cannot render visible, but simulates the paths of celestial bodies. Spectators were enthralled by the curved bands of metal. Today, their fascination is practically impossible to understand.

The work, measuring 147.3 x 203.2 cm, was first exhibited at London in 1766. Today it is in the Art Gallery at Derby, where Joseph Wright (1734–1797) painted it, and where he spent most of his life.

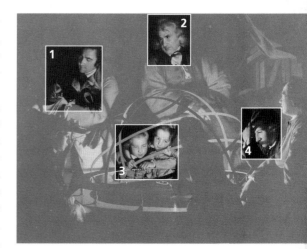

To make the teaching of science the subject of a large painting was most unusual. Most large-scale works showed scenes of historical or mythological signifcance. In Wright's painting, teacher and student remain anonymous, the setting is practically unrecognizable and the time is simply the present. The subject of the painting is nonetheless significant: the search for knowledge in the Age of the Enlightenment.

Science produces machines

The name of the man taking notes is known only because he sat for one of Wright's portraits: Peter Perez Burdett. He was a surveyor and cartographer; the painting suggests he was also interested in the calculation of celestial orbits. Burdett and Wright were close friends, sometimes playing music together. The artist portrays him here as an elegant figure in a pale, striped jacket, with his three-cornered hat tucked under his arm, clutching a fashionable-looking walking stick in the hand that holds the paper on which he is writing.

Demonstrations and lectures of this kind were organized in Derby and other English towns by the Lunar Society, so-called because its members met once a month on the Monday closest to full moon. They may have chosen the appointed day because – in the days before street-lighting – it facilitated their nightly journey home, or perhaps the reason was quite simply that they wished to document the importance of celestial bodies at their meetings.

The Lunar Society was given personal and financial support by men who were interested in the sciences, either because they earned their living as inventors or scientists themselves, or because they wished to discuss the latest scientific discoveries with men who were specialists in the field. The difference between a specialist and a layman was still undefined, for the field of knowledge was by no means as extensive or well-charted as it is today. But the demand for education, especially in the natural sciences, was great. The 18th century was the Age of Enlightenment, as well as the dawn of the Industrial Revolution. Scientific discoveries had begun to roll back the dark blanket of religious prejudice.

Inventions and discoveries were often exploitable for industrial purposes. One of the members of the Lunar Society was James Watt, who built the first steam engine in 1765. The power of electricity had not yet been harnessed; apart from horse and human power, the only other form of drive was provided by water. Watt's invention thus became a machine of paramount importance for the industrialization of Europe.

Another member of the Lunar Society, and one whose name is still known today, was Josiah Wedgewood, whose ceramics factory at Derby had, thanks to the latest technology, developed the capacity to turn out mass products of high quality. The prototype of the Lunar Society member was a man like John Whitehurst, another of Wright's music-making friends. He was a watchmaker, a maker of barometres and scientific instruments and the author of a scientific work on the origin of the Earth – exemplary, in other words, in his capacity to combine the practical skills of a precision mechanic or engineer with the theoretical bent of a scientific thinker. It was men like Whitehurst, Wegewood or James Watt who translated scientific discovery into useful machines. The capacity to combine practical and theoretical skills was also a prerequisite for the construction of an orrery, a clockwork model of the solar system. The reputation, or even renown, of this mechanical representation of the dynamics of celestial bodies was founded not only on its simulative capacity, but also on the apparatus itself as the product of the latest developments in technology.

As a testimony to the high value attached to machines of all types at this time, the "Encyclopédie", a work, published in France since 1751, whose aim was to collate the entire knowlege of the age, contained countless illustrations of machines and apparatuses. In the course of the 18th century, natural science and technology were accorded a status equal to that of religion, philosophy and art.

2

Mathematics replaces God

Whitehurst, watchmaker, amateur geologist and neighbour of the painter Wright, was a friend of the astronomer James Ferguson, who constructed orreries in his London workshop. Ferguson is known to have held a lecture at Derby in 1762, or possibly a series of lectures. He earned his living partly as a travelling scientist, moving – presumably with crates of instruments – from town to town. It was through men like Ferguson, as well as institutions like the Lunar Society, that scientific knowledge spread. According to Ferguson, the aim of one series of lectures was to explain, with the help of mechanics, those laws by which God regulates and rules over the movements of the planets and comets.

One of Ferguson's planetary demonstrations may have inspired Wright's painting. The philosopher resembles several figures whom Wright portrayed individually, but most of all he recalls the features of a person Wright never saw in real life: Isaac Newton (1643–1727). Like the philosopher in the painting, whom Wright shows head and shoulders above the other figures, the English philosopher, mathematician and physician towered like a great mountain over 18th-century thought.

At least one anecdote from the life of the famous scientist is probably still told to every schoolchild: sitting on the grass, Newton observed an apple falling to the earth from a branch. This everyday occurrence is said to have inspired his research on gravity in general, and the earth's gravitational pull in particular: he wanted to know why, since the apple falls to the earth, the Moon does not, or why planets should follow set paths in space.

Today, Newton's laws of gravitation belong to the basic principles of natural science. They have been verified beyond doubt. At the time in question, however, they created a sensation, provoking reactions throughout Europe, even from people with no knowledge of mathematics or physics.

In fact, the excitement was caused less by Newton's mathematical formulae than by his claim that the paths of planets were subject to calculation – his contention, in other words, that the acceleration of a falling apple, or the dynamics of celestial bodies, could be described with the help of mathematical concepts, and that the laws deduced from his calculations were universal. If all this were true – thus the argument of his enraged detractors – the universe was tantamount to a machine. Where, then, was God's place in it?

The mathematics of an apple falling to the ground, on its own, would have been unlikely to raise a scandal. The movement of the stars, however, had always provided an illustration of God's guiding hand, a belief which Newton's discoveries refuted. Whoever accepted the latter might continue to see God as the Creator of all things, as the *primum mobile*, but he would be forced to deny the notion of a God who intervened, or revealed His presence in physical phenomena.

Newton himself did not arrive at this conclusion. He was a pious man, and did not wish to question the omnipresence of God. Gottfried Wilhelm Leibniz, the great German scholar and sometime adversary of Newton, referred to this contradiction in his work. Poking fun at him in a letter, he suggested that although Newton's God had created the world clock, He was forced, in order not to appear superfluous, to constantly rewind and repair it.

The world as a clock, the cosmos as a machine or automaton – such notions excited Wright's contemporaries, preyed on their minds, left them unsettled. An orrery not only fascinated them as an example of technical progress, it also lent a more vivid dimension to theological debate.

3

Universal science for women and children

The brightest faces in the painting belong to the two children. They do not look bored, as the majority of children may do in maths lessons today, but dreamily content, as if watching something especially beautiful. They remind us of angels' faces in Nativity scenes.

It is not known whether the artist intended to forge a link with the tradition in religious painting. It is possible, however, that Wright's painterly emphasis of young faces reflects a growing awareness of the unique status of children. The literature of the period confirms this impression: the philosopher John Locke (1632–1704) had demanded that teachers pay special attention to the peculiar interests of children instead of making them learn by heart. His *Thoughts Concerning Education* enjoyed considerable currency during the 18th century.

Wright paints a picture of the ideal education: the children in his painting are not forced to learn by rote, but acquire scientific knowledge through their natural inclination to play. In painting, too, there was a growing interest in children. There had always been portraits of princes and princesses, but this was a privilege middle-class children now began to share, some family portraits no longer marginalizing children, but giving them pride of place.

There is a very beautiful portrait of a mother and daughter by Joseph Wright, who also painted two brothers hugging a pet dog. Neither subject would have been considered usual in England at the time.

To the left of the orrery Wright places a young woman, demonstrating that women too participated in intellectual life. Even more so than in England, this was the case in France, especially in aristocratic circles. Voltaire's friend, the Marquise du Chatelet, for example, translated Newton's works into French, and a portrait of 1753 shows a Parisian lady with a lectern, the word "Newton" decipherable on the page of an open book.

Special introductions to the sciences were addressed to a female readership: John Harris's *Astromomical Conversations between a Gentleman and a Lady*, published in 1719, for example, or *Newtonian Science for the Lady* by Francesco Algarotti, in 1737 (first English translation in 1742). However, knowledge did not always make a woman popular, as an acerbic comment made by Samuel Johnson in 1763 and reported by his friend James Boswell, clearly shows: "Mr Johnson said today that a woman's preaching was like a dog's walking on his hinder legs. It was not done well, but you were surprised to find it done at all."

Wright's painting derives its striking effect from lighting that appears to draw faces and objects from the surrounding darkness. But light not only acts as a formal device in this painting, it is also symbolic, representing the light of reason and knowledge. The terms used to describe the epoch itself reflect this concern: the Germans speak of the *Aufklärung*, the English word is "Enlightenment" and the French refer to the *siècle des lumières*; in each case, the image is one of increasing light and clarity. Newton, too, was celebrated as a leading light: "Nature and Nature's Laws lay hid in night", wrote the English poet Alexander Pope (1688–1744), "God said, Let Newton be, and all was Light."

The lighting effect used in the painting was not Wright's invention; Caravaggio, Georges de la Tour, Rembrandt and Gerard van Honthorst had developed tenebrist effects before him. Wright uses them again and again in his work. In his accounts he describes his paintings as "candle light pictures", although their light was by no means always provided by candles.

He was especially interested in powerful contrasts of this type, painting a fireworks' display in Rome and, during his stay in Naples, the eruption of Vesuvius by night. He also did several paintings of

The art of lighting a lecture

blacksmith's shops by night, with huge, water-driven hammers beating down on white-hot iron. It was a topical motif. He also painted the moonlit factory of Joseph Arkwright, a well-known English industrialist, whose cotton mill was kept running twenty-four hours a day, in two twelve-hour shifts; Wright painted the factory with its windows gleaming in the dark.

Wright's lasting fame was founded on two renderings of scientific demonstrations: the *Lecture on the Orrery* and *An Experiment on a Bird in the Airpump* (1768). The *Airpump* centres around a glass container from which the air has been removed; in it is a bird, sunk to the bottom in the vacuum. Once again, the dramatic quality of the work derives from its single source of light, leaving faces and instruments in partial darkness.

The format – over two metres wide – of the two paintings was generally reserved for history paintings, highly popular at the time. Thus Wright's lecture scenes competed courageously with large-scale battles and mythologies. Lectures and scientific demonstrations were not considered worthy of art, but Wright succeeded, with his "candlelights", in finding an appropriate form for his subject.

Wright earned his living, not with paintings of this kind, but by portraiture. In this sense, he was no worse off than his famous contemporaries, Sir Joshua Reynolds and Thomas Gainsborough. The role of 18th-century art was primarily determined by the demand for portraits of aristocrats and wealthy burghers. It was important to be able to lend one's subject a certain charm or nobility: Reynolds, for instance, invested his clients with classical dignity by dressing them in quasi-antique robes. Wright did not go quite so far, though he did tend to smooth out the wrinkles, as it were: his orrery painting can be seen as a group portrait of several unusually handsome figures.

Wrights clients, with the exception of a few Midland's gentry, came from his own class: his father was a Derby lawyer; one of his brothers also became a lawyer, the other a doctor. They were members of a middleclass that was intent on progress and industrialization, and whose efforts brought it economic and political power.

Wright went on the usual "grand tour" to Italy, but spent most of the rest of his life in Derby. An attempt to establish himself as a portraitist in fashionable Bath, a spa considered particulary chic by the aristocracy, was doomed to failure. The painter evidently had difficulty adapting to his clientèle: "The great people are so fantastical and whimmy", he wrote, "they create a world of trouble." The suffix "of Derby" was not given to him as a title, but as a means of distinguishing him from other painters called Wright.

The Orrery was bought by a certain Lord Ferrers, a member of the Royal Society who had published astronomical observations and constructed an orrery himself.

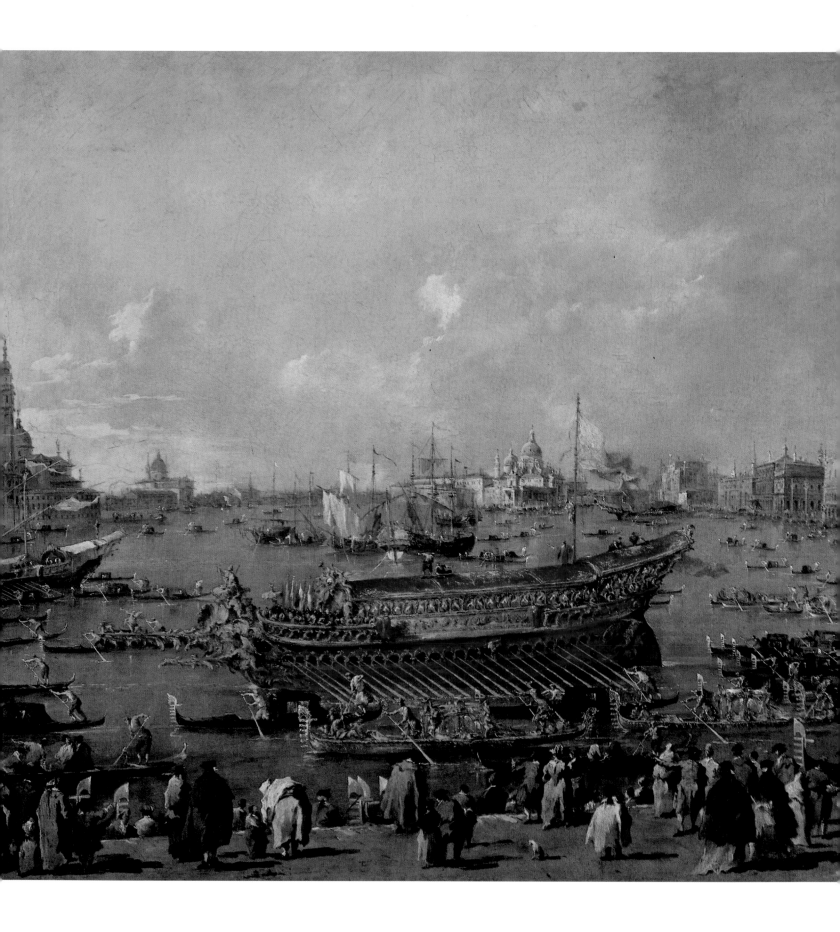

**Francesco Guardi: The Departure of the Doge
on Ascension Day, c. 1770**

The marriage of Venice with the sea

A few light clouds adorn a blue sky over Venice. The doge's palace and the Campanile can be seen on the right, the churches of Santa Maria della Salute and San Giorgio Maggiore in the centre and on the left. The artist evidently set up his easel at a point now occupied by the public gardens, the setting of today's Venice Art Biennale. Francesco Guardi has compressed the panorama a little in order to show as many famous buildings as possible.

The large ship floating in the harbour is the *bucintoro*, the Venetian Republic's ship of state. The name originally meant "ship of gold". The doge with his dignitaries and senators are on board to enact the symbolic marriage of the head of state with the Adriatic, a ceremony celebrated each year on Ascension Day.

This was the most important festival of the year, spread out over two weeks to allow the Venetians to celebrate as befitted the occasion. With masques permitted and theatres and the casino open, tourists flocked to the city. A trades fair, offering Venetian luxury goods, was mounted simultaneously. Ascension thus cleverly combined business interest with a pleasurable springtime extension of Carnival, officially opened with a popular, semi-religious ceremony of state.

The work belongs to a series of twelve depictions of Venetian festivals which Guardi probably painted for Doge Alvise Mocenigo IV, the third last of the doges before the annals of the Republic closed. Mocenigo celebrated his first marriage with the sea in 1763. As usual, the Venetians were entitled to inspect the *bucintoro* the day before. Those who possessed boats joined a flotilla which, in a manner resembling a wedding procession, accompanied the dream-ship along its route. According to Goethe, the ship showed both "what the Venetians were, and what they imagined themselves to be".

Every year on Ascénsion Day, in a symbolic act of union with the sea, the Doge of Venice boarded the ship of state, a ceremonial barge that was so heavily burdened with ornament, it was practically unseaworthy. The weaker the Republic became, the more pompous the ceremony, captured here by Francesco Guardi in 1770, only decades before Venice finally lost its independent sovereignty. The painting, measuring 67 x 101 cm, is now in the Louvre, Paris.

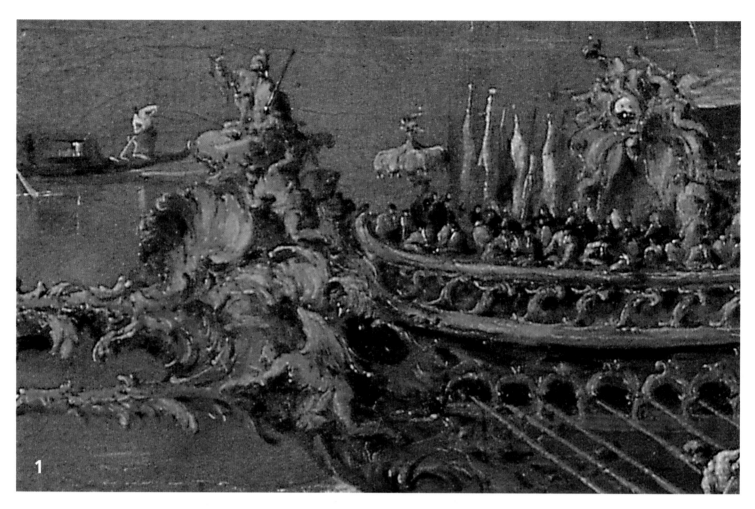

1

A golden parasol recalls Byzantium

Many ships were richly decorated in those days, but none weighed quite as heavily at the bows as the *bucintoro*. The lengthy, projecting wooden beak, usually attached to galleys for the purpose of ramming enemy ships, was here purely decorative; moreover, it was even complemented by a second such extension. The upper beak, ornamented with waves, seaweed and children, symbolized the sea, while the lower one, with bushes and stones, and with Zephyr puffing his cheeks, was the Earth. They joined in a gigantic bank of shells upon which Justitia was enthroned.

Behind the latter, the doge himself would be practically invisible were it not for his golden parasol. Whenever he left his palace on official business, this ancient, oriental symbol of power was carried along beside him, a reminder of the town's earliest days when it was part of the By-

zantine Empire. The marriage to the sea itself harked back to the first centuries of the maritime Republic. Originally the water was merely blessed by those on board, a ceremony resembling that in which the coastal dwellers of antiquity had asked for Nepune's clemency. Later, the Christians had adapted the heathen custom to their own ends. The ceremony was followed by a simple repast of chestnuts and red wine.

This altered again with Venice's rise to power. The ritual now began to incorporate reminders of Venice's former triumphs. On Ascension Day in 997 or 1000 (the exact date was a matter of dispute between town chroniclers), the Doge Pietro Orseolo II put out to sea to liberate the towns of the Dalmatian coast from pirates. The operation was successful and marked the beginning of Venetian hegemony over the Dalmatian coast. In 1177 Venice succeeded in arbitrating between Emperor Friedrich Barbarossa and Pope Alexander III. According to legend, the two greatest potentates of the age held their conciliatory meeting in St. Mark's, thereby involuntarily recognizing Venice's claim to dominion over the Adriatic. As a token of his grati-

tude, the Pope is said to have presented the doge with a consecrated ring, expressing the wish that he "marry the sea, just as a man marries a woman to become her lord".

Venice in its infancy had begged for the sea's clemency; now it presumed to declare itself the ruler of the waves. The religious ceremony was transformed to an act of state in which the town celebrated itself and its claims to power. Each year the doge had a ring made that was identical to that given to him after his election as an official symbol of his unity with the Republic, and each year he would throw the ring to the waves, uttering the declaration: "We wed ourselves to thee, O Sea, as a sign of our true and lasting dominion."

This avowal of lasting marital supremacy was the object of much ridicule. When the Turks became powerful during the 16th century, it was said that while Venice might be the sea's husband, Turkey was her lover. The 18th-century Venetian writer Giacomo Casanova commented that if the unseaworthy vessel were to sink "all Europe would laugh at the tragic accident, saying the doge had finally decided to consumate his marriage."

"The ship is a veritable monstrance"

For the lords and dignitaries of Venice to sail beyond the Lido in the *bucintoro* would have been rash; the Lido itself was navigable only on a comfortable breeze. According to Casanova, whether or not the *bucintoro* left its dock at all depended "on the courage of the Admiral of the Arsenal, who vouched for good weather with his head".

Thus laden with responsiblity, the official in question is seen in the present picture standing on the roof of the ship, setting the course with his commander's baton and leaning with his other hand against the mast which, instead of a sail, carries a flag with the emblem of the Venetian lion. The roof was hardly the best of places whence to maintain control or give orders, but there was none better to be had.

The commander is flanked by two other admirals, identifiable by their red coats. In wartime, admirals were not permitted to command the Venetian fleet, since this was the prerogative of patricians. High-ranking officers, on the other hand, were ordinary burghers who had won their colours at sea and were made responsible for the various districts of the harbour, including the shipyards, or Arsenal. Their most important public role came at Ascencion, or *La Sensa*, as the Venetians called it, or whenever the *bucintoro* was used to transport state visitors.

The Admiral of the Arsenal was a higher rank than other admirals, for it was in his area of control that ships were built and housed; the Arsenal was the shipping centre of Venice. The *bucintoro*, too, had its own, stylish boathouse there, designed in 1547 by the architect Michele Sanmicheli. Venice, in its heyday as a great, seagoing power, had been home port to over 3000 seaworthy vessels, almost all built in Venice herself. By the mid-18th century, there were only 60 or 70, all of which were built at foreign shipyards. The Dutch and English had developed better ships, forcing the Venetians to buy from them if they wished to hold their own as merchants.

The Arsenal was once the most important industrial quarter in Venice. The *arsenalotti*, or dockers, were employed by the

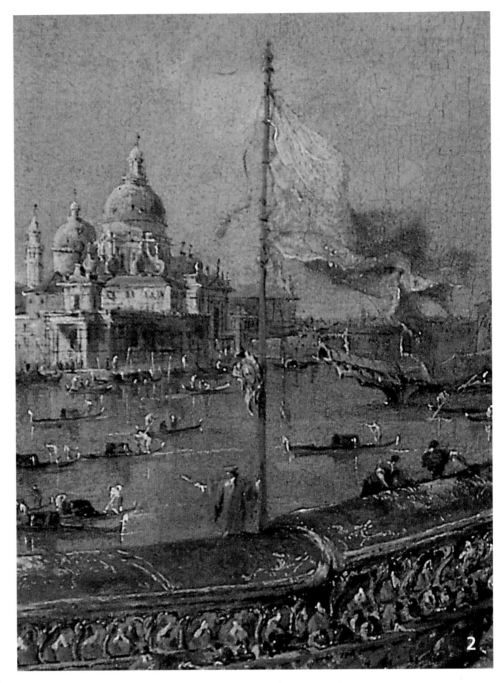

2

state, which, relying heavily on their services, treated them accordingly. If it is true that they were not paid as highly as workers at some private shipyards, they could not be dismissed either. They were responsible for supplying a fire-fighting service and guarding the three most important sites of the Republic: the doge's Palace, the Mint and, of course, the Arsenal itself. Only they were permitted to row the *bucintoro*, during which task they sang elaborate madrigals.

The ship of state was a galley, a type of vessel that was known for its seaworthiness. Unlike the *bucintoro*! "The ship is all decoration, ... all gilded carvings, a veritable monstrance, devoid of all purpose beyond exhibition to the people of the

lordly heads of its rulers", wrote Goethe, and went on: "For it is well known that people like their overlords adorned as sprucely as their hats."

The Venetians built a new *bucintoro* approximately once a century. The ship painted by Guardi was launched in 1729, and cost 70,000 ducats. It was 35 metres long and 7.5 metres wide, with four men at each oar. The enclosed upper deck was reserved for the senators.

The vessel's last voyage came in 1796, shortly before Napoleon's troops occupied the town and brought the history of the maritime Republic to an end. The Venetians were forced to stand by and watch while the French put their "gilded" "decoration" to the torch.

In Venice's heyday the *bucintoro* would be accompanied by some 4000 to 5000 vessels: fishing boats, gondolas and *peote*. The latter were gilded gondolas of state with ornately carved cabins. The doge owned three, using them on official occasions, or to meet royal visitors to Venice who preferred to travel incognito. For official state visits the *bucintoro* was towed from its dock at the Arsenal. Foreign diplomats owned *peote*, too, attempting to outdo one another with the splendour and number of the vessels in their possession.

The type of vessel known as the gondola gradually developed during the 16th century. By the 18th century, their appearance was much as it is today, with the exception that a larger number had roofs or cabins; the need for protection was evidently felt more keenly than the desire to see or be seen. Gondolas were used in much the same way as coaches in other towns, for trysts and everyday transport.

"The gondola is a peaceful way to travel, allowing one to lie back safely, whether alone or with company, laughing, having

Pleasure under the roof of a gondola

fun, playing games, enjoying oneself, doing whatever one wishes, and nothing one will ever regret." This paean was written in the 16th century; even then, the gondola, decked out with cushions, was seen as a "soft shell of love" – a love nest. It is no accident that the verb "gondolar", to "travel in a gondola", also means to "amuse oneself" in Venetian dialect.

Goethe, visiting Venice in 1786, also enjoyed the pleasures of travelling by gondola. Having come all the way from Weimar, however, where he had left Frau von Stein, he did not experience the vessel as a love nest, but as a kind of mini-*bucintoro*: "Grown weary, I took a seat in a gondola ... and, transported, suddenly was a ruler of the Adriatic: a feeling every Venetian knows who lies back in his gondola."

Gondoliers wore a special costume, usually consisting of knee breeches, white stockings and a red beret. When Venice was a leading sea-going power, some 3000 gondoliers were employed by the patricians; by Guardi's day there were only c. 300 left, sadly depleted, like the number and wealth of the patricians themselves. Gondoliers in private employ were expected to be especially discreet, since they, more than anyone, knew where the individual members of a family spent their time

away from home, or where letters and presents were taken. Carlo Goldoni, a Venetian writer of comedies, described them as "blithe, contended, honest men of honour, famed for courage and courtesy, always ready to share a joke, even with their Excellencies". One French traveller had quite a different, and rather more critical opinion, finding them "roguish, debauched and hypocritical". But the Frenchman had probably hired a public gondola, and cheating foreigners was practically a point of honour among hired gondoliers.

The gondoliers in the foreground wearing blue coats and hats with dangling gold coins were probably *arsenalotti*. They alone were permitted to row the *bucintoro*, or to steer the doge's *peote*.

The *arsenalotti* had a special role at all state ceremonies: it was they who carried the newly elected doge on their shoulders around St. Mark's Square; and it was they, too, who held the torches at his funeral, or who stood guard between the death of one doge and election of the next, a time when the doge's palace was especially vulnerable to thieves. On the eve of Ascension Day, the masters and foremen of the *arsenalotti* were invited, together with the members of the government, to take part in a festive repast at the doge's palace.

3

From harsh reality to the illusion of beauty

Those who did not accompany the *bucintoro* by boat stood at the edge and watched. Many of the spectators wore traditional white masks which covered only the upper part of the face, preserving anonymity while allowing the wearer to speak freely. One function of the masks, aided by capacious coats, scarves drawn over the head and three-cornered hats, was to obliterate gender and class difference. Social barriers seemed to vanish; tourists, too, looked much the same as Venetians.

But it was not the unusually prolonged Carnival alone that made Venice such a "must" on the "grand tour" itinerary of aristocrats and art-obsessed, middle-class travellers. Goethe, for one, was lavish with praise: "Everything around me is imbued with dignity, a great work of collective human power, worthy of the respect due to a splendid monument, not to a ruler, but to a people", he wrote, continuing, "even if its lagoons gradually silt up and its foul swamps exhale the ague, even with its merchant trade grown weak and former power sapped, the visitor will find the physical and spiritual consitution of the Republic none the less venerable. For, like all temporary phenomena, Venice too is subject to the passage of time."

Understandably, Venice was a place that inspired the traveller to take home some souvenir of his visit. It was this need, too, that provided the impulse for the painting of *vedute*, realistic "views" of landscapes and cities. *Vedute* were cherished for their accuracy, as well as for their small format. The latter quality meant they could be easily stowed in a traveller's luggage, which in turn encouraged sales. The *veduta* had its origins in 17th-century Rome and spread to Venice in the 18th century. The first Venetian *vedutisti* were Antonio Canaletto, followed by Guardi, probably one of his pupils.

Francesco Guardi (1712–1793) worked for many years in a workshop he shared with his brother Antonio (1698–1760), and historians of art often have difficulty in telling their work apart. Francesco was not elected to the Venetian Academy until

relatively late in life, for the *veduta* was not as highly regarded as the more traditional, figural genres such as mythologies, histories and Biblical subjects. Guardi sold his work at his workshop or in the marketplace, unless, of course, they had been commissioned, such as his series of twelve canvases showing the festivals of the doges.

Guardi's *vedute* differ from those of Canaletto in placing less emphasis on line. Line in Guardi dissolves, while atmosphere replaces the sobriety of Canaletto's realism, the latter's attention to detail yielding to Guardi's fields of colour. The dramatists of the day were turning away from reality, too, with Goldoni gradually eclipsed by Carlo Gozzi: Goldoni was a realist whose work contained scenes from

everyday Venetian life, whereas Gozzi favoured fables and fairy-tales, luring his public into a world of phantasmagoric grotesqueries.

Evidently, neither tourists nor the Venetians themselves wished to be accosted with images of real life, whether in paintings or on the stage. Instead, they took refuge in fantasy, preferring not to look behind the outward semblance of beauty. Art, like the Carnival, was there to help them forget the harsh realities of everyday life. The grand ceremony of Venice's marriage with the sea, too, was nothing more than an extravagant expression of wishful thinking. In the last decades of the Republic it was painted more than ever before.

Heathen carnival dance

Some time after 1812, in a period of hardship for his country and himself, Francisco Goya painted an exuberant scene showing the revelry of the people of Madrid on Ash Wednesday. Liberal spirits like Goya had suffered under absolutism and the terror of the Inquisition, and the painting, a testimony to the customs and zest for life of the common people, reflects the artist's own feelings of anxiety and affliction. Measuring 82.5 x 62 cm, the work is now in the Royal Academy of San Fernando, Madrid.

Believers throughout Catholic Spain flocked to church on Ash Wednesday. "For dust thou art, and unto dust shallt thou return" – uttering the sacred text the priest drew an ashen cross on the forehead of each member of the congregation, admonishing them to repent their sins. In Madrid, by contrast, Ash Wednesday was a day of dancing and drinking as the Carnival reached its climax.

A surging mass of people gathers under a February sky. Men, women and children, most of them masked or at least disguised, crowd around four dancing figures: three in white, the fourth dressed as a bull in a death-mask. The figures appear to dance in step, some with arms raised gracefully above their heads, others gesticulating wildly. They have no need of accompaniment; there is no sign of a guitar. The rhythm is marked by the clatter of castanets and stamping feet, and by the clapping and snapping fingers of the spectators.

The scene has an air of improvisation, as if a group of people had decided, quite spontaneously, to perform a folk dance or some form of hilarious grotesquerie, perhaps the caricature of a seguidilla – hardly surprising in a land where every little girl, according to local legend, is born dancing. There was dancing at every occasion in Spain, even at the most important religious festivals. When a procession took place at Valencia, for example, it was customary for seven gypsies to dance a sacred round in front of the Holy Sacrament.

Goya's dancing scene, including the figures in white, the "bull", the man with the lance and a "bear" padding about in the foreground, forms part of a bizzare ceremony which took place in Madrid each year on Ash Wednesday, called "The Burial of the Sardine".

After carousing and revelling all through the last night of the Carnival, the population of Madrid donned their masks and costumes and took to the streets for a final fling. Towards evening, crowding onto the packed promenade at the Prado, they swelled the ranks of a burlesque "funeral march" which left the town by the Toledo gate. Not until they had reached the banks of the Manzanares, a favourite recreation spot, did they finally come to a halt.

Traditionally, the march was led by three masked figures, who may be among Goya's dancers: "Uncle Chispas" (the spark) with wild, rolling eyes, the vain heart-breaker "Juanillo", and the headstrong, beautiful "Chusca". The procession, with the masked figures at its head, made a mockery of the earnest pomp of Church parades. To the solemn roll of drums, sombre-looking men in hoods carried – instead of pictures of the saints – banners proclaiming a moon-faced, grinning King of the Carnival, as well as a giant straw doll called "Pelele", with a tiny dangling sardine.

Goya painted neither Pelele nor sardine – whose origin, incidentally, scholars are unable to trace. Instead, he showed the procession at one of the stages along its route, or perhaps simply a scene in the meadows beside the Manzanares, while elsewhere, to the din of exploding fireworks, the fish was buried and the straw doll went up in flames.

It was not only an occasion for dancing, but for much eating and drinking: on this first day of Lenten fasting, Church rules were brushed aside while roast kids and fat hams were consumed.

It is not known whether the Inquisition, which continued to spread terror in Goya's lifetime, actually attempted to suppress this heathen revelry. As guardian of the one true faith and purest of moralities it would natually condemn dancing. Nonetheless, it preferred to avoid direct conflict with the common people, choosing victims instead of a higher social status: in 1778 the entire estate of Don Pablo Olavide was confiscated by the Holy Tribunal and his name outlawed unto the fifth generation. He was accused, amongst other things, of permitting his servants to dance on a Sunday.

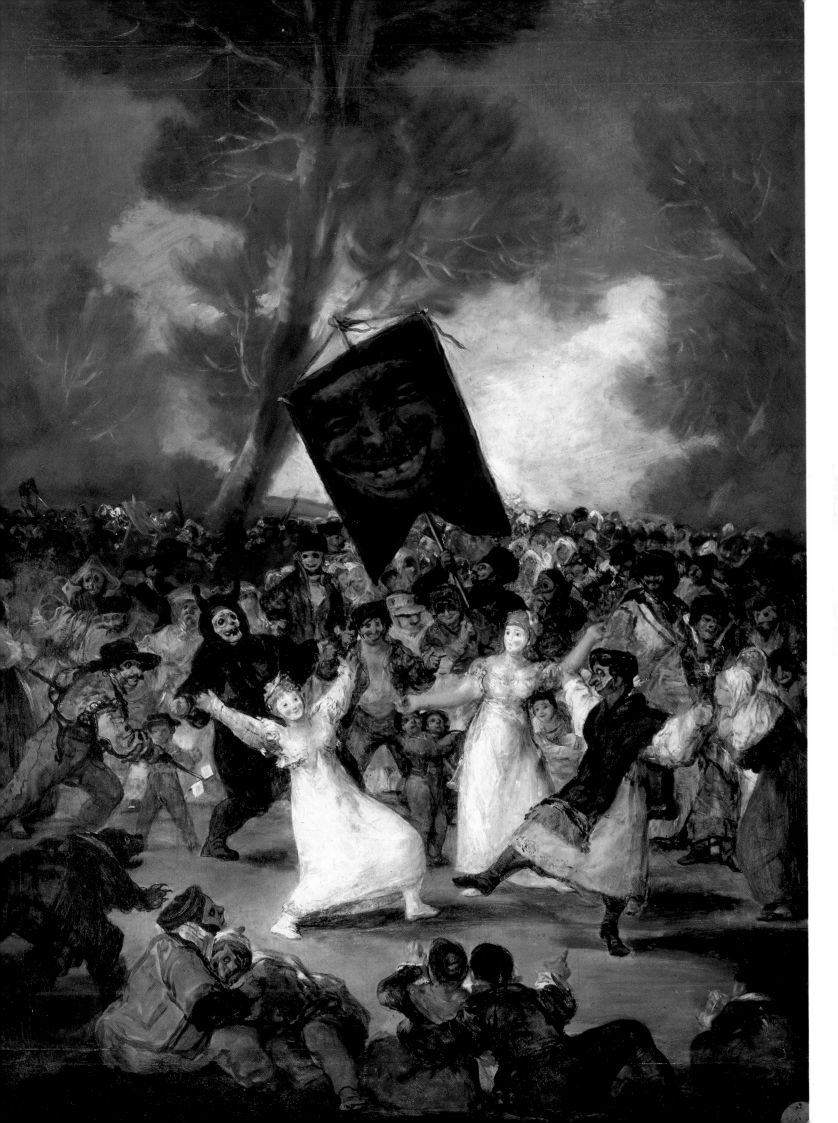

n contrast to the women among the spectators, whose hair and skin is largely veiled, the castanet player reveals naked arms and an ample bosom. The white mask and painted cheeks may well have concealed a man, or a prostitute. Carnival was an excellent opportunity for soliciting. Women wore trousers, men skirts, and everyone went about with notices, openly insulting figures of authority, pinned to their backs.

For a few days, the moral and social barriers of a rigidly hierarchical society were brushed aside, together with its sexual taboos. Periods of comparable orgiastic licentiousness, known as bacchanalia or Saturnalia, had taken place in pre-Christian times. The ascendant Christian Church had done what it could to control the revelry, incorporating it into its own calendar as a short

Days when barriers fell

period of roisterous behaviour leading to the 40 days of Lenten fasting before Easter.

Like the etymology of the word "carnival" itself, the origins of the customs associated with Carnival remain obscure. They may go back a long way – possibly as far as the archaic and bloodthirsty fertility rites of certain early agrarian societies. Thus the straw doll, Pelele, who goes up in flames on the final day of the Madrid festival, is said to be a distant descendant of certain kings who sacrificed themselves to ensure their people had a rich harvest. Later, their subjects were forced to take their place: Caesar wrote of gigantic wicker figures which the Celts packed with people and set alight. The custom of the carnival pyre continued to flourish wherever the Celts settled, including Spain. Figures were ignited, as in Madrid, outside the gates of the city. This was not for fear of fire, but because the ritual, whether designed to conjure or expel, was directed at spirits that walked in twilight zones.

A person who had committed a heinous crime or died a violent death did

not, according to popular belief, find everlasting peace, but returned as a ghost to haunt the living. Masks and painted faces were worn to ward them off. Death-masks with hollow eyes stare from Goya's crowd, while the word "Mortus" – death – can be made out, admittedly with some difficulty, on the dark banner above them. Carnival was not, originally, a festival of joy. According to ancient belief, the ghostly "undead" reappeared around the time of the last new moon in winter. This coincided with the old Celtic spring festival and, more or less, with the Christian Carnival.

The mask of the bear in the bottom left of the painting was appropriate to the occasion. As soon as spring arrives, the bear wakes from hibernation and staggers out of its cave. According to a curious tradition, to whose seriousness Aristotle testifies, the bear's first act upon appearing in this manner is to eat a laxative herb, causing it to expel, in a fart of tempestuous proportions, all those spirits to which it had played host during the winter months.

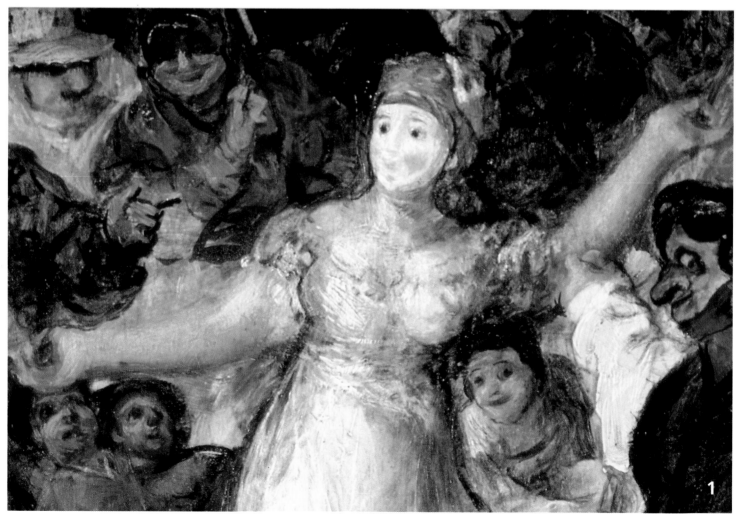

1

The duchess boozed in seedy bars

The bear was usually accompanied by the figure of a huntsman. However, the moustachioed figure with lowered lance joining the dancers may be the partner of the black bull in this folk dance. His costume, with the black, broad-rimmed hat, leather trousers and embroidered sleeveless waistcoat, is reminiscent of the traditional suits worn by picadors in Goya's renderings of bullfights.

The spectators at the "Burial of the Sardine" were also those who thronged to the arena for bullfights. Gathered around the dancers are the "lower" orders, people who lived in the poorer quarters of Madrid. This was "el commun", the common people, or, as those who could afford a coach called them, "la gente de a pie": the people who go on foot.

White mantillas gleam wherever one looks in the crowd. Worn black in the north, white in the south and Madrid, and accompanied by a broad dark skirt, they were traditionally worn by Spanish women of all classes. Among the spectators were probably housewives, servant girls and fishwives, as well as workmen, water salesmen and grocers, peddlers and shopboys. Like the dancer on the right, many are wearing a round Castilian leather cap over a knotted kerchief, pulled down over the forehead, as well as a woollen blanket slung across the shoulders, the poor man's apology for a winter coat.

With insecure wages, most would have lived in primitive housing, from which they fled whenever the opportunity arose. On official Church holidays they swarmed outdoors onto the street, or to the meadows by the river. They were drawn to any kind of mass entertainment, and their love of show and glitter drew them in great numbers to the *corrida*, the theatre and Church processions.

Goya achieved his first success as a young artist by painting various forms of Spanish popular entertainment. His colourful designs for tapestries, for instance, showed a local beauty under a parasol, a game of blindman's buff and a *Dance on the Banks of the Manzanares*. These works

were painted for an aristocracy who, determined to keep French influence at bay, were becoming nationally self-aware and developing a taste for folk culture.

Wearing the traditional folk costume of a *maja* or *manola*, an ordinary girl, the pampered Duchess of Alba accompanied the artist to the *corrida*, or to backstreet bars of ill repute. Her forays into this nether world allowed this lady of the highest nobility to enjoy the thrill of danger: unbuttoned, boisterous moods could change quickly, fights broke out without warning, knives flashed.

Goya, painting the bloody outcome of a spontaneous uprising on *The Third of*

May, 1808 in Madrid (ill. p. 161), captures something of this violent streak in the Spanish temperament. The Spanish had borne with equanimity the mismanagement of their economy by their own king, Charles IV. However, when the French occupied the country and plundered the churches, and when Napoleon took away their monarch, there was an armed rebellion. From 1808 until 1812 they fought a fierce guerilla war against the occupants, with torture, murder and other atrocities. Traces of the struggle are found in Goya's work.

One of the faces – or masks– in the crowd is particularly conspicuous, resembling a self-portrait Goya executed in 1815 at the age of sixty-nine, a painting approximately contemporary with *The Burial of the Sardine*. With his flat, peasant's face and deeply-set eyes, his slightly cocked head protruding from an open collar, the artist moved with ease among the common folk of Madrid. He was one of them – by birth, temperament and inclination.

Goya lived in Madrid for 50 years. Born the son of a gilder at Fuendetodos in

From bon vivant to lone wolf

Aragon in 1746, he had come to Madrid in 1774, achieving a certain renown through his large-scale cartoons for tapestries. In his book "Tableau de l'Espagne moderne" the French Baron de Bourgoing praised Goya's talent for "rendering the customs, costumes and games of his own country in a manner that is at once charming and true to life". As a portraitist, too, Goya was much in demand. With his passion for hard work, Goya's genius soon brought him success in the public sphere: in 1780 he was elected to the Academy of San Fernando, six years later becoming a court painter. In 1789 he was nominated "court painter to the king", a highly coveted position, bringing him a sizeable allowance. This not only secured his family's livelihood, but enabled the *bon vivant* Goya to indulge in the kind of extravagant lifestyle that a Madrid *manolo* would find appealing. Goya loved extravagance of all kinds; he dressed as a dandy and was especially proud of his fashionable coach. His correspondence shows him to have been an extrovert craftsman who, besides painting, was particularly fond of women, bullfights and hot chocolate.

Gradually, however, the uneducated artist came under the influence of his colleagues at the Academy: intellectuals, journalists and politicians. These men, with their dreams of a liberal Spain, had saluted with enthusiasm the outbreak of the French Revolution. Writing to a friend in 1790, Goya declared: "I have a mind to uphold a certain idea and to maintain a certain dignity that is said to belong to all men."

Two years later, Goya developed a near-fatal illness, leaving him stone deaf and increasingly isolated. The unsophisticated *bon vivant* turned into a brooding lone wolf. Though continuing his work as a portraitist, he refused to make any more cartoons of gay, folkloric scenes. He no longer painted for success, but in order "to occupy an imagination mortified by the contemplation of my sufferings."

He began a series of pictures of shipwrecks, night fires and dramatic scenes with brigands. These small pictures permitted him to capture observations "which one cannot express ... in commissioned works, since these do not allow free reign to fantasy and invention." Using engravings and drawings, Goya was able to give to each "fantasy" – each caprice, or "capricho" in Spanish – the most vivid expression possible. In 1799 he published a series of satirical engravings entitled *Los Caprichos*, castigating, in the manner of his "enlightened" friends, all kinds of stupidity, prejudice and superstition, and attacking the powers of oppression, including the Church and its Inquisition, for keeping the people in ignorance and misery.

There is a preliminary study for *The Burial of the Sardine* showing the wildly dancing figures as priests, monks and nuns. However, Goya did not dare ridicule such a powerful institution quite so directly in the painting itself.

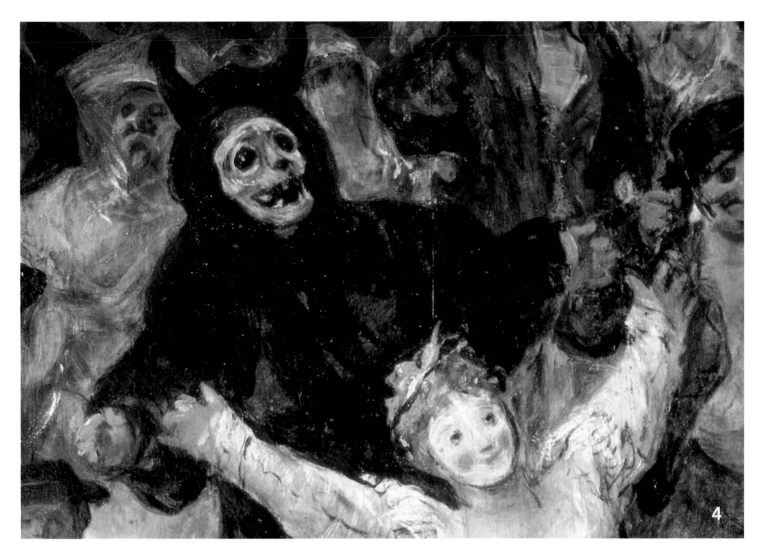

4

Death
in the guise
of a bull

The gathering is dominated by a sombre figure dressed in black, whose attributes, a death-mask and horns, have personified evil in myth and legend for thousands of years. Figures of this kind include a creature with a ram's head who accompanied the Celtic death god, the scapegoat sent into the desert laden with the sins of the Israelites, and Satan, in the guise of a black goat, celebrating eerie mass with his witches. In the arenas of Spain, black bulls, bursting with vigour, are vanquished by toreros who wear a glittering "suite of light", re-enacting, whether consciously or unconsciously, an ancient cultic ritual in which good triumphs over evil.

Goya himself is said to have been something of a bullfighter in his youth, and many of his works show the various stages of ritual killing. Together with *The Burial of the Sardine*, his *Bullfight in a Village* belongs to a group of five pictures donated by Manuel Garcia de la Prada, a friend of the artist, to the Royal Academy of San Fernando, where they hang to this day. Since the paintings are not mentioned in Goya's inventory of 1812, they were probably executed in the years that followed, a fateful period for Spain, as well as for the artist himself.

Though the Spanish had won the war against France, Ferdinand VII, the monarch they had "yearned for", returned in 1814 only to reintroduce absolute rule and, with it, the Inquisition. Reaction and the forces of oppression triumphed; whoever stood in their way was purged, tortured and hanged. One of Goya's friends, the actor Máiquez, lost his sanity in prison; others, liberals like himself, fled the country for France. Goya, too, was summoned before the Inquisition, probably to answer for the offence caused by his nude painting *Naked Maja*. He got off lightly, even retaining his allowance as a court painter. With the death of his wife and the Duchess of Alba, however, the artist became inreasingly reclusive, virtually retiring from public life altogether. The experiences and fears of these years are reflected in the five Academy paintings: besides *The Burial of the Sardine* and the *Bullfight*, there is an *Asylum*, a procession of fanatical, bleeding flagellants and a trial before the Inquisition.

These works mark a period of transition in Goya's oeuvre. Though remaining a painter of folk scenes containing realistic renderings of the customs of *la gente de a pie*, he began now to reveal the terrible abyss that gaped behind the seemingly harmless activities of the common people. His colours grew pale and ghastly, or deeply sombre, and his figures lost that characteristic "charm" which had once brought his work such admiration. Instead, they gesticulated like marionettes, with faces hidden behind masks: "For all life", according to the artist, "is a masquerade. Faces, dress and voice are false; each one decieves the other."

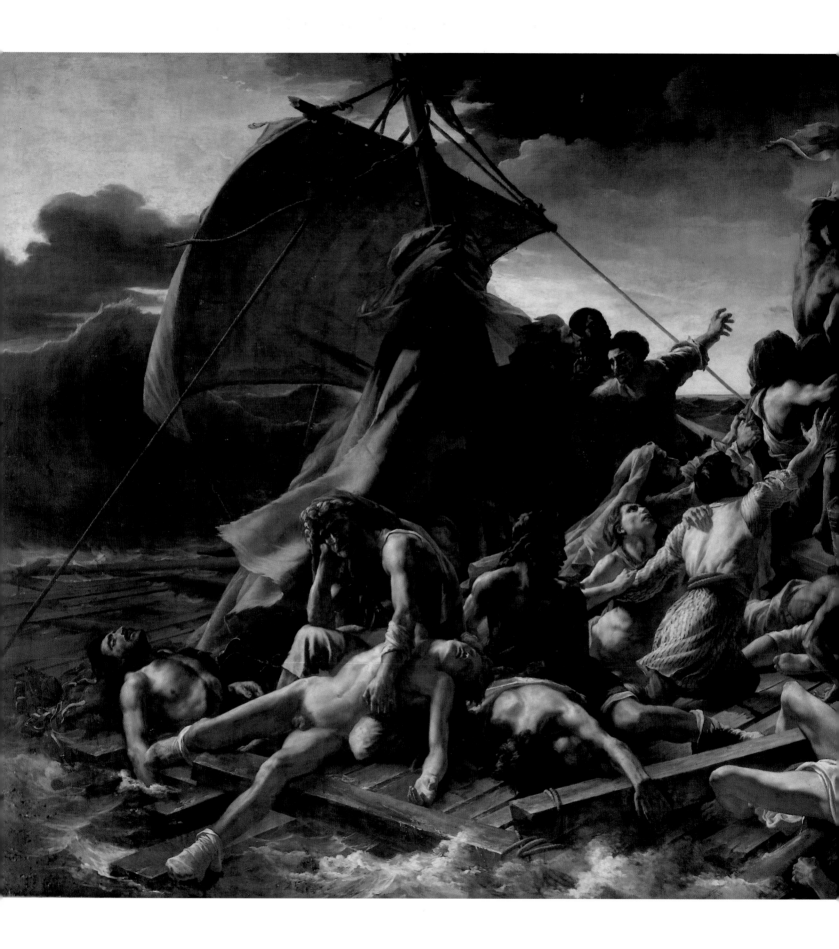

Dramatic struggle for survival

The press leapt on the story like a hungry animal. The first report of the wreck of the frigate "Medusa" was published in September 1816 by the Parisian *Journal des Débats*. Inquiry into the cause and exact circumstances of the disaster occupied the French newspapers for months to come. A tale of human misfortune – only ten of the 147 castaways on the raft had survived – snowballed into a political scandal. Government attempts to cover up the full extent of the catastrophe were exposed in the press by the opposition; public outrage led to the dismissal of the minister responsible, together with 200 naval officers.

The disaster and ensuing furore were not forgotten by the time Géricault came to exhibit his painting three years later. The title he had chosen for the work sounded anodyne enough: *Scene of a Shipwreck*. Without it, the painting might never have gained entry to the highly official Salon of 1819, an exhibition whose function was no less political than artistic. For the Bourbons, returned to the throne of France in 1814, needed a glamorous art show to demonstrate the nation's stability and prosperity under its legitimate ruler.

Inevitably, the artists whose submissions were selected for the exhibition were practically unanimous in the respect they brought to the regime and its closest ally, the Church. Two thirds of the large-scale history paintings – the centre of attention at every Salon – showed scenes from the lives of the saints; the rest paid tribute to previous French monarchs. (Interestingly enough, the majority of these works were by artists who had celebrated Napoleon's victories). By contrast, Géricault's painting flattered neither crown nor cloth; nor did it have much to contribute to "the nation's honour". On the contrary, it served as a reminder of a scandal which the new regime would rather have forgotten. The picture was a provocation.

Originally, twenty-seven-year-old Théodore Géricault had hoped his "Scene of a Shipwreck", submitted to the Paris Salon of 1819, would merely bring him fame. But it was not long before the monumental canvas, now in the Louvre, immediately recognized as a powerful testimony to the pathos of suffering humanity.

The first report of the wreck of the "Medusa" was published by Henri Savigny, one of the ten survivors, who had served on the frigate as the ship's surgeon. Géricault portrays him standing to the right of the mast, together with another survivor, the cartographer Alexandre Corréard.

Géricault was personally acquainted with both men and had read the book in which they recounted their experiences of the ordeal. The book was intended as a means of soliciting damages for the victims. Not only had all previous appeals been rejected, but their troublesome petitioning of the authorities had cost them their jobs in the civil service, as well as fines and even a brief spell in prison.

For all its subjectivity, there is no more revealing an account of the events that occurred on the raft: The royal frigate "Medusa" had left its French port on 17th July 1816, bound for Saint-Louis in Senegal. Described as the "swiftest and most mod-ern vessel of her day", her mission was to take possession of the West African colony of Senegal, which England had recently handed back to France. On board was the newly appointed Governor of Senegal, together with his family, civil servants and a marine battalion equipped "for the protection of overseas territories". Corréard was one of 60 scientists whose task was to explore and map the colony. All in all, there were some 400 people on board the frigate – more than usual, and certainly more than the life boats could hold.

Instead of obeying orders to sail in convoy with three other ships, the swift "Medusa" hurried on ahead, facing the long journey alone. The ship was under the command of Hugues Du Roy de Chaumareys, who, having fled from Napoleon, had spent the next twenty-five years of his career, not on the high seas, but visiting emigré salons in Coblenz and London. When the Bourbons took over from Napoleon, they rewarded their loyal subject by making him the captain of a ship: royalist sentiment was evidently more important than nautical prowess or sea-going experience.

En route to Senegal, aristocratic arrogance appears to have prevented the captain of the "Medusa" from heeding his officers' advice. Quarrels arose, and catastrophe finally struck: on 2nd July, calm seas and good visibility notwithstanding, navigational error and incompetence left the frigate stranded on the shoals of Arguin off the African coast between the Canaries and Cap Verde – a peril marked on every nautical map.

After several half-hearted attempts to refloat the vessel, the captain and leading officers lost their nerve and ordered the evacuation of the ship. The undue haste with which they did so led to panic, selfishness and brutality. The Governor, captain and officers crowded into six lifeboats, while 147 people, finding no room in the boats, were forced to clamber on board a makeshift raft, constructed out of planks, parts of the mast and rigging. A solemn promise was given that the boats would tow the raft to the nearest land. Two hours later, however, and under circumstances which have never been fully explained, the ropes linking boats and raft were severed. "We could not believe that we were entirely abandoned until the boats were almost out of sight," recalled Savigny, "but our consternation was then extreme."

Abandoned to the mercy of the Atlantic

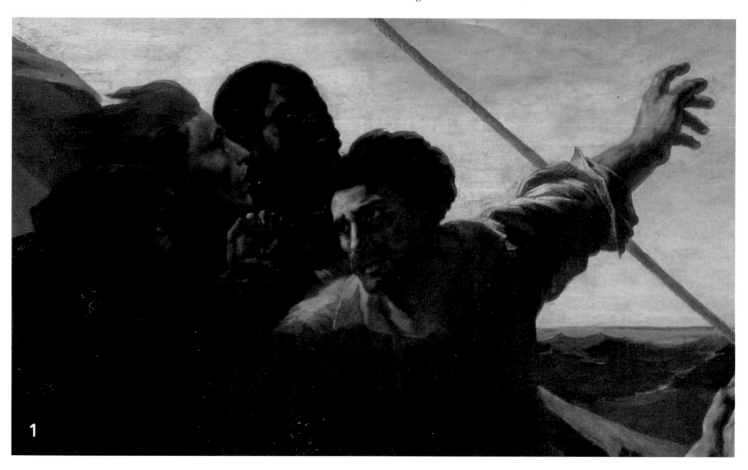

The survival of the fittest

The struggle for survival on board the raft now began in earnest. 147 castaways had only one case of ship's biscuit between them, and that was consumed on the first day. The water supplies went overboard during the first night; a few barrels of wine were all that was left to drink.

When fighting eventually broke out, it was not over biscuit and wine, but over the safest positions on the raft. A surface area of eight by fifteen metres ought to have left space enough for all, but the edge of the raft was frequently submerged under heavy seas, forcing the men to seek refuge nearer the centre. It was here that the few officers and civil servants who had not found a place in the lifeboats had taken up position, Corréard and Savigny among them. They had weapons, too, whereas the ordinary sailors and soldiers had been disarmed before coming on board. Twenty of these, who attempted to hold out at the edge of the raft, vanished overnight.

On the second night, fighting broke out as the men struggled for survival: "they all crowded towards the centre." The survivors of the ordeal, officers all but one, said there had been a mutiny: men who were drunk or mad with fear had tried to destroy the raft, attacking the officers who intervened. In legitimate self-defence, the latter had killed 65 men.

It is now generally thought that the officers exploited a welcome opportunity to rid themselves of as many rivals for wine and space as possible. After the first week only 28 survivors remained. However, even that was too many: "Out of this number fifteen alone appeared able to exist for some days longer; all the others, covered with large wounds, had wholly lost their reason", Savigny later wrote. "After a long deliberation, we resolved to throw them into the sea."

Savigny, a doctor of medicine, selected the victims himself. Later, he prepared a doctoral thesis on "The Effect of Hunger and Thirst on the Survivors of Shipwrecks", reporting that the survivors of the "Medusa" had supplemented their wine rations with sea water or urine from

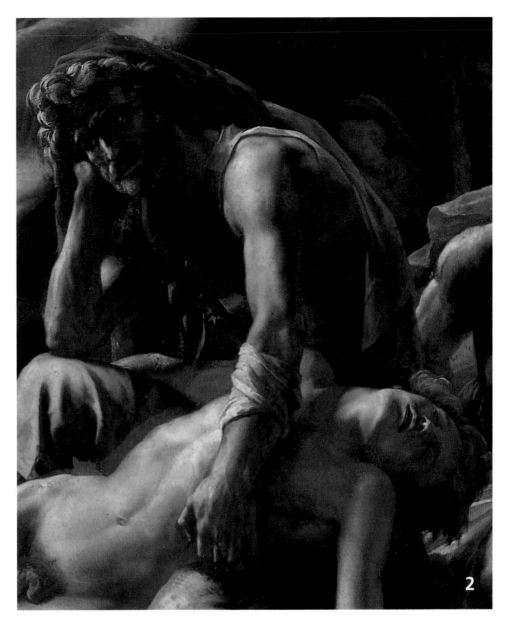

the fourth day onwards, and that cases of cannibalism had already begun to occur by the third day.

"Those whom death had spared", Savigny recalled, "threw themselves ravenously on the dead bodies with which the raft was covered, cut them up in slices, which some even that instant devoured. A great number of us at first refused to touch the horrible food; but at last, yielding to a want still more pressing than that of humanity, we saw in this frightful repast the only deplorable means of prolonging existence."

It was Savigny himself who suggested cutting the flesh of the dead into strips in order to let it dry in the sun. The sailors who later rescued the survivors found these shreds of flesh particularly repugnant, at first taking them for drying clothes, or sails. Géricault does not include this detail in his work; there is no

sign of cannibalism in the painting. Only in one of his many preliminary studies for the work did Géricault include two naked men eating a dead body. Cannibalism was taboo, and examples of its treatment in western art are few and far between. However, Géricault does include a cryptic reference to it in the form of the classically paternal gesture of a figure supporting the dead body of a youth. The figure was reminiscent of Count Ugolino, the subject of several well-known contemporary paintings. The legendary Ugolino, accompanied by his sons and grandsons, was imprisoned by his enemies in a tower without food. When the children died, the Count tried to keep himself alive by eating their flesh, as his account in Canto XXXIII of Dante's *Inferno* suggests: "and for two days I called them, after they were dead, then fasting had more power than grief."

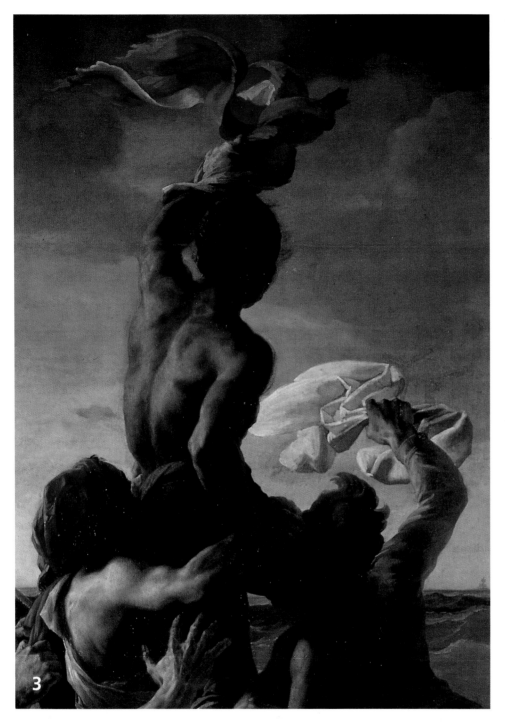

3

Hope
on a distant
horizon

After 13 days on board the raft, the remaining survivors of the "Medusa" saw a ship: it was a brig called the "Argus", which had been sent to search for them. It "was at a very great distance; we could only distinguish the tops of its masts", wrote Savigny. "Fears, however, soon mixed with our hopes; we began to perceive that our raft, having very little elevation above the water, it was impossible to distinguish it at such a distance. We did all we could to make ourselves observed; we piled up our casks, at the top of which we fixed handkerchiefs of different colours ..."

Géricault shows the tiny ship on the distant horizon; he paints the barrels and cases on which those waving supported themselves, with a black man at the highest point. The name of the latter was Jean-Charles, probably the only "common man" among the fifteen survivors, the rest being officers, scientists and clerks. Jean-Charles had to obey orders; it had been his job to throw overboard the victims of Savigny's selection. Like four other survivors, he later died on board the "Argus" after eating too much too hastily.

In order to paint the work Géricault went to considerable lengths to research his material thoroughly. He conducted interviews with Corréard and Savigny, and even had a small model built of the raft. The painting was so large (491 x 716 cm) that he was forced to hire a more spacious studio. He found one near a hospital where he was permitted to make sketches of the sick and dying, even taking home dead limbs in order to observe their discolouration in the early stages of putrefaction. He collected all the information he could find for a realistic picture, which he did not paint.

For example, he gives Jean-Charles the back of a muscular, well-fed young man; after 13 days without food, however, the muscles are reduced and bones show through the skin. In Corréard and Savigny's report, the mens' skin was burned red by the sun, their bodies covered with weals and fissures. There is no sign of this in Géricault's painting. Rather than the reddish blue of real corpses, his dead have a certain idealized lividity. Whether dead or alive, the men are all clean-shaven and relatively well-kempt, whereas reports of the incident speak of long and tousled hair.

Nor do the weather conditions depicted in Géricault's work reflect those actually recorded on 17th July 1816. The sky was clear and the sea calm, but Géricault shows gathering clouds and towering waves. The effect – a perilous sense of foreboding – would have been difficult to achieve against the background of a calm sea.

Despite the powerful presence exercised by the ocean here, it in fact occupies only a small area of the picture space. Traditionally, maritime scenes devoted large areas of the canvas to the water itself, with persons and ships kept relatively small. Earlier versions of Géricault's painting show similar proportions. As work progressed, however, increasing prominence was given to the raft, so that the spectator of the final version feels practically able to step on board. As the figures grew larger, the water was marginalized and emphasis was given to the pyramidal structure of the composition. It was not realism Géricault sought, but sophisticated grandeur on a monumental scale.

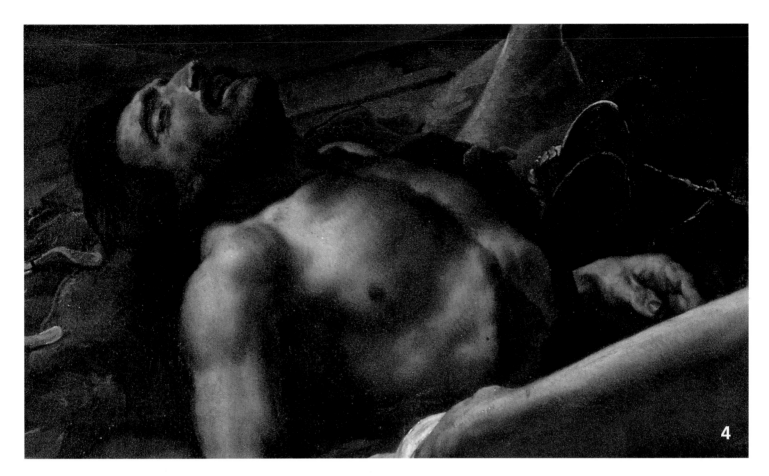

4

Flight from responsibility

On delivering the finished painting and seeing it for the first time outside his studio, Géricault discovered formal weaknesses. He is reported to have added, working at phenomenal speed, a corpse to the bottom left and bottom right of the canvas, broadening the base of the pyramid of bodies, stabilizing the composition and strengthening the monumental effect of the painting.

Monumentality, both in format and execution, was a stylistic feature of the history painting, a highly esteemed genre at the time. The history painting, so it was said, showed whether an artist was truly talented. Its prerequisites were stylistic fluency and thematic concentration on famous or dramatic incidents drawn from national, Christian or antique history. Géricault's work did not fulfil these requirements: the "Medusa" scandal was too contemporary. One of the spectators immediately accused the artist of "slandering the entire Ministry of the Navy with the facial expression of one of the men in the painting."

Contrary to Géricault's hopes, the painting was not purchased by the Bourbon king, and the criteria by which the critics judged it were not so much artistic as political. Echoes of its political resonance can be felt even in our own time: 1968 saw the première in Hamburg of an oratorio composed by Hans Werner Henze entitled "The Raft of the Medusa", which the composer deliberately turned into a demonstration with red flags and the appropriate slogans. The police intervened and the affair ended up in court.

It has never been satisfactorily ascertained whether Géricault actually intended his painting to have a political effect by denouncing the corruption of the regime. There is much to suggest that this was not the case. For one thing, the artist seems to have been genuinely surprised that the government did not buy his work. There is also his choice of potential subjects for the painting: Barbary horses being driven through the streets of Rome during Carnival, or a murder scene in provincial France. His real aim was to paint a work on such a grand scale and to such tremendous effect that he would finally – at the age of twenty-seven – achieve the recognition he felt he deserved.

Personal considerations may have been more important than political convictions in determining his choice of subject. He began to paint the raft after a love affair with the young wife of one of his uncles. His mistress was banished to the country, the child she bore him taken from her and given away for adoption, a course of events which the artist did nothing to prevent. So meticulous was his family in hiding the threat to its reputation that the affair only came to light recently, a hundred and fifty years after the event.

From what is known of this period in Géricault's life it seems he spent much of it in the big studio he had hired, tortured by the thought of his cowardice and guilt. For like the captain of the "Medusa" he had deserted his dependents in their hour of need. He cut himself off from his friends and had his head shaved to prevent himself going out, sentencing himself, as it were, to 18 months' hard labour. Evidently, however, the long hours he put into the *Shipwreck* were not enough to expiate his sense of guilt and personal failure, for as soon as his masterpiece was finished, he redoubled his efforts to punish and, indeed, destroy himself: he undertook several suicide attempts, and rode everywhere he went at breakneck speed, causing a series of accidents. Eventually, he was badly injured falling from a horse, and died in 1824, at the age of only 32.

Across the river and into the past

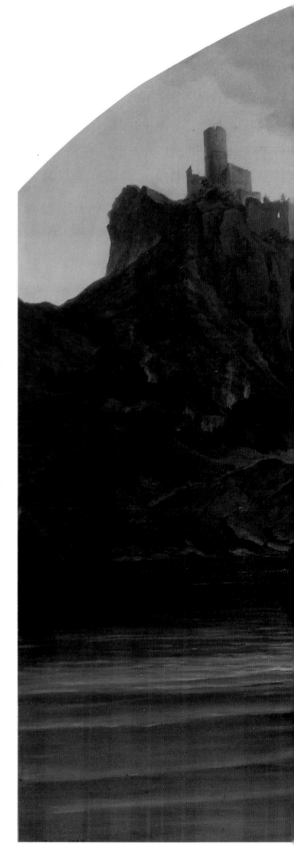

The ferry boat, with its passengers old and young, lends an air of tranquil contemplation to the scene. Yet Germany was already well on its way to becoming an industrial state: trains and steamships were the new forms of transport, and factories replaced the old artisans' workshops. Richter's flight from contemporary reality has ensured the popularity of his work to this day. The painting, measuring 116 x 156 cm, is in the possession of the Staatliche Kunstsammlungen, Dresden.

There is a condescending tendency among art historians to treat Ludwig Richter (1803–1884) as a minor craftsman rather than a real artist. Judging by his popularity, however, he must inevitably be seen as one of the great German painters of the 19th century. The subjects he chose – Romantic landscapes and sentimental idylls – were not alone in determining the popularity of his work; it was the printing press that established his mass appeal. His main customers were publishers and bookshops who commissioned him to produce illustrations for calendars, fairy-tales and songbooks. Ordinary folk could thus afford to buy Richter's pictures.

Richter's father, too, had worked as an illustrator. Ludwig was born at Dresden in 1803, leaving school at the age of twelve. He was expected to learn copper engraving to help his father, but his real wish was for freedom to paint his own work. He was twenty years old when one of his father's customers financed a much longed-for journey to Italy, and Richter travelled to Rome to paint "historic" landscapes.

In 1826 he returned to Saxony, becoming a teacher of drawing at the school of porcelain painting at Meißen. Lonely at first, oppressed by the narrowness of his environment, he longed to return to Italy. A turning-point finally came in the thirties, and the painting of the boat shows the direction his work now took. In his *Memoirs of a German Painter* he noted that, after an excursion near the town of Aussig in northern Bohemia, he had asked himself: "Why go looking for something in distant climes when you can find it so close to home?" Richter continued: "Returning to Aussig, I made several sketches of Schreckenstein and its surroundings. I was standing on the bank of the Elbe just after sunset ... when my attention was drawn to an old man ferrying people across. His boat, loaded with people and animals, pushed silently across the river, in which glowed the reflection of a golden evening sky ..."

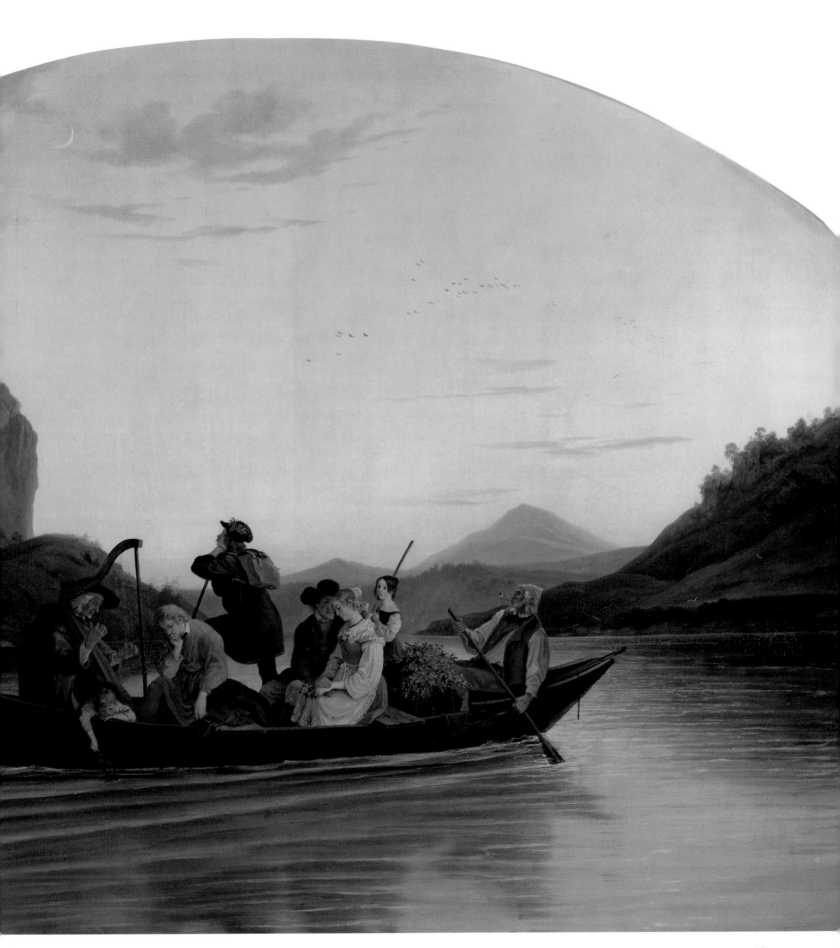

1

Gentle music of a bygone age

Richter's *Memoirs* contain the following observation: "Amongst other things I noticed a boat crossing with a motley crowd of passengers, one of whom was a old harper who paid his fare by playing to the assembled company."

In our own time the harp is rarely heard outside the concert hall, but in those days, a smaller version of the harp was one of several instruments frequently played by itinerant musicians on the streets of towns,

or at inns. As a boy Richter was evidently fascinated by these figures. In his memoirs he recalls visiting a coffee-house with his father: "But what interested me most was the blind harper sitting under a linden outside, playing ballads and singing some very funny folk-songs ... Whenever he sang, I went up and stood so close it must have appeared that I was counting the very words that came out of his mouth."

In fact, the group of figures in Richter's boat owes very little to chance; far from a "motley crowd of passengers", each figure has its own special significance – like the "bark" itself. A full boat crossing a river symbolized the journey of life: one was never sure whether it would arrive safely

on the other side. At a more or less subliminal level this ancient motif formed part of every contemporary spectator's response, though it might be as unobtrusive as it was in the present landscape.

The figure of the harper was equally significant. His instrument – like the guitar – generally served as a form of accompaniment. Poets of antiquity had been harpists, like Ossian, the 3rd-century Celtic bard. The Ossian cult, widespread in the second half of the 18th century, had led to one of the greatest scandals of literary history. A Scottish teacher by the name of James Macpherson had composed "translations" of Ossian which, especially in Germany, won him considerable acclaim.

The exposure of the forgery did nothing to diminish contemporary enthusiasm for bards. In the popular imagination these were semi-mythical figures, associated with notions such as the "mists of time", the "wisdom of the ancients" and the "mystery of Fate". Johann Wolfgang von Goethe established a literary monument to a bardic figure in his novel *Wilhelm Meister's Apprenticeship.*

But anyone who had Goethe's harper in mind necessarily also thought of Mignon, a character in the same novel, and it cannot be attributed to accident that Richter places a child next to the harper in the boat. Goethe's Mignon is the spirit of ideal childhood incarnate: she composes poetry, sings and – dressed as an angel – leaves a deep impression wherever she goes. Apparently neither male nor female, she seems rather to incorporate a higher synthesis of both, dying before she is forced to leave that state of innocence and purity. The writer thus spares her the trials and tribulations of puberty.

The apotheosis of childhood as the highest stage of life, from which human beings are forced to descend in order to become adults, is found in the works of almost all German Classical and Romantic writers: in Goethe, Schiller, Hölderlin, Tieck, Novalis and Wackenroder. "Wherever you find children, you will find a Golden Age!" enthused Novalis. And according to Wilhelm Heinrich Wackenroder: "That aetherial gleam, the token of a world once peopled by angels, lives on, stirring afresh in the vital spirit of each new-born child." Or Hölderlin: "Yes, the child is a divine being, so long as it remains untouched by the colours of chameleon humanity!"

2

Flight from a loathsome world

Richter's journey on foot across the Alps to Italy had taken him in search, not only of the South, but of the past. Italy was a land of ancient cultures, whose masters were required study. Here, the world of the past lived on in the present: "The entire region I had walked through along that coast was like some ancient, yellowed sheet of parchment from the book of history!" His aim was to paint "historic" landscapes. The world of the present evidently offered few attractions.

Richter's view of the Elbe, too, lends prominence to the past. His composition deliberately exaggerates the height of the rock on which Castle Schreckenstein stands, thereby heightening, too, the Romantic significance of the old building. The figure of the wanderer on board the boat, overcome by longing or lost in thought, gazes up at the ruin.

He may have been musing over the fate of German patriotism. Following Napoleon's humiliaton of Germany, the Wars of Liberation were fought in the hope of uniting the German states and establishing democratic rights to limit the power of the feudal princes. The kings and princes, politically divided amongst themselves as ever, were nonetheless united in their struggle to suppress the "democratic itch". Intellectual activity of all kinds was stifled by censorship and the exclusion of "radicals" from public service.

Only a small section of the patriotic movement resisted, attempting to establish the conditions for greater political participation. Most of these were doomed to failure: Joseph Görres, editor of the *Rheinische Merkur*, fled to Strasbourg in 1819; Heinrich Heine emigrated to Paris in 1831, and in 1849, Richard Wagner fought in vain on the side of the revolutionaries at Dresden.

Ludwig Richter belonged to the silent majority whose resistance was passive, who fled to the past: a world of castles in which Germany was strong and beautiful and Germans of all social strata lived together in peace and harmony. Or such was the illusion they cherished.

As a young man Richter had been treated with terrible injustice by a noble. He had been employed, at the age of seventeen, to make sketches for a travelling Russian prince, accompanying his entourage to France. For a young man of lower middle-class background, this was a unique opportunity to see a bit of Europe. However, the journey turned out to be a dreadful experience of dependency and cruelty at the hands of a moody despot. "I had fallen into total disgrace ... The thing that hurt me most was the way the other gentlemen spurned me whenever the Prince was present ... I sometimes felt like a ghost among the living, with no way of reaching their ears ... a dreadful predicament, with no hope of escape ..."

Even the seventy-year-old, composing his memoirs, cannot deny the depth of the wound; yet he puts it down to personal fate, or sees it as a trial sent by God. It evidently did not occur to Richter, whether at that time or any other, to make some contribution of his own towards changing the political or social conditions of the age. Apart from the war scenes of 1813, politics are not mentioned in his *Memoirs*. In the words of Richter's son: "He had no time for day-to-day political debate, for chewing the political cud, as it were; he felt it was all quite beyond him; it was like being asked to judge a painting someone was holding in front of your nose. In order to make a reasonable assessment, you had to look at a thing from the proper distance, or allow a certain amount of time to pass."

Richter was an unpolitical patriot; he loved his native German soil more than the power of a state: "How my heart leapt as we beheld once again a land whose people and customs were so obviously German!"

On returning from Italy, Richter had originally intended to publish a series of etchings, entitled *Three German Rivers*, with scenes of the Rhine, Danube and Elbe: "In fact, the entire artistic idea was born of patriotic sentiment."

The work on German rivers never happened, but the "artistic idea" stayed, informing everything he undertook from then on. Like the *Schreckenstein Crossing*, his work became a celebration of his native land – or what he wished that land to be. His paintings had little in common with contemporary reality.

The real world of "German rivers" saw an increasing number of steamships re-placing both sailing boats and the horses that had once pulled barges from tow-paths along the riverbanks. Rivers were made progressively navigable, and canals built in great number. In 1800 there had been 725 miles of navigable inland water-ways in Germany; by 1850 the distance, at 2200 miles, had more than tripled. There would certainly have been ferrymen in Richter's day, and they were probably even known to ferry the odd harper across a river, but both figures stood, not for what was new or typical of the modern era, but for timeless continuity with the past. Richter preferred to paint "historic" landscapes.

The real world also meant improved roads and new railways. But these are rarely found in the artist's work, appearing only in his memoirs, where he describes streets in towns as "racecourses for people and vehicles". He also recalls a suburb of Dresden where he lived for many years, where "steam locomotives pierce the air with their shrill whistles, and wagons clatter along railway tracks and through streets that have replaced once peaceful cornfields with a world gone steam-mad." In 1837, the very year Rich-ter painted his *Schreckenstein*, building work began on the railway from Dresden to Leipzig.

The real world meant factories, too, which Richter did not paint. When he paints people at work, they are invariably shown going happily about their business in a field or artisan's workshop. He wanted to show the "life and joys of the people" rather than their sorrows and woes. Had Richter wished to assemble in one boat figures who epitomized his period, its passengers would certainly have included a businessman and a factory worker.

Finally, there is no sign in Richter's pictures of the rocketing population growth, though the population of Germany practically doubled in Richter's lifetime, and indeed, that of Dresden tripled, growing from 60,000 to 180,000. Change on such a drastic scale may well have felt threatening to a timid man. Richter fought back with his paintings. In that sense, they are anti-pictures: unhoused in the present, the artist celebrated the ancient homeland of his fathers.

Native soil transfigured

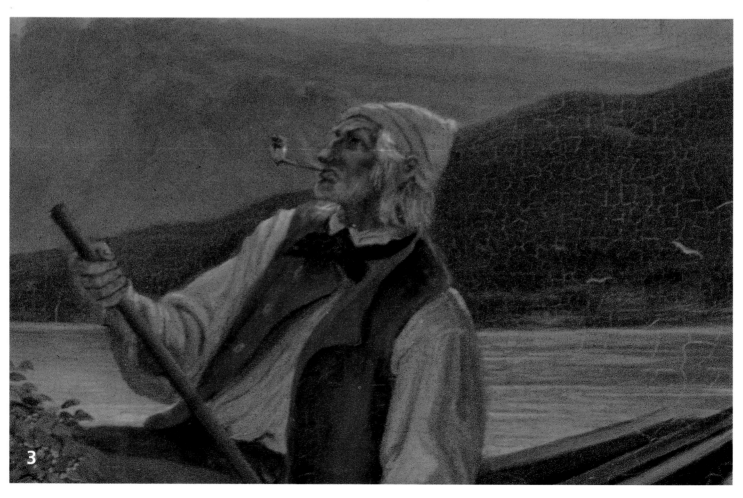

3

"A state of bliss that made us silent"

In the expanding 19th-century cities, the neighbourly spirit which continued to be found in villages and small towns, where everybody knew everybody else, had more or less dissolved: there were too many people one knew nothing about, and their number increased daily. The weakening bond of neighbourly relations, once the basis for help and safety through mutual observation, was now replaced by something new: the privacy of the family.

The change may be illustrated with reference to festive occasions of various kinds. In the 18th century Christmas was primarily a religious festival, celebrated in the community. It was not until the beginning of the 19th century that it became a family occasion. From now on, celebrants rejoiced not only in the birth of Christ, but in the community of parents and children. A similar change can be observed with regard to weddings. In smaller communities the entire neighbourhood was invited to take part in a celebration that generally lasted several days. A wedding was very much a public event. Ludwig Richter's wedding, on the other hand, in the growing city of Dresden in 1827, was an intimate affair with very few guests. Nor did he recall the official, demonstrative aspect of the wedding as its most noteworthy feature: "Our wedding day passed very simply, in an atmosphere of beauty and good cheer. As for us, we had entered a state of bliss that made us silent, for which there are no words, and which expressed itself in looks, tone of voice, and the warmth with which we took each other's hands." The young couple in Richter's boat has something of that blissful intimacy.

Feelings began to have a stronger say in more than choice of spouse. In previous centuries, families had resembled teams whose *raison d'être* lay in mastering the everyday tasks of survival. Relations between individual members of the family tended to be reserved, governed by practicalities. In Germany, children addressed their parents with the polite "Sie", and husbands and wives often used each other's surnames. Now, however, more intimate forms of address, the "Du" and first names,

4

tokens of trust and affection, began to replace traditional forms; fathers, too, spent more time with their children.

Richter recalls "with pleasure the long evenings we spent sitting around the stove with the children, listening to the same story for the tenth time, or making up new ones." A visitor to the Richter family speaks of the "poetry of a German household". The kind of "German household" he meant was inward-looking, closed to the outside world. Its warmth and homely security alleviated the burden of noisy machines and political oppression.

Their transfiguration of family life is one of the main factors contributing to the popularity of Richter's paintings in Germany. Equally important in this respect is their rejection of responsibility in the public sphere, their flight to the cosy refuge of hearth and home. Even the ferryman and his passengers have a certain homey familiarity. In moony silence, they listen to the harper, united by the "atmosphere" of the scene, and it would require few alterations to pose or dress to transpose them from their mighty river to a scene in a bourgeois sitting room.

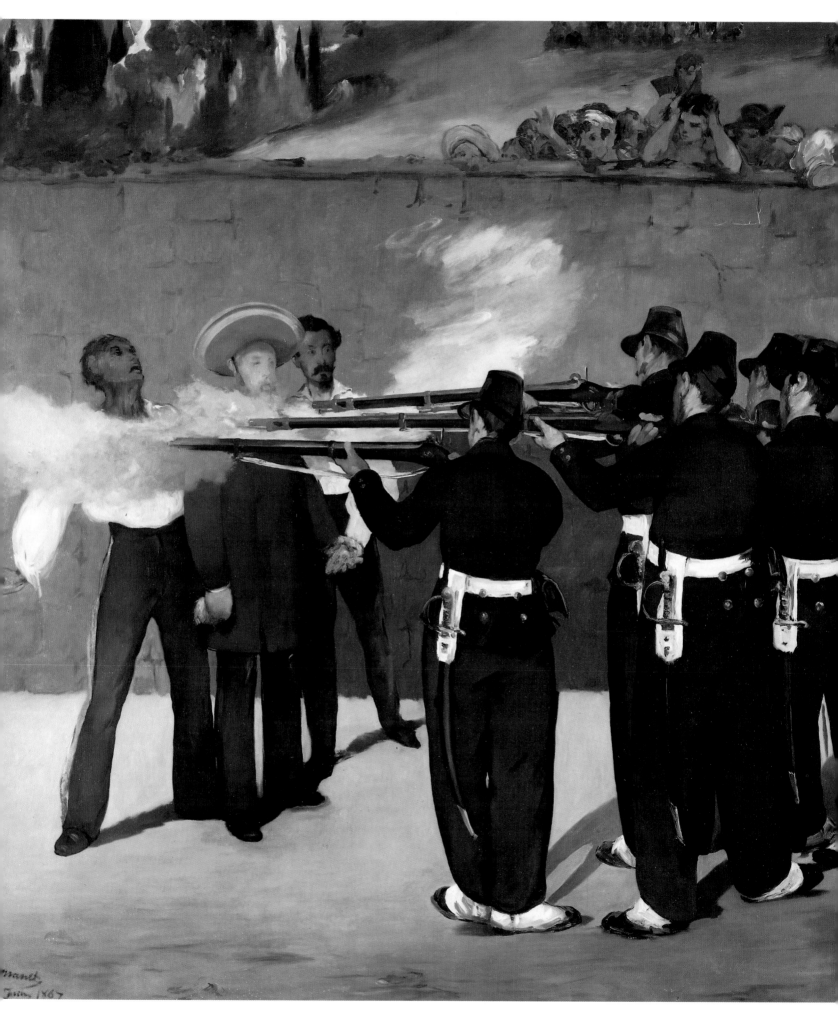

The wrong uniform exposes the true culprit

Edouard Manet intended this painting to denounce a political crime and stir up French public opinion. The imperial censor intervened, however, hindering his design. The authorities discreetly informed him that it would not be worth his while to submit his "otherwise excellent" painting to the official Parisian art exhibition, the Salon of 1869.

Manet's work showed the climax of a drama which had occupied the European press for years. Any regular newspaper reader would immediately have recognized the scene: during the early morning of 19th June 1867, near the Mexican town of Querétaro, a Republican firing squad had executed the Austrian Archduke Maximilian and two of his generals. For three years Maximilian had ruled as Emperor of Mexico. Officially invited to the land by a conservative minority, he had been persuaded to participate in the ill-fated adventure by the French Emperor Napoleon III, who had also supplied an army. When Napoleon withdrew his troops from Mexico, Maximilian was taken prisoner by his enemies. Forced to abdicate, he was sentenced to death and executed.

"You can understand the horror and the anger of the censors", wrote Manet's friend, the writer Emile Zola, in 1869. "An artist has dared put before their eyes so cruel an irony: France shoots Maximilian!" Manet had delivered a topical painting on a political scandal – as effective a medium at that time as the photos in some of today's news magazines. France had a tradition in such paintings: Théodore Géricault, in 1819, had attacked the criminal incompetence of the naval authorities in his *Raft of the Medusa* (ill. p.144/145), and in his *Massacre at Chios* (1824), Eugène Delacroix had pilloried Europe's indifference to the Greek liberation struggle. Both works were exhibited, caused a sensation, and achieved a political effect.

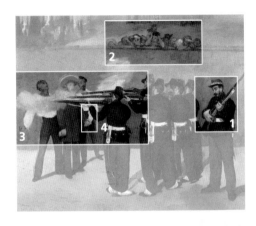

Manet must have hoped his *Execution* would be similarly received, and began work shortly after first reports of the execution reached Paris in early July of 1867. One and a half years later he had produced a small study in oils, a lithograph (prints of which the censor forbade him to sell), and three large-scale paintings. None of these works was exhibited in France during the artist's lifetime. The Second Empire's demise in 1870 brought no improvement, for few people in Republican France desired to see paintings that reminded them of the humiliating Mexican episode.

The canvases were consequently kept rolled up in a dark corner of Manet's studio; the largest, after the artist's death in 1883, was cut into several pieces, fragments later finding their way to London; the oil sketch, meanwhile, went to Copenhagen, and the first version of the large-scale work to Boston. The final version, completed in late 1868, and measuring 252 x 305 cm, carries the date of the execution. It was bought by citizens of the German town of Mannheim in 1909, who donated it to the Kunsthalle. The political atmosphere in the German Reich at the time was such that any reference to the fickleness and perfidy of France could be sure of a warm welcome.

While the squad fires upon its victims, a sergeant wearing a red hat, who, at first glance, seems peculiarly uninvolved, cocks his rifle. The inglorious task awaiting him is to deliver the *coup de grâce* to Emperor Maximilian. The sergeant, with his beard and sharply defined nose, bears a striking resemblance to Napoleon III. The similarity was intended. Manet, of upper middle-class background, was no friend of the Second Empire. By the time he came to paint the final version of the *Execution*, he had realized, like the majority of his contemporaries, that

"Napoléon le Petit"

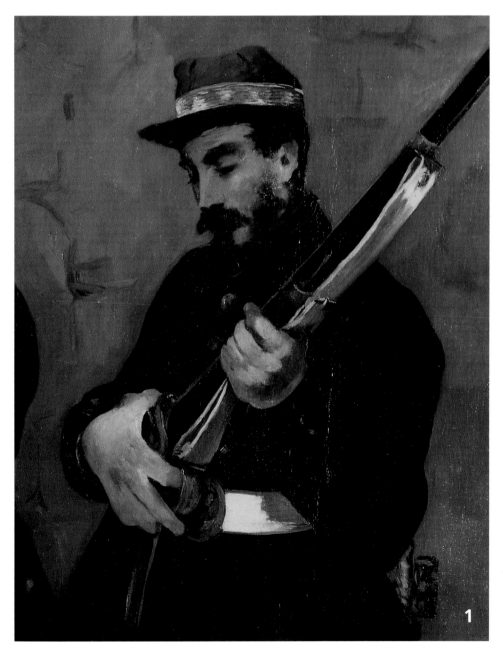

it was Napoleon who was responsible for Maximilian's ignominious demise.

Louis Napoleon Bonaparte (1808–1873) was contemptuously referred to by his enemies as "Napoléon le Petit". He spent most of his life trying to emulate his famous uncle, Napoleon I. In 1848 he was successfully elected President of the Republic; three years later he became emperor by virtue of a coup d'état. His next plan was to establish French hegemony in Europe. However, he was less fortunate in foreign affairs than in establishing his position at home. In the early 1860s, he endeavoured in vain to influence Italy. Searching for a new outlet for his intervention politics, he concluded, somewhat astoundingly, that the distant land of Mexico offered the key to establishing France as a great power.

It was a power vacuum which enticed Napoleon to Mexico, a country rich in mineral resources, but badly run down and heavily in debt. Since gaining its independence, it had been torn by chaos and anarchy, with a civil war raging between the conservatives – the aristocracy, big landowners and church – and the liberal, Republican forces.

When the reformer Benito Juárez was elected President in 1861, his opponent and the loser of the election, General Miguel Miramón, emigrated to France where he was succesful in enlisting the support of influential French financiers and of the court itself. Napoleon conceived of a plan to win Mexico while its powerful neighbour, America, was involved in the Civil War. Napoleon wanted to establish a "bulwark" on the American continent against Anglo-Amercian expansion – a Catholic, "Latin-American" empire, which would enjoy French protection, and from which France would profit economically.

From 1861 onwards, and under various pretexts, France sent 40,000 troops across the Atlantic. They were followed three years later, once the country had been temporarily "pacified", by the Austrian Archduke Maximilian, whose fate, as Emperor of Mexico, was utterly dependent on Napoleon. When he arrived, the land was still largely under the control of Republican forces. His sole support as a ruler, besides French bayonets, was Napoleon's solemn vow, laid down in writing, that France would never deny its support to the new empire "whatsoever the state of affairs in Europe".

However, the American Unionists, emerging victorious from the Civil War in 1865, recognized Juárez as the legitimate Mexican president, sending arms and refusing to tolerate a French presence on the North American continent. Napoleon finally acquiesced to U.S. diplomatic pressure, for his position in Europe was under serious threat. He needed every man he could muster to defend the Rhine against a superior Prussian army. The last French soldier left Mexico in early 1867. Napoleon III, in tears, had broken his word. This cost him whatever popular credit he had once enjoyed and contributed to the rapid decline of the Second Empire. Mexico proved both the Moscow and the Waterloo of "Napoléon le Petit".

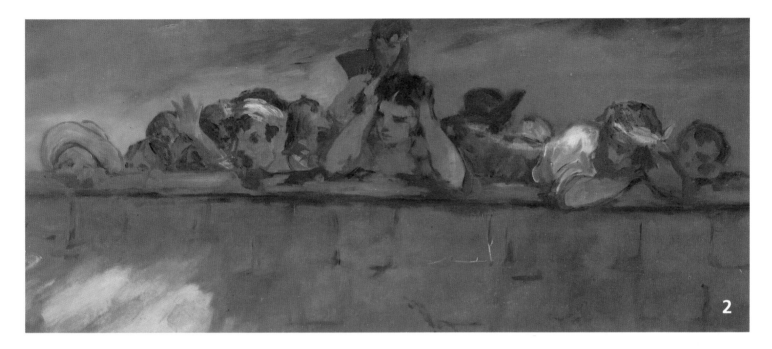

2

Not unlike spectators at a bullfight, a crowd of Mexicans has gathered in the background to watch the execution of the Emperor. They were probably part of the great mass of mestizos, mulattos, Indians and blacks who lived without rights or property. Benito Juárez,

The role of the Mexicans

a full-blooded Indian and former President of the High Court, had guaranteed them civic rights for the first time in his Constitution of 1857, expropriating the Church to provide the people with land. Juárez was their man, and they gave him their support in the guerilla war against the French.

Mexican national pride was, from the outset, unlikely to grant much of a welcome to a foreign monarch arriving from a distant continent. When Maximilian and his wife landed at Veracruz on 28th May 1864, a deathly hush fell on the harbour;

the inhabitants had all stayed at home. With the withdrawal of the French troops, Maximilian's fate was sealed. Abandoned by his Mexican officers, he was taken prisoner by the Republicans and placed before a military tribunal. Sentenced to death, he was refused a pardon by Juárez, a step which led to an international outcry. The President was accused of flagrantly violating international law.

When news of the execution arrived in Paris, the ensuing protest was therefore initially directed against the Mexicans. Commencing the painting in 1867, Manet may originally have wished to denounce the Mexicans: the first version of the *Execution*, now at Boston, shows the squad and sergeant in Mexican uniforms and sombreros.

In the course of July, however, it gradually dawned on the Parisian public that the true culprit was not Juárez at all, but Napoleon. Manet painted over details of the exotic costumes, refining the wide breeches and sombreros to suggest French uniforms. This gave the first version a peculiarly unfinished, ambiguous character, making it unsuitable for presentation. Manet went to work again, giving the sergeant, in each of the later versions, the features of Napoleon. From now on there could be no doubt of the artist's intention; the artist was criticizing his own government: Maximilian shot by Frenchmen, with the Mexican people as mere spectators.

The Emperor is shown at the place of execution, standing between two loyal generals: dark-skinned General Tomás Mejía, and the former president and infantry commander Miguel Miramón. Manet apparently took the Emperor's pale face and blurred features from a contemporary photograph. The French press had reported that Maximilian, on his last journey, had worn a dark suit, as well as the broad-brimmed sombrero of his adopted country. A handsome, erect figure with a thick blond beard, Maximilian had presented himself until the end – according to a conservative Parisian newspaper – with the dignity befitting a true Habsburg.

To Napoleon, Maximilian must have seemed the perfect candidate for such an unpromising campaign in distant Mexico. The prospect of "wresting a continent from the grip of anarchy and poverty" was not without appeal to the thirty-year-old Archduke Ferdinand Maximilian of Austria, unhappy as he was in his role as younger brother of Emperor Franz Joseph. Con-

demned to political inactivity in Europe, forced to occupy himself building palaces and collecting butterflies, he leapt at Napoleon's offer of the Mexican throne as if responding to the call of divine Providence.

Beguiled by Romantic dreams, Maximilian ignored all well-meaning warnings. Putting his trust in Napoleon's promises, he embarked on the Mexican adventure – though militarily and financially, the conditions for such an enterprise were as dire as they could be.

The Mexican state was heavily in debt; maintenance costs for the French taskforce alone swallowed up more than its entire annual income. Funds were too low to pay for the upkeep of an indigenous army; the few Mexican soldiers under French command, realizing they were unlikely to be paid for their services, deserted to the Republicans.

With his own zeal fully absorbed by the task of bringing "guidance and refinement to the people", Maximilian left everyday political business to his French advisers, who, deliberately withholding intelligence of the deteriorating military situation, persuaded him to lend his signature to unpopular measures, such as a summary death penalty for the slightest resistance to the imperial government.

When Napoleon withdrew his troops in 1867, Maximilian, with his handful of Austrian and Mexican loyalists, found himself

facing an army of 60,000 Republicans who had most of the country under their control. A sense of honour prevented the Emperor from leaving Mexico with the French troops. A Habsburg, he was reported to have said, "did not flee"; nor would he "desert the post which Providence had conferred upon him; no danger, no sacrifice could force him to recoil until such time as his task was fulfilled or destiny was stronger than he."

The Emperor, lured into a strategic cul-de-sac at the town of Querétaro, betrayed by a Mexican officer, gave up after 72 days of siege. He could have escaped even then, for the Republicans saw no advantage in turning him into a martyr. But Maximilian refused to budge, finally leaving his opponents with little choice about what to do.

When his adjutant found a crown of thorns on a broken statue of Christ in the monastery courtyard where the Republicans were holding him prisoner, Maximilian said: "Give it to me; it will suit me well."

Like Christ, he felt himself "betrayed, deceived and robbed … and finally sold for eleven *reales* …" In Edouard Manet's rendering of the execution, the bright, broad rim of the sombrero surrounding the doomed victim's face has the appearance of a halo.

Dignity befitting a Habsburg

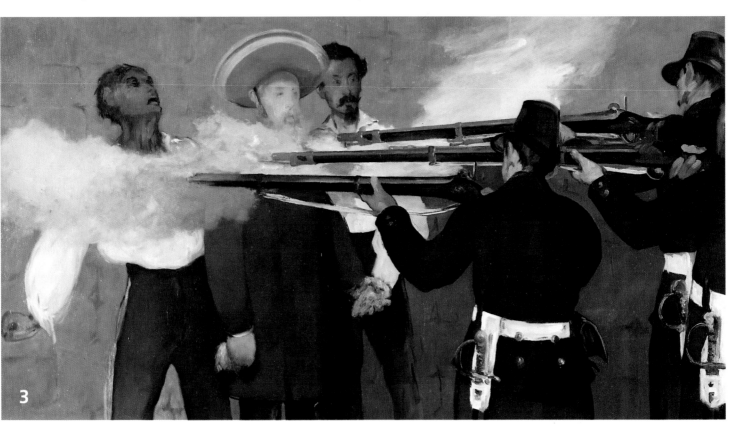

Goya provided the prototype

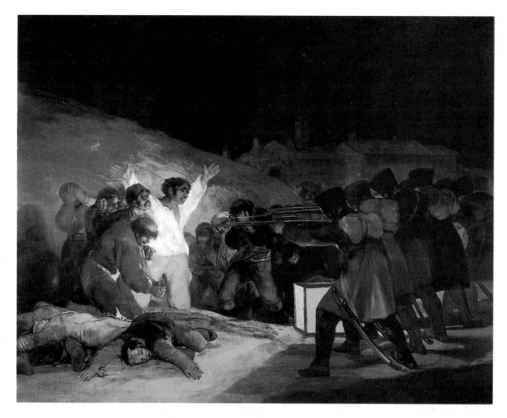

There is one thing I have always wanted to do", Manet once confided to a friend, "I should like to paint Christ on the cross ... What a symbol! ... The archetypal image of suffering." In the *Execution* scene Manet comes close to achieving this ambition. Emperor Maximilian may not be wearing a crown of thorns, but his left hand, and the hand holding it belonging to Miramón, already show signs of bleeding, though the squad is painted in the very act of firing. The detail is contrived, an allusion to the nail and lance wounds of Christ, the stigmata shown in traditional Crucifixions.

Manet had seen stigmata on the hands of an innocent victim during a journey to Spain: in a secular, and apparently realistic painting. The work was Goya's early 19th-century execution scene, his famous *Third of May, 1808*, in which invading

4

French troops under Napoleon I murder Spanish patriots. As well as the symbolic wounds, Manet adopted the structural arrangement of Goya's composition, including the position of the firing squad, which, seen from behind, gives the impression of a faceless, anonymous death-machine. The contextual links between the two paintings are not without irony: revolutionary patriots, the victims in Goya's painting, are the perpetrators of a crime in Manet's work; both works show French invading armies at work, and, in each case, a different Napoleon is responsible.

However, the French painting retains none of Goya's theatrical emotionalism. Manet transposes the scene from flickering lamplight to the cold grey of dawn, avoiding grandiose gesture, brushing aside the moving circumstantial detail that had been reported in the press: the waiting coffins, the priests, the tears of loyalists who had accompanied the Emperor on his last journey, the blindfolded generals. As a result, he was accused of witholding sympathy; in fact, however, there were artistic reasons for his abstinence. His frieze-like arrangement of figures – the victims and firing squad are unrealistically close together – against the neutral grey of the wall, together with his muted use of colour, acknowledge his debt to the painter Jacques-Louis David (1748–1825)

and the tradition of the French history painting.

Academic convention demanded the subject of a history painting be drawn from the Bible, antique mythology or an actual historical event; it had also to be morally or politically edifying and contain a universally significant moral lesson. In Manet's day, this "high" branch of art still commanded the greatest respect, celebrated as it was at the official Salon year after year.

All his life, Manet had craved recogniton, preferably in the shape of an official prize, at the Salon: in vain. With *The Execution of Maximilian* the renewed prospect of success appears to have inspired him with hope yet again. However, by the time he came to paint over the Mexican uniforms, replacing them with French, Manet must have realized that the work could only meet with the opprobrium of the political and artistic establishment. He continued work nonetheless, driven by an ambition even greater than his desire for recognition: the *Execution* was to be his Crucifixion, and the great, modern history painting of his age. The "moral lesson" was equally important: to denounce treachery and breach of promise, and lodge an indictment: "France shoots Maximilian!"

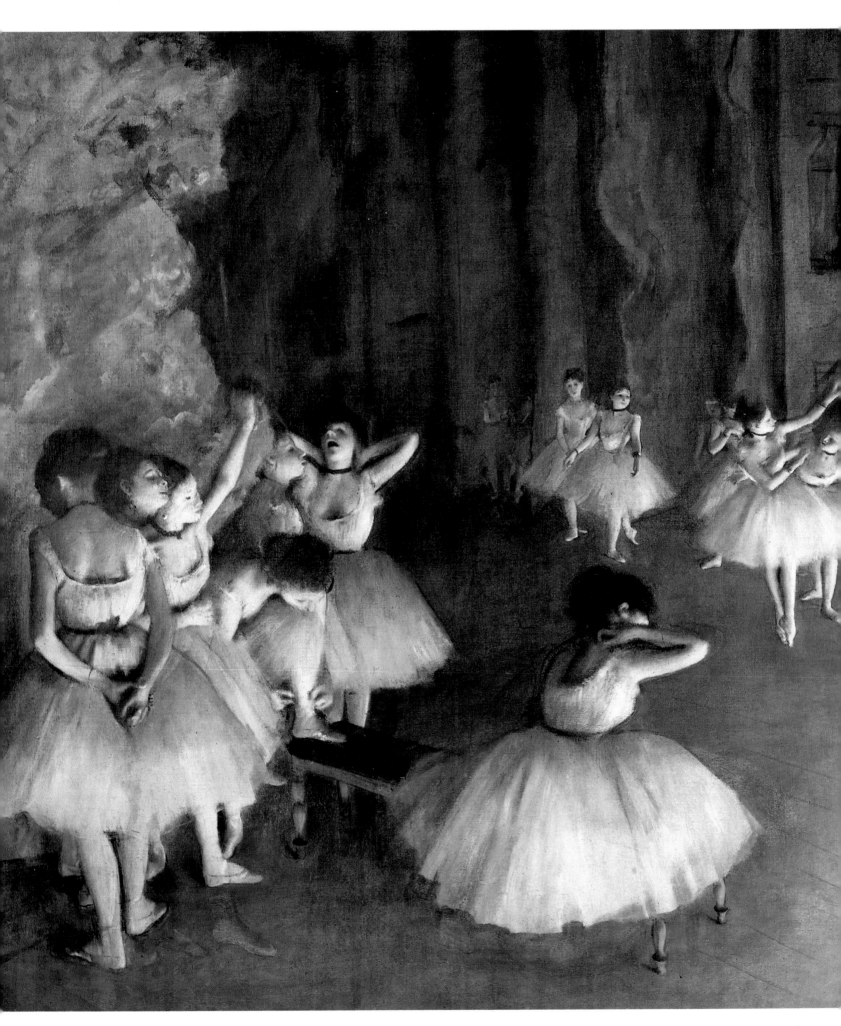

A look behind the scenes

At his death in 1917, the eighty-three-year-old Edgar Degas left behind some 1200 paintings and sculptures, more than 300 of them depicting ballerinas: at the bar, at their toilet, resting, or rehearsing – witness the present work – on a half-lit stage. It was through Degas that ballet attained its renown as a subject of painting, though by Degas' time, the stage art itself was in dire need of innovation.

The history of ballet had begun some 300 years earlier in the form of a ceremonial courtly dance whose function was to demonstrate the glory of the sovereign. Only when ballet became professional were the dancers joined by women. During the Romantic era, the female dancers became the centre of attraction, appearing to float across the stage, scorning gravity. The new technique of the toe dance made ballerinas more suited to typical Romantic parts, such as elves, spirits or fairies. Their male partners receded into the background, their main task from now on to support or lift the ballerinas, emphasizing the latters' lightness and grace.

The Romantic ballet was born in the 30s and 40s of the 19th century and, in Paris, was the dominant style even when Degas came to paint the present picture in 1873. In literature and theatre, Romanticism had been largely repudiated by more realistic modes, while in Italy, a choreographer had attempted to convert current events, like the construction of a tunnel through the Alps, into dance. No such development took place in Paris, however, where the theatre-going public stuck largely to what it knew.

Degas's exclusive preference for female dancers, too, conformed to contemporary taste. Eventually, helped by Tchaikovsky's music, ballet was given a new lease of life at St. Petersburg; but it was not until the 20th century that male dancers regained some of the recognition they had once enjoyed.

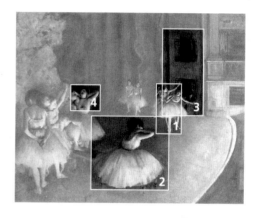

In 1873, when Edgar Degas painted this picture, "tout Paris" revelled in the romance of the ballet. But the elegance and grace of the ballerinas, who appeared to float across the stage, was not its only source of appeal. It was the done thing for a Parisian gentleman of leisure to maintain a "liason" at the theatre, while dancing offered many girls their only opportunity to escape from poverty. The painting *The Rehearsal on the Stage*, measuring 65 x 81 cm, is now in the Musée d'Orsay, Paris.

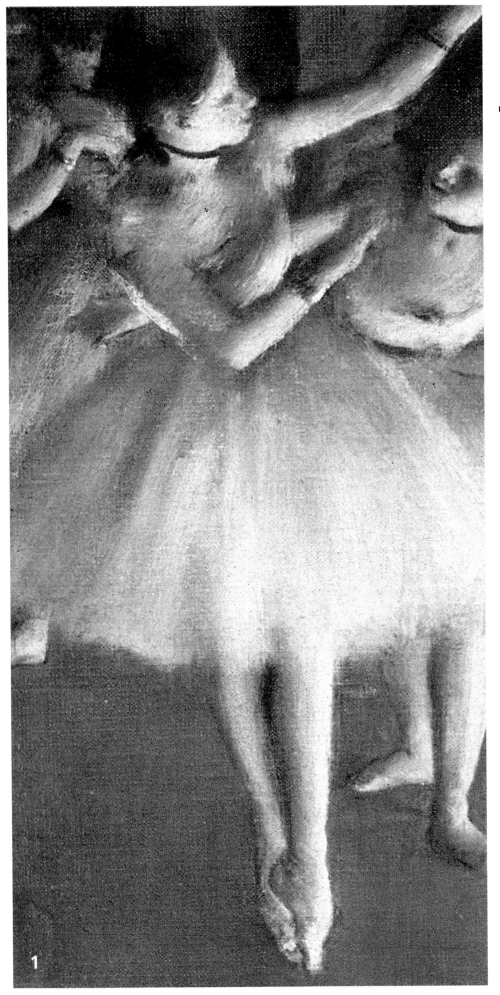

"Long, lascivious legs"

The lightness of the Romantic technique allowed the ballerinas to lay aside all heavy clothing and shoes. Elves floated better without such unnecessary ballast: ballet shoes were now made without their formerly wide soles and heels, and the ballet costume itself was reduced to a sleeveless bodice and flared skirt of white muslin. The skirt billowed when the ballerina alighted, prolonging the illusion of her floating gently to earth. Originally calf-length, the skirt had shortened to the knee by Degas's day.

Ballerinas had now begun to reveal more of their bodies, especially their legs, covered only by thin tights. Though this favoured artistic expression, it was also seen as an affront to conventional morality; for it was considered indecent in the nineteenth century for ladies to show their legs. Heinrich Heine cites two English ladies who "were barely able to express their disgust at what met their eyes when the curtain rose and those wonderful, short-skirted ballerinas began a graceful, elaborate movement, stepping out with long, lovely, lascivious legs and, with a sudden bacchanalian leap, falling into the arms of the male dancers who came springing towards them ... Their busoms grew pink with indignation. 'Shocking! For shame, for shame!', they constantly groaned."

Understandably, few male spectators showed signs of outrage. Unlike women and girls, men were given more or less free rein to seek gratification for their erotic urges. For them, ballet took on a new meaning, and the pronounced tendency among 19th-century choreographers to bring ballerinas up to the footlights more frequently than their male colleagues surely cannot be ascribed solely to the artistic gain derived from the introduction of the toe dance.

The ladies in the boxes may occasionally have been consoled by the knowledge that their stage rivals were deemed unmarriageable. From low-class backgrounds, with perhaps a laundress or seamstress as a mother, they were as likely as not to have grown up in a one-room flat at the back of

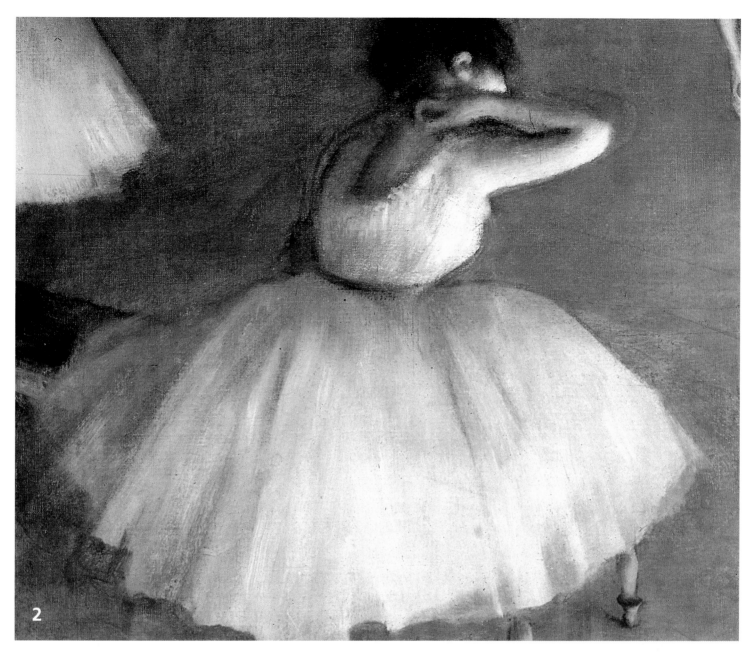

2

some dingy close. The theatre offered one of the few opportunities to escape a life of poverty and misery. With luck, they would be accepted, at the age of eight or nine, into the Opera dance school, the Académie Royale. They made their first stage appearance at the age of 14 or 15, and retired 20 years later. Though a girl of mediocre talent might never be more than an ordinary dancer in the corps de ballet, earning no more on stage than she would as a seamstress, she nonetheless had a better chance as a ballerina of attracting the attentions of a wealthy gentleman. She was in dire need of his self-centred favours if she were to escape from hunger and her dingy close. Apart from anything else, male patronage could be advantageous in determining the outcome of professional rivalry between dancers.

Rear view of a career

The biography of almost every 19th-century Parisian ballerina contains the name of a rich, and more or less powerful, patron. One example serves to illustrate many: that of Emma Livry and her mother. Emma's mother, an unsuccessful ballerina at the Paris Opera, had become the mistress of a baron; Emma was their child. The baron eventually left Emma's mother to marry a princess, and was replaced by a viscount. The viscount was said to have had a whole string of relationships with ballerinas. He "knew all the scandals and intrigues, was informed of all

the storms in teacups that constantly shook this small, inward-looking world. He liked to intervene, too, taking sides, hoping to influence matters to further his own interests and, more importantly, those of his mistress."

He also exerted his influence to help Emma, the daughter of his mistress. He ensured that her début in the corps de ballet did not go unnoticed, put in a good word for her with the director of the Opera, used his good offices in the imperial household, negotiated her contract himself, and even protected her against a series of intrigues designed to delay the première. In the end Emma Livry's performance in "La Sylphide" in 1858 was a sensational success; she was 16 years old at the time. She died at the age of 21, her short skirt set alight by a gaslamp behind the scenes.

Patronage of ballerinas was a pleasure-able diversion for gentlemen of leisure from traditionally affluent backgrounds. Since the latter were disinclined to be punctual, the ballet were not introduced before the second act. The Paris première of Richard Wagner's "Tannhäuser", with ballet included in the first act, was booed out in 1861. Though not the only reason for the flop, premature entry of the dancers was certainly a major contributive factor.

The power of subscribers

The ballerinas in Degas's painting are nameless, like the gentleman sitting on the chair. He may be the director or choreographer, or perhaps the especially privileged friend of one of the girls. The theatre itself is easily identified: the Grand Opéra in the Rue Le Peletier. It was here that Emma Livry's star rose so briefly, and here, too, that Richard Wagner's Tannhäuser flopped.

The theatre in the Rue Le Peletier had 1095 seats; it became the Grand Opéra as a result of an assassination in 1821. The son of the French heir to the throne was attacked near the building in the Rue de Richelieu which had housed the opera hitherto. The injured man was carried into the theatre. Meanwhile, his friends sent for the Arch-bishop of Paris to administer the last sacra-ment to the dying man. However, the bishop agreed to enter the building only on condi-tion that it was torn down afterwards. This was done – an impressive demonstration of the Church's power in its struggle against the theatre as an immoral institution.

The narrow boxes vaguely indicated be-hind the sitting gentleman were a charac-teristic feature of the new Grand Opéra in the Rue Le Peletier. These boxes, built above rather than in front of the stage, were referred to as *baignoires* or *boîtes tiroirs*, in other words as "baths" or "drawers". They were reserved for the director, or for in-fluential subscribers who were more inter-ested in physical proximity than the aes-thetic experience.

The power of subscribers had continu-ally grown in the 19th century. The future of a theatre now depended less on the good will of a local ruler than on its ability to sell

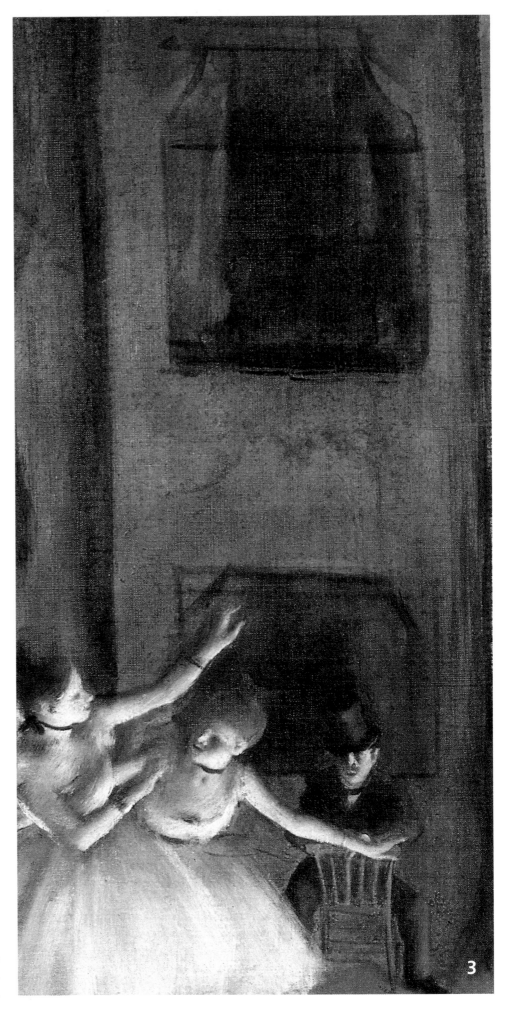

seats. Subscribers could rent a box, or a seat in the stalls (for men only), which, during the season, they occupied at least once a week. Their interest was in constant need of renewed stimulus, and in their attempt to provide it, theatres would occasionally seek recourse to methods that were less than artistic: in 1831 the Director of the Grand Opéra allowed access to the Foyer de la Danse, the dancers' rehearsal room, to some of his more refined clientele. Degas would often sit there himself, sketching the scene. It was a large room with a golden frieze below the ceiling and imitation marble columns along the wall, a high mirror and the usual training bars, hardly comparable with those neon-lit, highly functional rooms with mirrors covering all four walls in which today's dancers practise their steps.

The Foyer de la Danse was open, during intervals and after the performance, only to the girls' mothers and certain male subscribers. The purpose of this was obvious. The modern equivalent might be the welcome-lounge of a massage parlour.

In October 1873 the theatre in the Rue Le Peletier was destroyed by fire. A new, magnificent building, the Palais Garnier, where ballets are still performed today, was opened in January 1875. A competition for the design of the new opera house was held in 1860. Both the text of the announcement and, ultimately, the building itself betrayed the social function of opera at the time: artistic performance seen as the appropriate ambience for the cultivation of social status and gratification of the male libido. Boxes, according to design recommendations, were to have an adjoining salon whither parties who wished to converse might withdraw. The plans were to include "drawers", too, which remained in use until 1917. The building was to have three separate entrances: one for the Emperor, who no longer existed after 1870, one for the subscribers and a third for the public. The broad staircase to the first floor, imitating the stairway at the Rue Le Peletier, had 63 steps. The much cosseted subscribers were not expected to alter their habits. They were provided with a special lounge for intervals, and the Foyer de la Danse was transformed into a palatial hall with chandeliers, stucco and the portraits of famous ballerinas. At the same time, however, the director raised the entry fee; only gentlemen who subscribed three evenings a week were allowed access.

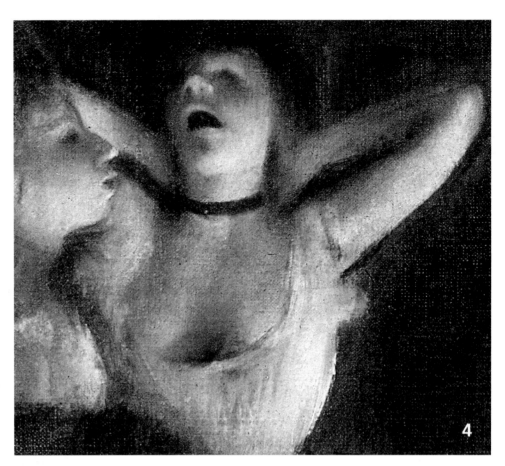

4

Like looking through a keyhole

Degas made the preliminary sketches for his painting in one of the front boxes, executing the painting some time later in his studio. By the time he painted *The Rehearsal on the Stage*, the theatre in the Rue Le Peletier had probably burned down. Like all contemporary stages, it was lit by dangerous, open gas flames. The lights were generally situated at the edge of the apron. Degas marks the footlights with a series of bright brushstrokes.

He was almost 40 at the time, but was not one of the ballerinas' lovers. On the contrary, he lived the life of a reclusive ascetic, rarely leaving his studio. He needed to be alone, remaining a bachelor, declaring, on one occasion: "A painter has no private life!"

Besides ballerinas, there were two other subjects he favoured: women at their bath and jockeys at the races. All three have one thing in common: movement. The details printed here make it clear that Degas was less interested in the ballerinas as individual characters than in their movement and gestures. Their faces are usually pale, anonymous. With regard to their gestures, what interested him most was what they did more or less subconsciously when they were not playing to the public. Degas paintings are full of women combing, washing and dressing themselves – automatically, as it were. "Up until now, the portrayal of nudity has always presupposed exposure to the public eye", he wrote, "but the women in my paintings are simple, good people, thinking of nothing and preoccupied with nothing but their own bodies"; it was "like looking through a keyhole." On another occasion he referred to them as "animals in the act of washing themselves".

In the *The Rehearsal on the Stage*, too, the girls stand or sit about quite unself-consciously: yawning, scratching, stretching, utterly self-absorbed and attending to their own needs. There was a grace here which fascinated Degas. It was a quality he found in dancers who were resting between scenes, but also – on few and fortunate occasions, and with a different level of intensity – in those who were actually dancing: it was not the natural grace of a woman which interested him then, but a grace she had acquired by dint of artistry, the grace of a ballerina who is entirely engrossed in her art.

Adolph Menzel: The Steel Mill, 1875

Keeping in time with machines

After extensive research at the Silesian industrial centre of Königshütte, then the site of one of the world's most modern steel mills, Adolph Menzel (1815–1905) painted this renowned view of everyday work in the industrial age. The large-scale painting (158 x 254 cm) can be seen at the Nationalgalerie, Berlin.

This painting was completed in 1875. It was purchased in the autumn of the same year by the Nationalgalerie, Berlin. At that time, museums were full of scenes of heroism, thrilling histories, romantic depictions of Nature, fauns, water-nymphs and flattering portraits. A painting that showed factory workers was most unconventional. The director of the gallery must have been a brave man.

Persuading the appropriate minister to lend his approval to the purchase may have been facilitated by the artist's excellent reputation at court: Adolph Menzel had delivered the official painting of Wilhelm I's coronation ten years earlier. However, the director was also under pressure to persuade the public of the work's merit. He thus called it *Modern Cyclopes*, equating workers and machines with a race of giants in Greek mythology who forged bolts of lightning for Zeus. The people who visited his musuem would have felt more at home with figures drawn from Greek mythology than with factory workers.

Driven by curiosity, and by a compulsion to capture the world in his paintings and drawings, Adolph Menzel travelled for this work from Berlin to Königshütte in Silesia, the site of one of the world's most modern steel mills. Of the figures and machines which appear in the present painting, all are contained in the preliminary sketches made at Königshütte or another steel mill in Berlin.

The factory is shown in the process of producing rails. Two workers have already wheeled a glowing piece of steel to the nearest roll, while three others, equipped with large tongs, feed it into the roll. With the help of suspended poles, the men on the other side of the machine will then push the piece of metal back under the roll for further pressing.

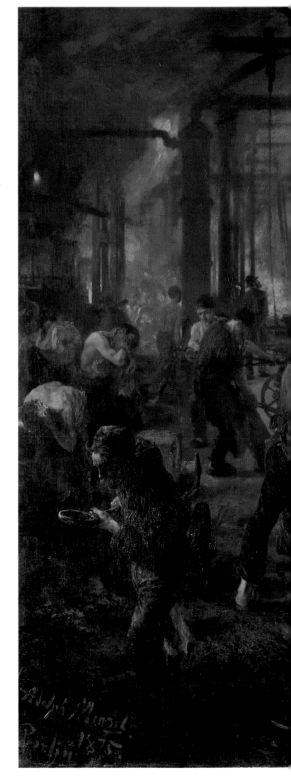

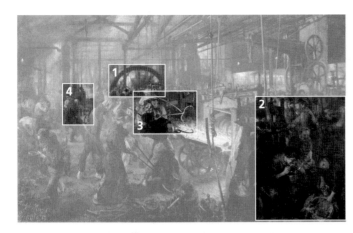

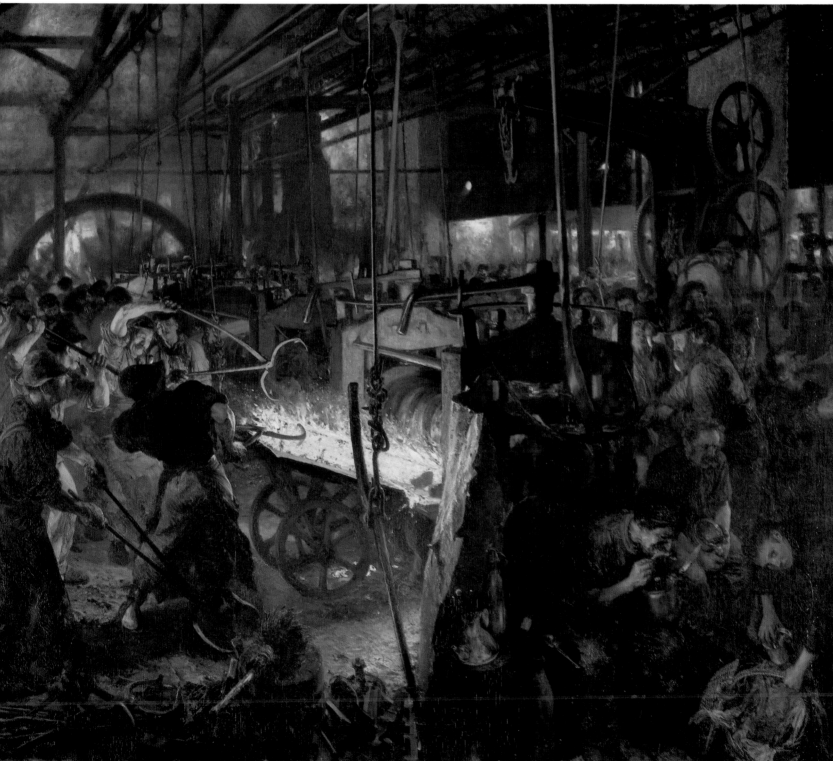

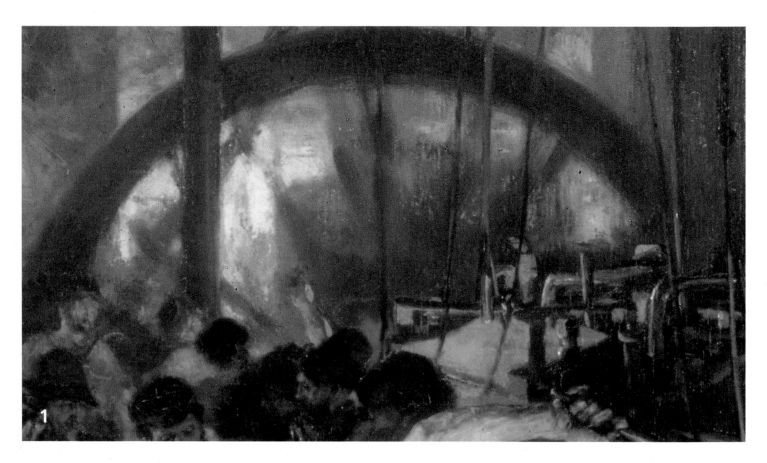

Consequences of the steam-engine

Power was transferred from the fly-wheel to the three rolls by dint of crankshafts, cogwheels and metal rods. The wheel's enormous size and weight ensured that the axles turned evenly. Menzel's emphasis of the wheel in the background underlines its integral importance to the entire scene.

The wheel is part of a steam-engine – the invention which had made industrialization in Europe possible in the first place. Previous machines had been driven by people or animals, by wind-power or water. Though the discovery of the new form of propulsion is generally attributed to James Watt, it would be wrong to ascribe its emergence to him alone. Its development had encompassed everything from research into air pressure to the construction of the steam-turbine. Progress had included a vast number of adjustments and improvements. Smaller and more mobile engines were constructed, making them suitable for use on ships and rails. They grew more powerful, too, increasing their drive during the 19th century from 20 to 20,000 horsepower.

The steam-engine changed the landscapes, demography and national economies of Europe. The varying response provoked by the invention may be demonstrated with the help of two poems. Though neither can claim to be important works of literature, they nonetheless illustrate opposing points of view. The first, by one J. A. Stumpff, published in 1831, celebrates the latest technology:

Fierce flames the boiler fire,
the surging waters seethe with ire,
yearn to vent avenging force,
oppressive prison walls to burst.

The second, written in 1840, bemoans the consequences of the railway:

Existing relations evaporate all,
And mortals now are driven by steam:
Universal equality's breathless harbinger.

The first poem was composed by a bourgeois writer whose class stood to gain from industrialization; the second was written by Ludwig I, King of Bavaria, who had every reason to fear imminent social change.

Steam engines were originally developed in Britain. One of the first models to be transported to the Continent was brought to Silesia in 1788. Its fiery furnace drove a pump at a colliery and was so famous in its day that even Goethe travelled to see it with his patron and boon companion, Duke Karl August of Weimar.

Industrialization of Silesia had initially been the policy of Frederick the Great. It was during his reign, too, that hard-coal extraction began. The new fuel produced more energy than wood. Frederick founded state-controlled coal and ore mines; blast furnaces followed. Königshütte, or the "King's Works", the scene of Menzel's painting, was founded by the Prussian state to accelerate industrialization and experiment with model factories. By the end of the 18th century, when the "King's Works" were built, Silesia contained the only fully integrated industrial region on the European continent; it was not until the middle of the 19th century that the Ruhr began to catch up.

However, by the time Menzel came to visit, the state had sold the works at Königshütte for one million thalers to a big Silesian land owner, Count Carl Hugo Henckel von Donnersmark, who, riding the investment boom unleashed by German Unification in 1871, had turned the works into a shareholding company. Only a year later he was able to sell Königshütte, together with a second factory, for 6 million thalers.

A hurried bite and a swig from the bottle

The workers ate surrounded by the noise, dirt and heat of the machines; a makeshift shield of sheet metal was their sole protection against the sparks that sprayed from the roll. There was neither canteen nor washroom at Königshütte; Menzel shows workers washing at the left of the painting. It was uncommon for factory owners to show any concession to the needs of their employees.

Eating habits were changed by industrialization. In a craftsman's workshop, or in the country, large families would eat with their maids, apprentices and farmhands. Grace was said, and seating arrangements and food rationing reflected domestic hierarchy. A meal therefore meant more than nourishment. It might involve a break of up to two hours, allowing its participants a midday rest during their long working day. An interruption of this kind was unimaginable in a factory, where the tune was called by machines and foremen.

Menzel also paints a man with a bottle raised to his lips. Alcoholism was rife among industrial workers. The writer Moritz Bromme frequently returns to this problem in his autobiographical "Life of a Modern Factory Worker", published in 1905: "Here in Ronneburg drinking schnapps was even more widespread than it had been in Schmölln", he wrote. "Being the youngest I naturally had to fetch the schnapps, even filling up soda bottles for some of them." The working day was twelve hours long or more, the work itself monotonous and physically arduous, endurable for many workers only with the help of stimulants. Unable to bear the pressure of work, they took to drink, "seeking the illusion of freedom in schnapps, the scourge of modern civilization ..." They would then often find themselves sacked for drunkenness, turned out to enjoy the "freedom" of unemployment, which they found equally impossible to bear without alcohol.

Besides pressure of work, the destruction of social ties also made factory workers susceptible to the dangers of alcohol. Factories were rarely built where workers already lived. During the 19th century a constant stream of people in

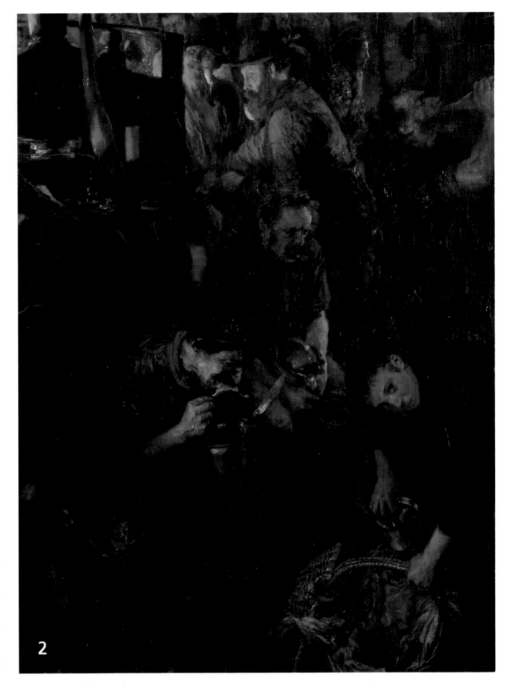

2

Germany moved from the country to the towns and from east to west, most of them to the Ruhr. Families and neighbourhoods were torn asunder. The older folk stayed on while younger people left in search of work. They found the simplest of accommodation as so-called "night lodgers" in other workers' homes, living in miserable conditions without social support of any kind.

One critically-minded contemporary observed: "It is only because many of these poor souls have brought to these hovels a vast wealth of moral standards, Christian values and general decency from the places they have left that the worst has not yet happened. As for the children and young people who live in these holes, they must

surely grow up without acquiring the virtues of thrift, domesticity or family life, and without respect for propriety or property, manners or morals."

The proletarian writer Moritz Bromme, too, grew up in "hovels" of the kind mentioned above: "As I had been obliged to take two or three of our beds ... to the pawnshop, my little seven-year-old sister Elsa had to sleep with her mother, who had galloping consumption. I also slept in the same room as my parents ..."

People took jobs in factories because they could no longer find work on the land; or because they wanted to escape the power of landowners who were able to do with "their people" practically whatever they wanted. Work in factories was at least subject to a number of regulations drawn up by the government, and it was the job of factory inspectors to make sure these regulations were put into practice. Bromme describes the situation as follows: "One day the cry went up that the factory inspector was on his rounds. Now, I had no idea at all what this official's job was. So they said to me: 'If he asks how long you work, tell him 10 hours; youths are not allowed to work more than that.' Meanwhile, the cleaning boys, usually between 9 and 11 years old, were told to leave the shopfloor post-haste, returning home via the back garden .."

In contrast to agricultural labourers, craftsmen and factory workers had the

Workers discover solidarity

right to form associations. Steel mill workers could join the "General German Metalworkers", officially described as an "Unemployment Insurance Association". Self-help was the principal motive for the formation of such associations; solidarity and the defence of workers' interests against the employer followed. The power of these forerunners of the trade unions naturally grew with that of the workers' political organizations. In 1875, the year in which Menzel completed his *Steel Mill*, the two hitherto competing parties united to form the "Socialist Workers' Party of Germany", later known as the Social Democratic Party of Germany (SPD).

It is possible that the workers depicted by Menzel at Königshütte refused to join the "German Metalworkers", objecting to the word "German". Contrary to their foremen and managers who spoke German and were from German cities elsewhere, they spoke Polish and thought of themselves as Poles. In 1868 the villages and housing schemes surrounding the works merged to form one town whose purpose – significantly enough – was "to provide a place of refuge in which German life, German customs and German strengths may

be nurtured and flourish within an order established by Germans." The "order established by Germans" proved problematical. Starting in 1871 a number of disturbances took place at Königshütte which only the combined forces of police and army were able to suppress; a special unit was stationed there until 1881. Königshütte fell to Poland in 1921, returned "home to the Reich" in 1939, finally reverting to Poland in 1945. Today it is called Chorzov.

The majority of contemporary spectators probably knew of the Silesian problems of the 1870s and of the measures taken by Prussia to suppress the drive for Polish home rule. Menzel, a Silesian himself, was well acquainted with the situation. It is possible, too, that visitors to the Nationalgalerie did not therefore think merely of mythical cyclopes or industrial progress when they saw this painting, but of German superiority: "German strengths" flourishing "in an order established by Germans" – and feeding off the strengths of others. During the First World War the painting was directly exploited for nationalistic purposes: subscribers to war loans were presented with a print of the work.

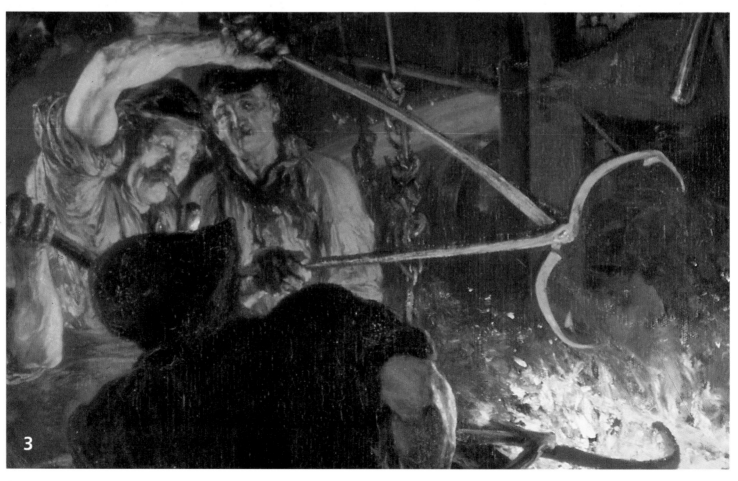

3

The hat as a sign of authority

In a short statement on his painting Menzel wrote: "The director can be seen in the background, behind several people operating a puddling furnace." It was in the flames of the puddling furnace that iron was turned into steel.

The most obvious difference between the director and his employees was the former's hat. Workers wore headgear, too: caps, generally of softer materials such as felt or cloth, whose purpose was to protect them from cold, dirt and flying sparks. Headgear had greater significance altogether in those days, and workers would often keep on their caps at home or in alehouses. In a street scene, headgear served to identify social rank, and the matter of who should take off his hat to whom, doff his cap or touch a forelock, was a vexed issue. Bromme wrote of one new worker: "Whenever he asked the master-turner something to do with work, he removed his cap, a gesture which the former answered with a condescending smile. 'That's what I call a real worker, standing there dressed in his humility', was the sarcastic remark then heard passing between bystanders."

The director is wearing a bowler. This was more expensive and less practical than workers' headgear, but less extravagant than the top hat which had been considered respectable headgear among the bourgeoisie until the middle of the 19th century. Dress at this time became plainer and more comfortable, at least everyday wear. Silk knee-length stockings and knee breeches, tails and narrow-waisted morning coats either disappeared altogether or were promoted to the status of festive clothing. The new everyday wear consisted of drainpipe trousers and long, straight jackets like the one worn by the director in the painting. Bowlers replaced tricorns and tall top-hats. Bourgeois rather than courtly fashions now determined the character of everyday clothes.

Increasing bourgeois influence in the world of fashion reflected the growing power of the class in society as a whole. It had been the bourgeoisie, after all, who had proclaimed the French Revolution and led their king and queen to the scaf-

4

fold. The new middle class, too, had backed the Wars of Liberation against Napoleon's armies, and had been the driving force behind the Revolution of 1848. Capital, extracted from trade and industry, accumulated in bourgeois hands on an unprecedented scale, while economic power frequently facilitated bourgeois influence in areas where that class had no direct political control.

The bourgeoisie, and the middle class of citizens in general, had once thought themselves the "progressive class", a claim which now passed to the working class, the industrial proletariat. Just as the liberal citizenry had once fought against the class hegemony of the feudal aristocracy, industrial workers now struggled against bourgeois employers to obtain human rights and change society for the better. The date which best marks this historical sea-change is 1875, the year in which the two

workers' parties united and – coincidentally or not – Menzel completed work on his *Steel Mill*.

There has been some debate over whether Menzel's painting contains a deliberate political bias. Could it not be construed as symbolic that the artist had banished the bourgeois capitalist to the background of the painting, while allowing workers to dominate the foreground? Unfortunately, there is no evidence to support the hypothesis that Menzel was politically motivated. It has been mooted, too, that Menzel wished to demonstrate the workers' confidence, their belief in progress during the early years of a new, united Germany – or, conversely, that he intended to show the exploitation and alienation of the workforce. Such contentions amount to little more than speculation. All that can be said for sure is that he wanted to show what he had seen: workers in a steel mill.

Laughing struggle for freedom

A sombre sky, uproarious laughter, Cossacks in their camp – a scene in 1676, painted some 200 years later by Ilya Repin, the Russian realist. Cossacks, in Repin's time, were considered "the symbol of Russian nature"; the great writer Nikolai Gogol, too, sang their praises, calling them a people "whose souls were like wide-open skies, yearning for never-ending feasts and festivals." But all that belonged to the glorious past, evoked as an antidote to the Tsarist dictatorship. Repin's painting was a patriotic commentary on the contemporary scene.

Cossacks have a symbolic function in Russia similar to that held by trappers, cowboys and pioneers in North America: they epitomize a heroic notion of freedom, their deeds and legends providing the stuff of which national identities are forged.

The Cossacks are not a nation, but the descendents of refugees who collected on Russia's southern borders from the 14th century onwards. To their east lay the Tartars, to their south the Ottoman Empire; Poland, Lithuania and the Russian state with Moscow at its centre lay to the north and west. They were thus surrounded. Initially, they included a large number of Tartars from whom they assumed certain characteristic features, such as their tufts of hair and bald heads.

However, it was first and foremost their form of government which distinguished the Cossacks from their neighbours. They were not ruled by princes, kings or sultans, potentates who endeavoured to bequeath their power to their heirs. Cossack leaders were elected for a limited term, and important issues were decided by a system of votes. The Cossacks had no wish to be anybody's vassals.

At first, the majority of these people lived along the banks of the Don and the Dnieper. Those who settled along the lower Dnieper were called Zaporogian Cossacks, after the Russian words "za porogi": "beyond the rapids". In 1676 they defeated the army of the Turkish Sultan, who nonetheless demanded they submit to his conditions. In reply the Zaporogian Cossacks wrote a letter to the Sultan that was thick with insult: "For all we care, you and your hordes can eat the Devil's shit, but you'll never gain an ounce of power over good Christians … you … pig-snouted mare's arse, you butcher's cur …" Stalin is said to have loved telling this story.

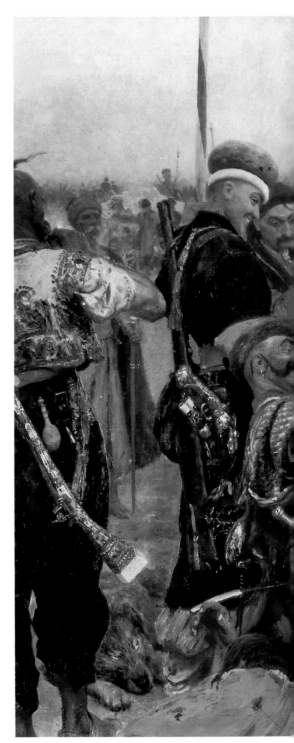

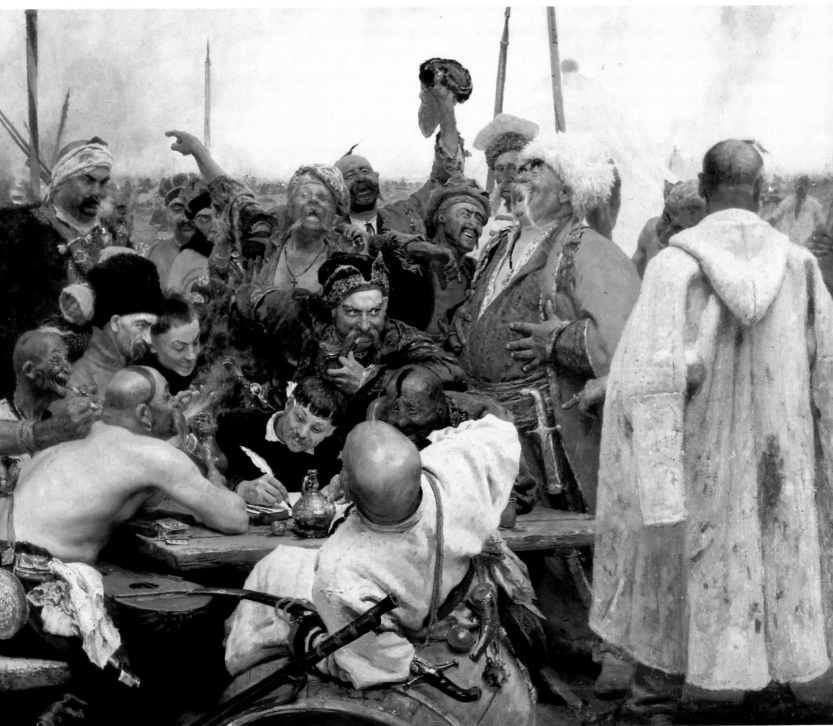

Not given to writing

Ilya Repin worked on his Cossack picture from 1880 to 1891, a fact noted at the bottom centre of his 203 x 358 cm painting. He thus showed an event which had taken place 200 years previously. The Cossacks had long since become subjects of the Tsar, their collective self-government stifled or replaced by imperial bureaucracy. They nevertheless retained a special status: treated as a caste of warriors, the state provided them with land and exempted them from taxes; in return, the men were expected to serve in the Russian army for twenty years, providing their own horses and equipment. In the 1880s they made up roughly a half of the Russian cavalry.

However, the enthusiasm for the Cossacks which abounded in Repin's time was not directed towards the contemporary warrior caste, but towards their ancestors.

In Nikolai Gogol's story *Taras Bulba*, these early Cossacks are characterised by their love of freedom, fighting and festivities: "Their constant drinking, the way they threw care to the four winds, had something quite infatuating. This was no band of boozers drowning their sorrows, whining in their cups; this was untainted, untrammelled zest for life. Anyone who drew near felt its pull, left whatever he was doing and joined them; the past no longer counted; sending care to the dogs he abandoned himself to the freedom and fellowship of spirits who thirsted for adventure like himself ... whose souls were like wide-open skies, yearning for never-ending feasts and festivals. Here was the source of that unbridled joy ..."

Nostalgic glorification of the ancient Cossack community was facilitated by the lack of contemporary documents. The Cossacks had compiled very few records before the 18th century. They were not given to writing. It was true that each hetman, as the Cossack captains were called, had a secretary at his side, but the latter's

abilities were employed almost exclusively for external correspondence. There were no registers of birth, marriage or deaths, no written laws, no lists defining privilege. This was not due to inability, but conviction: the Cossacks thought of written documents as dangerous instruments of oppression; they had probably learned as much at the hands of both the Turks and the Russians.

A contemporary of Repin, the Russian anarchist Michail Bakunin (1814–1876), was of a similar mind. According to Bakunin, the first aim of an insurrection should be to set fire to the town halls, for it was here that the "paper empire" stored its documents, which must be annihilated if a fresh start were to be made. Criticism of the unwieldiness and corruption of Russian bureaucracy came not only from reformers and revolutionaries. On the contrary, it was so widespread that the notion of a society in which men took matters into their own hands and then "abandoned" themselves to "freedom and fellowship" found admirers even at the Tsar's court in St. Petersburg.

Some of Repin's contemporaries wrongly imagined that the artist was of Cossack descent. Flattered, he rejected the proposal, referring to it in the first sentence of his memoirs as "a great honour indeed". The full extent of his admiration for these people was made evident in 1881 by his four-year-old son, whose head, in accordance with contemporary custom, Repin had shaved, while insisting at the same time that a single tuft of hair be left in place – a tradition that had practically died out even among Cossacks.

Ilya Repin was from the Ukraine, one of the original Cossack homelands. He was born in 1844 in a military settlement: an arrangement whereby peasants were given land by the state in return for providing billeted soldiers with food and lodging. The situation was not unlike that found in Cossack villages. Repin's father had been an ordinary soldier.

Owing to his extraordinary talent, Repin was accepted into the Imperial Academy of Arts at St. Petersburg, which also paid for him to travel abroad in 1872, visiting Paris in 1873. On his return to Russia he lived in St. Petersburg and Moscow, though he travelled constantly throughout the land, always on the lookout for interesting people and subjects, or searching for signs of the supposedly glorious Cossack era of yore.

By contrast, Cossack life in contemporary Russia was hardly uplifting. Their former martial spirit was sapped by loss of independence as a warrior people. Moreover, they had become intellectually and economically backward. When the railway reached the Don, for example, the Cossacks demanded it bypass their town for fear the tracks might hinder their access to grazing land. The horses and the animals they kept for meat were more important to them than industrial progress.

If the Cossacks held by their traditonal way of life, they also made much of ancient superstition, a phenomenon Repin experienced on several occasions. The further he penetrated into the Russian interior to sketch Cossacks for his paintings, the more frequently he met with rejection from a people who feared forfeiting their soul to the devil by allowing themselves to be painted.

Repin also had difficulty finding authentic clothes, weapons and other objects. As a realist, he was unwilling to improvise, and yet a cultural anthropology worth the name, whose collection and study of utensils might have facilitated his project, was still in its infancy. He was forced to give up, and it was not until 1887 when he found a scientist who owned a collection of Cossack artefacts that he decided to resume painting. He was by no means alone in his interest in things ancient. Among the nobility and the thin band of the middle classes was a movement whose aim was to promulgate whatever was truly Russian or Slavic against the strong influence of Western Europe, and which sought to establish, by prosecuting indigenous tradition, a new sense of pride in all things Russian. For Repin, too, there was more at stake than realism or historical accuracy: "What I feel in each tiny surviving detail of that era is an unusual form of spirituality, a kind of energy; it all seems so rich in talent, so vigorous, so replete with liberal social significance ... The freedom of our Cossacks, their chivalry, I find quite delightful."

Every detail counted

2

3

Hilarity on canvas

The oppression of women was part of Cossack freedom. Not a single woman appears in Repin's picture, a detail that may simply reflect the reality of a military encampment, but which is also in keeping with a widespread opinion which held that women, to a Cossack, were there for work, lust and beating. This, at least, was the view presented by writers like Gogol, or in Sholokhov's novel: *And Quiet Flows the Don*. "Don't listen to her blether, my boy, she's a woman and doesn't know what she's talking about ...", says Gogol's Taras Bulba. Or: " ... stop your whining, woman! A Cossack shouldn't need to worry himself with females!"

The weapons, fur hats and coats in the picture also evoke a life of freedom under "wide-open skies". During the 16th century Siberia was penetrated by Cossacks who kept Moscow supplied with valuable animal skins and furs. In the 19th century it was Cossacks again who defended Russia's Asian borders. They settled in places as far apart as the Dnieper and the Pacific coastline, 5000 miles to the east, where, far from Moscow and St. Petersburg, they retained some of their original autonomy.

Russia's old rivals to the south were still strong, and the Russians needed to secure access to the Black Sea and weaken Turkish influence in the Balkans. However, the Crimean War (1853–1856) ended in Russian defeat – an outcome which admittedly owed more to the action of the British and French than that of the Turks – and notwithstanding their victory in the Russo-Turkish War of 1877/8, the Russians did not achieve their aims. Repin painted his Cossacks at a time when the Russians considered the Turks their sworn enemy. For many years, Russian soldiers had gone into battle not only for their own country, but to defend Christendom against the encroachment of Islam.

Repin saw the 17th-century Cossacks in a similar light: "It was here that certain intrepid elements within the Russian people spurned a life in comfort to found a community of equals whose purpose was the defence of those principles most dear to them – Orthodox worship and personal freedom. This may seem old-fashioned by today's standards, but at that time, when thousands of Slavs were made slaves by the Muslims, it was an exhilirating prospect." According to Repin, the Cossacks "defended the whole of Europe" and "laughed heartily at the arrogance of the East."

Repin's history painting contains a wealth of reference to his own time. Contemporary relevance was, by definition, part of the genre. The history painting provided a vehicle by which the past could speak to the present in a manner edifying to moral and national sentiment. It was considered the highest branch of art throughout Europe, and its themes were nobility and heroic grandeur.

There is no indication that Repin or his contemporaries noticed that the letter-writing scene contained something quite unusual in art: laughing men. One may search far and wide in museums of European art before finding a scene with figures who are not simply smiling or grinning, but laughing aloud; and one is even more unlikely to find such a scene in a history painting. Hilarious laughter may be in keeping with an occasion where men invent a series of increasingly rude insults; it does not consort well with the dictates of a genre expected to awaken feelings of a more solemn nature.

This, at least, may initially seem to be the case. To the contemporary spectator, however, the story taken up by Repin's painting was part of traditional lore; they knew the artist did not merely wish to portray superficial amusement. Repin was concerned to show the latent vigour of the Russian people, a force which, put to proper use, could defeat both external aggressors and the bureaucracy.

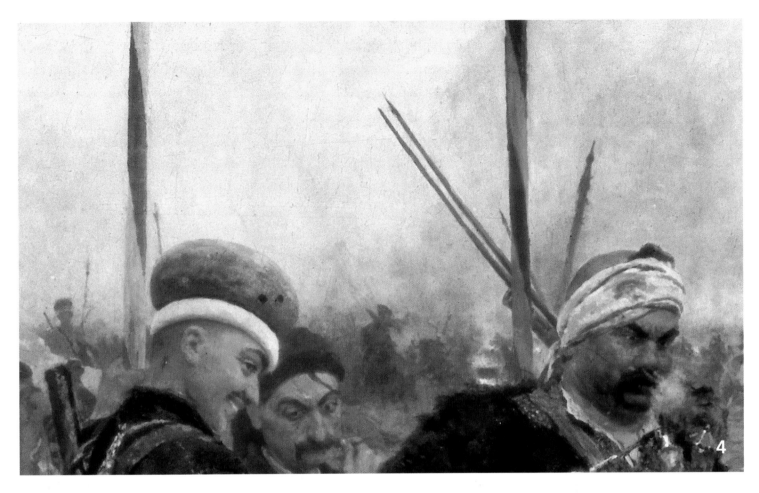

In search of Russia

When Repin became acquainted with the letter of the Zaporogian Cossacks in 1878, the final year of the Russo-Turkish war, he immediately began a sketch. Two years later he travelled to the Ukraine to collect further material, starting work on the painting itself in October 1880: "It all happened by accident – I was unrolling a canvas and then suddenly I just couldn't stop myself picking up a palette and starting work ... Everything Gogol wrote about them is true. A hell of a people! No one in the world has drunk so deeply of liberty, equality and fraternity!"

In 1881 Tsar Alexander II was assasinated by revolutionaries. Repin attended their execution and witnessed the reprisals meted out by Alexander III: "What dreadful times were those ... We lived in constant fear ..." He set aside his half-painted canvas with its scene of hilarity and did not return to it until 1889, after a further research trip. He had considerable trouble completing the work: "Working on the

harmonic proportions of the painting ... I have been forced to leave out some things and alter others – both colours and figures."

The colours in the final version of the painting are restrained, contrasting soberly with the sheer vitality of the figures and stark crudity of the letter. Moreover, Repin paints a cloudy, grey, sunless sky. Most of his paintings are sombre in this way. "The Russian national scene is grey, even when the weather is fine. Let it be grey then, not pink or sunny or joyous blue!" Thus the demand of a Russian art critic in 1892, one of Repin's friends. His article castigates the imitation by Russian artists of Western styles and colours and draws a comparison with Russian literature: "Pushkin, Turgenev and Tolstoy's literary colour was powerfully grey, powerfully Russian. Only if Russain art takes a leaf out of their book will it attain the high distinction of Russian literature."

It had been clear to Repin ever since his first period abroad, after completing his studies at the Academy, what he wanted from art: to paint Russia. He had found little to interest him in the Paris of the Impressionists, nor did he share the French artists' enthusiasm for light and atmo-

sphere; it was not a new technique he was searching for, but his own subject. His great wish was "to study what is truly ours", he wrote; for the "study of the idiosyncrasies" of the Russian people "had barely begun".

It was a planned retrospective of his work at St. Petersburg in 1891 that finally made Repin complete the work. "All those legends, stories, memories, even Taras Bulba himself – it all came back ...", enthused one of Repin's artist friends. It is unlikely that a man like Alexander III, whose fear of revolutionaries turned Russia into a police state, really understood the painting's apotheosis of the Cossack sense of freedom. He may have felt drawn to pugnacious and powerfully-built men who were able to hold their liquor simply because that was the kind of man he was himself. Whatever the reason, he purchased the painting – now in the State Russian Museum, St. Petersburg – there and then, paying the handsome sum of 35,000 rubles: apparently, the highest sum hitherto paid to a Russian artist for a single work.

Venue for gentry, bourgeoisie and bohème

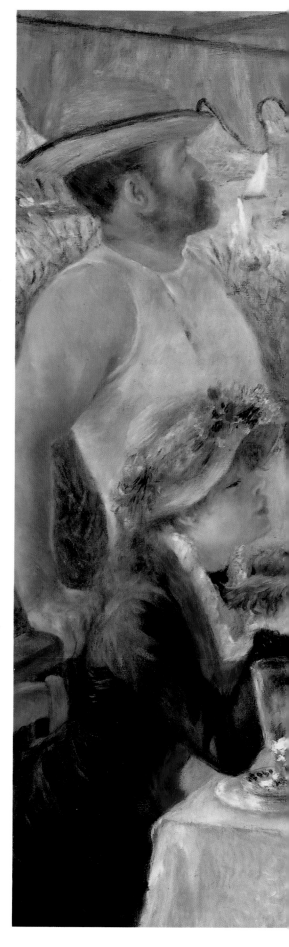

It took Pierre-August Renoir, from his studio in the centre of Paris, a mere 20 minutes by train to reach the open countryside. Every half hour, a train left on the new line to St. Germain – a popular technical achievement in an era which could boast of so little in the way of public transport. As a consequence, rural Chatou on Sundays was packed with Parisians who, like the artists, longed for fresh air and light. They promenaded along the banks of the Seine, "roamed aimlessly under high poplars", went boating or swam in the Seine, unperturbed by the many floating carcasses of dead animals.

Thus the account that Renoir gave retrospectively to his son, the film director Jean Renoir, and to the art dealer Ambroise Vollard, both of whom recorded the artist's memoirs in writing. The circumstances under which Renoir painted *The Luncheon of the Boating Party* are therefore extraordinarily well documented.

According to Renoir, two establishments were especially popular among Sunday trippers. One, situated on an island on the Seine, was called the "Grenouillère", literally the "frog pond". The name was a pun, referring less to croaking amphibians than to the Parisian girls who went there in search of a lover.

The clientele at the "Restaurant Fournaise", on the other hand, consisted largely of "young sporting types in striped singlets", Renoir recalled. "It was a sort of water sports club", a hotel proprietor having "hit on the idea of doing up a wooden shack he owned on the island and serving lemonade there to Sunday-trippers ... He was a rowing enthusiast himself and knew all about hiring boats out to Parisians." Monsieur Fournaise appears in the picture in the appropriate outfit, a white cotton singlet stretched over his bulging chest; he is apparently observing the activities of his guests.

Renoir had frequented this establishment since the 1860s, forming an acquaintance with the proprietors and introducing several of his artist friends. He loved to patronise this "amusing restaurant" where "you could always find a volunteer to play the piano of an evening" – whereupon the tables would be cleared aside on the terrace outside to make room for dancing.

Here, over the years, Renoir painted a large number of landscapes, as well as portraits of the landlord and his family. In 1880 he decided to embark on a large-scale work, "a picture of boaters, which I've been itching to do for a long time ... One must from time to time try things beyond one's strength." The painting measures 129.5 x 172.7 cm and is therefore equal in size to another ambitious work begun five years earlier: *Le Moulin de la Galette*. Before completing it at his Paris studio, Renoir had worked on the painting from April to September 1880 on the terrace of the riverside restaurant. It would appear that he enjoyed himself: "The weather is good and I have models", he wrote in a letter. He later looked back on the experience with nostalgia: "We still had life ahead of us; we denied ourselves nothing ... Life was a never-ending celebration!"

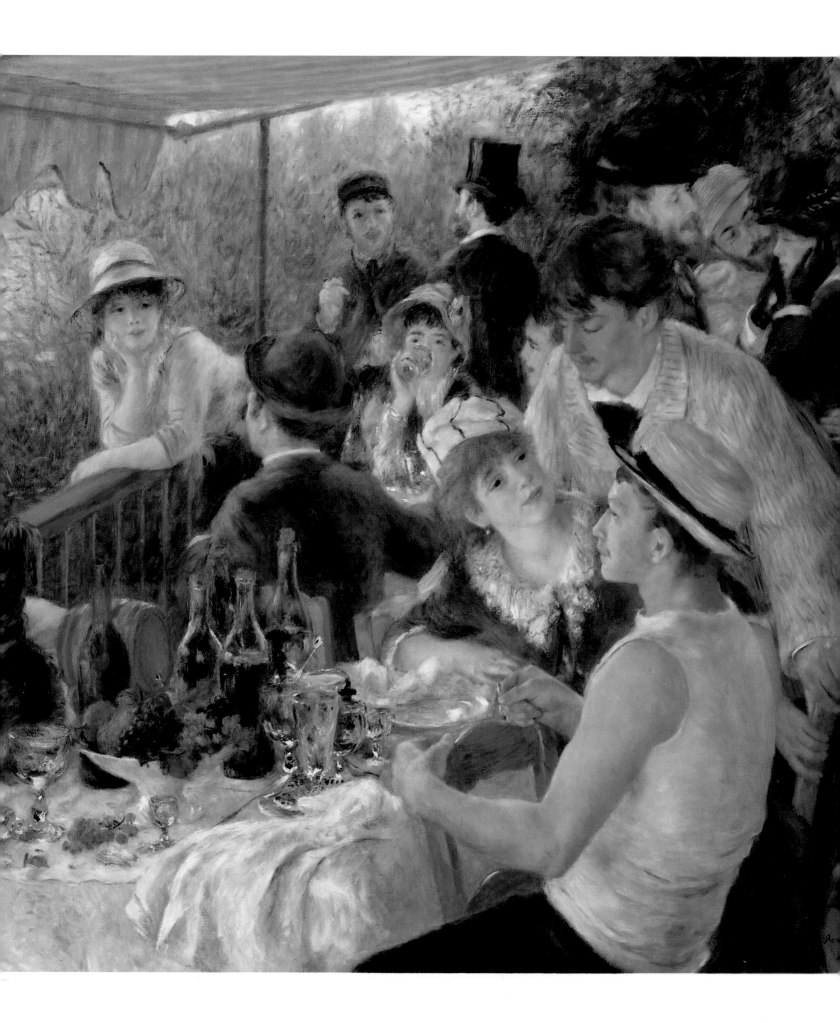

1

Paintings
to pay
the bill

The boaters and their lady-friends, having finished eating, sit back among the "debris" of the meal, relaxed and sated. In a novel written in 1868, the brothers Edmond and Jules de Goncourt, contemporaries of Renoir, described the mood after a full meal in the country: "The day was there solely to be enjoyed: the fatigue … the fresh, invigorating air, quivering reflections on the surface of the water, piercing sunlight … that almost animal intoxication with pleasure."

On the white tablecloth, besides crumpled linen napkins, we see a bowl of fruit, a small barrel of brandy, half-full bottles of wine and various glasses: round ones for red wine, tall ones for coffee, smaller ones for "chasers", cognac or liqueurs. In his *A Day in the Country*, published in 1881, Guy de Maupassant includes the menu of a simple riverside restaurant: baked fish, rabbit stew, salad and a sweet. The characters also order a local wine and a bottle of Bordeaux to go with their meal. This was a fairly large repast, costing about one and a half francs per person, a luxury Renoir and his artist friends were unable to afford for many years.

"I don't always have enough to eat", he told the artist Frédéric Bazille in 1869. "I'll write you more some other time, because I'm hungry and I have a plate of turbot with white sauce in front of me. I'm not putting a stamp on this letter. I have only 12 sous in my pocket, and that's for going to Paris, when I need it." In the 1860s and 1870s the works of avant-garde painters who were ridiculed as mere "impressionists" were worth practically nothing. Artists who, unlike Edouard Manet or Paul Cézanne, did not come from wealthy families, had a particularly hard life. Claude Monet had the hardest time of all; with a wife and child to support, he very often had little more than the bread Renoir sometimes brought him after visiting his parents.

The latter, artisans who had retired to the country, may not have been rich, but at least they had bread on their plates and a coop full of rabbits. Renoir, too, would probably have been better off had he stuck to the trade he had originally learned: porcelain painting, a skill which had enabled him to earn a living at the age of fifteen. But at 21 the artist, born in 1841, turned his hand to painting in earnest. He learned "anatomy, perspective, drawing and portraiture" at the studio of a well-known teacher, where he also met other young painters.

These artists would meet at a Parisian café to talk about new forms of perception and revolutionary painting techniques. Meeting at a café was necessary because most of them stayed in such miserable lodgings. (It is thanks to deplorable housing conditions that cafés, restaurants and bars have come to play such a vibrant role in French culture.) For many years Renoir's furniture consisted of no more than "a mattress lying on the floor, a table, chair and chest of drawers … and a stove for the model".

The artist used the stove to make his daily bowl of bean or lentil soup. According to his son, Renoir enjoyed "fresh basic foods", detesting margarine or sauces made with flour. However, he was able to indulge his innate epicurean leanings only by accepting the occasional invitation of some rich patron, or by dining at the "Restauarant Fournaise". Here he was seldom presented with a bill at the end of the meal: "You gave us that landscape", the proprietor would say. "My father insisted his painting was without value: 'I'm warning you, nobody will want it.' 'What does that matter to me if it's beautiful. Anyway, one must hang something on the wall to hide those patches of damp.'"

For much of his career Renoir could not afford to pay the fees of professional models, a single sitting costing as much as ten francs – the price of several meals. However, even when he was much better off, he preferred to paint his family and friends. He was interested in people and their relationships. He was a social being: "I need to feel a bustle going on around me."

According to Renoir, all the social classes met under Fournaise's striped awning. They had two things in common: friendship to the artist and an interest in art or sport. The man in the shiny black top hat, for example, was an art collector called Charles Ephrussi, a banker and owner of the art magazine *Gazette des Beaux-Arts*,

Sporting and other friends

in which, in 1880, he devoted a study to the Impressionists.

By contrast, the bowler-hatted man at the centre of the painting was interested only in "horses, women and boats". The former officer and diplomat, Baron Barbier, is reported to have told Renoir: "I don't know anything about art, and even less about your art, but I like helping you."

When he heard of the artist's plans for a boating picture, he offered to take over the organization and provide boats. Aristocrats like himself kept fit by riding, boxing and tennis, whereas ordinary people made do with walking, or riding the newly-invented bicycle. (It was in falling from a bicycle that Renoir broke his arm in 1880). But the gentry, bourgoisie and bohème would generally meet in order to indulge their passion for rowing. Fournaise "knew all about hiring boats out to Parisians, entrusting them only to trained enthusiasts ... Everyone pulled on their oars as hard as they could, trying to break records and become expert rowers."

One such expert was Gustave Caillebotte, a wealthy bachelor, here shown sitting astride a chair next to the actress Ellen Andrée. A trained engineer, he built racing boats, using them to participate in competitions. At the same time, he was an enthusiastic painter, though aware of the limitations of his talent. He was a generous man, paying a good price for his friends' works.

Wearing the appropriately named *canotiers* – "boaters" – on their heads, and with necks and muscular arms bared, Fournaise and Caillebotte stand out among the other guests in their correct city clothes. In an era which devoted so much attention to the "decency" of clothing, a girl might easily feel embarrassed by a sportsman's bare arms, as Maupassant recounts in his *Day in the Country*: "She pretended not to notice them", whereas her mother, "bolder, and drawn by a feminine curiosity which may even have been desire, could not remove her eyes ..."

2

The guests gathered on the terrace had yet another thing in common: their youth. Even the solemn-looking banker Ephrussi was only 31. Caillebotte was 32, while the girls in their fashionable hats, whose healthful, rosy bloom Renoir so loved to paint, were little more than twenty years old. "Come tomorrow with a pretty summer hat", the artist wrote to one of them on 17th September 1880, "in a light dress. Wear something underneath, it's starting to get cold …"

None of the sportsmen's lady-friends would have been seen dead without a hat. The hat was an indispensable sign of re-

Ideal woman in a hat

spectability and social status. The actresses Ellen Andrée and Jeanne Samary, the latter of whom is shown holding her hands over her ears in the background, refusing to listen to the compliments of two admirers, wear highly fashionable headgear acquired from a milliner's. The landlord's daughter Alphonsine, leaning on the railing at the edge of the terrace, like the seamstress Aline Charigot and the flower-girl Angèle, have trimmed their simple straw hats with flowers or ribbons.

Angèle, seen in Renoir's painting with a wine glass raised to her lips, was one of the many prostitutes who roamed Montmartre. This, at least, was the account Renoir gave his son. While he was working on the boating picture at Fournaise's, Angèle had managed to "pick up" a young man from a well-to-do family who married her and

took her to live in the country, where he turned her into a lady with affected manners. Aline Charigot, here seen entirely engrossed in her little dog, had recently moved to Paris from her home in Burgundy. She, too, had found a serious admirer: Auguste Renoir. Since his decision to devote his life to painting, Renoir had subordinated everything to this aim, even suffering hunger or cold if need be. According to his son, he went "through life with the delicious feeling of possessing nothing" but "the hands in his pockets", avoiding serious relationships of any kind.

For "I have known painters", Renoir recalled, "who produced nothing of value because they spent their time seducing women instead of painting them." The actress Jeanne Samary, who wanted to marry him, was eventually forced to resign: "He was not made for marriage; with his brush he weds every woman he paints." However, what had been so easily acceptable to a young bohemian proved increasingly onerous to the forty-year-old artist: "When you are alone, the evenings are deadly dull." In 1879 he met Aline.

The young seamstress was mad about water and "adored rowing". Renoir took her with him to Chatou. During the evenings, Baron Barbier waltzed her round the terrace, while Caillebotte looked after her "as he might have done a younger sister" and Ellen Andrée was determined to "give this delightful peasant girl a bit of polish". But Aline refused to give up her Burgundian accent and "become an artificial Parisian".

She sat for Renoir, and he taught her to swim. At that time, according to Maupassant, only women who were sufficiently well-rounded dared bathe in the river. "The others, padded out with cotton-wool, shored up with stays, propped up a little here, touched up a little there, looked on in blank disdain while their sisters splashed about in the water."

Aline could show herself without fear. The 21-year-old Burgundian was "slim and yet everything in her was rounded"; she was one of those "privileged beings whom the gods have spared the horrors of acute angles." But she not only incorporated Renoir's ideal of feminine beauty, the artist felt that, with her, he was altogether in the best of hands. Aline appeared to him to be "extraordinarily gifted to succeed in an area of which men scarcely dare dream: making life bearable".

4

Air, light and water

Ironically, while he was painting the apparently so light-hearted and harmonious *Luncheon of the Boating Party*, Renoir's life had entered a crisis. No longer as young as he had been, the artist suffered from lack of recognition, honour and money. He had also come to a crossroads in his art: "I no longer knew what I was about."

For many years Renoir had belonged to the group of artists known as "Impressionists". Together with Frédéric Bazille, Camille Pissaro, Alfred Sisley and Claude Monet, he had left his studio in the 1860s to paint out of doors, sailing down the Seine painting and drawing with Sisley in 1865, or competing to produce the best work with Claude Monet at the "Grenouillère", near Chatou, four years later. The young artists tried "to capture the light and project it directly onto the

canvas", as Monet put it. They developed new methods of reproducing the effect of light in the trees and its reflection on the surface of the water. They dissolved solid forms and revolutionized painting. At the same time, however, they met with the stern disapproval of the critics and the public, and their exhibitions of 1874 and 1876 ended in failure, leaving them lucky if they managed to sell a painting for 50 francs. By 1878, Renoir had had enough and began to do traditional portraits of rich Paris society ladies. "I think he's sunk", wrote Pissaro in 1879. "Poverty is so hard to bear", he added sympathetically. "The problem isn't art, but a hungry stomach … and an empty purse."

However, Pissaro was doing his friend an injustice. Renoir's break with Impressionism – the group was in the process of dissolving anyway – had artistic reasons: "I had travelled as far as Impressionism could take me", he later recalled, "arriving at a point where I could no longer paint or draw … I began to notice that the paintings that came out were too complicated and that one was constantly forced to cheat."

In the *Luncheon of the Boating Party* Renoir "cheats" in virtuoso fashion once again. His reflections of light and reverberating shadows, the atmosphere of a hot summer's day spent on a riverside terrace, remain a masterpiece of Impressionist "plein-air". The Seine landscape in the background is composed of air, light and water. The figures, however, acquire a new sense of solidity. Rigorously composed, and far from dissolving into their hazy surroundings, they attain an almost monumental stature at the centre of the canvas. They are harbingers of the new "rigorous style" that Renoir was soon to evolve under the influence of the Old Masters.

After completing the *Boating Party*, the artist – with the money from his portraits – allowed himself a trip to the South. The break had a considerable effect on his life and art. On returning to Paris in the autumn of 1881, his decision was made: he set up house with Aline, who made his "life bearable", and returned to work with renewed confidence.

Otto Dix: Metropolis (Triptych), 1928

Not long until it bursts apart

Otto Dix (1891–1969) completed his *Metropolis* triptych (181 x 403 cm) with the "roaring twenties" in full fling. Berliners danced the shimmy, the Charleston and the one-step; jazz was played even at the opera. Yet the consequences of defeat in the Great War were conspicuous even ten years after Armistice Day: begging war veterans, cripples and the victims of inflation were in sharp contrast to the hectic pace and fun-loving frenzy of the big city. Dix captures the contradictory scenes in this secular altarpiece. He, too, found it difficult to put his wartime experiences behind him.

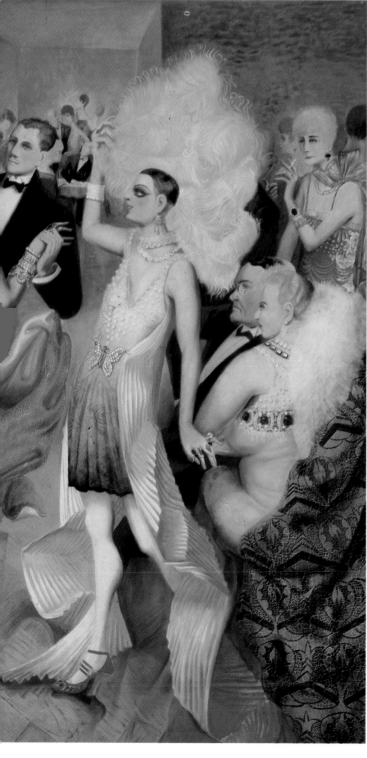

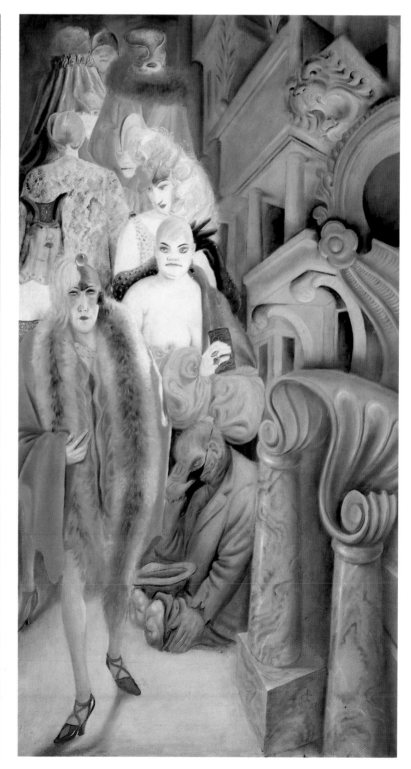

The painter of the *Metropolis* triptych hailed from Untermhaus, a small town near Gera in Thuringia. Gera belonged to one of the smallest German states, the princedom of the Junior Branch of Reuß. Otto Dix was born there on "2nd December 1891 at 1.30 in the morning in the house next to the old Gothic church". Untermhaus was a small town in a small state, with a rigidly structured society in which everybody knew everything about everybody else and in which the upper class, even according to the proclamations of the church, was God-given. Keeping order was seen as every citizen's duty, and private charities provided even the under-privileged with a minimum of social security.

Dix's father worked as a moulder in a foundry; he was thus near the bottom of the social ladder. At the top, in distant Berlin, was the Emperor himself. The local ruler was Prince Henry XIV of Reuß. Dix's father was unable to pay for his son's education as a painter; the Prince stepped in to help, but only on condition that the boy learned a decent trade first. Dix left school at the age of 13, apprenticing himself for four years to a decorative artist.

Finally putting the small-town atmosphere behind him, he left for Dresden, the Saxon capital and a centre of art. Here he entered the School of Arts and Crafts. In 1915 he went to war and was deeply affected by the collapse of every kind of order, by the misery he saw at the front, by fear, mutilation and death. Never again would he be able to paint pictures that conformed to the rules of conventional aesthetics. The role of art was not to make life pleasant. Dix's paintings disillusioned their specators; many found his manner revolting. He was twice charged with painting obscene portraits of whores and brothel scenes, and twice acquitted. In 1923, the director of an art museum bought one of Dix's war pictures, entitled *Trenches*, but was forced to remove it by the museum's governing board. One sensitive critic wrote: "Rembrandt's second anatomy lesson is charming. The Dix – excuse my language – made me want to throw up."

Dix painted numerous self-portraits. With his thrusting chin and provocative, even aggressive expression, he resembled the war cripple in the left panel of the triptych. Perhaps – though the artist never said so himself – his overpowering desire to dis-

illusion his spectators was fed by his proletarian background. He may have wanted to get his own back on the bourgoisie, with their cosy notions of beauty, security and order.

After the war, Dix lived at Dresden and Düsseldorf, then moved to Berlin, a metropolis of four million inhabitants, and became "famous". The greater part of his work now consisted of coldly realistic, large-scale portraits of doctors amd artists, as well as bohemian types who frequented the "Romanische Café". In 1927 he was offered a professorship at the Dresden Academy, where he had graduated only five years earlier. Notwithstanding his success in Berlin, he returned to the town he knew and liked. With him, he took the preliminary studies for the *Metropolis* triptych, finally executing the painting in his quiet Academy studio on the Brühlsche Terrasse, with its broad vista over the Elbe. Full of personal experience, the work also typified the mood of the twenties.

Cripples

Though the *Metropolis* triptych was painted ten years after the armistice, the war is still very much in evidence: in the right panel is a man without legs, the remains of whose face suggest the effects of makeshift surgery; in the left panel a man in a field-grey uniform lies on the ground behind a war-cripple with artificial limbs and crutches.

The lost war still felt uncannily close, not only in Dix's paintings, but also in

contemporary books, diaries and magazines. Ludwig Renn's novel "War" appeared in 1928; Erich Maria Remarque's *All Quiet on the Western Front* in 1929; and in August 1927, Harry Graf Kessler, diplomat and man of letters, noted in his diary: "Went to an American war film this evening: "What Price Glory?" – best I've seen to date …"

In August 1928 Kessler crossed the battlefields of Verdun to Rheims, where he saw "the hurt, dreadfully abused cathedral, exhausted by fire". He expressed the wish that the whole region be made sacrosanct, a mecca to pilgrims who condemned war. The entry also contains an *aperçu* reminiscent of the kind of contradictory scene Dix captured in the panels of his triptych, where destruction and amusement exist side by side: "The only pilgrims there now are crowds of tourists, desecrating the landscape like a revolting swarm of flies."

"War", "soldiers" and "the military" were key words in the parliamentary debates of the Weimar Republic, too. The Left had made Prussian militarism responisble for the disaster, while the Right blamed the ignominy of defeat on mutiny in the ranks. The Left saw the threat of a new war in the nationalist and racial politics of various right-wing groupings, while the Right saw the socialist parties plunging the country into anarchy – and so it went on. The election of Field Marshal Hindenburg, himself a symbol of the Prussian militarist tradition, as President of the Reich was a victory for the Right. That was in 1925, three years before Dix painted maimed soldiers in his *Metropolis* altarpiece.

It is unlikely that Dix wanted the motif to be understood as party political propaganda. At least this was not his primary intention. Dix was haunted by memories of horror, destruction and wartime suffering. The figure of the cripple is synonymous with these memories. This was true not only for Dix. No period in German art has produced so many paintings of cripples as the Weimar Republic. They made frequent appearances in the literature of the period, too. Erich Kästner's urban novel *Fabian* (1931) contains passages that could almost be read as a commentary on Dix's portrayal of the cripple with the botched-up face whose hand is raised to his temple to salute women bent on ignoring him.

Fabian, the hero of the novel, hears that "soldiers were still lying maimed in lonely hovels throughout the land: men without limbs, men with horrifically distorted faces, men without noses or mouths. And nurses who stopped at nothing would pour food through thin glass tubes, poking them through scarred, excrescent tissue into holes where these deformed creatures once had mouths – mouths capable of laughing, speaking, screaming."

The Negro

" … in a bastardized, nigger-ridden world, all that we think of as human beauty and nobility … would be lost forever." A "nigger-ridden world" was the nightmare-vision invoked in 1927 by a politician: Adolf Hitler, in *Mein Kampf*. Many Germans thought and felt in that way. "Negroes" and Jews threatened the Germanic race and, more especially, its culture. They were enemies.

The French army of occupation in the Rhineland was also considered an enemy, partly composed as it was of black soldiers from the French colonies. For blacks to have power over Germans on German soil was deeply humiliating to many German patriots.

But public attitudes towards blacks during the Weimar Republic were determined not only by racist propaganda and the presence of black soldiers in the occupying army. Blacks, identified with America, were harbingers of a New World. Before the Great War, Europeans had viewed the United States as a kind of colony. They had looked down on the Americans as the valiant, but primitive colonists of a vast wilderness – especially with regard to cultural matters. For where was their music, their painting, their literature?

By the end of the First World War America had unexpectedly shot to the position of number one world power. Its industry had reached a higher stage of development than those of Europe. Taylorism, the principle whereby manufacturing was broken down into a series of easily defined and easily executed steps (at the conveyor belt), had become the model to which European industrialists aspired. The general standard of living, industrial relations and the practical effects of

democracy all seemed equally admirable, or in any case better than their equivalents in Germany. However, the most important thing to come out of America, especially as far as the cities were concerned, was its new lifestyle. "Ah, but it seems the days of old Paris are numbered: it's becoming Americanized. And it's Berlin, they say, who calls the American tune on the Continent."

This view of the contemporary scene was the subject of an article, appropriately entitled "The Americanization of Europe?", by the Swiss essayist Max Rychner. Published in the *Neue Rundschau* in 1928, the year in which Dix completed his *Metropolis*, the article lists several features Rychner considered typical of the new lifestyle: aggressive optimism, unassuming self-confidence, an unbroken faith in the goodness of the world, youth, vitality. He sees the musical expression of this temper in the music of the blacks: jazz.

Jazz

Jazz took off in Germany in the mid-twenties. Sam Wooding and Duke Ellington toured with their bands in 1925, and a journal called *Musikblätter des Anbruchs*, in the same year, devoted an entire issue to the latest music. This contained a description of another aspect of jazz: "Revolt of the darker national instincts against a music without rhythm. Reflection of the times: chaos, machines, noise, extensity to the limit. The victory of irony, the defeat of ceremony, the wrath of the custodians of all that is precious …"

The custodians of all that was precious were those who prosecuted a strict division between music as entertainment and music as art. Jazz satisfied the demands of both categories: it was as popular as the commercially produced hits of the era, yet it lacked the latter's sickly-sweet superficiality. Jazz consorted badly with the assumed hierarchy of German cultural values. It was "high" culture that came from "below". Many music critics, if they took note of this kind of music at all, were left confused, their "wrath" aroused.

However, they could hardly avoid taking note when jazz musicians took to the opera stage in Ernst Krenek's "Johnny Strikes up the Band!" in 1927, with performances at 50 German theatres. Chaos, machines and noise were certainly part of the experience: telephones rang, sirens howled, machines pounded. The hero of the piece was a black jazz violinist. For the finale, the choir came in with: "A new world crosses the ocean and takes Old Europe by dance."

Charleston

Knees together, feet apart – the couple in the painting can only be dancing the shimmy or the Charleston. Both dances were new at the time, imports from the USA. Charleston was made popular in Europe by an American chorus girl called Josephine Baker. With her brown, supple body, her grand gestures and hair slicked down with pomade, she established a trend followed by many of the women and girls who frequented bars and nightclubs.

The twenties, especially in the big cities, were "a wild ball, sweeping along even the tired and weary", according to Walther Kiaulehn, the Berlin feature writer. Dancing took place not only at bars and clubs; people danced at home, too, thanks to the phonograph, and gramophone records, which entered mass production in 1925. In 1927 a poem published in the magazine *Weltbühne* began:

> *Discs in a pale lilac glow,*
> *Violin's syrupy squeak,*
> *Smart set's flitting shadow,*
> *Filtered negro musique …*

and ended:

> *For all their life's evanescent,*
> *They live as if in a trance,*
> *Since Heine's day incessant –*
> *On a volcano's edge they dance.*

There is much in the writing of the period to suggest a link between the dancing mania of the twenties and the anxiety of a society teetering on the edge of a volcano, an anxiety also found in contemporary painting. In the work of artists who were interested in the portrayal of society – Max Beckmann, George Grosz, Otto Dix or Karl Hofer – bars, nightclubs and carnivalesque festivities were, like the crippled, a recurrent theme, only here the dancers seem bored rather than amused, and disturbed rather than exuberant: not one person is smiling in Dix's bar.

Flappers

Much had changed since the war, including women's fashions and hairstyles. Before and during the war women had worn ankle-length dresses with long sleeves and laced-up waists, emphasizing their hips and bosom, as well as full coiffures. In the 1920s skirts rode up above the knee; European women had never been permitted to show so much leg. Dresses were straight, while breasts, waist and hips were concealed, indeed denied. It was now deemed permissible, too, to reveal one's arms, including the shoulders, and women began to shave their armpits. Hair, which once, like the bosom and hips, had been a signal zone of female eroticism, was cut short, like a man's.

This departure from traditional female dress had its own reasons. Pre-war society had been strongly male-oriented, with the officer providing the dominant role model. While the brisk military type had determined men's notions of manliness, women had been expected to exude femininity. In 1918, however, their menfolk came back from the front. Far from basking in glory, the latter had been forced to look on as their supreme commander, the Emperor, that paragon of manly virtues, had fled the country. Meanwhile, during the war, women had learned to fend for themselves and their families without the support of a husband. Gaining self-confidence, they had grown estranged from their traditional role as "little women". Many were war-widows, and had to go to work. Women poured into the factories, staffed offices, convinced professors they could study as well as any man. In the new Republic, as opposed to the old Empire, they had also won the right to vote.

Besides their debt to military defeat, changing gender roles also drew their impetus from a long, if initially weak, struggle for women's emancipation. American influence also played a part, brought home to European audiences by American-style chorus girls. Unlike French cancan dancers, these girls did not try to whip up their audiences into an emotional frenzy. On the contrary, precisely choreographed, in long lines, they looked more like the interlocking parts of a machine. The sociologist and film critic Siegfried Kracauer had this to say:

"Their lines snaking up and down the stage were an ecstatic advertisement for the merits of the conveyor belt; their quickstep sounded like: business, business; their legs, simultaneously thrown in the air, gleefully approved progress by rationalization; and their constant repetition of certain set pieces without ever breaking ranks projected upon one's mind's eye the image of a never-ending line of automobiles leaving the factory for the great wide world …"

The word "girl" became synonymous with a certain female type, the "flapper": down-to-earth, neat, sporting, confident. A typical flapper was unromantic, scorning jealousy and laughing chivalry in the face. The latter was now considered part of the dead stock of the Empire, with no place in the modern world. The flapper had her counterpart, however, in the man-eating "vamp", later personified by Marlene Dietrich. Essentially a later version of the *femme fatale*, there was nothing especially new about the vamp; she may not have epitomized the period to quite the same extent as the flapper, but she resembled the latter in that she, too, refused to subordinate herself to men. The large standing female figure in Dix's painting illustrates aspects of both: the ostrich plumes and eye make-up of the vamp, combined with the flapper's male hair-do, loose hanging dress and sporting legs.

4

Waiting room

The 1920s in Germany are referred to as the "Weimar period", after the Weimar Republic, but the period should really be known after Berlin, since it was here, in the city of four million, that the typical features of the period made themselves felt: constant political struggle, the American influence, the theatre boom, press diversity, intermingling of politics and art, the mania for entertainment. To many contemporaries, especially intellectuals and artists, the constant tension of living in Berlin was unbearable. Siegfied Kracauer: "In the streets of Berlin it can suddenly strike you that it is unlikely to be very long until the whole lot bursts apart."

The feeling was widespread in the Weimar Republic that things were not "quite right". People did not feel at home in the world; something had to "happen". Rather than developing naturally and gradually, the new state had taken the place of the old far too abruptly when the Emperor abdicated. With the Emperor gone, the political and social head and cornerstone was missing. Deprived of their guiding star, the people had lost their bearings. There was no basic political consensus. Parliament, where more than 20 different political parties sat, proved an inadequate tool of government. The general mood was one of anticipation: something had to change. The protagonist of Erich Kästner's *Fabian* describes the mood as one imbued with the sense of the "provisional". People led a temporary existence, as if in a gigantic "waiting room".

The spaces depicted in Dix's triptych, too, with their uninviting atmosphere, are reminiscent of waiting rooms: on the right, lavishly lit, fake architecture of the grotesque sort found in movie palaces at the time; in the middle, a dance bar whose lighting alone would put most people off dancing; on the left, a gloomy bridge, with lemonade-coloured light spilling onto the cobbles from the brothels. Dix's metropolis is anything but hospitable.

Kracauer's presentiment that everything was about to burst asunder has found its way into the paintings of the triptych. Picture space appears to have come apart at the seams. On the right, pieces of architecture are meaninglessly piled on top of one another; the parquet floor in the middle slopes down to the picture-plane, and the cobbles on the left are much too large in relation to

5

the bricks of the bridge pillar. There is also something inveterately "wrong" with the painting's use of depth: the dancing couple is shown further away from the large standing figure than the lines on the parquet floor allow; the brightly-dressed whore stroking the horse's head with her pointed fingers is standing next to the head of the lying man at the front of the passage, but the horse is standing at the back. The feeling is that something has gone terribly "wrong". The horse, too, with its sack of oats, looks oddly out of place.

"What was the point of his staying in this town, in this box of building-bricks gone mad?" Erich Kästener asks on behalf of Fabian, the hero of his novel. "After all, he could watch Europe's decline and fall just as easily from the town where he was born." Kästner has Fabian return to his place of origin: Dresden. By coincidence, Otto Dix too returned to Dresden in 1927, when he was offered a professorship there, carrying in his portfolio the preliminary sketches for the triptych. He was travelling to a town he knew well, a place where he felt at home; he may even have felt safe there.

Degenerate

Once in Dresden, Dix increasingly turned his hand to family portraits: his wife, his children, himself as a father. More than ever before, he seems to have lived in harmony with the world around him. He began to paint Biblical motifs. It was hardly coincidence that led him to tell people he had been born "next to the old Gothic church".

The *Metropolis* triptych also invites certain religious associations, though not only because of the Dix's chosen form: the winged altarpiece. The vertical row of women set out of perspective in the right panel recalls the angelic hosts of medieval art. The position of the ostrich-plume fan is reminiscent of a halo. The lengths of material draped over knee-length dresses remind us of the trains of show stars, or of fallen angels' wings. The cripple on the left may not be nailed to a cross, but he is certainly hanging on wood. Dix might have entitled the triptych "Harlot Babylon".

Dix was one of the first to lose his position when the Nazis came to power in 1933. The Nazis demanded that art use its power to make life beautiful again and, in particular, to glorify German history and the Aryan race. The paintings that had made Dix famous did not fulfil these requirements. Instead, they were accused of "deeply offending the moral sensibility of the German people … and of undermining … the will of the German people to defend their country."

Exhibitions held in the spirit of propaganda used Dix's paintings as a method of intimidation. The exhibitions had titles like "Art as Demoralization", or "Mirrors of Corruption", or quite simply "Degenerate Art". The Nazis placed such "demoralizing" pictures in a political context, interpreting them as "mirror images" of the Weimar period.

In 1934 Dix was banned from exhibiting his work, and 260 of his paintings were confiscated in the course of that year. He retired to the country, living in Hemmenhofen on Lake Constance from 1936 until his death. *Metropolis* triptych, which remained in his estate until 1965, entered the possession of the Städische Galerie Stuttgart in 1972, where it is now exhibited, together with the large-scale preliminary studies, to the painting's best possible advantage.

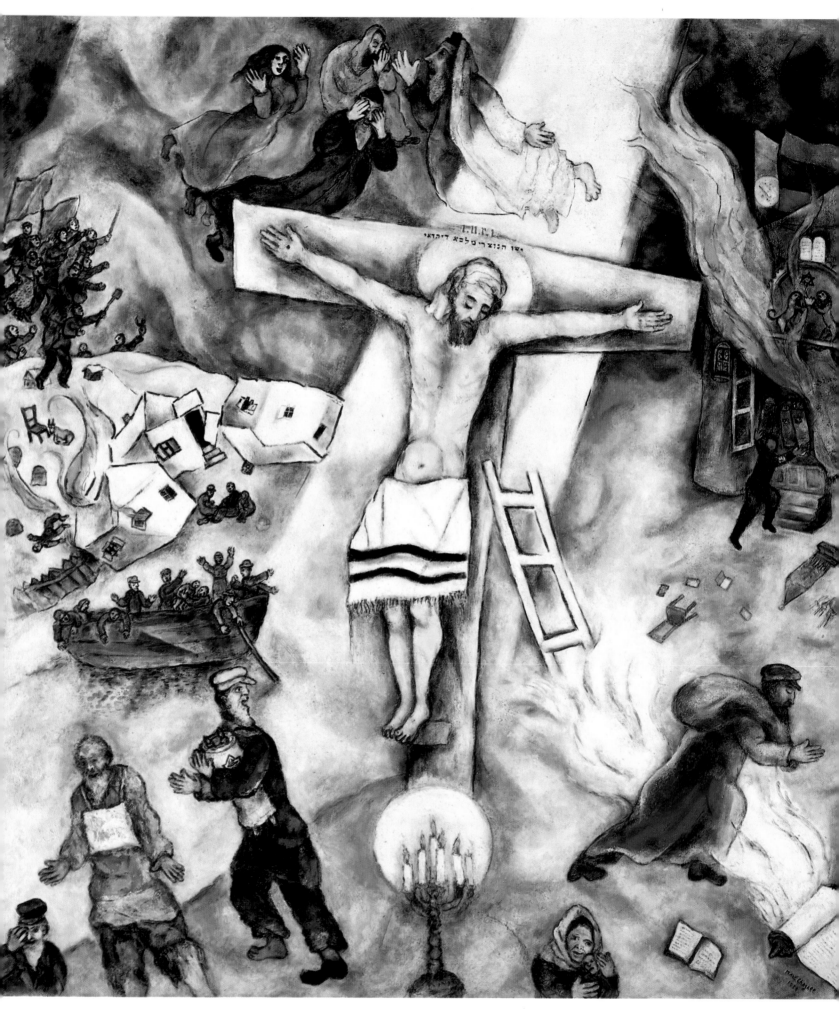

Marc Chagall: White Crucifixion, 1938

The Vitebsk Man of Sorrows

In his novel *The Brothers Karamazov*, Dostoyevsky tells of a Jew who crucifies a child. The Jew, according to the story, cuts off all the four-year-old boy's fingers before nailing him to a wall and standing back to enjoy the sight.

This horrific tale epitomizes the image of Jews presented in all of Dostoyevsky's books: Jews are dishonest and malicious, exploiters, conniving hoarders of gold and silver, and perhaps – one is never quite sure – they slaughter little children at Easter.

Dostoyevsky's allegations and insinuations were a reflection of the anti-Semitic attitudes of many of his countrymen. The Tsars, in tandem with the Orthodox Church, had long deprived Jews of the right even to dwell on "holy Russian" soil. This situation did not change until the 18th century when the partition of Poland paved the way for Tsarist Russia to expand west. Among the country's newly acquired subjects were a million Jews – at that time practically half the world Jewish population.

From then on their predicament, not unlike that of Jews in many other European states, varied between periods of toleration and persecution, without their ever being fully accepted. The Tsars repeatedly outlawed Jewish books and schools, attempting to coerce the "unbelievers" into accepting the Christian faith; there were pogroms, synagogues and shops were plundered, people killed. Writers like Dostoyevsky provided moral justification.

The Brothers Karamazov appeared in 1879 and 1880; not long afterwards, in 1887, Chagall was born at Vitebsk, a small town where Jews enjoyed relative freedom of movement. To visit St. Petersburg, however, the capital of Tsarist Russia, special permission was required. Permits, highly coveted, were granted only to those with proof of employment: as a servant or a sign-painter, or a student at one of the art academies. Chagall, each of these in succession, frequently found himself sharing cramped sleeping quarters with many of his fellow men: "I began to understand that we Jews were not the only ones to be forbidden the right to live in Russia, for there were many Russians too, all crawling over each other like lice on a head of hair."

Professional status allowed a small number of privileged Jews, most of them doctors, lawyers or bankers, to live in St. Petersburg. They would often support young artists, and one paid for Chagall to visit Paris in 1910. It was a long journey – not only in kilometres. Chagall had come far: from an isolated township in provincial White Russia, via St. Petersburg, to the cultural centre of Western Europe.

However, in this respect Chagall was not unique. Many artists, members of the oppressed Jewish minority, left Russia for the West in the period before the First World War, and again after the Russian Revolution. Their contribution to western culture was both enriching and influential. They included writers like Ilya Ehrenburg, the set designer Leon Bakst, the sculptors Jacques Lipchitz and Ossip Zadkine, as well as Chaim Soutine and Issai Kulviansky, two of the many painters of whom Marc Chagall was only the most famous.

Among the artists, only Chagall remained faithful to his Russian-Jewish background. His paintings return again and again to the same motifs: the small huts of Vitebsk, devout Jews with the Torah scroll, rabbis and synagogues. "I have continued the work passed on to me by my parents and by their parents in turn for thousands of years", he said. "I shall never forget the land of my birth." Thanks to Chagall's paintings, many people – even those to whom the world of the Jews otherwise means very little – have become acquainted with Jewish motifs.

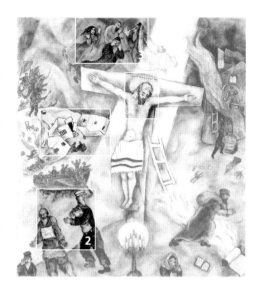

Marc Chagall died in 1985 at the age of 97. Many of his paintings plead for love and understanding between the peoples of the world, or warn of terror and violence. When the National Socialists intensified their campaign to exterminate the Jews, unleashing the "Kristallnacht" pogrom in 1938, Marc Chagall, a Jew, painted the Christian Redeemer surrounded by scenes and symbols taken from the life and beliefs of the artist's own Russian-Jewish homeland. The painting was not a work of protest. As an allegory of human suffering, it pointed to a divine order behind the misery and afflictions of this world. The painting, measuring 155 x 139.5 cm, is now in the Art Institute of Chicago.

The houses in Chagall's painting are depicted lying on their sides; one is on its roof, another is up in flames. The laws of statics and gravity seem no longer to apply in the world of the painting; the buildings appear to be made of folded paper, or part of a dream. In any case, they look very different from those we are used to seeing. Chagall does not attempt to copy the recognizable world, but creates a world of his own, selecting and juxtaposing otherwise disparate fragments of reality. Among these are simple houses of the kind in which he was born at Vitebsk. At the time of Chagall's birth in 1887, Vitebsk, situated on the river Drina near the former Lithuanian border, had some 60,000 inhabitants, over half of them Jews. Some were tradesmen and craftsmen, or founded factories, but the majority, like the Chagalls, were poor. Chagall's father earned his living in a fishmonger's shop "hoisting heavy barrels, and I felt my heart twist like a Turkish pretsel when I saw him lift such heavy weights or go rum-

Pictures of a world without pictures

maging in barrels of herring with his frozen hands."

Though in material terms, standards were extremely modest, Jewish tradition and religious devotion made life culturally rich. The Sabbath and the different religious festivals determined the course of the year. "On Fridays, when we'd eaten the Sabbath evening meal, our father would always fall asleep at the same place in the prayer", so that Chagall's mother, he recalled, would say to her eight children: "Come on! Lets sing that song about the rabbi!" Thus Chagall's account in his memoirs. "My mother was the eldest daughter of a grandfather who spent half his life by the stove, a quarter in the synagogue, and the rest at the butcher's shop."

"Thou shalt not make unto thee any graven image, or any likeness of any thing that is in heaven above, or that is in the earth beneath, or that is in the water under the earth." The Old Testament commandment forbidding idolatry was interpreted by Jews as a prohibition against the painting of pictures. "No picture hung on our walls, not even a print … Until 1906, in all the years I spent at Vitebsk, I had never seen a single picture." In 1906 Chagall, 19 years old at the time, was permitted to re-

ceive lessons from a portraitist in his home town. However, his father refused to place the money for tuition in his hand, throwing it on the ground in the yard instead. As a devout Jew he did not wish to encourage painting; but neither did he wish to prevent his eldest son from doing so. Chagall later recalled: "My uncle is too frightened to give me his hand. He has heard that I am a painter. What if I wanted to paint him? God forbids such things. Sin."

Not only the houses, but the scene with the prostrate woman and child, too, derive from the artist's memories of his childhood and youth. Though he had not seen these figures himself, he had been told about them, and was evidently deeply impressed. He recalled: "I no longer remember – could it have been my mother who told me? Apparently, at the very moment of my birth a great fire broke out in a little house near Vitebsk, on the road behind the prison. The town was in flames – the poor Jewish quarter burning. They took the bed and mattress, with the mother and the baby at her feet, to a safe place on the other side of town." The artist has thus included himself in the form of an anecdote relating to the day of his birth in a great painting of fire, persecution and floating figures.

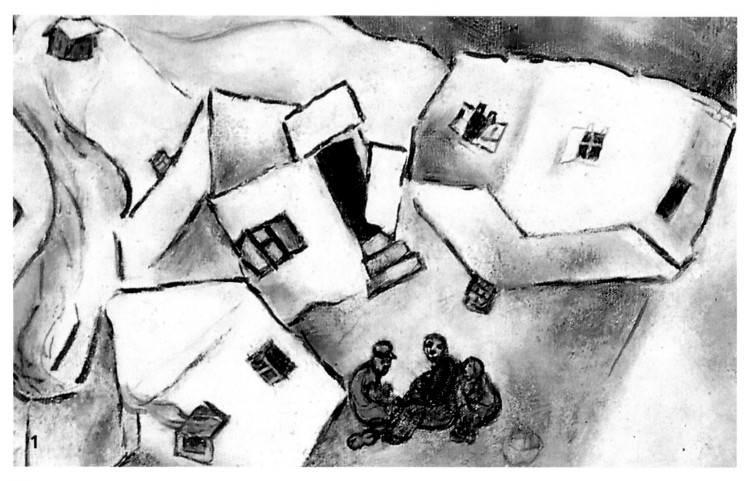

1

The inscription "I am a Jew" deleted

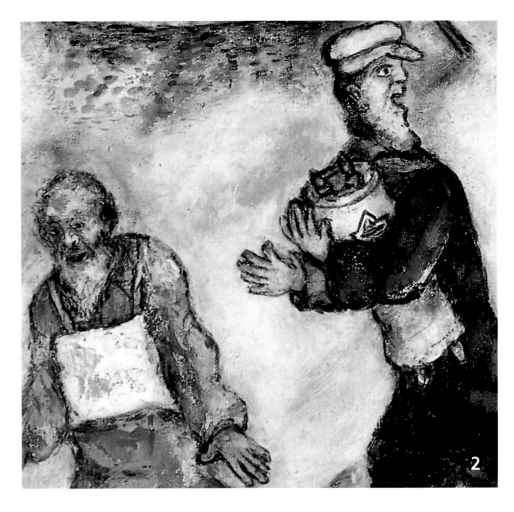

When Chagall painted these childhood memories he was over 50 years old. He had incorporated them in a picture whose subject was inspired by a misfortune of quite different proportions to that of a local fire: the persecution of the Jews by the Nazis. Chagall painted the *White Crucifixion* in 1938, the year of the "Kristallnacht" pogrom in Germany, when Hitler's Brownshirts set fire to the synagogues, plundered Jewish shops and physically abused Jewish citizens. The mass extermination of Jews in concentration camps had not yet begun, but the "Kristallnacht" and banning of Jews from German public life were stages on the way.

Only a tiny detail betrays the occasion that gave rise to Chagall's painting: in front of the burning synagogue is a figure apparently clad in the uniform of the Brownshirts. However, as if shrinking from so unequivocal a statement, the artist has avoided painting the Nazi emblem on the flags. He also later deleted an unambiguous clue from the white piece of cloth covering the chest of the man in the blue smock. It originally carried the German inscription: "Ich bin Jude" (I am a Jew), as an extant preliminary sketch for the painting reveals.

But Chagall was not a political realist, nor was he interested in current affairs, or he would not have painted refugees in 1938 who, with their long beards and Russian smocks, resembled the Jews of his old home town. Moreover, the painting not only avoids precise indications of time or place, but does without aids like perspective or a recognizable horizon, both of which usually facilitate orientation. This contributes to the altogether dreamlike tenor of the work.

Torah scrolls are twice depicted in the painting: one is burning on the ground in the bottom right; the other is in the rescuing arms of a man on the left. The Torah is essentially the Jewish Bible, comprising the first five books of the Mosaic law, the Pentateuch; it is kept in the synagogue, and an exerpt is read on the Sabbath. When a boy is accepted into the community, he reads the weekly portion in Hebrew, and when a Jew dies, the Torah is brought from the synagogue to his home. The Torah forms the basis of Jewish religious practice, as well as of social cohesion in the Jewish community. Adherence to the letter of Hebrew texts in the Torah helped Jews survive through periods of persecution and exile.

It is rather more difficult to establish the exact significance of the red flags shown entering at the top left of the picture. Do the armed men belong to the oppressors, or are they liberators? Are the flags red because Chagall felt the painting needed the colour, or did he intend us to think of Communists? In fact, Chagall was a Bolshevik Commissar for Fine Art, with the task of founding an art academy at Vitebsk. He was forced to yield the post two years later, however, not because of political difficulties, but because of quarrels about art with two of the teachers he had appointed at his institute: El Lissitzky and Kasimir Malevich.

Prior to returning to the West, travelling first to Berlin and then on to Paris, Chagall worked as a stage designer in Moscow, largely for the State Jewish Theatre, and taught at an orphanage. There is practically no evidence to suggest he studied Marxism or Lenin's politics. Chagall saw the Revolution as a means of releasing creative potential, a project to which he willingly lent his support. He had no time for political structures or ideological battles.

The floating, birdlike figures shown wailing and gesticulating above the Cross are evidently Jews rather than Christian saints. Two are wearing a "tallith", or prayer shawl, over their heads, and one has a small leather box at his forehead containing parchments inscribed with passages from the Old Testament. These are the "tefillin", or phylacteries, worn by devout Jews at prayer.

Chagall, more than any other 20th-century painter, is the artist of floating figures, figures who appear to recline on air. Some of the figures are dreaming; many are lovers; yet others are musicians. These figures have in common their "heightened" state; their bodies appear to respond to intense emotion. The present scene possibly depicts the exaltation of the devout. The motif is reminiscent of a Jewish anecdote: "Sometimes, when Rabbi Elimelech spoke the Shema on the Sabbath, he

Joyful are those who perceive the divine purpose

would take out his pocket watch. This being the hour when he felt his soul most likely to melt in sheer bliss, he looked at his watch to keep himself locked in the present, and thereby attached to the world."

But perhaps the artist intended to suggest not a state of emotional intensity, but the presence of Jewish teachers and prophets; or possibly he had reason to mean both. In his memoirs Chagall recalls the very real presence of the prophets in his parents' house: "Ordering me to open the door, my father raised his glass. Were we opening our door, the outside door, at such a late hour to let in the prophet Elijah? A silvery sheaf of white starlight darted into my eyes out of the blue velvet sky – and straight into my heart. But where was Elijah and his fiery white chariot? Perhaps he was still out there in the yard, about to enter the house as a frail old man, or a stooping beggar with a sack hung over his back and a stick in his hand? 'Here I am. And where, I pray you, is my glass of wine?'"

The story of the rabbi keeping himself in the present by looking at his pocket watch is part of the Chassidic tradition in which Chagall grew up. The Chassidim, or

"pious ones", aspire to the perfection of a divine purpose in reality, no matter how imperfect, miserable or painful reality itself might be. One who succeeds in this endeavour, even briefly during prayer, is filled at once with joy, ecstasy, enthusiasm. It is no coincidence that the Chassidim are great singers and dancers.

Chassidism was originally a response to the more intellectual discipline of Talmudism; the "pious" held intuition and the emotions in higher esteem than logic. Chassidism has no firm doctrine, but is rich in tales and legends. Many concern the right way – the pious way – to look at things. One tells of how Rabbi Löb visited an elder, "not to hear his teachings, but merely to see how he tied and untied his felt shoes". Rabbi Menachem Mendel, from Vitebsk like Chagall, is reported as saying: "When I see a bundle of straw lying lengthways rather than sideways on the ground, it is to me a sign of divine presence."

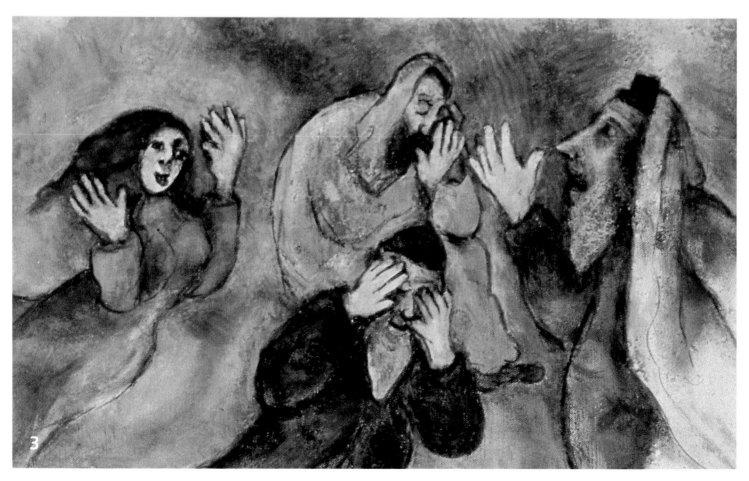

Chagall had little time for political protest

Stories like these were part of Chagall's childhood, and it was perfectly in keeping with their undogmatic spirit for the artist to paint Christ with a halo. For in orthodox Judaism, Christ is not seen as a Messiah sent to redeem the world and propagate the Kingdom of Heaven; a halo would normally therefore be considered inappropriate. Nor is Christ, according to Jewish belief, what the Roman Pontius Pilate ironically dubbed him: "The King of the Jews". Yet Chagall not only uses the Roman abbreviation for Pilate's epithet, I.N.R.I., but writes it in Jewish lettering, as if it expressed the Jewish view. To orthodox opinion the descending beam of light would also be unacceptable. For the Jews, Christ was a normal being; he may have led an exemplary life, and perhaps he was even a prophet, but that was all.

Such matters were of little interest to Chagall, who felt indifferent to the opinions of the rabbis. In leaving his home town, he had also left behind him the Jewish religion; he no longer went to synagoge or celebrated Jewish festivals. Nor, for that matter, did he bother with the New Testament, not even – according to his daughter Ida – when designing the cathedral windows at Rheims and Metz.

"I am not a Jewish artist", he once said. "To me the Bible means only one thing. It is the most important source of material for poetry." Chagall inhabited a world of his own, a world of ideas and images, among which were not only praying figures, the Torah scroll or wooden huts at Vitebsk, but also the Crucifixion. Altogether he painted over twenty Crucifixions, the first, in 1912, showing Christ with the body of a child. Later, he appears to have identified as an artist with the figure of Christ. By 1940 he was painting Eastern European Jews nailed or bound to the Cross in the village streets of his youth. All his depictions of Christ and the Crucifixion have one thing in common: they are symbols of suffering.

To suffer the world and accept, with all that means in terms of social relations, is a characteristic feature of Chassidism. Its origins lie in the predicament of an oppressed minority who were unable to defend themselves, and whose watchful attempts to see a divine purpose in the reality of their wretched condition was virtually a means of survival. In his autobiography Chagall wrote of the indiscriminate, "sheep-like" love he felt for his fellow beings, but there is no indication that he defended himself against discrimination. Nowhere does he mention the Socialist or Zionist movements that inspired many Russian Jews. They could not reach Marc Chagall; they bore no relation to his world.

There is a famous counterpart to Chagall's painting of the Crucifixion: *Guernica.* Executed a year earlier than Chagall's picture, Picasso's work expressed indignation at the bombing of the Spanish town by planes of the "Condor Legion" in 1937. Thus both artists adopted an attitute towards atrocities committed by the German Facists. Picasso's work is an appeal for resistance, calling for immediate protest; the artist wants to change the world. By contrast, Chagall's masterpiece points to a different world altogether, a world beyond death, the central column of white light pushing the more colourful scenes away from the centre towards the edges of the canvas. Flight, fire and pillage pale into insignificance for those to whom the divine purpose is revealed.

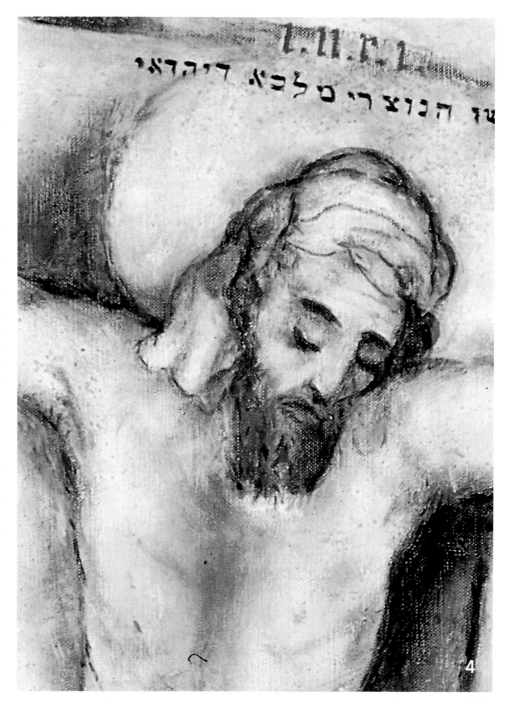

Appendix

Artist unknown
The Bayeux Tapestry, after 1066
50 cm x 70.34 m, Bayeux, Centre
Guillaume Le Conquérant

Literature:
Bertrand, Simone: La tapisserie de Bayeux et la ma-
nière de vivre au onzième siècle, np 1966. – Grape,
Wolfgang: Der Teppich von Bayeux, Triumphdenk-
mal der Normannen, Munich 1995. – Parisse, Michel:
La tapisserie de Bayeux, Un documentaire du XIe
siècle, np 1983.

Upper Rhenish Master
The Little Garden of Paradise, c. 1410
26.3 x 33.4 cm, Frankfurt, Städelsches
Kunstinstitut

Literature:
Hennebo, Dieter and Hofmann, Alfred: Geschichte
der deutschen Gartenkunst, Gärten des Mittelalters,
Vol. 1, Hamburg 1962. – Vetter, Ewald M.: Das Frank-
furter Paradiesgärtlein, in: Heidelberger Jahrbücher,
9, np 1965. – Wolfhardt, Elisabeth: Beiträge zur Pflan-
zensymbolik, Über die Pflanzen des Frankfurter
"Paradiesgärtlein", in: Zeitschrift für Kunstwissen-
schaft, Vol. VIII, Berlin 1954.

Petrus Christus (c. 1415–1473)
St. Eligius, 1449
98 x 85 cm, New York, The Metropolitan Mu-
seum of Art, Robert Lehmann Collection, 1975

Literature:
Comeaux, Charles: La vie quotidienne en Bourgogne
au temps des ducs Valois, Paris 1979. – Metropolitan
Museum of Art: Petrus Christus, Renaissance Master
of Bruges, New York, 1994. – Pirenne, Henri: Ge-
schichte Belgiens, 2 vols. Gotha 1902. – Prevenier,
Walter and Blockmanns, Wim: Die burgundischen
Niederlande, Antwerp 1986. – Schabacker, Peter:
Petrus Christus, Utrecht 1974.

Hieronymous Bosch (c. 1450–1516)
(Jerome van Aken)
The Conjurer, after 1475
53 x 65 cm, Saint-Germain-en-Laye,
Musée Municipal

Tarot card: The Conjurer
Private Collection

Literature:
Fraenger, Wilhelm: Hieronymous Bosch, Dresden
1975. – Geremek, Bronislav: Truands et Misérables
dans l'Europe moderne (1350–1600), Paris 1980. –
Brand, Philip L.: The Peddlar by Hieronymous Bosch,
a study in detection, in: Niederlands Kunsthistorisch
Jaarboek, Bussum 1958. –Schuder, Rosemarie: Hiero-

nymous Bosch, Wiesbaden nd (c. 1975). – Tolnay,
Charles: Hieronymous Bosch, Baden-Baden 1973.

Sandro Botticelli (1444–1510)
(Alessandro di Mariano Filipepi)
Primavera – Spring, c. 1482
203 x 314 cm, Florence, Uffizi

Literature:
Cleugh, James: The Medici, New York 1975. –
Duberton, Jean Lucas: La vie quotidienne à Florence
au temps des Médicis, Paris 1958. – Levi d'Ancona,
Mirella: Botticelli, Primavera, a botanical interpreta-
tion including astrology, alchemy and the Medici,
Florence 1983. – Lightbow, Ronald: Sandro Botticelli,
Life and Work, 2. vols. London 1978. – Warburg,
Aby: Sandro Botticelli, Geburt der Venus und
Frühling, Hamburg, Leipzig 1893.

Hans Baldung (c. 1485–1545)
(alias Grien)
The Three Stages of Life, with Death, c. 1510
48 x 33 cm, Vienna, Kunsthistorisches Museum

Literature:
Boll, Franz: Die Lebensalter, Ein Beitrag zur antiken
Ethologie und zur Geschichte der Zahlen, Leipzig,
Berlin 1913. – Herter, Hans: Das unschuldige Kind,
in: Jahrbuch für Antike und Christentum, Jahrgang 4,
Münster 1961. – Von der Osten, Gert: Hans Baldung
Grien, Gemälde und Dokumente, Berlin 1983. –
Wirth, Jean: La jeune fille et la mort, Geneva 1979.

Albrecht Altdorfer (c. 1480–1538)
The Battle of Issus, 1529
158.4 x 120.3 cm, Munich, Alte Pinakothek

Literature:
Buchner, Ernst: Die Alexanderschlacht, Stuttgart
1956. – Krichbaum, Jörg: Albrecht Altdorfer, Meister
der Alexanderschlacht, Cologne 1978. – Winzinger,
Franz: Albrecht Altdorfer, die Gemälde. Munich,
Zurich 1975.

Titian (1488/1490–1576)
(Tiziano Vecellio)
Venus of Urbino, c. 1538
119 x 165 cm, Florence, Uffizi

Giorgione
(Giorgio da Castelfranco)
Sleeping Venus, 1510
Dresden, Staatliche Kunstsammlung

Literature:
Gronau, Georg: Die Kunstbestrebungen der Her-
zöge von Urbino, in: Jahrbuch der Königlich-Preußi-
schen Kunstsammlungen, Berlin 1904. – Hollander,
Anne: Seeing through clothes, New York 1975. –
Hope, Charles: Titian, London 1980. – Rostand,
David: Titian, New York 1978. – Valcanover, Frances-
co: Das Gesamtwerk von Tizian, German edition:
Lucerne nd; Italian edition 1969.

Lucas Cranach the Younger (1515–1586)
The Stag Hunt, 1544
117 x 177 cm, Vienna, Kunsthistorisches
Museum

Literature:
Friedländer, Max J. and Rosenberg, Jakob: Die Ge-
mälde von Lucas Cranach, Basle, Boston, Stuttgart
1979. – Grimm, Claus; Brockhoff, Evamaria and
Erichsen, Johannes, (eds.): Lucas Cranach, Ein Maler-
Unternehmer aus Franken, Augsburg 1994. – Kunst-
historisches Museum, Vienna: Lucas Cranach der Äl-
tere und seine Werkstatt, Katalog zur Jubiläumsaus-
tellung museumseigener Werke, Vienna 1972. –
Schade, Werner: Die Malerfamilie Cranach, Vienna
and Munich 1977.

Tintoretto (1518–1594)
(Jacopo Robusti)
Susanna and the Elders, c. 1555
147 x 194 cm, Vienna, Kunsthistorisches
Museum

Literature:
Holy Bible: New Revised Standard Version, Oxford
1989. –Molmenti, Pompeo: La storia di Venezia nella
vita privata, Bergamo 1905–1908, Reprint, Triest 1973.
– Palluchini, Rodolfo and Rossi, Paola: Tintoretto,
Florence 1982. – Ruggiero, Guido: Violence in Early
Renaissance Venice, New Brunswick, New Jersey
1980. – Valcanover, Francesco and Pignatti, Terisio:
Tintoretto, New York 1985. – Zorzi, Alvise: La vita
quotidiana a Venezia nel secolo di Tiziano, Milan 1990.

Pieter Bruegel the Elder (c. 1525–1569)
Peasant Wedding Feast, c. 1567
114 x 163 cm, Vienna, Kunsthistorisches
Museum

Literature:
Alpers, Svetlana: Bruegel's festive peasants, in: Simi-
olis, 1972/3. – Claessens, Bob and Rousseau, Jeanne:
Unser Bruegel, Antwerp 1969. – Hagen, Rose-Marie
and Hagen, Rainer: Pieter Bruegel der Ältere, Cologne
1994. – Simson, Otto von and Winner, Matthias, (eds.):
Pieter Bruegel und seine Welt, Berlin 1979. – Stechow,
Wolfgang: Bruegel the Elder, New York 1980. – Strid-
beck, Carl Gustav: Bruegelstudien, Stockholm 1956. –
Wied, Alexander: Bruegel, Milan 1979.

Antoine Caron (1521–1599)
Caesar Augustus and the Tiburtine
Sybil, c. 1580
125 x 170 cm, Paris, Musée du Louvre

Literature:
Cloulas, Yvan: Catherine de Médicis, Paris 1978. –
Ehrmann, Jean: Antoine Caron, Peintre à la Cour des
Valois, Geneva 1955. – "L'école de Fontainebleau",
Exhibition Catalogue, Grand Palais, Paris 1972. –
Jacquot, (ed.): Les fêtes de la Renaissance, Paris
1956.

El Greco (1541–1614)
(Domenikos Theotokopulos)
The Burial of Count Orgaz, 1586
480 x 360 cm, Toledo, Santo Tomé

Literature:
Gudiol, José: El Greco, Geneva 1973. – Mâle, Émile:
L'art religieux de la fin du XVIe siècle, du XVIIe siècle
et du XVIIIe siècle, étude sur l'iconographie après le
Concile de Trente (Italie, France, Espagne, Flandres),

Paris 1951. – Schroth, Sarah: Burial of the Count of Orgaz, in: Studies in the History of Art, Vol. II, National Gallery of Art, Washington, D.C. 1982.

Michelangelo da Caravaggio (1571–1610)
(Michelangelo Merisi)
Martyrdom of St. Matthew, 1599–1600
323 x 343 cm, Rome, S. Luigi dei Francesi

Literature:
Delumeau, Jean: Vie économique et sociale de Rome dans la seconde moitié du XVIe siècle, Paris 1957–1959. – Friedländer, Walter: Caravaggio Studies, Princeton 1955–1974. – Hibbard, Howard: Caravaggio, London 1983. – Mâle, Émile: L'art religieux de la fin du 16e et 17e s., étude sur l'iconographie du Concile de Trente, Paris 1932.

Rembrandt (1606–1669)
(Rembrandt Harmensz van Rijn)
The Blinding of Samson, 1636
205 x 272 cm, Frankfurt, Städelsches Kunstinstitut

Self-portrait, c. 1628
Amsterdam, Rijksmuseum

Literature:
Eich, Paul: Rembrandts "Die Blendung Simsons", Kleine Werkmonographie des Städelschen Kunsinstituts, Frankfurt am Main, nd. – Gerson, Horst: Rembrandt, Gemälde, Gesamtwerk, Wiesbaden 1968. – Haak, B.: Rembrandt, sein Leben, sein Werk, seine Zeit, Cologne 1969. – Tümpel, Christian: Rembrandt, Mythos und Methode, Königstein 1986. – Tümpel, Christian, (ed.): Im Lichte Rembrandts, Das Alte Testament im Goldenen Zeitalter der niederländischen Kunst, Munich, Berlin 1994.

Diego de Silva y Velázquez (1599–1660)
The Tapestry-Weavers, 1644–1648
220 x 289 cm, Madrid, Museo del Prado

Literature:
Defourneaux, Marcelin: La vie quotidienne en Espagne au siècle d'or, Paris 1964. – Gudiol, José: Velazquez, Sa Vie, Son Oeuvre, Paris 1975. – Hume, Martin A. S.: Spain, its greatness and decay, Cambridge 1925. – Justi, Carl: Diego Velazquez und sein Jahrhundert, Munich 1903. – Rey, José Lopez: Velazquez, Catalogue Raisonné, Lausanne, Paris 1981.

David Teniers the Younger (1610–1690)
Archduke Leopold Wilhelm's Galleries at Brussels, c. 1650
127 x 163 cm, Vienna, Kunsthistorisches Museum

Literature:
Brieger, Lothar: Die großen Kunstsammler, Berlin 1931. – Garas, Klara: Die Entstehung der Galerie des Erzherzogs Leopold Wilhelm, in: Jahrbuch der kunsthistorischen Sammlungen in Wien, 63 (New Series 28), Vienna 1967. – Das Schicksal der Sammlung des Erzherzogs Leopold Wilhelm, in: Jahrbuch der kunsthistorischen Sammlungen in Wien, 64 (New Series 26), Vienna 1968. – Rosenberg, Alfred: Teniers der Jüngere, Bielefeld, Leipzig 1901. – Speth-Holtershof, S.: La célèbre Galerie de Tableaux de L'Archiduc Léopold-Guillaume, in: Reflets du Monde, Brussels 1952.

Charles Le Brun (1619–1690)
The Chancellor Séguier, after 1660
295 x 357 cm, Paris, Musée du Louvre

François Chauveau or Charles Le Brun
From the cycle: The Chancellor Séguier, after 1660
Stockholm, Statens Konstmuseer

Literature:
Exhibition Catalogue: Charles Le Brun, Versailles 1963. – Erlanger, Philippe: Louis XIV, Paris 1965. – Gaxotte, Pierre: Louis XIV, Paris 1974. – Mauricheau-Beaupré, M.: Le Portrait du Chancelier Séguier, in: Bulletin de la Société de l'histoire de l'art Français 1941–1944, Paris 1947.

Antoine Watteau (1648–1721)
The Music-Party, c. 1718
69 x 93 cm, London, The Wallace Collection

Literature:
Le Nabour, Eric: Le Régent, Paris 1984. – Moureau, François and Morgan Grasselli, Margaret: Watteau, le peintre, son temps, sa légende, (Actes du colloque Watteau 1984), Paris, Geneva 1987. – Posner, Donald: Antoine Watteau, London 1984. – Rosenberg, Pierre and Morgan Grasselli, Margaret: Catalogue: Watteau Exhibition, Paris, Washington, Berlin 1984–1985. – Rosenberg, Pierre: Vies anciennes de Watteau, Paris 1985.

Giambattista Tiepolo (1696–1770)
The Death of Hyacinth, 1752–1753
287 x 235 cm, Madrid, Museo Thyssen-Bornemisza

Literature:
Levey, Michael: Giambattista Tiepolo, His life and art, New Haven, London 1986. – Luze, Albert de: La magnifique histoire du jeu de Paume, Paris, Bordeaux 1933. – Sack, E.: Giambattista und Domenico Tiepolo, Hamburg 1910. – Schaumburg-Lippe, Wilhelm Graf zu: Philosophische und politische Schriften, ed. Curd Ochwadt. 3 vols. Frankfurt am Main 1977-1983.

Joseph Wright of Derby (1734–1797)
A Philosopher giving a Lecture on the Orrery, c. 1764–1766
147.3 x 203.2 cm, Derby, Derby Museum and Art Gallery

Literature:
Boime, Albert: Art in an Age of Revolution, 1750-1800, Chicago, London 1987. – Egerton, Judy: Wright of Derby, London 1990. – Paulson, Ronald: Emblem and Expression, Meaning in English Art of the Eighteenth Century, London 1975.

Francesco Guardi (1712–1793)
The Departure of the Doge on Ascension Day, c. 1770
67 x 101 cm, Paris, Musée du Louvre

Literature:
Jonard, Norbert: La vita a Venezia nel 18 secolo, Milan 1967. – Lane, Frederic: Venice, a maritime Republic, Baltimore 1973. – Mazarotto, Bianca Tamasso: Le Feste veneziane, Florence 1961. – Molmenti, Pompeo: La Storia di Venezia nella vita privata, Bergamo 1905-1908, Reprint, Triest 1973. – Morassi, Antonio: Guardi, l'Opera completa di Antonio e Francesco Guardi, Venice 1973.

Francisco de Goya (1746–1828)
The Burial of the Sardine, after 1812
82.5 x 62 cm, Madrid, Academia di S. Fernando

Literature:
Casas Gaspar, Enrique: Ritos agrarios, Folklore Campesino Espanol, Madrid 1950. – Chastenet, Jacques: La vie quotidienne en Espagne au temps de Goya, Paris 1966. – Gaignebet, Claude: Le carnaval, essais de mythologie populaire, Paris 1974. – Gassier, Pierre and Wilson, Juliet: Francisco Goya, Goya, Leben und Werk, Frankfurt am Main 1971. – Helman, Edith: Trasmundo de Goya, Madrid 1963.

Théodore Géricault (1791–1824)
The Raft of the Medusa, 1819
491 x 716 cm, Paris, Musée du Louvre

Literature:
Anthonioz, Pierre: La véritable histoire du radeau de la Méduse, in: "L'Histoire", No.36, July/August 1981. – Bellec, François: L'affaire de la Méduse, Documentation du Musée de la Marine, 1981. – Catalogue de l'exposition Géricault, Paris 1991-1992. – Eitner, Lorenz: Géricault's Raft of the Medusa, London 1922. – Nicolson, Benedict: The "raft" from the point of view of subject matter, in: Burlington Magazine, 1954.

Ludwig Richter (1803–1884)
The Schreckenstein Crossing, 1837
116 x 156 cm, Dresden, Staatliche Kunstsammlungen

Literature:
Neidhart, Hans Joachim: Ludwig Richter, Leipzig 1969. – Richter, Ludwig: Lebenserinnerungen eines deutschen Malers, Selbstbiographie nebst Tagebuchniederschriften und Briefen, Leipzig nd. – Ludwig Richter: Zeichnungen, Druckgrafik und Gemälde, autobiographische Texte, ed. Johannes Beer, Königstein 1984. – Ludwig Richter und sein Kreis, Ausstellungsbuch und Katalog der Ausstellung zum 100. Todestag im Albertinum zu Dresden 1984, Königstein 1984.

Edouard Manet (1832–1883)
The Execution of Maximilian, 1868
252 x 305 cm, Mannheim, Städische Kunsthalle

Edouard Manet
The Execution of Maximilian, 1867
Boston, Museum of Fine Arts

Francisco de Goya
3rd May 1808, 1814
Madrid, Museo del Prado

Literature:
Catalogue: Edouard Manet and the Execution, List Art Center, Brown University, Providence 1981. – Hamann, Brigitte: Mit Kaiser Max in Mexiko, Aus dem Tagebuch des Fürsten Karl Khevenhüller, Vienna, Munich 1983. – Hanson, Ann Coffin: Manet and the Modern Traditon, New Haven 1977. – Rouart, Denis and Wildenstein, Daniel: Edouard Manet, Catalogue Raisonné, Vol. I, Lausanne 1975. – Wilson, Michael: Manet at Work, National Gallery, London 1983.

Edgar Degas (1834–1917)
The Rehearsal on the Stage, 1873
65 x 81 cm, Paris, Musée d'Orsay

Literature:
Browse, Lillian: Degas' Dancers, London 1949. – Cabanne, Pierre: Degas, Munich nd (1964). – Guiral, Pierre: La vie en France à l'âge d'or du capitalisme 1852–1879, Paris 1976. – Merlin, Olivier: L'Opéra de Paris, Fribourg 1975.

Adolph Menzel (1815–1905)
The Steel Mill, 1875
158 x 254 cm, Berlin, Staatliche Museen zu Berlin – Preußischer Kulturbesitz, National-galerie

Literature:
Bromme, Moritz Th. W.: Lebensgeschichte eines modernen Fabrikarbeiters, Reprint of 1905 edition, Frankfurt am Main 1971. – Hofmann, Werner, (ed.): Menzel, der Beobachter, Katalog, München 1982. – Jensen, Jens Christian: Adolph Menzel, Cologne 1982. – Kaiser, Konrad: Adolph Menzels Eisenwalz-werk, Berlin 1953. – Riemann-Reyher, Ursula: Moderne Cyklopen, 100 Jahre "Eisenwalzwerk" von Adolph Menzel, Berlin 1976.

Ilya Repin (1884–1930)
Zaporogian Cossacks Composing a Letter to the Turkish Sultan, 1880–1891
203 x 358 cm, St. Petersburg, Russian Museum

Literature:
Karpenko, Maria et al.: Ilja Repin, Malerei, Graphik, Leningrad, Düsseldorf 1985. – Parker, Fan and Parker, Stephen Jan: Russia on Canvas, Ilya Repin, London 1980. – Hilton, Alison Leslie: The Art of Ilya Repin. Tradition and Innovation in Russian Realism, Ann Arbor 1979. – Repin, Ilja: Fernes und Nahes, Erinnerungen, Berlin 1970.

Pierre-Auguste Renoir (1841–1919)
The Luncheon of the Boating Party, 1881
129.5 x 172.7 cm, Washington, D.C., The National Gallery, The Phillips Collection

Literature:
Crespelle, Jean-Paul: La vie quotidienne des Impressionistes, Paris 1981. – Daulte, François: Auguste Renoir, Catalogue Raisonné de l'oeuvre peint, Lausanne 1971. – De Goncourt, Edmond et Jules: Manette Salomon, Paris 1868. – Ehrlich White, Barbara: Renoir, his life, art and letters, New York 1984. – De Maupassant, Guy: Une Partie de Campagne, Paris 1881. – Renoir, Jean: Renoir, mon père, Paris 1962. – Vollard, Ambroise: Auguste Renoir, Berlin nd.

Otto Dix (1891–1969)
Metropolis (Triptych), 1928
Centrepiece: 181 x 201 cm; outer panels: 181 x 101 cm, Galerie der Stadt Stuttgart

Literature:
Conzelmann, Otto: Otto Dix, Hannover 1959. – Giese, Fritz: Girl-Kultur, Munich 1925. – Hermand, Jost and Trommler, Frank: Die Kultur der Weimarer Republik, Munich 1978. – Kessler, Harry Graf: Tagebücher 1918–1937, Frankfurt am Main 1961. – Kracauer, Siegfried: Das Ornament der Masse, Frankfurt am Main 1963. – Löffler, Fritz: Otto Dix, Leben und Werk, Dresden 1977.

Marc Chagall (1887–1985)
White Crucifixion, 1938
155 x 139.5 cm, Chicago, The Art Institute of Chicago, Gift of Alfred S. Alschuler

Literature:
Alexander, Sidney: Marc Chagall, Eine Biographie, Munich 1984. – Chagall, Bella: Erste Begegnung, Brennende Lichter, Hamburg 1980. – Chagall, Marc: Ma Vie, Paris 1931. – Chagall, Marc: Rétrospective de l'oeuvre peint, Katalog der Fondation Maeght, Saint Paul 1984.

The publisher would like to thank the museums, archives and photographers for their kind cooperation and permission to reproduce photographic material. Besides the collections and institutions acknowledged in the appendix, we are grateful to:

Archiv für Kunst und Geschichte, Berlin: Cover, 11, 48–52;
The Art Institute of Chicago, photograph © 1994 All rights reserved: 192–197;

Artothek, Peissenberg: 12–17, 42–47, 90–94 (Blauel); 78–83, 138–143 (Martin); 24–29 (Willi); 30–35 (World Photo);
Bildarchiv Preußischer Kulturbesitz, Berlin: 6–11, 168–179;
Deutsche Fotothek/Sächsische Landesbibliothek, Dresden: 150–155;
Kunsthistorisches Museum, Vienna: 36–41, 54–71, 102–107;
The Metropolitan Museum, New York, Copyright © 1975: 18–23;

Museo del Prado, Madrid: 96–101;
Phillips Collection, Washington, D.C.: 180–185;
Réunion des Musées Nationaux, Paris: 72–77, 108–113, 132–137, 144–149, 162–167;
Scala, Florence: 84–89;
Statens Konstmuseer, Stockholm: 111;
Museo Thyssen-Bornemisza, Madrid: 120–125;
Wallace Collection, London: 114–119.